2-

Joseph Stella

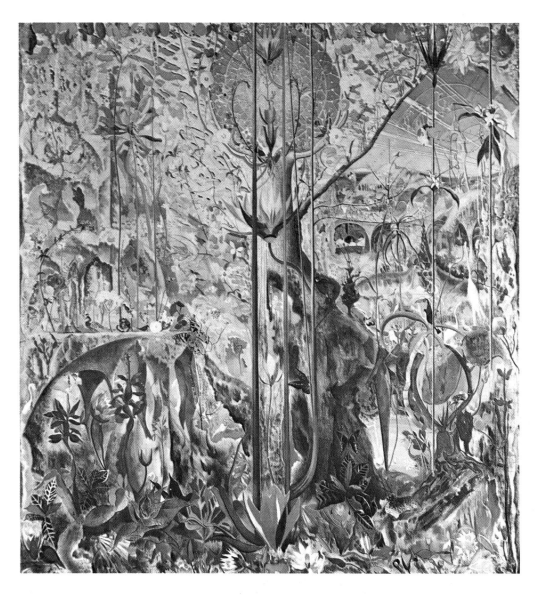

Tree of My Life (Figure 59)

IRMA B. JAFFE

Joseph Stella

HARVARD UNIVERSITY PRESS

Cambridge, Massachusetts

1970

To my Mother, Yvonne, and Karin

Nulla dies sine linea.
— The Birth of Venus (I,60) *

Preface

In 1963 the Whitney Museum of American Art held a large retrospective exhibition of the work of Joseph Stella. For seventeen years, since his death in 1946, his work had been neglected. Critics and scholars, while recognizing his major place as a pioneer in the modern movement in the United States, nevertheless had passed over his achievements with admiring but brief comment, without seriously examining the problems his work posed. Collectors, confident of their investment in an artist of rare quality, had maintained interest, but the general public had had little opportunity to recall the artist of whom Henry McBride, one of America's leading art critics, wrote, "Everything he does must be seen" (New York *Sun*, April 11, 1925). The Museum's retrospective was therefore an important contribution toward re-establishing Stella's reputation as a major American artist.

John I. H. Baur, now Director, at that time Associate Director of the Whitney, prepared the exhibition, which occupied two floors of the museum, and wrote a study of the artist.† It was my agreeable task to

* The epigraphs at the head of each chapter are drawn from Stella's writings, a few of which have been published, as indicated in the bibliography; the large mass of them, from which I have chosen those in this book, had remained buried in the artist's effects, in the possession of his nephew, Sergio Stella. The figures in parentheses (Roman I or II, followed by Arabic numerals) here and throughout this book, refer to Appendix I and Appendix II, where the full original text of Stella's writings and writings about Stella in a language other than English may be found.

† John I. H. Baur, "Joseph Stella." Since it is unpublished at present, no page references are given for this manuscript; it is referred to hereafter as Baur, "Stella."

participate in the preparation of the show, and to contribute much of the research on which Baur's study is based. This book incorporates that material and continues the research in an effort to trace in greater detail Stella's development as an artist. I have attempted to interpret Stella's art, not only in the light of what the forms and the content of his paintings show, but in terms of his character as revealed by personal writings. These documents have never been published, nor even examined; it is unlikely that they have ever before been read.

It was a scholarly thrill to discover the prose-poems, essays, jottings, and fragmentary memories of Joseph Stella. Carelessly tossed into an old carton many years ago, ragged and dusty, these odd scraps of graph paper, typing paper, ship's stationery, and backs of old exhibition catalogues record the inner life of a man whose life was his art. *Nulla dies sine linea* (I,60), Stella quotes, he thinks, from Giotto.* "My devout wish — to begin and end each day with the study of a flower," he writes, with St. Francis in mind (I,22). Scribbled, scratched out, blotted, written in his mother tongue, the racing Italian hand betraying the flow of feeling, the pages reveal the emotional landscape that is the background of Stella's paintings.

The writings from which I quote, included as Appendix I, comprise approximately 80 percent of the sheets I found. The remaining pages, which contain material that is more or less repetitive, have been omitted. In translating Stella's text I have not always indicated missing passages or words, omitted usually because of illegibility but sometimes because the missing words and phrases are only elaborations or modifications of ideas and images already expressed. I have tried to suggest the long flowing line of the artist's Italian style, and the flavor of his speech as it is recollected today by those who knew him. Some difference in style between those writings of Stella's that he himself translated into English or originally wrote in English, and those I have translated may be noted. I felt it would be impossible, and certainly contrived, to imitate Stella's use of the English language. I have chosen to translate his writings into correct English — as the originals are in correct Italian. Only those documents that Stella himself put into English will be quoted as he wrote them, with incorrect spelling and foreign syntax intact. The picturesque charm of Stella's own

* The proverb actually originated, according to Pliny, with Apelles: "Moreover it was a regular custom with Apelles never to let a day of business to be so fully occupied that he did not practice his art by drawing a line, which has passed from him into a proverb" (Pliny, *Natural History* [trans. H. Rackham; IX, 322], vol. 35, bk. 36, sec. 83).

Italianized English does not obscure its serious content, bitterness, and power.

Except in two instances, the writings are not dated, and it has proved impossible to date them with any certainty. We do not know, for example, whether a prose-poem describing the coming of morning (I,37) is a verbalization of the painting *Morning*, c. 1927 (Figure 88), written at approximately the same time, or if it was written at another time in connection with a different painting on the same theme, *Green and Gold*, c. 1930. We cannot tell whether "Mater Dei" (I,51) is contemporary with the painting *Mater Dei*,* or if Stella wrote his description many years later, in the forties, after one of his frequent trips to the warehouse where his paintings are still stored.† Andy Konitzer, the warehouse attendant, remembers him well. "He used to come here often, Mr. Stella. He was a nice man. He used to come with a little barrel, one of those little wine barrels, to sit on. And he'd sit up there in front of the storeroom, and take his pictures out, and hold them in his hand a long time, just looking at them. And then sometimes he'd sign one; even if it already had his name on it, sometimes he'd sign it again. A nice man, Mr. Stella, short, wore a soft hat, sloppy, looked something like La Guardia, Fiorello la Guardia."

Many of Stella's works are signed twice, and it seems entirely possible that he was moved to write about some of them years after painting them. Some of his personal writings were probably written years after the event they record. We know that he returned to his native village in 1909, his first visit to Italy since his arrival in New York in 1896. He recorded his reactions in pieces such as "My Birthplace" and "The House of my Father." We do not know, however, whether he wrote these at the time, shortly after, or toward the end of his life. I have therefore quoted these writings at various points where they help us to understand his personality or relate to his painting.

Two dated pieces, "Orvieto, 1927" (I,39) and "Travels, 1937" (I,34), indicate that Stella wrote over the period of these ten years, at least, and it seems unreasonable to suppose that these were the only years in which he wrote; it is far more probable that the writings extended over the second half of his life and express his mature personality.

* Works by Stella cited but not illustrated in this book are illustrated in Irma B. Jaffe, "Joseph Stella," unpublished Ph.D. dissertation, Columbia University, 1966, unless otherwise noted.

† Sofia Brothers Warehouse, 4396 Broadway, New York; *Green and Gold*, not illustrated in Jaffe, "Stella," is stored here.

A further aim of this book is to place Stella's art in the framework of contemporary painting in Europe and the United States. I have tried to evaluate the strengths and the weaknesses of a stance that straddled the Atlantic Ocean, with one foot in the most advanced industrial civilization in the world, and the other in the living soil of centuries-old tradition. My goal has been to produce a full-length portrait that comprises the three major viewpoints from which I have studied Stella: his art, his personality, and his relation to his contemporaries.

A work of research depends for help on many persons, in varying degrees, and no apportionment of gratitude can convey the unqualified appreciation felt for each instance of assistance. It is not only to those named here, but to many others — collectors of Joseph Stella's works, museum personnel, librarians, art dealers, friends and acquaintances of the artist — that I wish to express my sincere thanks.

My first and greatest debt is to Professor Meyer Schapiro, of Columbia University, who suggested the subject. His awesome standard of scholarship has been a constant goal; his careful reading of the early drafts was vital to the style, form, and content of the finished manuscript. Professor Theodore Reff, of Columbia University, and Professor Robert Rosenblum, of New York University, were extremely generous with their time and contributed valuable suggestions for revisions and additions.

John I. H. Baur, Director of the Whitney Museum of American Art, was another source of inspiration to me for his scholarship and discriminating taste. It was a privilege to work with him for over a year in preparing the Stella exhibition at the Whitney in 1963, and I cannot overstate the continuing benefit the knowledge gained during this association has been to me.

If to the foregoing I owe so much of the spirit of this book, to Sergio Stella and Bernard Rabin I owe a good part of the body. Mr. Stella's devotion to the memory of his uncle is great. I am deeply appreciative of his trust and generosity in allowing me unlimited use of Joseph Stella's papers. Mr. Rabin of the Rabin and Krueger Gallery, Stella's art dealer for a number of years in the thirties, lent me his collection of newspaper clippings and catalogues; his cooperation in answering my many questions and in showing me the works by Stella in his personal collection as well as those in the collection of the gallery, have put me deeply in his debt.

Robert Schoelkopf has been helpful in showing me his Stellas, giving me leads to collectors, and allowing me to use the Fornaro manuscript which he bought from the Misses Hotchkiss. Stephan Bourgeois regaled me with stories of the early days of modern art in the United States, in which movement he participated as one of the few courageous and discriminating dealers who brought the new art before the public, and kindly lent me his catalogues of exhibitions in which Stella took part.

Among my greatest debts is that owed August Mosca, a devoted friend and pupil of Stella's. I long ago gave up keeping a record of my conversations with Mosca about Stella. His evident pleasure in talking about his dear friend and revered teacher allayed some of the anxiety I felt about imposing so heavily on his time. We saw the Stella Retrospective together several times; on each occasion he would point out this or that feature of technique or approach: "Start with the eye, in portraits — the eye is the most important feature," Mosca quoted Stella. Mosca's correspondence with Stella and his short manuscript, quoted in the text, have been in my possession since our first meeting, in March 1962.

A fellow artist as well as a personal friend, Moses Soyer's memories of Stella were acute and revealing. He and his wife, Ida Soyer, added much to my understanding of Stella in his late years. Several long talks with the sculptress Clara Fasano were of inestimable value because of the vividness of her recollections and the vivacity of her account. Aristodemus Kaldis was another artist who contributed several colorful stories about his friend Joseph Stella.

Stella's closest friend in the pioneering years following the Armory Show, the late Edgard Varèse, was gifted with a memory that selected those special traits of character and those revealing moments that make the past live. My interview with him and Mrs. Varèse was crucial to my knowledge of Stella's personality. Marcel Duchamp provided insight into those first years of the abstract movement in American art when he and Stella were closely associated.

Mrs. Mildred Baker, Associate Director of the Newark Museum, was a friend of Stella's during the twenties; she helped fill in the rather sketchy picture one has of the artist's personal life. Professor William Gerdts, formerly Curator of Painting and Sculpture at the Newark Museum and author of the book on Stella's drawings, gave me every opportunity I requested to study the Stella paintings in the museum collection.

Preface

I want to thank Professor George Heard Hamilton for permission to study the Stella material in the Yale University Library, and David R. Watkins, formerly Chief Reference Librarian there, now Director of Libraries at Fordham University, for permission to publish that part of the material that I have used. I must also express my deep appreciation to Professor Gernando Colombardo of Fordham University. Without his determined effort to read the all but illegible passages in Stella's Italian writings, a large part of those writings could not have been included in this book. Since I consider the writings a significant element in the study of Stella's painting, my gratitude for his assistance is profound. Mrs. Beulah Harris must know how much I appreciate her editorial contribution. I thank Mrs. Ann Louise Coffin McLaughlin for her suggestions in getting the manuscript to press.

To my daughter, Yvonne Schwartz, I am indebted for the enlightening discussion we had on several important points as a result of the penetrating insight she brought to her reading of the manuscript. To her, and to all, I give humble thanks. Especially, I thank my husband, whose interest in my work has been essential. His encouragement, patience, and respect for my task were gifts offered in abundant quantity.

Fordham University　　　　　　　　　　　　　　　　　　　Irma B. Jaffe
October 1968

xii

Contents

Illustrations

Illustrations

Photographic Credits

Angiporto Galleria, 86, 90; Oliver Baker Associates, 33, 35, 69, 76, 104; Lillian Silodor Bristol, 87; Carlan Photo Service, 14; Geoffrey Clements, 21, 43, 99, 106, 110; Frank W. Coggins, 94; Sam Denburg, 1–6, 11, 22–23, 27, 38–39, 51–52, 67–68, 108; *Il Progresso Italiano*, 25; Indiana State University Art Department, 74; Iowa State Education Association, 59, 79, 84; *Italiani pel Mondo*, 83; Thomas Kay Studio, 10, 16, 58, 105; Lewis Studios, Inc., 109; *The Little Review*, 32, 40, 54, 77; *New York Sun*, 20; Karl Obert, 107; *The Outlook*, 7–9; Rabin and Krueger Gallery, 17, 19, 34, 92–93, 95–96, 103; Percy Rainford, 55; John D. Schiff, 15, 24, 26, 29, 36, 48, 53, 60, 89, 111–112, 114; Soichi Sunami, 31, 57, 65, 71; *The Survey*, 12–13, 18, 41–42, 45, 61, 63; Eric Sutherland, 91; Charles Uht, 82; University of Nebraska Photographic Productions, 37; Bill Witt, 28; Yale University Art Gallery, 30, 44, 46, 49, 66.

Joseph Stella

In the life of every true artist
there comes a moment when a whole
hidden world lying in the abyss of
his soul demands to come forth into
the light and be revealed.
— Thoughts (I,43)

I

Introduction

Joseph Stella's art, like his personality, is not easy to understand. Even a cursory glance at his painting and writing makes one aware of conflicting elements in his personality and his art that arouse curiosity. Those who wrote about him in his lifetime frequently commented on the paradoxes, ambiguities, and contrasts felt in the man and his work; everyone I interviewed expressed similar feelings.

Some writers attributed the contradictions to Stella's having imposed the new concepts of art on a temperament that was not naturally disposed to them. A reviewer of Stella's first one-man show of drawings and paintings, while sympathetic to the artist's earlier work and proud of the young immigrant's success in the United States, was moved to wonder how the "Stella who found his hand so docile in disposing his colors . . . and giving form to landscapes and figures . . . can be now a post-impressionist? . . . he can not, he cannot renounce the past." He warns Stella: "An artist who works as others do, *because* they do it that way, deforms his character and compromises himself" (II,1). Others did not try to account for what they found ambiguous, or unresolved; Ernesto Valentini, critic for the *Bollettino della Sera*, hoped and predicted that

"sooner or later Stella would find his *true* artistic soul, which slumbers apparently in his subconscious, waiting only to be awakened" (II,2).[1] Henry McBride, trying to cope with the problem of evaluating the artist and understanding the man, gropes for something he knows evades him. "As a critic, I do not say an instant 'yes' to everything he produces. Such work, delved out of a man's inner consciousness, sometimes requires time on the part of the spectator. . . . Who could presume to know his way about in the unknown world that lies inside another's brain?" [2]

The two-sided nature of Stella's personality most forcibly struck Antonio Aniante, interviewer for an Italian newspaper,[3] who explained the dichotomy on the grounds that Stella was in a sense a foreigner wherever he was, in Europe or the United States.

> Having left as a young man with a Latin soul immersed in classical studies, he returns to the old country as an American painter. Two-sided, alienated, he views the greatness of America with the eyes of a European, and the gentleness of the Neapolitan sea with the eyes of a stranger. It is here we find the secret of Stella's art. Two instincts clash in him, two contrasting elements, two passions; two homelands crowd his creative thought; Europe and America torment him and weigh him down with daily care. The gigantic Brooklyn Bridge and the tiny little bridge of *Capo di Giano* of his native village Muro Lucano give him sleepless nights. Seated in a blaze of light, looking at the White Way, Broadway, with his palette and easel before him, the evening breeze carries to him a song of Posillipo from a small organ that has strayed to the Little Italy of the Bronx. Feeling, which is missing in the pragmatic spirit, is strong in the emigrant painter. (II,3)

An art critic for the Paris edition of the *Tribune*, B. S. Kospoth, began his article on Stella with the comment that he "is a painter with a paradoxical passion for such apparently irreconcilable things as skyscrapers, steel bridges, birds, fruits, African jungles and Italian landscapes, which he combines in compositions of singular beauty." [4]

There is hardly an aspect of human or artistic experience that does not confront us with a tangle of contradictions in Stella. Edgard Varèse, his close friend for many years described him as "sometimes friendly, and sometimes hostile — you never knew, with Stella, how he would be, the next time you saw him. He was in some ways so refined, so delicate — a

purist — and then he could be so vulgar, obscene. And physically, too, he was a paradox — big, fat, heavy-bodied, and yet so graceful. What beautiful hand gestures he had!" August Mosca, devoted pupil and friend of his late years, mentions the sweetness of Stella's nature and his sudden rages. Robert Schoelkopf, a young art dealer, remembers that he was, on some occasions, violently and vociferously passionate in his defense of Mussolini, while Bernard Rabin, Stella's dealer during the thirties, remembers equally his fierce denunciations of the Fascist leader, and Mosca claims that Stella was a "political liberal."

Capable of every kind of verbal sacrilege, according to Varèse, never known even to enter a church, Stella reveals nevertheless a deeply religious, mystical nature, both in his paintings and his writing. Ferdinando Santoro, an Italian critic, asks: "Who, today, dares to drape the Madonna in the graces of art? Stella. And perhaps he alone. To him belongs that special state of pure fervor. And from such a state of the painter's poetic soul is born the *Virgo Purissima*" (II,4). But Stella shows himself at times as much a pagan as religious mystic. Antonio Porpora, in an article written during one of Stella's visits to his native land, observes that "the artist still finds in Italy the divine inspiration of our ancient, native gods. The glorious tradition of our frescoes gleams again. The paganism of our sunny countryside rises once more!" (II,5).[5] He goes on to comment on the dual qualities of "Franciscan Christianity and pagan pantheism" in Stella's artistic sensibility.

John I. H. Baur conveys the essence of these critical and personal observations:

> With a truly awesome vitality, Stella moved from style to style, from realism to abstraction, forward and back, mixing media, painting simultaneously in different manners, reviving older styles and subjects years later. The result is a nightmare for the art historian.
>
> The complete Stella remains, as perhaps all good artists must, an enigma compounded of widely conflicting elements. How the traditionalist of the early drawings attained, at one leap and with no visible transition, the mastery of an advanced abstract idiom is remarkable enough. How the esthetic sensibility that shaped the collages could also delight in *The Apotheosis of the Rose* is even more baffling. Such contradictions and stylistic gyrations abound in his

work, without apparent explanation other than the romantic exuberance of his nature.[6]

Prudence is indicated, then, in the face of Henry McBride's warning, "who could presume to know his way about in the unknown world that lies inside another's brain?" and Baur's comment that there is "no apparent explanation." Nevertheless, with Stella's musings and memories before me, I have tried to understand and explain this puzzling man and his art. For, reading his words, it seems that the hand with the pen illuminates the hand with the brush.

Everything around us smiles with the
assuring smile of Divine Friendship.
— Nostalgia (I,3)

II

Growing up in Muro Lucano 1877–1895

When an Italian speaks of his *paese*, he does not mean Italy; he means
the very special part of Italy where he was born. Joseph Stella's *paese* was
Muro Lucano, not far from Naples, a mountain village of a few thou-
sand inhabitants in La Basilicata, a province whose history goes back
to the Byzantine conquests of Basil II in the tenth century.[1] Its people
cling to it like the houses cling to the rock cliffs on which the village is
built. Even far away in the New World, immigrants from Muro Lucano
formed an association, La Società di Mutuo Soccorso Muro Lucano, keep-
ing alive for a while in the new home the mores and memories of the *paese*.

Stella remembered his birthplace, remembered, even more acutely than
most, a childhood surrounded by its mountains, valleys, rivers, its Peru-
ginesque trees, its people, and its legends.

> I thank the Lord for having had the good fortune to be born in
> a mountain village. Light and space are the two most essential ele-
> ments of painting, and my eager art took its first flights there in that
> free, light-filled radiant space. My native village, Muro Lucano, in
> the harsh Basilicata, wedges its stubborn roots in the tortuous viscera
> of a rocky hillside. Its sturdy houses are constructed of living rock
> and fieldstone, and, pulled together of rocks scattered all around,
> they stand in the form of an amphitheater, back to back, leaning against
> each other like rows of sentinels ready for an attack, protected from

above and watched over by the crenellated towers of the medieval castle that encloses within its sad dark walls the mystery of the frightful murder of Queen Giovanna.[2]

At its side the mother church raises its short stocky bell tower, and the tolling of its bell that floods the air with joyous clangor at Easter counts the rosary of hours for the small village, marking out with appropriate notes the happy or sad events of life. . . . (I,1)

. . . how tenuous the threads that bind us to the life of exile endured for years — more tenuous than mist that vanishes in the wind — when suddenly there leaps before our eyes, intact, clear, and distinct, our birthplace, incised by our unfaltering memory. . . . (I,2)

My native village is situated high up in the cliffs, with the spreading countryside rising all around. The room where I sleep opens onto a large terrace which, projecting into space, gives me the sensation of a motionless balloon from which, suspended in air, I have a vertiginous, limitless view of an immense valley that falls away into the infinite, and climbs again into the azure distance, indenting the rumps of the massive blue mountains that hold suspended, enchanted, the spirit of adventure. . . .

And like the blue spots on the misty horizon, through the various sounds that suddenly surge up all around, episodes and fragments of that life of so long ago appear. A rhythmic sound rings out with the clattering steps of the wood-shod donkey on the pavement, and the vision is lively and gay, racing with the joy of sparrows through the springtime-green meadows, through the rows of arbors heavy with mature grapes. From the distant countryside that stretches away into the infinite come voices of young peasants. The green crystalline distance clears their voices of all harshness, and transmits only the dreamy, subtle, silvery thread of sound. (I,4)

Joseph Stella was born on June 13, 1877, the fourth of five sons in a middle-class provincial family.[3] His father, Michele Stella, was a lawyer who, family tradition claims, was more apt to see the opponent's side of a litigation than his own client's; as might be expected he did not become a wealthy man. But Michele's respect for education and professional training was strong, and his five sons were sent to school through the higher levels. Antonio, the eldest, and Giovanni, the youngest, became doctors; Luigi, the second son, an army career man, graduated from the University

6

of Modena Military School; and Nicola, the third son, became a pharmacist. Joseph's mother, Vicenza, seems to have been the typical Italian housewife and mother. There were no surviving daughters in the family.

Stella's boyhood was spent in the small town of his birth. According to family accounts he was a lonely child, fat and clumsy. In all his many memories of childhood, there is not a single reference to other children, to games with playmates, confidences exchanged, adventures shared. He recalls instead his inner life, the emotions experienced alone, in secret. One experience stands out perhaps above all others:

> I remember the bursting out of art in my early childhood. It was like a sudden flash of light, thunderous as some celestial torrent — and my poor soul, overwhelmed, trembled like one of those slender stalks in the furious explosion of an autumnal golden sunset, atop one of my mountains. My soul leaped with joy, as at the unexpected discovery of a real treasure, the treasure of the Holy Friend, the consolatrix whom I must always have loved, and who must always have been smiling upon me, who must always have strewn with roses the path of my life. And overflowing like a filled vase, I thrilled with the secret delight of one who knows that for him alone there exists an eternal fountain of heavenly joy, of one who keeps hidden, for the consummate pleasure of his senses, a hopeless love, unknown to anyone. The secret of that pleasure — its possessiveness, to which he remains bound with jealous tenacity. (I,6)

The pleasure of his discovery may have remained a secret; the discovery of his artistic bent did not. Many years later, at the height of his success, the artist recounted to his friend and fellow-artist, Carlo de Fornaro, the story of his earliest recognition. When Joseph was in his early teens, De Fornaro writes,

> Young Stella had observed that there was no representation of the exploits of the local saint in the village church. He conceived the ambitious idea of depicting some miraculous incident in the life of San Gerardo da Maiello and with tremendous energy and faith carried it out to a successful issue. The whole village and the peasants of the surrounding mountains visited the precocious effort of the incipient Raphael. The Church and the State visited the painter and his painting. The work was so naive, but at the same time so sincere in its religious fervor, that all decided unanimously to honor the

youthful artist by carrying the painting with great ceremony from his home to the church. From that day on Joseph Stella became the painter laureate of Muro Lucano of the Basilicata.

In the same article, De Fornaro recounts another of Stella's boyhood memories:

> At the age of eight he was sent to school, which he hated with an intense, white rage, since he believed schools were a punishment for man's original sin. One day he was looking out of his window towards a cherry tree in full bloom. A bird flew into the classroom. Young Beppino thought the bird was singing to him, "Come and have some fun outside."
>
> Impelled by a power greater than discipline, he rushed up to his teacher.
>
> "I have to go out," he shouted excitedly.
>
> "And why?" asked the amazed pedagogue.
>
> "He is calling to me!"
>
> "Who is calling to you?"
>
> "A bird!"
>
> The teacher struck him a blow over the shoulders, but young Stella bit savagely into the man's hand and rushed madly out of the school to join the joyful little bird.[4]

These anecdotes establish the image of Stella as a young boy set apart from those around him. In the first he is an object of admiration, in the second, of violent attack, to which he responded "savagely"; in both cases he sees himself as alone, different, and surrounded. His boyhood loneliness is expressed in a fragment of an outline for an autobiography in Italian, planned but never written, in which Stella writes of his early "hatred for closed places, the boarding school.[5] Love of solitary living, in the fields, mountains, hillside, in the wind and sun, in the scorching afternoon with the shrill chirping of the birds" (I,7).

Perhaps one of the most revealing passages is that in which Stella describes the awakening of sexual passion:

> From the tree of my young budding life, fragrant with flowers and harmonious with shining angels intoning the psalms of spiritual joy, there suddenly broke out, bristling and spiky with thorns, the first red fruit of passion, acrid, sharp, bitter, but heavy with deli-

cious, woody perfume. Into the tender blue and yellow of spiritual
happiness this red poured itself with violence, intense, thick, bloody,
and my whole being, possessed as if by a sudden storm, shook,
churned, twisted like a slender treetrunk in March, in the violence,
the shocking fury of every new tempestuous gust. Many blossoms
fell.

Desire rose, imperious, demanding, becoming more acute, sharper
each day, urgently claiming the immediate satisfaction of its needs.
And all at once, spurred by hunger and thirst, the conquest of my
prey became the daily objective of my life. In the torment of the
breathless, stubborn chase, the woman hunt, a dumb numbness would
hold me still, and I would feel myself turning violently red. In the
sleepness nights there burned like an eternal flame before me, like a
lure, the vision of virgin breasts, firm as shining crystal globes, the
nipples erect, pink, temptingly displayed before me on a marble table.
In my excited imagination I held them in my hands, my trembling
fingers tracing the full, velvety modeling of their contours. Secretly
I sharpened my knife, the knife of my violent desire. I cut them, and
as I opened the mysterious fruit I felt the violent spasm of relief and
liberation. (I,8)

The full significance of such fantasy is sharpened by the fact that this is
the single passage in all of Stella's writings that refers directly to sex. No-
where else is there a description of, or reference to, a woman, real or
fancied, never an expression of longing.

As a boy at school young Joseph "began to draw everything of interest,
and was always busy in making likenesses of his classmates." [6] His father
was determined that Joseph, however inattentive a pupil, should remain in
school. One can well imagine the struggle between the rebellious adoles-
cent who hated restraint and authority of any kind and the father who
was determined to educate his sons. It is not known with certainty where
Joseph went to school after the elementary grades, but it is most likely
that he followed in the footsteps of Antonio, who had been sent to a
liceo in Naples when he was twelve years old. The same school probably
awarded Joseph the Licenza Liceale to which he refers in "Discovery of
America." [7]

In his petition for naturalization, Stella stated that "he had entered the
United States on March 1, 1896, at the port of New York on the S.S.
Kaiser Wilhelm der Grosse, from Naples, Italy." [8] Although we do not

have a picture or description of the young immigrant, an impression of what he might have been like may be gained from the description of the young southern Italian in "The Broken Toys," a short story by Corrado Alvaro, one of Italy's leading writers of the mid-twentieth century, a contemporary of Stella's and also from the south of Italy:

> a young man, a student by appearance, of that intense darkness of certain South Italians on whose faces the clearly outlined and thick eyebrows open out like two feathers . . . he was of modest social position, but . . . he had gotten a summary education living in cities and attending universities . . . he moved, half embarrassed and half distinguished, with an acquired distinction and a natural embarrassment; his head full of . . . those distinctions and cavils which give South Italians an expression of avidity, a flash of pride in their eyes, as if they were sharers of the secrets of the past. South Italians feel the past strongly; they stand in it as in the shadow of a mother. They stand in it as if there were nothing more to say in the world and as if all had been said.[9]

Soon I became very busy in
drawing from the striking
characters that I could hunt
in the streets, in the parks,
and in the lodging houses of
the slums.
— Discovery

III

Young Artist in New York 1896–1908

From the *Kaiser Wilhelm*, carrying her packed load of immigrants who
were arriving in the United States by the tens of thousands in those days,
the eighteen-year-old Joseph Stella stepped into his future. For him, New
York was the city of Poe and of Whitman, poets he had read and for
whom he had "the greatest admiration";[1] but even so prepared, the im-
pact of this vertical city was overwhelming. It was to implant in him the
seed of the idea that, fertilized, nourished by many other experiences,
blossomed at last into the great creation of his life, *New York Interpreted*.

Antonio Stella took charge of his younger brother.[2] He sent him first
to study medicine and then pharmacology, but Joseph, whose heart was
set on art, would not submit to the discipline of the schools. Antonio sought
advice from an artist friend, and Carlo de Fornaro recognized the natural,
though undeveloped, talent of the aspiring painter; so, late in 1897, Joseph
was enrolled at the Art Students League. It was probably to this brief
experience that he referred in an interview published in the New York
Sun (May 25, 1913): "One of the objections young Stella had to the pro-
fessors' teaching was a rule forbidding the pupils to paint flowers. There
were no rules forbidding the pupils to paint vegetables or dead fish. This

rule came into vogue for the simple reason flowers were pretty and old maids were in the habit of painting them." This amusing comment shows the beginnings of Stella's lifelong enjoyment of flower painting.

According to the school's records (which are not exact), Stella spent only a few months some time during 1897–98 at the Art Students League. Later he enrolled in the New York School of Art, where he came to the attention of William Merritt Chase. Stella also painted at Chase's summer school, and the artist-teacher "did not hesitate to characterize him a second Manet, when at Shinnecock Hills, he saw one of Stella's portrait studies. He said before the class: 'Manet couldn't have done it any better.' All the pupils broke into applause." [3] Only a few paintings of this period, showing the bravura-type of brushwork and the "dark impressionist" influence of Chase, still survive, such as *Laughing Man* and the *Nude* (Figure 10).

There is a problem in connection with the exact years of Stella's attendance at the New York School of Art. Chase closed the Shinnecock Summer School in 1902. It is likely that Stella left the Art Students League in 1898 and enrolled in the New York School of Art shortly thereafter, since he must have been at Shinnecock sometime before 1902. He explains in "Discovery" that he won a scholarship for one year's free tuition, but it is not clear whether this was a second year. In "Notes About Stella," we read that "After one year, Stella sent a picture (the portrait of an old man) to the American Artists League. It was accepted and hung in the Vanderbilt Gallery." Actually, Stella exhibited a *Sketch of an Old Man* in the Society of American Artists' twenty-eighth and last annual exhibition, March 17–April 22, 1906. [4] This painting must have been *Tarda Senectus* to judge from the reference in *Il Progresso Italo-Americano* (March 21, 1937) that Stella exhibited one of his first oils, *Tarda Senectus*, at the Society of American Artists *con grande successo*. Stella's work drew the attention of the *American Art News* critic who wrote: "Among the best pictures at the Society of American Artists are canvases by William M. Chase, Robert Henri, Kenneth Hayes Miller, instructors in the New York School of Art, and Joseph Stella, Frank Buttner, George Bellows, J. W. Koopman, Rockwell Kent, and Kathryn T. Raymond, students in the school." [5] This places Stella in the school in 1906, and we have a lacuna of eight years between his enrollment at the Art Students League which he attended so briefly, and his presence at the Chase school. The stylistic closeness to Chase exemplified by *Laughing Man* and *Nude* suggests, how-

ever, that he studied at the school around 1900–1902, and exhibited as a guest in 1906; *Tarda Senectus* reveals a shift away from the influence of Chase.

Formal training was not Stella's principal preparation for an artistic career. Rather than work from studio models, he preferred, in these early years, to sketch "the striking characters that I could hunt in the streets, in the parks, and in the lodging houses of the slums . . . to catch life flowing unawares with its spontaneous eloquent aspects, not stiffened or deadened by the pose." His approach to a subject was conditioned by "the forceful, penetrating characterizations of Mantegna's engravings and the powerful dramas depicted for eternity by Giotto and Masaccio." [6] He searched everywhere for "tragic scenes."

In Naples, Stella must have seen not only examples of Italian Renaissance masters but also Italian, and especially Neapolitan, painting of the nineteenth century. The emphasis in much of that art was exactly on those aspects of life — picturesque poverty, rusticity, pathos — that attracted Stella and appear in his work at this time. The academic nude, too, was still a mainstay of the nineteenth-century Italian painter's repertory, and Stella was probably influenced by the kind of painting he doubtless had seen by a Giacomo di Chirico or a Gioacchino Toma, both southern Italians of previous generations. Toma's work in particular suggests a possible influence on Stella, drawing on the lives of the lowly for subject matter, idealizing figures and investing them with a kind of simple, direct humanity that can be termed "primitive." Enrico Somaré does so term it, and elsewhere describes this Neapolitan school as "panoramic with the art of Posilippo, naturalistic with Filippo Palizzi, melodramatic with Domenico Morelli, fantastic with the eye of Edoardo Dallbono, sentimental with Gioacchino Toma." [7]

In New York, in the first few years of the century, the younger, more adventurous painters were discovering a new mine of imagery in the streets of the city. The sense of raw life and spontaneous emotions characterizing the immigrant society of poor Jews, Italians, and Irish that poured from the steerage into the melting pot attracted the young artists who had come under the inspiring influence of Robert Henri at the New York School of Art.[8] The immigrant community's freedom from Victorian patterns of respectable behavior and middle-class refinement coincided with those Whitmanesque concepts of democracy that conditioned

13

the thought of progressives in that period. The half-century of the common man had begun, and beauty's face became moral in the dignity and simplicity, the suffering and the fortitude of the poor and humble, or charmingly picturesque in the quaint, almost rustic atmosphere of their lives.

Did Stella see the East Side genre painting of Jerome Myers or the Daumier-inspired work of Eugene Higgins? He probably did. What was his reaction to the group of city realists, known after 1908 as the "Revolutionary Black Gang" or "The Ash Can School" by some, or by others as "The Eight"? * Its leader, Robert Henri, was teaching at the Chase school during part of the time Stella was there. The young artist doubtless frequented the galleries, and surely included the few where the progressives were exhibiting between 1901 and 1907 — the Alan Gallery, for example, where Glackens, Henri, and Sloan exhibited, or the National Arts Club, where Davies, Glackens, Luks, Henri, and Prendergast were shown.[9] But I am not persuaded that the American realists exerted a decisive influence on Stella's art. Similarities existed because sensibilities of the period were ready and disposed to respond to this new subject matter, and because the dominant old-master influences of the period — Rembrandt, Hals, and Velásquez — were felt by all of these artists as well as by the majority of those working in Europe.[10] The differences between Stella's work and that of the American realists are more significant than the similarities. As Meyer Schapiro points out, "Henri, Luks, Sloan, Shinn, Glackens, Bellows . . . approached their subjects with a rapid, sketchy, illustrator's style repugnant to the traditional draftsmen; often shallow, it was a frank style, adapted to the kind of perception their content required. Their awkward composition was less calculated than the composition of the schools, but more natural and with abrupt, surprising contrasts." [11]

Stella's early drawings are not journalistic, even when he is actually reporting; there is a deeper emotional level in his characterizations at their best, or a more sentimental one in others less successful. The choice of subject and the depth of feeling in *The Cripple* (Figure 14), the textural quality of the coat of the *Old Man, Seated* (Figure 5) convey Stella's love and sympathy for old things and old people.

* "The Eight" consisted of John Sloan, George Luks, William Glackens, Everett Shinn, Maurice Prendergast, Arthur B. Davies, Ernest Lawson, and Robert Henri.

Schapiro continues: "This American art sprang from an ever growing sentiment of freedom, the joys of motion and the excitement of the city as an expanding world of gigantic creation and the ceaseless play of individual lives, which Whitman had celebrated and which now offered themes and a viewpoint to Dreiser's tragic novels."

Although Stella's art shares some of these responses with that of Henri and his followers, the emphasis differs, for Stella is motivated in part as an immigrant who identifies with the everyday life of the realists' subjects. Years later he expressed the basis of his claim to special insight about New York to Frank E. Washburn Freund who echoes him, asking: "Who can describe New York? Who can bring its essential nature to representation so that the viewer feels: this is the city . . . who can do this? A native hardly; he would lack the moment of wonder, the moment of actuality; he would see particulars. A foreigner, however, such as Joseph Stella, was the right man for the job" (II,17).[12]

While the American-born painters, under the influence of Duveneck and Chase, had derived a style leaning primarily on Hals and Velásquez that was well-suited to express their response to the vitality of popular life, Stella was drawn more to Rembrandt. This is shown in a number of youthful works in which the choice of an aging model and the treatment of light falling on the figure to bring it out of the dark ground that surrounds it, however inexpertly executed, reveal the Rembrandtesque leanings of the young painter. This influence characterizes the first decade of his painting, judging from the few works that have survived [13] and from newspaper reviews of Stella's first retrospective exhibition, in April 1913, at the Circolo Nazionale Italiano. Agostino de Biasi, critic for *Il Progresso Italiano*, wrote:

> The first room contains the work that Stella executed partly in America and partly in Europe in his academic period. They are figures that reveal in him a mastery of color, a sureness of touch and the capacity to express the spirit of the subject. What is striking is the variety of types that leap out from the dark backgrounds under the brush of the artist who loves to linger over the minute details of the faces and hands. *The Old Woman Praying* (International Exhibition, Rome 1911) may be remarked for its solidity and representational ability, for the rightness of tones and the evidence of psychological character. (II,6)

Ernesto Valentini, reviewing the same show for the New York *Bollettino della Sera*, remarked: "If you ask, however, which canvases are the best, those of the first room or those of the third, I would be tempted to answer with a paradoxical and exaggerated comparison saying that between the pictures of the old woman, the interiors, the nocturnes, of the first room and the post-impressionism of the third, there is the same difference as between Rembrandt and Matisse" (II,7).

Three factors, unrelated to purely artistic influences, were decisive in Joseph Stella's early style and choice of subject: the reality of his life as an immigrant; the needs dictated by his personality; and Antonio Stella's concern and activity on behalf of immigrants.

Between 1900 and 1909, Stella lived on the Lower East Side of New York, in the heart of immigrant New York — the Bowery. The contrast between "the free, easy and sunny life of Naples" and "the ugly squalor" of his new surroundings was described by Stella to Carlo de Fornaro as a "contrast of light against darkness and shadows." It was "unlike the Neapolitan surroundings where cheap and excellent wines flowed like freshets; the drinking in his new surroundings was cheap firewater and as a consequence violence, brawls and sluggings were daily and nightly occurrences." [14] The artist did not have to go far to satisfy his "preference to curious types, revealing with the unrestrained eloquence of their masks the crude story of their life." [15] He prowled the streets, sketch pad and pencil in hand, alert to catch the pose of a moment, the detail of costume or manner that told the story of a life.

The difficulty of dating the drawings of these years, as with much of Stella's work, is complicated not only by the fact that the artist worked in many styles simultaneously, but that, even if a drawing bears a date, it may not be reliable, for there is no guarantee that it was not added afterward. The problem of accepting the dates — as well as signatures — that appear on Stella's works can be seen by examining Figures 1 through 4, and Figures 6 and 11. Figures 1, 2, and 3, all signed, are dated 1900; but each reveals a different approach to form and texture, although the hand of the artist can be recognized in each, particularly in the way the shapes produced by the shadows are often pulled out to end in a point, like a leaf or a flame. In Figure 6, *Standing Young Girl*, the technique is loose and light in the rendering of the dress, where the main interest lies, sharper in the drawing of the face. In Figure 3, *Head of a Man with a Hat*, the

drawing is even looser, with the outlines of the forms produced entirely by means of shading rather than by drawn contours. In Figure 4, *Head of an Old Man VIII*, the drawing is tighter and the forms are more fully described and have more weight. The elongated, pointed shape is least noticeable in Figure 4 and most prominent in Figure 6. The latter is signed "Joseph Stella," while Figures 3 and 4 are signed "G [Giuseppe] Stella," suggesting an earlier date, when he was still likely to think in Italian. Although Figure 1, *Head of an Old Man V*, is signed Joseph Stella and dated 1898, the signature and date are written with a sharper pencil than that used in executing the drawing. Figure 11, *Face of an Elderly Person*, in chalk, reveals an approach to plastic relief and textural effects similar to Figure 1, allowing for the difference in media, but is dated 1907 and signed in a style consonant with that of the drawing.

Stella's interest in meticulously rendered wrinkled, weathered surfaces seems to belong only to the early years. He applies this technique not only to the living models, but to other subjects such as the *Bark* (Figure 2), signed and dated 1900. A spread of years from approximately 1900 to 1907 is suggested for this style, although we must be cautious in fixing this or any other style of Stella's between specific dates. Stella's wide technical range is evident in his earliest published works — drawings for *The Outlook* and illustrations for Ernest Poole's first documentary novel, *The Voice of the Street*.[16]

The Outlook drawings consisted of a series of sketches by Stella which formed a small brochure within the body of the magazine. The first page, which featured the title "Americans in the Rough" over the illustration of *The Gateway* (Figure 7), was followed by full-page drawings of *A Native of Poland, Italians, A German, Irish Types*, and *A Russian Jew*. *The Gateway* centers on a vertical architectural element, the gateway through which the immigrants are passing. The dramatic eye of the artist is evidenced in the way he focuses attention on this center passageway, suggesting a kind of mouth into which the little people are being fed. Significantly, even at this early stage and lacking the stylistic instrument that Cubism would later provide to give full expression to his vision, Stella responded to the geometric pattern of the wires against the sky in the background. This early, representational work shows some of the preferences that would appear more fully developed in the abstract and stylized paintings of his mature years, such as the emphasis on the vertical axis

and the silhouetting of sharp-edged forms against the sky seen in *Moon Dawn* (Figure 55) and *Full Moon, Barbados* (Figure 105).

The style of the figure studies ranges from *A German* (Figure 8), softly modeled to bring out the firm structure of the head, with lights and darks rather evenly distributed and narrowly graded, giving an air of quiet resolve to the character, to *A Russian Jew* (Figure 9), dramatically rendered in heavy blacks accented with sharp-pointed forms of light, flattened up against the picture plane, looming, oversized, a tragic image with the half-seen, cloaked, Goyesque head over the left shoulder. In this series, Stella's skillful delineation of national characteristics is like the performance of an actor who, transforming himself by a subtle combination of gesture and facial expression, portrays a variety of characters instantly recognizable as types. The illustrations for Poole's novel, similar in range, do not come up to the level of these drawings. Perhaps their expressiveness was weakened by the sentimental narrative they were designed to accompany.

On December 6, 1907, the country was shocked by a mining disaster which decimated the working population of Monongah, West Virginia. *The Survey** sent reporter Paul V. Kellogg to the scene, accompanied by Joseph Stella, who was to illustrate the account of the tragedy. Kellogg's companion must have interested him for he found time in the story he wrote to describe him and his reaction to the dreadful scenes they witnessed together. His fellow traveler was Naples-born,

> bighearted in his love for humble folk, and his ears caught the judgments being passed by these peasants from the Abruzzi, from Terra di Lavo — and Calabria . . . whose words broke off in sighs — sighs, he told me, "for the fate met by their brother workers, and for the destitute condition in which so many families had been left. Today, tomorrow, and God knows 'til when, these laborers are to be grave-diggers. That is the new mission imposed on them. Ignorant they are, these men, but they know the significance of this new job. They know the treasure of love and hope that they are going to bury along with

* Cited in the Union List of Serials (third edition) as *The Survey*, from December 1897 to May 1952, the title of this journal actually changed several times. From December 1897 through October 1905 it was known as *Charities*; from November 1905 through March 1909 it was called *Charities and the Commons*; and from April 1909 until it ceased publication in 1952 it was *The Survey* (although October 1921–August 1932 alternate issues are titled *Graphic Survey*, and September–December 1932, *Survey Graphic*).

the mangled bodies from the mines — God knows whose shall be the graves in this America!" [17]

Kellogg's ears caught a judgment, and we shall have occasion to recall the bitter tone of Stella's words, "this America."

In Stella's Monongah drawings the range of figure styles is the same as in *The Outlook* drawings, with certain mannerisms appearing — the drawing of the ear of the miner at the left of *Rescue Workers* (Figure 13) is the same ear seen on *A Native of Poland*.[18] However, in *Morning Mist at the Mine Mouth* (Figure 12) the artist seems interested for the first time in a pictorial effect for its own sake, without reference to the human element; significantly, it is here he is at his best. The charcoal in his hand responds to the nuances of lights and darks in the wet gray morning as if there were no other story to tell. *Rescue Workers*, by comparison, is self-conscious and less convincing, the arrangement of heads suggesting a kind of academic solution to a problem in composition, the desperation on the men's faces applied rather than expressed.

In 1908, *The Survey* commissioned Stella to do a large series of drawings of the Pittsburgh industrial scene. This experience affected him deeply. The romance and stark realism fused in the spectacle of coal being mined and steel manufactured became a major force in shaping his responses to American life, planting an image that matured over a period of ten years of crucial artistic development. The modern world, the United States, steel, and electricity were forged into a single concept then and forever in his imagination.

The Pittsburgh visit produced over one hundred drawings. Despite some fine figure work, the best of the series are city landscapes, and some of the steel mill scenes rendered in large areas of blacks and grays accented with white, with figures reduced to looming, dark, almost abstract shapes. This sensibility is paralleled in Stella's "Discovery": although he had been sent "to draw steel mill workers and miners," it was clearly not the men and their labor that attracted his real attention.

> I was greatly impressed by Pittsburgh. It was a real revelation. Often shrouded by fog and smoke, her black mysterious mass cut in the middle by the fantastic, tortuous Allegheny River, and like a battlefield, ever pulsating, throbbing with the innumerable explosion of its steel mills, was like the stunning realization of some of the most

stirring infernal regions sung by Dante. In the thunderous voice of the wind, that at times with the most genial fury was lashing here and there fog and smoke to change the scenario for new unexpected spectacles, I could hear the bitter, pungent Dantesque terzina.[19]

In "Notes About Stella" he does mention, briefly (in two lines) the workers in the mines and mills. Referring to his drawings, he writes:

> In them, the artist succeeded to portray the spasm and the pathos of those workers condemned to a very strenuous life, exposed to the constant MENACE OF DEATH. Besides, he discovered for himself the aesthetic beauty of Pittsburgh and surroundings as a landscape, beauty lying in the arabesque forms given by the structures of those huge volcano-like steel mills, emerging from the fluctuating waves of smoke and fog, with an eloquent mystery. A charcoal drawing, made more effective by a few telling strokes of pastel, in red, gives the sense of grandiose horror and beauty of the flames exploding through the white high columns of smoke out of the converter, at night.

Whatever the genesis of Stella's response to the Pittsburgh landscape, his imagery suggests that the memory of Vesuvius rising out of the foggy, dusky bay of Naples in the evening lay close to the base of this particular sensibility and made it possible for his poetic nature to see a modern form created by man in terms of an ancient form created by nature, to see beauty in what had generally been regarded as unmitigated ugliness.[20] Stella's special gift enabled him to see his contemporary world in such a way as to absorb its images into his total awareness. In the years ahead modern steel bridges and old stone cathedrals synthesized seemingly without effort in his imagination.

The Pittsburgh drawings offer arresting examples of the variability of the artist's approach at any one moment — from composed, studied representation as in *Four Miners* (Figure 19) or *The Stokers* (Figure 20), to the impressionistic *Pittsburgh, Winter* (Figure 21) and the near-abstract, expressionistic *Before the Furnace Door* (Figure 18). In *The Stokers* attention is focused on the strong, sturdy muscular bodies. These are modeled in light and dark and arranged friezelike along the picture plane. At left and right, a figure frames the scene, enclosing it in classical style, while the central figures are arranged in classically reciprocal poses (see Appendix III, Figure 20).

At the opposite stylistic pole is *Before the Furnace Door*, so similar in subject, so different in treatment. Here, instead of the anatomical studies of *The Stokers*, are barely definable figures summarized in black forms that loom through the dark shadowy space against the eerie light and fiery glow of the furnace (see Appendix III, Figure 18). The scene, going beyond the limits of popular illustrations, is like a vision of hell, the workers damned, condemned to this region of infernal heat and suffocating blackness.

Workers' Houses (see Appendix III, Figure 17) portrays some company-owned shacks in a section of Pittsburgh that was known as "Painter's Row." The sense of pathos sometimes present in Stella's figure drawings is felt here, although restrained by the elimination of details. The specific horrors of life in these unsanitary, squalid, infested hovels are transformed into a generalized scene of dark and dingy desolation, reflecting not the spirit of a crusading social realist but that of the humble man who identifies with the sad, neglected, marginal living of the oppressed, the cast-outs, the uprooted — the exiles from beauty. *Dark Bedroom* (Figure 16), a "hole in the wall" in one of the "Painter's Row" shacks, shows Stella at his best. Darkness closes in on the small room and darks and lights contrast sharply to convey the highly charged emotional content of the scene, reminding us of Stella's "hatred for closed places."

The panoramic *Pittsburgh, Winter* introduces still another subject and style into this series (see Appendix III, Figure 21). The mood of the drawing is expressed in a reminiscence of the city called "White and Vermilion," which Stella wrote in English, in heavily blotted ink on yellow foolscap.

> I was in Pittsburgh and winter was raging. It had been snowing day and night, and a sharp wind was blowing, unmercifully lashing the poor mortals. The candor of the snow was intensified, magnified by the black sky eternally black and throbbing with black smoke luridly sincopated here and there by bloody spots. The tragic town of the steel mills seemed transformed. She had lost that oppressive atmosphere of a damned infernal city. But the black imprint on the snow [was] becoming more and more conspicuous. The true dark personality of the town was ever asserting itself, and this ermine dress was like an ironical white dress of the first communion, barely concealing the hard-boiled structure of a civic arpy.
>
> It was midday, and . . . I went to the first restaurant I came

across . . . The place seemed forlorn, silent, nobody talking, and I felt chilled. It was more like a funeral parlor than a place where the gargantuan joy of life was supposed to be celebrated.

I have not seen a version of this drawing, *Pittsburgh, Winter,* touched with red; however, many of the industrial scene drawings are so accented, making it likely that such a version of this particular view was executed. In it, in charcoal and white chalk, the dark buildings linger in a snowy, already grimy haze; here is a silent, cold purgatory rather than the black fiery hell of the mill interiors.

Among the anonymous portrait studies of the miners and steelworkers, the most authoritative is the well-known *Italian Leader* (Figure 15), which may serve as a characteristic example of Stella's approach to this kind of subject. Interest is divided between the character of the man and the details of his surface appearance: the folds around the eyes are carefully given, the strong structure of the head is indicated by the dark–light modeling, while the rather long, unruly hair provides a romantically irregular contour that emphasizes the personality of the sitter. A balance between idealizing and describing, together with the appeal of the model, makes this one of the most successful heads Stella ever drew, superior even to the fine portraits of Marcel Duchamp (Figure 65) and Edgard Varèse.

In considering the forms and shapes of the designs observed thus far, certain features begin to appear and recur regularly from which it is possible to derive some evidence of Stella's stylistic tendencies. There is his insistence on a centralized composition. Again and again, with few exceptions, Stella stresses the central area of his sheet, either through the massing of darks and lights or through a strong vertical pictorial element. He begins to show a preference for a strong contrast of form and color or black and white, realized by silhouetting one kind of shape against another and sometimes by juxtaposing diverse kinds of shapes: slender verticals against wide space, ragged forms against unbroken ground, irregular contours played off against smoothly outlined or straight-edged forms. Particularly interesting is the emergence at this time of a tendency to create shapes which, while justified as shadows within the representational context of the drawing, assert themselves as independent, abstract forms. These strange shadows lie against the face of the *Italian Leader* and become particularly striking in drawings, not of the Pittsburgh series but apparently

slightly later, of which the *Man Seen from the Rear* (Figure 26) and the *Back of a Woman, Sleeping* (Figure 23) are but two examples.

While there is no proof that the last-named drawings are later than the Pittsburgh work, another of this type, Figure 24, is signed and dated 1910, and in the following years a number of *The Survey* drawings reveal the same trait. In *A Bearded Bulgarian* (see Appendix III, Figure 38), an illustration which appeared in the May 6, 1916, issue, these blotches are very prominent, and in Figure 39, in the same issue, the shadow that lies along the line of the bust and shoulder area and the patterning of the background around the head almost compete with the subject in visual interest. This tendency anticipates Stella's instinctive response to the evocative power of abstraction which was soon to revolutionize his style.

There was in the air the glamour of a battle,
the holy battle raging for the assertion
of a new truth. Fauvism, Cubism, and Futurism
were in full swing. My youth
plunged full in it.
— Discovery

IV

Return to Europe 1909–1913

In the early decades of the twentieth century, American art was still a kind of poor relation whose sons went to be educated in the rich palace of European culture. During the eighteenth century, Allston, Durand, Homer, Eakins, and Ryder had shaped an American art out of European formal and technical traditions and American empiricism, giving it a range from sharp-focus realism to visionary symbolism.[1] Whistler, Sargent, and Mary Cassatt developed successful careers in Europe in the nineteenth century, while Childe Hassam and many other Americans returned to the United States after studying in France in the eighties and nineties, their painting decisively affected by the French Impressionists. "The Eight" had followed the tradition, going to school in Dusseldorf and Paris; and between 1897 and 1912, almost all the painters who were to form the American modern movement arrived in the City of Light: Alfred Maurer in 1897, Bernard Karfiol in 1901, Samuel Halpert in 1902, Maurice Sterne in 1904, John Marin and Max Weber in 1905, Morgan Russell and Patrick Henry Bruce in 1905 or 1906, Abraham Walkowitz in 1906, Arthur Dove, Arthur B. Carles, Walter Pach, Stanton MacDonald

24

Wright, and Charles Demuth in 1907; John Covert, Thomas Benton, and Morton L. Schamberg in 1908; Charles Sheeler and Andrew Dasburg in 1909, followed by Preston Dickinson in 1910, and Marsden Hartley in 1912.

It was, therefore, almost but not quite in the best American tradition that Stella went abroad in 1909, with the financial aid of his brother Antonio. Unlike the majority of the other American painters, who were in their teens or twenties when they arrived in Europe,[2] Stella was thirty-two and deeply aware of an Italian artistic heritage. Unlike the others, whose curiosity and excitement had been increasingly stimulated by the reports coming from Paris, he was drawn to Italy. Stella must have heard the rumors about the new French revolution in art. Very likely in 1908 he had seen the Matisse exhibition at "291," the gallery of Alfred Stieglitz, although there is no evidence of it in his own art; and he surely had mingled with the young artists at the Macbeth Gallery in that year, taking part in the art life of New York, listening to the gossip and the "latest news" from Paris. But, lonely and homesick for his native land, he went to Italy instead.

Stella seems never to have been really happy in New York with its great walls closing him in. Nowhere in his writing does he express happiness at being there. On the contrary, he wrote of "the great evils of the city . . . houses close it off from the sky and countryside, which are furthermore obstructed by thronging crowds from morning to evening. Everyday life is mean and low. In order to have the energy to live one must cover over its cruel wounds with our dreams, with our most intense strivings for the highest realms of blessedness, where our weightless soul becomes immersed in the celestial blue. Our father's house is the sole link with the past. It is the solid, firm bridge" (I,58).

It was not only New York and the image of the city that weighed so heavily on him that he felt the need to escape; the whole industrial society that attracted him so powerfully, repelled Stella equally. The tone of his utterance at Monongah in 1907 is echoed in a newspaper interview in 1913, after his return from Europe: "he had seen the blazing nights at Monongahela and in order to free himself from the deep depression caused by that memory, he had tried to think of a humanity clothed in a less bloody light. Where else but in Italy could one find the sunlight that restores the soul? "[3] (II,8).

While others went to Paris to catch up with the future, Stella went to Italy to re-establish ties with the past. It was the first of many such trips, for, like other southern Italians, he "felt the past strongly." It may have been in connection with this trip that he wrote of his intense yearning to return and his ecstatic joy at finding himself once more in "his father's house."

> With ever-heightening eagerness during my long period of exile, I awaited this return to my native land. Toward the end, the waiting tore my tormented soul completely to shreds, tortured by the constant pain of an enforced stay among enemies, in a black, funereal land over which weighed as a supreme punishment the curse of a merciless climate.
>
> What a tremor of joy erupted at last! And how my spirit soared in the radiant light of this supreme happiness. Like an urn overflowing with honey, my heart filled instantly with good feeling. Before my ecstatic eyes everything seemed sprinkled over with rose. Smiling visions arose like white clouds shining with laughter, and a great chorus of rejoicing, friendly voices intoned a hymn to my return to the land of my ancestors. I felt so humble: a true Franciscan humility clothed my soul. It seemed to me freed for the first time of every useless burden of ambition and worldly care, to feel for the first time the breathing, pulsing earth, like an infant awakening to the awareness of its own mother. (I,9)

Home meant youth and innocence and hope; home was the source of strength and vitality, peace and protection; it was the symbol of Stella's completeness, just as New York was the symbol of his alienation.

> Our physical being seems instantly strengthened, reinvigorated as if by magic. Our youthful confidence miraculously restored gives us a deep awareness of our energy, of our power, of our daring to attempt everything, to use to the utmost all the gifts at our command. . . . Suddenly we have the sensation that our feet are sinking into the viscera of our mother earth. It reclaims us and repossesses us with maternal jealousy, and we yield ourselves to its warm breath, as when we were small we fell asleep at our mother's breast. (I,3)

Home was the past, and he stood in it "as in the shadow of a mother," in Corrado Alvaro's phrase.[4] "I feel all around me the warm presence of

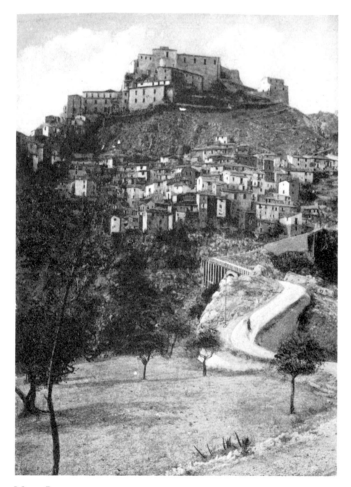

Muro Lucano

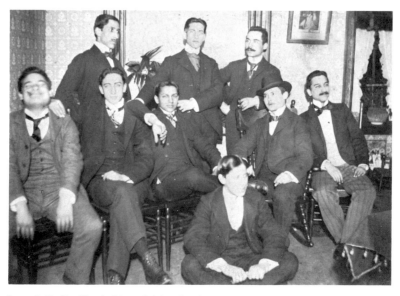

Joseph Stella (far left) and friends, about 1905

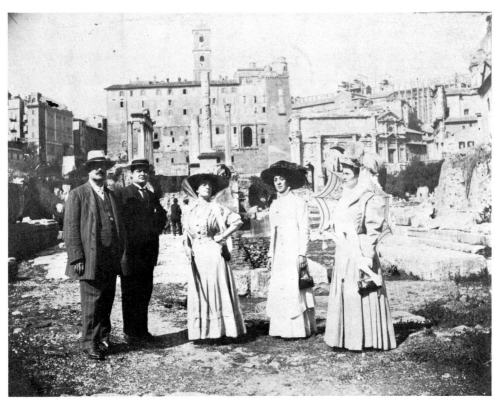

In the Roman Forum about 1911

Joseph Stella, around 1912

About 1930

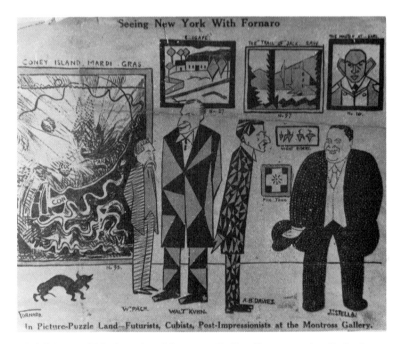

"Exhibition of Modern Art, Montross Gallery"; cartoon by Carlo de
Fornaro, 1914

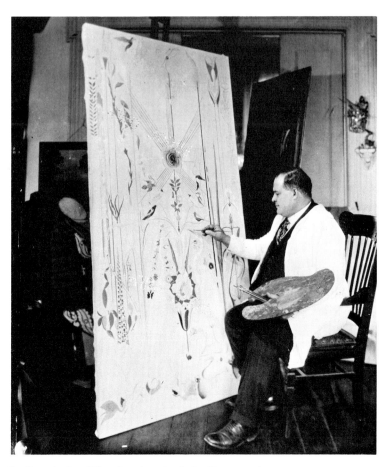

Stella painting *The Apotheosis of the Rose*, 1926

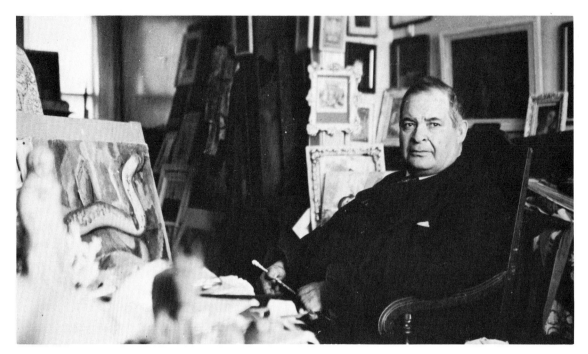

In 1937

"Autobiography" (Appendix I, 1)

my family, far away, some dead; my soul had the sensation of being embraced by a soft, downy garland, like a tender, smoothing caress. Is it perhaps the return of the gentle maternal spirit that protects and takes care of our childhood?" (I,4).

Stella did not remain in his *paese*. He had come "to renew and rebuild the base and structure of [his] art," [5] and he traveled to Venice, Florence, and Rome. Undoubtedly he also visited many other art-rich centers, such as Siena, Perugia, and especially Assisi, the birthplace of St. Francis, for whom he felt a deep, oft-expressed veneration.

Either before he left the United States or after he reached Venice, Stella took up the technique of glazing. In "Discovery," he implies that it preceded his trip. "To avoid the superficial effects of virtuosity I became very inquisitive in regard to the marvelous results obtained by the great masters of the past. After reading Cennino Cennini, I took up glazing." In the next paragraph he writes, "in 1909, I went to Italy," giving the impression that his interest in glazing had begun earlier. However, in "Notes about Stella," we read:

> The Venetians at first impressed him very strongly with their wealth and display of rich colors. He read every volume, ancient and modern, dealing with their technique, from which he learned the process of glazing, which consists in placing as a base the body of color in tempera, and after getting upon the tints in diluted oil color.* This method is nowadays not used anymore and it is ignored by the majority of artists. The quality that one gets by employing it is a great solidity and a marvelous transparency and depth of color. Here, in America, the only painter that has used it effectively to some extent is Ryder, the late deceased distinguished artist.

None of the works executed in the glazing technique seems to have been painted in the United States before 1910. *Italian Church* (see Appendix III, Figure 24), however, employs this technique, and I believe that Stella began to practice glazing as a result of his trip to Venice. Further, there is a hint in a magazine article, where Stella wrote: "I took up glazing in the real way, with an underpainting of tempera, like the Venetians. The subjects I treated lent themselves most readily to my new conception of painting. In color I searched for warmth, depth and transparency empha-

* This passage is unclear as Stella has written it. He seems to mean that the local color was established in tempera, over which were then laid tints and shadings in thin oil paints.

sized by that impasto enamel like that the ancients called smalto — and in composition I tried to be very stern and severe, hating all the bric-a-brac and the charming bits of color that people want." [6] The luminous glowing surface of *Italian Church* indicates how quickly and how successfully Stella absorbed the technique of the old Venetians. At the same time, as Baur points out, the "dark tonality and mysteriously looming forms" [7] recall Ryder, an artist of curiously similar mystic, visionary, and romantic sensibilities.

According to himself, Stella achieved considerable recognition on this first trip home: the municipalities of Rome and Florence acquired two of his canvases — one of which was shown in the International Exhibition of Rome in 1910 and acquired by the Campidoglio, or city hall.[8] He notes that a "portrait of an architect, now in the possession of the Brooklyn Museum, was taken for an original old Venetian painting by the expert of the Nulla Osta of Rome," and that he had to produce the sitter in order to prove that he was indeed the artist (see Appendix III, Figure 25).

It was not long before he realized that his enthusiasm for the old masters had led him into a blind alley. In unusually forthright and disarming words, he recalls his growing awareness of being caught and his struggle to free himself.

> My enthusiasm for the old art, that was rising higher and higher on account of the vulgarity of the current exhibitions (of course I had not been in Paris) got the best of me and I must confess it blinded me in many ways. I began to ignore nature and truth, and I had to consult the old teachers before talking.
>
> Love of any sort ends in slavery. My motives were soon exhausted and I understood that glazing, although bewitching, and giving me some very fine results, was depriving me of that liberty of movement that a true artist must have.
>
> What made me finally leave glazing was the experience I had on a journey to the south of Italy — to my native town.
>
> When a child I had made drawings, and some of them I still consider my best things. After years of experience in foreign countries, here I was back to the scenes that had given me my first emotions — and what a change!
>
> No more divine innocence, whose loss we cannot miss enough, but formulas, schemes, and so many pictures had I seen! I tried to forget all schooling of any sort, and see if I could reveal something

that belonged to me and to me only. But, in spite of my efforts, prejudices and conventions would tear me down. I felt then all the antagonism that anyone should have against the schools.[9]

His growing desire to render more spontaneous effects was frustrated by the old slow method of glazing. The moment of liberation came, Stella recalls, "when in my native town one morning, in front of a rosy mountain, I felt unable to realize my vision quickly without waiting for the preparations required by glazing, I tossed out this method without any stupid regret. I was getting more and more convinced that the true lessons given by the old masters is an ethical one, how to organize the personal capacities in order to be true to his own self, how to derive credit by his own experience lived at his own time, if not to project his vision into the future instead of walking back to the past."[10]

Stella gives the impression that he arrived at his new insights independently, led to them by the desire to express himself more directly. It is, however, quite possible that he was guided at this stage of his development by Antonio Mancini, a successful and respected painter who became a close friend during his stay in Rome in 1910–11. Mancini was not in the ranks of the new progressive painters, the Futurists, who had recently come together to give expression in Italy to twentieth-century sensibilities. Stella seems to have had no contact with the Futurists at this time, and appears never even to have heard of them before his trip to Paris in 1911, despite the considerable *rumore* that the young Italians were making. The "Manifesto of Futurist Painters" was proclaimed in Turin in March 1910, and the "Futurist Painting: Technical Manifesto," signed by Balla, Boccioni, Carrà, Russolo, and Severini, appeared that April. It is true that the Futurists were most active in northern Italy, but Boccioni, Carrà, and Russolo participated personally in a Futurist presentation in Naples, at the Teatro Mercadente, on April 20, 1910.[11] Stella's movements through Italy in this period are not known with any accuracy, however, and he may not have been around Naples at the time of the Futurists' presentation. That he did not know them then is certain, for in 1920 he wrote a letter to Carrà, the tone and contents of which make clear the very negligible personal contact he had had with them, and reveal that slight contact to have been limited to Paris. He had been asked to write Carrà, inviting him and "all the artists you think suitable" to show at the Société Anonyme, which had just been formed in New York.

Dear Carrà

We met at the Bernheim Gallery in Paris at the first Futurist exhibition [February 1912] . . . and perhaps you will not remember me, as we have not seen each other again.

Although far away, I have always followed with interest and strong admiration your vigorous work as an artist and innovator, and I have always had hopes because of the great love I feel for my native land, for a show in New York of the bold new conquests made by you and your companions to the Glory of Italy. (I,10)

Evidence that he had not seen examples of painting in any of the new art styles is shown in the New York *Sun* article of May 25, 1913, when Stella told the reporter that the shock of Paris art was so overwhelming and dazzling that he was incapacitated for work for nearly six months. "He absorbed with his eyes, his mind and his ears, and when he returned to his beautiful mountains in the South of Italy, he had found a new point of view. He feels he owes to French artists the awakening of his dormant individuality. After leaving Paris he did not visit any more museums, but traveled in Italy, studying the country and the people and went back to his mountains."

In 1910, the living Italian artist with whom Stella had the closest personal ties seems to have been Antonio Mancini * whose style at that time combined a heavy impasto and the light, bright hues and broken strokes of Impressionism with conventional composition and a strong streak of sentimentality.[12] When they met, Mancini's bright color and vigorous brush stroke could well have represented for Stella, steeped in Renaissance tonality and glossy surfaces, a courageous modernity that raised doubts in his mind about his own work and the path he was on. His admiration for the artist is clear, and I quote his description at length because there is no specific reference to indicate Mancini's possible influence; it is rather a question of a certain tone in Mancini as Stella quotes and describes him that suggests the role he might have played in the first steps of the younger artist's liberation from the past.

I met Mancini in Rome in 1910, when he had his studio in Via

* A photograph of Stella with a group of friends standing in the Roman Forum includes a man who resembles Mancini, according to self-portraits, although he looks younger than the artist would have been. Judging from the dress style, the photograph should be dated about 1911, when Stella was in Rome; Mancini then would have been fifty-eight.

Margutta. . . . It was one evening at the modest *trattoria* Volpacci in Via Delle Vite. I had gone to dine with a few artist friends when there suddenly appeared a small round man, pink-faced and smiling. Our dear Don Antonio, everyone called out, and the famous artist, with the most natural manner in the world, as humble as the most modest workman, sat down among us and ordered his favorite dishes, and started talking with all of us equally like an old friend.

Our acquaintanceship arose spontaneously, without formal introduction, both the artist and the man revealed instantly, awakening in me a lively sympathy and the greatest surprise, surprise because, of all I had heard and read I found nothing in the artist sitting next to me.

His inextinguishable smile which often opened up into a bubbling laugh attested to an extraordinarily charming temperament. Having arrived at more than easy circumstances, he was neatly dressed like a born gentleman, elegant without any pretensions.

I had the good fortune to see him often for one or two years of my residence [in Rome] either in his studio in Rome or fairly regularly in the evenings in the *trattoria* mentioned above, and I can say that I enjoyed his intimate friendship. He was a born painter, by instinct. He was completely lacking in knowledge of art history; his judgments, which used to spill out in pure Neapolitan slang about some work or other, ancient or modern, that might have struck him, were interesting because they were spontaneous and original. "Greek art is a big white spot in a clear cloudless sky. Because you see, the Greeks didn't have any lice — they were all gentlemen — they ate and dressed well. Where's the comparison with the poor slob of today, eaten alive with the lice of misery?"

He had a horror of painting with slashing dripping strokes. As that simpleton Vittoria Pica used to define it, paintings that were successful at the Venice Biennale. "Those gentlemen give a swoop of the brush and off they go."

Face to face with the most vital problems of pure painting, he had a spasmodic smile confronting the productions that echoed with imitation. . . . He hated cerebral art. "Botticelli — I've said it often — he's no painter. An engineer you should call him."

His most absorbing concern was the most exact reproduction of Truth. With constant tricks and threats to nail the model down if he moved, he tried to render the exact measure of Truth. When he exaggerated (for display as he used to say) and would forget to do his duty with respect to Truth to nature, he lashed out with invective

against himself. "Mancini idiot, Mancini fool, Mancini stinker." He would keep on repeating, stopping, moving away from the easel, going up to it, in order to get the right perspective and to take again the correct proportions. One day I found him deeply preoccupied in front of a head in oil. "I worked all morning and what've I got — a head of an ox like that stinker Michetti."

He had no respect for Michetti. "He didn't know the essential thing about art — about decency." Speaking of Michetti's *Voto*, "Good God, those four stinkers and phoneys licking that tilted filthy pavement — It should be prohibited. If it were up to me I would say to that so-and-so Michetti, "Hey, jerk, . . . don't come around here . . . get lost!"

He was a hard worker: he painted from morning to evening. He often came to the *trattoria* to eat late, extremely tired. As soon as he had eaten and relaxed a little, he would begin right away to laugh, forgetting his fatigue. Having sipped his coffee, he would take off his jacket and with the little pencil and charcoal always at arms reach, he would start to sketch furiously with the drive and enthusiasm of a young man of twenty. He would moisten the charcoal and pencil with his tongue and sharpen it. (I,11)

Stella's warm feeling for Mancini endured throughout his life. Recalling his close ties many years later, he told Alfredo Schettini, in an interview which appeared in an unidentified Italian newspaper on September 24, 1938, that he had been "on terms of great familiarity with Antonio Mancini who used to call him 'The Savage' " (II, 9). It is impossible to determine exactly what influence Mancini exerted on Stella. There is no proof of any direct influence. However, it is reasonable to suppose that such a close association with a highly respected artist must have had some effect. Since he rejected the old-master technique at this time, it seems justifiable to assume that Mancini played a role in this rejection.

I have seen no painting by Stella that I can place with any assurance in the years 1910–11 which would reveal the new step he had taken, although I am tempted to suggest the *Study of a Woman* (Figure 29) for tentative consideration. The woman's costume places this painting before the end of World War I. Since the style and technique are unlike anything of Stella's up to 1910, and equally unlike anything I know after 1913, the work can be placed between those years. But was it painted before

the 1911 visit to Paris or after? There is a quality in it that suggests that Stella could have done it before going to Paris. Casting off the restraints of glazing, it was possible for an artist of Stella's knowledge and experience to have arrived at this kind of painting, especially under the stimulation of Mancini's work. The palette is in pastel hues, a mauve dress against a light, slightly gray-green ground, with touches of mauve and pink in the hat, highlighted with sweeping strokes of yellow and bright green. The neckpiece and light area on the figure's back and the background are stroked in with a rather dry brush, and there is a general attentiveness to stroke variations and thicknesses of paint that suggests Mancini. A puzzling element in this little canvas, however, is the cursive stroke used in rendering the tree foliage; it is this detail that favors a date shortly after Stella's contact with Parisian art, for a painting that can be dated with fair certainty to 1912, *The Shepherd's House* reveals similar stroking. It is conceivable that Stella began *Study of a Woman* before going to Paris, and worked on it again afterward to give it the more "modern" look he then wanted.

Stella was not satisfied with his work in Italy, and a letter from Walter Pach finally persuaded him that Paris offered the best hope of finding the help he needed. "A dear friend of mine, a fine artist and a true sincere man, Mr. Pach, urged me to go to Paris to renew myself. In need of help, I soon went to the real realm of modern art." [13] "Paris had become the Mecca for any ambitious artist in search of the new verb in art — and in 1911, with great joy I flew to the *Ville Lumière*.[14]

He found his way straight to Montparnasse and soon began to meet the artists who filled the studios of the quarter.

> By that time anyone in Paris could meet and know the most prominent artists right in their studios, without the need of any red tape of introduction. I took full advantage of this great chance. I met and conversed with Matisse. I was enchanted with the intense freshness of his alert color and his keen perception of Cimabue and Giotto. At the Cirque Medrano I had the pleasure to tell Picasso in company with the poet Max Jacob how much I admired his blue period. Every Friday I went to the Closerie des Lilas at Montparnasse, near the Observatoire, crowded with the leading painters and writers led by the prince of poets, Paul Fort. I became the friend of many promising young men: Gromaire, Pascin, Dubreuil, the Futurists Boccioni, Carrà,

33

Severini.* Modigliani was painting at the Impasse Falguière, in a studio near mine. By that time, Modigliani, unrecognized, was struggling very hard, and many times, going together through the Boulevard Pasteur, my large frame emphasized by my large American overcoat shielded his figure from the inquisitive sight of his ferocious creditors standing at the door of their groceries.[15]

Stella also met Gertrude Stein and her brother Leo, but the mutual impression was not entirely sympathetic and the acquaintance did not develop: "Somehow in a little side street in Montparnasse there was a family that had acquired some early work of Matisse and Picasso. The lady of the house was an immense woman carcass austerely dressed in black. Enthroned on a sofa in the middle . . . of the room where the pictures were hanging, with the forceful solemnity of a pitoness or a sibylla, she was examining pitiless all newcomers, assuming a high and distant pose." [16]

Resentful of all restraint, Stella was attracted to the vanguard movements he encountered.

> I began to work with real frenzy. What excited me most was the vista in front of me of a new panorama, the panorama of the most hyberbolic chromatic wealth. No more inhibition of any kind for the sake of inanimate sobriety, camouflaged poverty derived by the leavings of past art, but full adventure into a virgin forest of thrilling visions, heralded by alluring vivid colors, resonant as explosions of joy, the vermilion, green, violet, and orange high notes soaring upon the most luscious deep tonalities. To feel absolutely free to express this adventure was a bliss and rendered painting a joyful source, spurring the artist to defy and suffer any hardship in order to obtain his goal.
>
> History proves that a true artist needs an art center for the full growth of his work. A beneficent spirit of emulation seizes him and spurs him toward the most ambitious heights.[17]

Paris was the germinating art center of the world in that period, and in 1911–12 the intensity of creation and cross-fertilization was at its height. The challenge in the air was enormously invigorating, and Stella comments

* Stella is the source of the widespread but false impression that he was close to the Futurists. The letter to Carrà proves the contrary. He apparently became friendly with Severini in later years, according to a letter to me from Mme. Gino Serverini.

in "Discovery" that his work "advanced rapidly with the singing strides of a triumphing march leading to victory." The advance was indeed rapid; it was "remarkable," Baur observes, "how the traditionalist of the early drawings attained, at one leap and with almost no visible transition, the mastery of an advanced abstract idiom." [18]

The explanation for his quick progress lies in Stella's seriousness and dedication combined with his rebelliousness of spirit and tendency to see abstractly which gave him the will and the eyes to grasp the meaning of the new art. Above all, he was capable at critical moments of feeling the humility that is an attribute of many thoughtful and creative people. Humility underlies his discussion of his grasp of Cubism and Futurism in the article he wrote for *The Trend*, when his impressions were completely fresh:

> Although I couldn't grasp all at once the greatness of Cézanne, I realized what was false in my production, and for the first time I really understood the old masters. The best lesson that they can give is to be free and to go to nature and try to get from it the nourishment for your temperament (provided that you have one) as they did themselves.[19]

> I took up post-impressionism, not as a fad, but as a necessity at the time. . . . Technically speaking, the question of values and color interested me the most. The color of Matisse haunted me for months: I could feel in it a great force and a great vitality not dreamed of. . . .

> Of course it goes without saying that I have not done much yet along this path. I consider my latest work as only the first experiments of something big that will surely come. Cubism and futurism interest me to a very great degree. Although they resemble in many ways from an exterior point of view and they both strive for some similar points, they are apart in many ways. Cubism is static. Futurism is dynamic. Cubism tries to find and finds its descendence [sic] in the work of the old masters. Futurism strives to be absolutely free of any tradition: its effort chiefly lies in creating a new sort of language to express the feelings and the emotions of the modern artist. . . .

> Stagnation is death. The artists that claim that we must be the result of tradition and nothing else are those whose spiritual life is at an end. . . . A true art is always more or less a reflection of everything that is going on in its epoch, and therefore cannot live on the crumbs of the past.

The futurists and cubists try to find a new sort of language and it is logical that this language at the start should be chaotic. Our epoch is the transitional but perhaps the more vital and important because all the seeds of a gigantic futurist achievement are now being put into the soil.

France understood all this and as a result marched triumphantly in the front. I think that America should follow this glorious example — America which is so young and energetic and has the great futurist work first achieved by Walt Whitman.[20]

The rare sober tone of this passage emphasizes the impact the new art had had on him. It is as if, on the threshold of what was to be the most creative decade of his life, he had steadied down in order to gather strength for the demands he was to make on himself in the years immediately ahead.

He had not yet gone far along the new path. *The Shepherd's House*, to which I have already referred, is typical of his transitional period, with loose, broad brush strokes and arbitrary color that seemed revolutionary at the time, to judge from the comments of Agostino de Biasi, the critic who reviewed Stella's exhibition in April 1913 at the Circolo Nazionale Italiano. From him we learn that the show was arranged in three rooms of the club, the first two given over to the Pittsburgh drawings and oils of Stella's first ten years of work, and the third to the recent paintings. De Biasi was horrified as he entered "the third room, an orgy of colors. What is the meaning of this transformation? Who had treated, or rather, mistreated canvases, brushes, paints in such a way? Stella? No, because we find Stella a man of reason and sound artistic background in the small picture, *The Window*; we admire his tenderness in the *Old Houses on a Misty Day*. Here we find fruit, flowers, leaves, vases. Are they paintings? Not even Stella could have thought he was making paintings when he laid his colors on those canvases. They are strongly brushed, violent as the sun that bathes the countryside, but too green, much too green!" (II,10).

The vivid color of *The Shepherd's House*, dominated by a high-keyed green, and its loose, excited, nondescriptive strokes, sometimes blunt or dash-shaped, sometimes cursive, like calligraphy, bring to mind similar characteristics common to the painting of the leading Fauves — Matisse, Braque, Vlaminck, Derain, Dufy, and Friesz.[21] Although Fauvism was no longer a radical movement by 1911, it seems still to have represented to

Stella advanced painting, together with Cubism and Futurism. The cursive strokes in *Study of a Woman* seem to confirm the chronology of Stella's development, indicating that, although Mancini may have struck the first blows, it was Paris and Fauvism that drove the final wedge between Stella's past and future as an artist.

But there is an important difference between Fauve paintings and Stella's Fauve-influenced work. The Fauves distributed their design over the entire canvas, while Stella divides his field into two unequal areas, one for the motif, the other for unbroken space. His preference for a more structural composition led him to reject the over-all decorative aspects of Fauvism and drew him to Cézanne. In *The Shepherd's House* he tried to construct form with color and strokes as Cézanne had done. This attempt to fuse Fauvism with Cézanne is not successful, but we can admire the artist who at this stage of his development could write, "I couldn't grasp all at once the greatness of Cézanne." He recognized the need for patience: "The new effort in art appears in a sudden flash, unexpected, like a turning on a mountain peak, intense. But to be brought to realization, to mature and be ready to pick from the tree, it needs time. It dawns, like the promise of morning over the tree of our hopes, and all at once our spirit rises . . . But one must be patient . . . Silently, in the shadows, one acquires each day greater strength and form — and one fine morning, our energy ready for the test, calm in the heaven of our soul, to our great surprise the flower becomes mature fruit, pouring out, breaking out into the open, luminous" (I,4a).

The interest in blocky masses and the attempt to develop planes of form through color and stroke can be seen in a drawing closely related to *The Shepherd's House*, called *Rocky Landscape with Trees* (Figure 27), and thus datable to 1912, when Stella returned to Italy. Compared to the earlier drawings, such as *Pittsburgh, Winter* (Figure 21), with its impressionistic, atmospheric handling, or such characteristic early figure studies as in *The Stokers* (Figure 20), with the forms modeled in light and dark, *Rocky Landscape with Trees* is more structural; one feels the effort of the artist to see the forms objectively, to understand them as form rather than as summary impression or particularized description.

Although I have seen no dated oils of the years 1911 through 1913, certain works can be placed here with the help of hints contained in the descriptions of some of the paintings in Stella's new style in the reviews of

the exhibition at the Italian club. For example, Ernesto Valentini describes one of the paintings as "representing a table with glasses, fruit, and a vase at the center, against a background of soft pink" (II,11), and adds that it was also included in the recent exhibition of Cubists and Post-Impressionists held in New York — obviously referring to the Armory Show.[22]

Another critic says Stella "does not fall into the eccentric exaggerations of the Futurist painters or the excessive preciousness of chromatic effects of the imitators of divisionism, but fuses the qualities of both, taking from the past and the present what is beautiful and instructive, and then adding the range of his own perceptions of light, of impressions, of feelings, expressed realistically, with formal immediacy, and with an appealing and sincere effect" (II,12). Still another admires Stella's moderation compared to the "hoaxes" recently exhibited, remarking that his works "never exhibit the 'trickiness' of the fools or simpletons that we saw exposed in New York and that seem to us to be atrocious jokes played on the eyes and the taste of people who until recently were in full possession of their common sense" (II,13).[23]

Some of Stella's paintings immediately suggest the style implied in these remarks: pastel in color but with high-keyed effects, a limited use of broad broken strokes, a close fidelity to (natural) appearance, yet shocking enough to worry those who admired his old-master style. *Still Life* (Figure 28) is one of a number of paintings characteristic of this period.

Paris had freed Stella from the past; late in 1912, he returned to the United States to find his future, "having been both spectator and actor in the revolution of modern art in Paris. New York, whose growth I had witnessed during my earlier years there, stood revealed to me as a fabulous mine of truly extraordinary motifs for the new kind of art. The bandages of stale prejudices torn from my eyes, the shackles of every school broken, I was in full possession of a great freedom of movement to start off the race through new fields that opened before me, to pursue and possess every new adventure that offered itself" (I,12).

For the first time I realized that there
was such a thing as modern art and as true and real
as the old one. It was to me
the revelation of truth and gave me a great shock.
— *The Trend* (June 1913)

V

Battle of Lights 1913–1918

The first adventure to confront the returned artist was the International
Exhibition of Modern Art, organized by the Association of American
Painters and Sculptors and held at the 69th Regiment Armory in New
York in February 1913. The Armory Show, as it has been known ever
since, is considered by many to have been the pivotal event in American
art history. As Milton Brown observes, "It was the outgrowth of years
of experiment, experience, and development among American artists and
it served as a stimulus to a new sequence of events. And just because it
stands in such direct and structured relation to both the past and the
present, it has rightfully achieved the status of a symbolic moment in our
artistic history." [1]

For Joseph Stella, who was both technically and psychologically pre-
pared for it, the Armory Show provided the stimulus that propelled him
into the front ranks of the modern movement, although his representation
in the show was modest stylistically. As we know from the reviews of his
exhibition two months later at the Circolo Nazionale Italiano, he had cer-
tainly not gone beyond *Still Life* (see Appendix III, Figure 28). His first
major Futurist work was painted as a direct reaction to the Armory Show:
"Soon after the show I got very busy in painting my very first American

39

subject: *Battle of Lights, Mardi Gras, Coney Island*" [2] (see Appendix III, Figure 30, Note 1).

De Fornaro writes that, in preparation for this painting, "Several weeks were dedicated to myriads of observations . . . in a manner of an artistic detective in a hunt for the solution of a pictorial mystery. He had to visualize the picture on a flat and square canvas . . . Several nights were dedicated to meditation upon the accumulation of impressions, and then followed the execution in oils of his clear drama . . . While discussing this artistic parturition, Stella remarked that after weeks of studies and cogitations the full-blown idea had flashed into his mind like an inspiration." [3]

Battle of Lights is a composition of colors and shapes distributed densely, although not evenly, over the entire canvas. The heaviest concentration of design elements occurs in a roughly triangular area that rises from the base of the painting and converges toward the apex of the masklike form at the center. This figure, recognizable as a decorated pole that was a well-known landmark in Coney Island, is transformed into an image that dominates the bursts and swirls exploding all around with orgiastic fury. Along the lower border small chips of blue, green, yellow, and red, liberally interspersed with black, suggest the confettilike crowds that surge through the park. These bits of color are massed into two main waves that rise from the bottom margin and recede only slightly from the picture plane so that no horizontal three-dimensional base is developed. The spears of color in this zone, representing darting light beams, are short and broadly slanted so that the limited effect of recession is retained. In the corresponding upper area, the color facets are very much larger, black is eliminated completely, red is almost absent, and the spears representing light beams — the Futurist "lines of force" — are deeper and longer. The result of the larger facets, the longer spears, and the lighter color is a greater spaciousness at the top compared to the tighter, heavier packing of elements in the lower section; this provides breadth and depth, allowing the spinning composition to explode upward and outward toward the top, like a pinwheel firecracker, while it is caught and held by the compactness at the bottom.

Although the composition of *Battle of Lights* is read horizontally and vertically more than inwardly, the three-dimensional space into which the curves and diagonals penetrate is essential to the design. This is probably

what led Stella to remark years later to Moses Soyer that in his Coney Island pictures he had solved the problem of space and light and the explosive content of the subject better than Jackson Pollock had done.[4] The balance between the horizontal, vertical, and inward directions imposes stability on the whirling and explosive movement of the painting. The emphasis on the central axis produced by the decorated pole and the brilliant cascade of red at the center of the picture also contributes a steadying effect.

Stella uses the forms found at the amusement park with inventiveness, weaving the serpentine tracks of the high-rides, the rollercoaster, the revolving ferris wheels, the beams of colored searchlights, and the crowds of people into a thick fabric. In this are integrated fragments of words,[5] several small figures of dancing girls, like those that sway invitingly on the platforms in front of sideshows, and animal heads such as the ones carved on decorative posts in the park. Of particular interest is the profile head along the lower right edge next to the black elephant (Figure 30a). Painted in a crazy quilt of colors, the general shape of the profile and the large head planted almost neckless onto bulky shoulders strongly suggests Stella himself and may be a self-portrait.

A preliminary oil sketch for this large mural-size painting, *Study for Battle of Lights*, *Coney Island* (see Appendix III, Figure 31), reveals the tremendous advance Stella made in the short space of time between the study and the finished work. This was the first sketch, as can be seen from a letter written by Carlo de Fornaro to Hazel and Ruth Hotchkiss:

> My dear girls,
> As promised, I leave in your care the painting of Stella called "Coney Island" and which I have owned since 1914. Even after thirty years of looking at it almost every day I never get tired of admiring the lovely conception of art, as it was at my suggestion that he painted this first sketch and to tell the truth I prefer it to the large and second painting of which there are two copies in different museums.[6] (see Appendix III, Figure 30, Note 2)

The *Study* is delicate, pastel in color, and not really Futurist. It is, rather, closer to pre-Futurist work such as Severini's *Spring in Montmartre* of 1909, with its large pointillist dots and livelier rhythms.[7] Although this painting was not included in the Futurist exhibition at the Bernheim-Jeune Gallery in February 1912, it is most likely that Stella saw it, or

works like it, in Severini's studio. There is no direct documentary of a link between the men at the time, but Modigliani was a friend of both artists, so Stella may have had an opportunity to see Severini's unexhibited work. This may also account for the fact that Stella's first Futurist-style canvases are closer to the work of Severini than to that of any of the other Futurists in 1912.

This Italian painter's work between 1910 and 1912 contains a number of general resemblances and specific devices that appear in *Battle of Lights, Coney Island*: in the *Boulevard* the surface is faceted with irregular asymmetrical geometric blocks of color; in *The Modiste* and *The Obsessive Dancer* radiating spokes translate light and act as lines of force, producing movement across the surface and uniting the planes. *Dynamic Hieroglyphic of the Bal Tabarin*, which, although not in the Futurist exhibition, was painted shortly after, in 1912, and therefore probably seen by Stella, contains similarities in the use of lettering, and of small doll-like figures and a carnival atmosphere.

Despite his debt to Severini, Stella's painting is quite different. It is more explosive, with its small, crowded forms moving outward from the center, and more vivid in color. The expression of sense impressions — noise, glitter, and churning motion — and the psychological effect of experiencing a total environment, is sharper. Although I agree with Werner Haftmann's observation, "One recognizes Severini's kaleidoscopic shuffling of fragments, but the turbulence of the movement and the dramatic expression of whirling space go far beyond Severini's charming decor," I am not in accord with his conclusion that "There is a lack of restraint and a spaciousness which may justly be called American." [8] Lack of restraint is a characteristic as southern Italian as American, and I do not find spaciousness in this painting. It is, on the contrary, crowded to the point of suffocation, and it is exactly this choked quality of the composition that conveys the "hectic mood," the "violent dangerous pleasures," the "carnal frenzy," the "surging crowd," the overheated drunken atmosphere of a "bacchanal" of which Stella speaks. [9] The spaciousness is only relative to other sections of the composition; the composition itself is not spacious.

Severini is not the only artist whose influence on Stella at this point in his career should be considered. The program of dynamism and the devices mentioned above had been adopted by a number of painters, and more

importantly, painters whose work was represented in the Armory Show, such as Jacques Villon, Francis Picabia, and Robert Delaunay.[10] Consider, for example, Jacques Villon's *Puteaux: Les Fumées et les Arbres en Fleur* (Smoke and Trees in Blossom).[11] Here, too, the surface is constructed of bits of color in various sizes and irregular shapes, with doll-sized houses imbedded in the over-all design. And here we find some of the looping arabesque ribbons so prominent in Stella's painting, and absent from Severini's. For the actual character of the shapes used by Stella for the faceted areas, we must look at still another painter, Francis Picabia. In both *La Procession, Seville* and *Dances at the Spring* we find chips of color juxtaposed in strong contrast that resemble several areas in *Battle of Lights*. But the way Stella varies the sizes of his chips of color is entirely different from that of Picabia, closer to that of Villon, but ultimately like neither.

Stella had doubtless seen the work of Robert Delaunay in Paris and become familiar with his ideas, which were widely discussed in 1912. The gyrating force of *Battle of Lights* easily could have been inspired by what Delaunay called *le sens giratoire* of colors.[12] With so many new ideas and new ways of expressing them current in the cluster of years around 1912, it is impossible to extricate and label the separate influences Stella absorbed. As with Fauvism, it is less a question of the direct influence of a single painter than of a stimulation in a general direction.

Stella's expression for his experience of the new movement was that his "youth plunged full in it," and this plunging quality is important when considering the *Battle of Lights*: Stella risked his own personality, the essence of his art, as he struggled to learn the expressive language of Matisse, Picasso, and the Futurists. He had the courage fully to accept the new influences. As it turned out, he had the strength to maintain his own vision. To Futurism, to the several variations of dynamic Cubism he brought, in *Battle of Lights*, the same sensitivity revealed in his writings on Pittsburgh. He felt again the oppressive atmosphere of a "damned infernal city" and saw "the grandiose horror and beauty of the flames exploding at night" in the garishly lit amusement park where colored searchlight beams raked the surging crowd and fireworks exploded in the dark sky.

In the following six to eight years Stella painted a large number of canvases in a style more or less related to that of the *Battle of Lights*, but

in a range so wide that they defy group labeling. Their common characteristics are a degree of abstraction, a composition constructed of relatively small highly activated elements scattered in a fairly dense design, and a palette of primary hues. There is perhaps a development within this style toward greater abstraction, while certain motifs appear to belong more to the early years.

Spring, c. 1918 (see Appendix III, Figure 47), for example, is composed almost completely of the chips of color that make up so much of the surface of *Battle of Lights*, and the color moves upward from dark to light. A shallow space is permitted in the lower area, as in the other Yale painting. But, although a quality of landscape may be felt in *Spring*, it is considerably less figurative than the 1913 *Battle of Lights*, less specific in its reference to place, and the prominent streamers of the Coney Island painting are missing. A pastel *Composition* (Figure 35), signed and dated 1914, though less abstract than, seems related to *Spring*, showing the serpentine movement from the lower area to the upper, and containing certain of the same peaked forms suggested in the upper area. A small oil, also called *Spring* (Figure 36), has the same general design, but differs in that it is executed in broad blunt strokes, again recalling the 1912 *Still Life* and therefore suggesting a date of around 1913–14. A pastel, *Abstraction, Garden* (Figure 34), reveals some of the irregular free forms found in the 1914 *Composition*, while the swirling ribbon strokes of *Battle of Lights* are also prominent here. Difficult to see at first, the design emerges as figures against an abstract ground. This suggests a close relation to *Battle of Lights* and a probable date of 1914. *Der Rosenkavalier* (Figure 33) can be dated with certainty to 1913–14; among Stella's papers an unidentifiable clipping of a newspaper review of the Montross Show of 1914 refers to it. "There is one picture the visitor is told rather proudly is Joseph Stella's impression of *Der Rosenkavalier*. Look long upon it and the impression grows that the artist did not go directly home after the opera. Fancy Egyptian figures are mixed up artistically with strange snakes." The checkered surface with its beam-shaped diagonals and the small particolored figures set into it relate *Der Rosenkavalier* quite closely to *Battle of Lights*. Sharing the features I have pointed out, the foregoing group of paintings leads me to conclude that the combination of faceted color, serpentine forms, and small embedded figures belongs to the earlier stage of this general style (see Appendix III, Figure 37).

We cannot be sure exactly when Stella painted *Spring* (Figure 47). In the letter to Katherine Dreier of July 7, 1939, he says it was painted in 1918; in a letter of January 22, 1942, he claims to have painted it in 1919. Writing about his trip to Italy in 1922, he remembers: "From the elysian lyricism of the Italian spring I gathered the elements of *The Dance of Spring* (acquired by Adolphe Lewisohn and used as a cover for *The Studio* August 1925)," and in pencil adds, "and for the abstract composition *Spring* owned by the Yale Museum.[13]

Thus Stella provides three dates from which to choose. It can only be said that *Spring* is a late work in a series, probably the last of a group that began with *Battle of Lights*. There is no way to establish the sequence of the paintings in this group, and therefore no evidence of a consistent evolution of Stella's style during these years. I am satisfied at present to ascribe works of this type to the years between 1914 and 1918, feeling that even if Stella painted *Spring* as late as 1922, by 1918 he had largely abandoned this style.

At the moment of his successful entrance into the world of modern art with *Battle of Lights* Stella was in his middle thirties. He was a heavy-set yet strangely graceful man, not as tall as photographs make him appear. He was usually carelessly dressed, with a rope tied around his waist as a belt. In spite of his shyness, he was an aggressive conversationalist on the subject of art, holding forth with confidence and color on any period or style from cave drawings to the latest exhibitions.[14]

Stella's days and nights were filled with work and thought and talk of art. When not in his studio, he often could be found at his favorite haunt, Renganeschi's,

> one of the earliest among the many bohemian resorts which grew up like mushrooms after the epoch-making International Exhibition in 1913. Renganeschi was not just another "Spaghetti Joint" . . . but a rendezvous for painters, sculptors, illustrators, journalists, musicians, models, warblers and even opera singers. It was a stone's throw from Jefferson Market and the Eighth Street Studio and a few blocks away from Cafe Martin and the Brevoort House while a little further up there was the exclusive restaurant for gourmets, Solari.[15]

The proprietor was Giovanni Renganeschi, whose wife sat

throned at the high desk while his brother and himself attended to

the guests, a motley crowd of bohemians and rebels and hungry artists who were offered credit by the golden-hearted boss.

After luncheon and dinner the crowd began to gather for the cafe noir and liqueurs, while musicians played impromptu dancing music and tunes to accompany the singers while the crowd joined in the choruses of the Neapolitan *canzoni* . . . as well as partitions [scores] from operas by Rossini, Verdi, Wagner and popular songs like "Tararabumdeaye!" and "Her Golden Hair was Hanging Down Her Back!"

The restaurant apparently also served on occasion as an unofficial and free model's agency.

The artists who frequented such bohemian gatherings soon made friends with the girls of the better social milieus who came there attracted by the glamour of the free and amusing artistic surroundings so different from their own dull home lives. . . . For those females the most acceptable cards of introduction were sketches of themselves or caricatures of the males. This method of picking suitable models was realized by Stella and all the other artists who had discovered that there was a vast difference between the professional models who were as a rule girls of the lower social strata and who by reason of poor nourishment, manual work and unsanitary conditions could not compare with the better fed leisure castes . . . all the artists including Stella agreed that the average American girl born and bred in the United States was infinitely superior in features, figure, silhouette and poise to the average European female, for she was the perfect blossom of fine interracial mixture, the fruit of a new culture and civilization.

It was at Renganeschi's in the early years of the first decade that De Fornaro first had seen sketches by that

untutored youth who because of his bulk was called familiarly Beppino, or Giuseppino . . . for his good nature, kindness and joy of life. From his sketches and paintings I guessed his wonderful gift for color and design. Dr. Antonio Stella . . . knowing of my studies in Munich and Paris asked for my frank opinion as to the artistic possibilities of his young brother. I replied that there was no doubt as to his talents and even latent genius! "Are you quite sure that he can achieve something worthwhile with his art?" "If you can assist

46

him during his first steps and permit him to mature properly I prophesy that within a decade or two Dr. Antonio Stella will be spoken of as the brother of the world renowned Joseph Stella." Dr. Stella . . . agreed to become the Maecenas of his brother. Two decades later, c. 1926 . . . he remarked, "My friend, you have proved yourself a true prophet, for now they speak of me as the brother of the famous artist."

Stella's fame as an artist had begun in 1914 with *Battle of Lights*. This painting, according to De Fornaro, "caused a general sensation, an artistic upheaval as sudden and unexpected as it was universal. It became the most widely discussed work of art in a decade and caused anger and dismay among the academic mummies."

While the effect of Stella's painting was not quite as universal as De Fornaro would have it, in avant-garde art circles his reputation soared. The April 1914 issue of *The Century* devoted most of its pages to a five-part article called "This Transitional Age in Art," with sections written by important figures in the art world: John W. Alexander, Edwin Blashfield, Ernest Blumenschein, Jay and Gove Hambidge, and Walter Pach. It was profusely illustrated with black-and-white reproductions of paintings, including a Cézanne *Landscape* and *Portrait of a Woman*, the Duchamp *Nude Descending a Staircase*, a Matisse *Self-Portrait*, Picasso's *Trees*, a Redon *Buddha*, a Prendergast *Sea-Shore*, two figures by Luks, a *Laughing Girl* by Henri, and two paintings by Arthur B. Davies. But the only color reproduction was Joseph Stella's *Battle of Lights*. Beneath it the following appeared:

> This painting, which in all probability is the last word in modernism, is a daring interpretation of the artist's impression of the dazzling light, the noise, the confusion, and the ceaseless motion of Coney Island. It represents an attempt to express the brilliance and the dynamic energy of modern life so evident in America. This artist believes that the static traditions and conventions of the past must be abandoned before art can reflect the changing material conditions and theories on which a new civilization is being founded. He has evolved a style of his own from various elements in the modern movement. Had he merely represented the physical appearance of the American fiesta, he believes that he could not have given the rhythm of the scene, which transforms the chaos of the night, the

lights, the strange buildings and the surging crowd into the order, the design and the color of art.

Ironically, the painting that brought Stella his first recognition in advanced circles caused the loss of his brother's support on the grounds that he was a "failure." The show at the Montross Gallery had drawn fire, as one would expect. Even three years later Frederick James Gregg recalled the quip current during the Montross Show that "a local wit . . . burst into a perfectly respectable luncheon of publishers at the Century Club with the question, "have you seen the Montrossities up the Avenue?" [16] De Fornaro records that

> a hack writer on the *Evening Sun* who was in charge of book reviews took up the cudgels for the reactionary peewees and launched onto a violent tirade concentrating venomous squirts upon Stella and his *Coney Island*. As the *Evening Sun* set a high standard upon its literary, musical and art criticisms, being considered the highbrow among the newspaper world, this sudden pushover caused considerable impression, and among those who took such opinions as gospel truth was Dr. Antonio Stella. Sadly but firmly he declared to his brother that now there was proof of his failure as a painter. . . . Stella was almost floored by this second body blow and in utter disgust and discouragement declared that he was ready to give up his ambition of devoting his life to art and would gladly go to work if a job could be found for him.

Seen for the first time, as a weird metallic
Apparition under a metallic sky it impressed me
as the shrine containing all the efforts of the
new civilization of America.
— "Brooklyn Bridge, A Page of My Life"

VI

Brooklyn Bridge
and the Industrial Scene 1916–1919

It seems to have taken two years to find a job for Stella; fortunately, when found, it allowed him ample time to study and paint. In a fragment entitled "My Sermon about Christ," from which the sermon itself is missing, Stella describes his mood and the circumstances surrounding this job.

During the first period of the great war, in 1916, Art came to a standstill, hardly any exhibition and hardly any sale. I felt desparate and at the same time urged by an absolute need of finding something to do for the gain of my living. When my brother offered me the position of a teacher of the Italian language in a Baptist seminary somewhere in Williamsburg, Brooklyn, although the remuneration was scanty . . . I accepted with joy, because I realized that occupied only in the morning (from 9 to 12) I would have the whole afternoon to . . . be able to enjoy my art work, exactly what I wanted without having to submit . . . to the approval of anyone, my brother included. I was in the most heroic . . . period of my artistic development. . . . The keen thirst of new adventures . . . kept me

awake with a throbbing energy. . . . Art was always my only reason of existence, everything was centered and focussed on her, and no hardship or difficulties of any sort with events and human beings, would have the power of extinguishing this sacred fire always burning into me. . . . I fixed the day and the hour for the meeting of the Baptist pastor that was going to appoint me teacher. . . .

It was one of those gloomy days, the sun concealed by a dense heavy sheet of steel covering tightly the sky, that I went to the meeting. A little preoccupied about the result of this meeting, I felt very hopeful nevertheless: I mostly feel strong in advance. Soon I was confronted with the Pastor. His black raven appearance impressed me quite familiar: where, and when I had seen him before? Perhaps in some bad dream . . . He did not put me to any ordeal of . . . investigation about my knowledge. He told me, with a solemn air, pointing his index finger, that he was only interested in the perfection of the soul. . . . The pupils affidato [entrusted] to him could be indulged in being ignorant, but not impure. . . . he invited me to the supper for some day the following week in order to solemnly introduce me to my future pupils.

. . . that evening I was ushered in a room full of clergymen discussing aloud various topics of the Bible. . . . The gathering . . . brought to my recollection the usual crowd of peasants gathered in the square of my little village every Sunday for the sale of their pigs. I felt that I should evade everybody . . . I put up the usual idiotic smile . . . and I began to roam, circle around, . . . turning right or left whenever I felt the danger to be dragged into a discussion . . . showing . . . the lack of my knowledge in the Bible. . . . [T]he Director appeared with his fulgent smile. . . . With a scream of real triumph he trumpeted my name and as the crowd suddenly became still he announced my next appointment as a teacher.

Although his first recognition came with a work based on a Brooklyn subject and some of his most memorable work was done in the years he lived there, Stella's memories of that New York borough were anything but pleasant. He hated it. In an interview years later [1] he related the following incident:

One evening I was in that horrible city of Brooklyn, an industrial inferno. I warn you . . . a place to run away from with both feet flying. Snow covered everything. A snow that was blackened with

coal: everything so icy and slippery that you were in danger of fall-
ing and breaking your bones at every step. . . . Not a soul out at
that hour. Not even a dog around. The houses and shops in that
anonymous neighborhood were locked and bolted. And everywhere
a deathly darkness, a pitiless silence. I was waiting for a bus . . .
cold . . . alone. To warm myself I tried to move a few steps on the
slippery walk. I saw nearby a bright light shining through the snow.
Not bad, I thought, it must be a bar open, a café, or perhaps a res-
taurant. Happily I went over toward that area of bright light that
seemed to rise up through the shadows. Slowly, slowly, I reached the
corner, and as I turned it I was almost blinded by a kind of electric
furnace. It turned out to be a dreadful window of a funeral parlor
that vomited a white fire from a hundred dynamos over the snow
on the street. In the middle of the window there was a coffin of white
enamel, lined with white silk. On the coffin was a card reading: "As
you like it?" This is America of the iron fists and steel nerves. (I,13)

Perhaps Brooklyn's depressing effect accounts in part for the change in
Stella's art that began around 1916. The atmosphere of the war years may
have contributed also. De Fornaro writes that "The period of the Great
War followed in the wake of the new movement in the arts and it proved
to be oppressive and tragic to a sensitive nature like Stella, who felt that
this orgy of slaughter was the negation of all civilized restraint and a
barbarous reversal to the primitive passions of rape, loot, murder and de-
struction." [2] The atmosphere of pessimism affected other artists; Thomas
Hart Benton, for example, said: "When the time for America's entrance
into the World War arrived, I was in the most confused and, secretly, de-
pressed state of mind I had ever been in." [3] It was about this time that
Stella began to produce works that, while exhibiting certain schematic
and abstract forms, are recognizable representations.

The war years witnessed a shift in style among most of the leading
painters not only in the United States but in Europe, a shift characterized
by greater simplification of forms, and/or a rewakened concern for rep-
resentational or figural elements. Alfred Barr notes:

During the winter of 1914–15, Picasso abandoned his rococo cubism.
He still used pointillist dots to enliven certain passages, but returned
to predominantly straight lines and used larger and fewer forms,
mostly flat rectangles tilting slightly to the left or right to form

opposing diagonals. His best paintings of 1915 and 1916 are impressive in size, bold in their color and abstract simplicity. . . . In August 1915 Picasso drew the portrait of Ambroise Vollard with an exquisite and precise realism.

By 1920, cries back to Poussin! back to Ingres! back to Seurat! rang through Paris . . . back to discipline and order, clarity and humanity.[4]

It was during this period that Mondrian, from earlier Cubist experiments, worked through the "plus and minus" style into Neoplasticism, with its severe reductions to primary colors and rectangular forms, and Malevich's influence through his Suprematist work, begun possibly as early as 1913,[5] expanded into the Constructivist movement of 1917. Ozenfant and Jeanneret published their Purist theories of clarification of form in *Après le Cubisme* in 1918. This was about the time that Italy saw the development of Pittura Metafisica and intensification and reduction of representational form, and Severini was moving to a classical position, arguing for a scientific, intellectual control and objectivity that he was to set forth in his *Du cubisme au classicisme* of 1921.[6]

The taste for broader, uncluttered surfaces was found in 1916 in the United States in the work of Marsden Hartley, who continued his interest in abstraction until about 1918, while the majority of American artists who had embraced the new art began even earlier to turn away from it. Katherine Metcalf Roof, in her biography of William M. Chase, observes gratefully, in 1917, that the madness of abstraction is over;[7] and in Frederick J. Gregg's review of the group show at the Bourgeois Galleries in November 1918, carrying the heading "Show in Bourgeois Galleries Indicates 'Wild Men' Have Settled Down to Get Best of Their Experience," we read:

> Most of the artists represented used to belong to what the sane called the "wild men." Their productions of, say, five years ago . . . were to the dealers foolishness and to the general public a stumbling block. But all that is changed, and now it is hard to see how the more timorous could have imagined that Ben Benn, Oscar Bluemner, Horace Brodsky, Arnold Friedman, Albert Gleizes, George Of, Joseph Stella, Maurice Sterne and Abraham Walkowitz could ever have been regarded as enemies of art society. . . . How is it to be explained: Have these artists given up their old tricks and settled down

to serious day labor? Have they changed or is it the spectator who is no longer capable of being surprised by anything hung upon a wall? Whatever the answer may be, it must be admitted, and frankly, that anybody who had passed years in weary pilgrimages through galleries would find it hard to specify anything in this interesting exhibition which could get even a member of the Academy into a heated argument. . . . The nine painters shown here have been out in the artistic No Man's Land. They are back within the lines, but what they are showing now is better or more significant than anything that they ever conceived before. Take a case in point . . . that of Joseph Stella! [8]

Since the details of Stella's life are unknown, we can only speculate about any personal causes which might have contributed to changes in his art that began to appear. He speaks of a sense of desperation, his driving need to earn a living, the fact that the art market had fallen ("Hardly any exhibition and hardly any sale"). And yet he mentions the "throbbing energy," the "keen thirst of new adventures." Certainly the conflict of hope and despair generated a period of exceptional creativity, the most creative six years in his entire life, and produced a number of stylistic variations that have in common the use of representational form.

Stella's early contact with the American industrial scene left an indelible impression on his memory. That impression, with its infernal imagery of smoke, fire, and blackness, was renewed when, during the war years, *The Survey* commissioned him to make a series of drawings of industrial subjects. It would be helpful to know exactly when he began work on these drawings, in order to clarify the relation between them and the series in oil of factory and gas-tank subjects usually dated to the same period, and to throw light on the possible genesis of his first painting of the Brooklyn Bridge. It is my opinion that the renewed contact with factory subject matter occasioned by the *Survey* commission inspired this group of works and that the earliest date for an industrial theme should probably be 1918.

The Survey for November 2, 1918, announced a forthcoming series of drawings, "The War Workers," by Joseph Stella, adding, "Readers of the *Survey* whose acquaintance goes back ten years will recall the remarkable series of drawings of Pittsburgh workingmen . . . miners and puddlers and rolling mill hands, native stock and immigrant, drawn by a

young Italian artist for the Pittsburgh *Survey*. This was Joseph Stella. . . . In our magazine numbers beginning with the Christmas issue in December, we shall publish the first of a series of four inserts showing the men who are fashioning ships and uniforms, guns and airplanes." [9]

Ten days later the war was over, but the November 30, 1918, issue carried illustrations by Stella of *The Shipbuilders* (Figure 45) and other war industry drawings; the promised series did actually appear in January, February, and March 1919. The commission probably had been given early in 1918, possibly even in 1917, when United States industry was actively engaged in the war effort.

Stella's work was not exactly what *The Survey* had requested. The difference between what the magazine expected and what it received throws significant light on Stella's art and personality. In the February 1, 1919, issue the editors confided that "As a portrayer of American workers in action, Joseph Stella is a trial, but perhaps he has done something more important than his actual commission for us." Referring to *The "Insides"* *of the Clock of War* (Figure 41), they explained: "When, after his return from Bethlehem, we asked Joseph Stella to draw us a group of steelworkers, he drew us this picture. To draw the men by themselves was to get them out of focus, he said, just as to draw a landscape and call it "America" was to get the United States out of focus. . . . The working team in the steel mills is one in which the machine dwarfs the human element." [10]

The "Insides" of the Clock of War differs radically from Stella's drawings of the earlier decade, revealing the knowledge of abstract design he had gained in the intervening years. The geometrically designed space is defined by a web of crisscrossing lines that suggests something of Cubist interpenetration of planes, although the romantically gloomy atmosphere imparts to the abrupt linear changes of direction more the air of Piranesi than of Picasso. The war workers with whom *The Survey* was concerned are reduced to all but invisible black calligraphic shapes scurrying in the darkness. Where figures do appear in this series, one no longer sees behind them the old-master draftsmanship of the Italian seventeenth century. The dominant interest has shifted from the earlier picturesque and humanitarian concerns to more formal problems of rhythm and planes, always, however, charged with Stella's emotional vision.

The catalogue of exhibitions in which Stella participated between 1917 and 1919 confirm my view that the industrial paintings grew out of *The*

Survey commission and thus must be dated from 1918 on. In October 1917, in a group show at the Bourgeois Galleries, Stella was represented by *Southern Italy, Night, Early Morning, The Country Church,* and *Evening.* (These paintings represent still another aspect of his work at this time, to be discussed presently.) In March–April 1918, again at a Bourgeois group show, he exhibited *La Fusée, Night, The Sanctuary,* and *Aquatic Life;* and in November–December 1918, there were *Solitude, Night, Head of Old Man, Three Silver Points,* and an etching of an *Old Woman.*[11] Not until May 1919 are titles indicative of the industrial subject matter found; then, along with titles similar to those in the previous three shows, we find for the first time an *American Landscape* (see Appendix III, Figure 43) and *Pittsburgh* (glass).

The major painting belonging to this category of Stella's work of this period is *Brooklyn Bridge* (Figure 50). In answer to a letter of inquiry from Katherine Dreier, he wrote on January 22, 1942, that *Brooklyn Bridge* was painted in 1917–18. In "Discovery," he writes: "In 1918 I seized the . . . American theme that inspired me so much admiration since I landed in this country, the first erected Brooklyn Bridge."[12] Catalogues prove that Stella had the opportunity to exhibit *Brooklyn Bridge* on at least three occasions before 1920 in company with such painters as Robert Delaunay, Albert Gleizes, Jean Metzinger, André Derain, Maurice Prendergast, and John Marin, but he did not do so. When he did finally exhibit it in a one-man show at Bourgeois in March–April 1920, the painting was reproduced in the catalogue and listed as *The Bridge* under the heading, "Paintings, 1919–1920." Thus, evidence indicates that the painting was not completed until late 1919 or even early 1920 although it was probably started in 1918 (see Appendix III, Figure 50).

Brooklyn Bridge is a large, wide, vertical canvas, organized asymmetrically around a central axis. The objective elements — bridge cables, wires, arches, tunnels, towers, and the New York skyscrapers beyond the bridge in the distance — all have been organized into a semiabstract design that gains effectiveness from the interplay between its surface and recessed planes. The diamond-shaped form at the base of the vertical axis seems to come forward, even to project beyond the picture plane, and as the eye moves upward the forms are read as receding into distance, thc lines of the roadway converging toward the arches of the tower. The broad arch that extends from one edge to the other across the upper section

seems to lie, in the center area, in a plane even deeper than the tower, although at the left margin it appears to be close to the surface and at the right margin is actually on the surface. Do we really read this, then, as an arch, or as the distant segment of a cylindrical rim: does it move upward, or inward? In the former case, the tower must lie behind it; in the latter, the tower is in front.

If we look to other relationships in the painting in the hope of clearing up this single problem, we find our hopes thwarted by a maze of criss-crossing wires and cables. The problems increase, as the cables that dart up diagonally from either edge appear to recede, the one on the left actually passing behind the tower but in front of the arch (or rim), the one on the right either ending abruptly in midair or tapering into a thin black line that cuts across the right corner of the tower and under the arch (or rim). But these cables must also be read as rising upward, meeting like crossed swords near the upper edge. The effect of depth that would ordinarily develop as a consequence of the many stabbing inward thrusts produced by the diagonals is reduced by the repetition of vertical forms in the lower and upper sections. The eye is led in and out through the interplay between diagonals and verticals, and reads the tower as far distant each time it rests there. But the compositional devices that Stella sets up to oppose the illusion of depth returns the eye to the plane close to the surface and the viewer is thus made to experience a constant tension between near and far.

The entire surface is kept alive with sudden shifts of direction and varieties of shapes. In the lower area, representing the underground, the forms are thicker, heavier but more widely spaced; in the upper section the forms are thinner, lighter but more clustered. The web of verticals and diagonals knits the surface into a unified design.

The painting is on a fine-grained canvas, prepared with a gesso ground.* This ground, beige-gray in color, together with the very dry paint and thin texture, gives something of the effect of fresco painting. (Stella's awareness of and ties to the great Italian tradition were never far from his mind.) The effect of shifting light flickering over the surface and into the recesses is obtained by the dry-brush technique of scumbling the

* The legend that *Brooklyn Bridge* and *New York Interpreted* were executed on bed-sheets is false. Stella wrote Katherine Dreier, on July 7, 1939: "Your Bridge was painted on the same canvas, with the same gesso ground, that I used for *New York Interpreted*" (Yale University Sterling Library, "Stella").

paint, an effect seen in some early Cubist paintings of Picasso and Braque. There is also a hint of the kind of transparency found in the Cubist paintings of Albert Gleizes.[13]

It is easy to recognize in *Brooklyn Bridge* the techniques of fragmentation of form and *passage* adapted from Cubism and the lines of force and fusing of planes adapted from Futurism, but Stella's use of these formal ideas is unique, and the painting stands as a major work in twentieth-century American painting. It is a culmination of Stella's experiences of art and life up to that time, integrated into a unified vision of intense complexity and profound expression. In "Discovery," he wrote of it:

> To realize this towering imperative vision in all its integral possibilities I lived days of anxiety, torture, and delight alike, trembling all over with emotion like those railings in the midst of the bridge vibrating at the continuous passage of the trains. I appealed for help to the soaring Walt Whitman's verse and to the fiery Poe's plasticity. Upon the swarming darkness of the night, I rung all the bells of alarm with the blaze of electricity scattered in lightnings down the oblique cables, the dynamic pillars of my composition, and to render more pungent the mystery of the metallic apparition, through the green and the red glare of the signals I excavated here and there caves, as subterranean passages to infernal recesses.[14]

Stella's essay "Brooklyn Bridge, A Page of My Life" confirms the impression of mystical fervor that seems to animate this image.

> Seen for the first time, as a weird metallic Apparition under a metallic sky, out of proportion with the winged lightness of its arch, traced for the conjunction of Worlds, supported by the massive dark towers dominating the surrounding tumult of the surging skyscrapers with their gothic majesty sealed in the purity of their arches, the cables, like divine messages from above, transmitted to the vibrating coils, cutting and dividing into innumerable musical spaces the nude immensity of the sky, it impressed me as the shrine containing all the efforts of the new civilization of America . . . the eloquent meeting point of all the forces arising in a superb assertion of powers, in Apotheosis.
> To render limitless the space on which to enact my emotions I chose the mysterious depth of night . . . and to strengthen the

effective acidity of the various prisms composing my Drama I em-
ployed the silvery alarm rung by the electric light.

Many nights I stood on the bridge — and in the middle alone —
lost — a defenseless prey to the surrounding swarming darkness —
crushed by the mountainous black impenetrability of the skyscrapers
— here and there lights resembling suspended falls of astral bodies
or fantastic splendors of remote rites — shaken by the underground
tumult of the trains in perpetual motion, like the blood in the arteries
— at times, ringing as alarm in a tempest, the shrill sulphurous voice
of the trolley wires — now and then strange moanings of appeal from
tugboats, guessed more than seen, through the infernal recesses below
— I felt deeply moved, as if on the threshhold of a new religion or in
the presence of a new DIVINITY.[15]

In a letter to Katherine Dreier, September 26, 1929, from Naples, Stella
comments, "*The Bridge* is the *Drama*, while *Coney Island* is the *Comedy*
of Modern Machinery."

Brooklyn Bridge was a *succès d'estime* and advanced Stella's already
substantial reputation in American art circles. Hamilton Easter Field,
editor and publisher of the highly important monthly *The Arts*, devoted
an article to him in the issue of October 1929, focusing his discussion on
the painting of the bridge.

The Brooklyn Bridge must mean more to me than to most Ameri-
cans. From my bedroom window I watched it grow. . . . The paint-
ing to me is more real, more true than a literal transcription of the
bridge could be. The cables are ghostly threads, as they approach
the electric lights, only to be lost in darkness as they go up into
space. To the right there is the suggestion of an ever flowing line
of trolleys and of trains from the elevated, and green lights to show
that the way is clear. The whole picture is throbbing, pulsating,
trembling with the constant passing of the throng of cars. . . . So
far I have spoken only of its suggestiveness. . . . Apart from this
there is its value as pure design, and it is in its design that the painting
is strongest. The design is as compact as in a Luca Signorelli.

The Gas Tank (Figure 43), exhibited in 1919, provides a basis for
making comparisons and drawing conclusions in an effort to establish a
chronology for the industrial paintings. Like *Brooklyn Bridge* it is an
over-all design composed of geometric shapes. Only a minimum distinction

is made between the solids and spaces so that the gas tank seems hardly more palpable than the atmospheric night in which it is placed and the beams of light that slice diagonally across the surface. These diagonals function similarly to those in the bridge paintings: the dominant spear shape that crosses the painting from lower left to upper right lies on the surface; others, beams of light and some structural forms, lie further inside the picture space. The relationship between the various diagonals produces a flattening of space, again as in the bridge paintings, so that the effect of the composition is abstract although the subject is recognizable. It apparently was not always as recognizable as it seems now to our abstract-sophisticated eyes: in 1944 *The Gas Tank* was reproduced upside down on the cover of an art gallery pamphlet,[16] even though the artist's signature appears at the lower right of the painting.

The Gas Tank is a dark picture, the tonality dominated by black and deep blue pierced by glowing, fiery reds. Its atmosphere suggests the "pulsating, throbbing . . . explosions of the Pittsburgh steel mills" that seemed to Stella "Like the stunning realization of some of the most stirring infernal regions sung by Dante," and the serpentine curves that writhe along the lower area and coil around the long diagonal beam are probably the fog and smoke lashed by the wind in which he hears "the bitter, pungent Dantesque terzina." [17]

The design of *Factories* (Figure 71), differs considerably from *The Gas Tank* and *Brooklyn Bridge*. The surface is not broken up into geometric shapes, nor does the composition have the character of an over-all design; the crisscrossing web and the thrusting diagonals have disappeared. There are, however, segments of circles and ovals in the upper right area that are similar to forms found in *Brooklyn Bridge*.

The tendency to more realistic representation is carried further in *Smoke Stacks* (Figure 74). Here, although the building contours have been sheared off and regularized, the forms nevertheless present recognizable factory buildings silhouetted against the fire-lighted skies, and the smoke shapes, however subjectively projected, are unmistakably smoke. Stylistically, *Smoke Stacks* falls between *Factories* (Figure 71), which seems to predate it, and *Factories* (Figure 72) and *Factories at Night* (Figure 73), in which the newer tendencies are more completely realized. Shapes, as in the earlier paintings, are simplified, generalized, and enclosed in sharply silhouetted contours, but they are pushed closer up to the

picture plane, looming large against the sky and crowding out the space around them.

The problem of dating these industrial paintings is complicated some-what by the appearance in *The Survey* for March 1, 1924, of a series of drawings by Stella illustrating an article, "The Coal By-Products Oven." These studies, based on direct observation, carry long explanatory titles such as *The By-Products Storage Tanks That Receive the Distilled Ammonia and Tar From The Ovens* (Figure 61), and *The Traveling Pusher, Which Lifts The Doors, Pushes Out The Hot Coke And Levels The New Charge of Coal.* Significantly, the drawings exhibit stylistic resemblances to the paintings just discussed and contain actual details recognized in them. *The By-Products Storage Tanks* provides the central motive for *Factories* (Figure 72); the steel structure and coal pile from another of the drawings, *Bituminous Coal Storage Piles* (Figure 62), appear at the right of *Factories at Night* (Figure 73); and the *Crusher and Mixer Building* (Figure 63), is easily recognizable at the right in *Factories* (Figure 71 and *Factories* (Figure 72) as well. It would seem probable, therefore, that the commission for these drawings was given to Stella in the year preceding their appearance in the magazine, and that the related paintings were executed during 1923–24 or later (see Appendix III, Figure 74).

On other accounts, however, it is more likely that the commission was given to him several years earlier, and that the drawings simply were not published until later. In "Brooklyn Bridge, A Page of My Life," Stella recounts that he went to live in Brooklyn "during the last years of the war," and it is clear that his insight into the poetic drama of the Bridge and Brooklyn factories is associated with those years.

> War was raging with no end to it . . . so it seemed. There was a sense of awe, of terror weighing on everything . . . obscuring people and objects alike. Opposite my studio a huge factory . . . its black walls scarred with red stigmas of mysterious battles . . . was towering with the gloom of a prison. At night fires gave to innumerable windows menacing blazing looks of demons . . . Smoke, perpetually arising, perpetually reminded of war. One moved, breathed in an atmosphere of . . . the impending Drama of Poe's tales. My artistic faculties were lashed to exasperation of production. I felt urged by a *force* to mould a compact plasticity, lucid as crystal, that would reflect . . . the massive density, luridly accentuated by light-

ning, of the raging storm, in rivalry to Poe's granitic fiery transparency revealing the swirling horrors of the Maelstrom. With anxiety I began to unfold all the poignant deep resonant colors, in quest of the chromatic language that would be the exact eloquence of steely architectures . . . in quest of phrases that would have the greatest vitriolic penetration to bite with lasting unmercifulness of engravings. Meanwhile the verse of Walt Whitman . . . soaring above as a white aeroplane of Help . . . was leading the sails of my Art through the blue vastity of Phantasy, while the telegraph wires, trembling around, as if expecting to propagate a new musical message, like aerial guides leading to Immensity, were keeping me awake with an insatiable thirst for new adventures. I seized the object into which I could unburden all the knowledge springing from my present experience, The Brooklyn Bridge.

Another reason for assigning a date earlier than 1923–24 to these *Survey* drawings is indicated by a passage in "Discovery." In connection with the period during which he was working on *New York Interpreted* (1920–1922), Stella writes: "Besides these large canvases I painted many others of limited size: *Factories* (in the possession of the Museum of Modern Art), *Pittsburgh* and *Man in the Elevated* (two oils painted on glass), *New Jersey Gas Tanks* (acquired by the Newark Museum in 1934), to name a few." [18] In the catalogue of the Stella-Schnakenberg exhibition at the Whitney Studio Club in November 1921, a painting, *Factories*, is listed, which is probably the one (Figure 71) Stella refers to. This work was not exhibited in his retrospective show at the Bourgeois Galleries in the spring of 1920, and it probably was painted sometime during the eighteen months between the two shows.

Furthermore, a gouache, *Telegraph Pole* (Figure 69), signed and dated 1917, bears some of the features of *The Survey* factory drawings and the related oils. The architectural forms are generalized blocks silhouetted against a light sky. A landscape area below, painted in rich reds, blues, greens, and yellows that run together in ragged forms, contrasts with the straight-edged, brown and gray posts of the structural elements. *Telegraph Pole* in all likelihood predates the "1924" works, for it appears in "The Port" canvas of *New York Interpreted* (Figure 75d). How much earlier it is, is difficult to say, although I am reluctant to accept the date of 1917.

A painting on glass, title unknown (Figure 60), has in common with *Telegraph Pole* and the factory paintings regularized contours and silhouetted forms. But the objects are less clearly read than those in this group. The use of pointillist dots for what I take to be rays of light reminds us of "White Way I" and "White Way II," in which the spirals and serpentine forms seen in this painting on glass occur (Figures 75b, 75c).* The style relates it, therefore, to *New York Interpreted*, which accords with Stella's comment in the above passage, that he painted two oils on glass in those years. However, we remember the coiling forms also from *The Gas Tank* (Figure 43) of 1918, and we note in a Bourgeois Galleries group show catalogue of March 25–April 20, 1918, that Stella exhibited *La Fusée* on glass, and that in a group show at the same gallery in May 1919, he showed *Pittsburgh*, on glass. It is possible that the untitled painting on glass illustrated here is one of these and that it can be dated as early as 1918. I am inclined to think that *Telegraph Pole* is in fact a watercolor sketch for "The Port" (Figure 75d) and thus dates to 1920–1922, and that the factory paintings were also executed within these years, with *Factories* (Figure 71) the earliest of the group.

About 1920 a new movement in American painting, usually referred to as Precisionist, had begun to emerge. The Precisionists found in industrial and urban architecture both form and subject ideally suited to a representational application of Cubist methods. It is interesting to compare Stella's treatment of those themes with that of the leading Precisionists. Charles Sheeler, followed by Preston Dickinson, Niles Spencer, Charles Demuth, and others, found "in skyscrapers, factories, grain elevators, bridges and machine-age structures of all kinds . . . pure, clear-cut forms and a functional rightness." They "were not interested in . . . the dynamism and romance of the modern world, like Stella," their chief concern being in "a complex of forms," a "controllable arrangement of forms." [19] In Stella, by contrast, we feel the dark mystery of symbolism in the looming black shapes touched with red, yellow, blue, or green, like colors seen leaping in a roaring fire, and in the tall verticals erupting clouds of smoke that seem strangely animated, and sometimes almost anthropomorphic (Figure 74). The identification of beauty with functionalism, a basic assumption of the Precisionist style and an equation that is deep-rooted

* I have affixed the numbers I and II for convenience in referring to these two parts of *New York Interpreted* which allude to the theatrical section of Broadway.

in American tradition, was foreign to Stella's sensibilities; this "poet of the industrial scene among American modernists," [20] was closer to Poe than to William Carlos Williams. There are similarities between Demuth's *I Saw the Number 5 in Gold*,[21] with its design conceived as an interplay between two- and three-dimensional forces and its forms sliced by stylized beams of light, and Stella's "Bridge" and "Skyscraper" paintings in *New York Interpreted*. But the atmosphere in most of Demuth's painting is not like that in Stella's work. Although the former possesses a strong current of subjectivity and an expressive weirdness, it seems intellectual and coolly objective compared to Stella's spectacular and dramatic spirit. The Precisionists' homage to America was to its practicality; Stella paid tribute to its power.

I gathered all my strength to assault with the
theme that for years had become an obsession:
'The Voice of the City of New York Interpreted.
— Discovery

VII

New York Interpreted 1920–1922

New York Interpreted (Figure 75a–e), painted between 1920 and 1922, is Joseph Stella's most ambitious work. Composed of five canvases, four of equal size separated by a taller center section, the over-all painting is 8¼ feet high at the center (the four flanking sections are 7⅓ feet high) and 22½ feet wide. It unites motifs drawn from architecture with street and harbor views, and combines them with forms representing sounds and smells. The painting projects a powerful image of the city, and in its originality and grandeur of concept is a significant work in twentieth-century American art.

Stella's contribution may be better evaluated, his treatment of the city more properly appreciated, if we consider briefly other artists' approaches to this theme. The city as a pictorial motif had been treated as a symbol of divine power, as a view in itself, and as a setting for genre. Among Stella's papers, magazine clippings of the apse mosaic in Santa Pudenziana and of Ambrogio Lorenzetti's *Veduta di Città*[1] indicate his interest in the first two concepts; and both works contain certain features prominent in *New York Interpreted*. In Santa Pudenziana the winged arrangement of the roofs symmetrically flank the tall vertical axis composed within an enframing arch; the Lorenzetti work has a prominent boat-shaped form in the upper right. (In Stella's own description of *New York Interpreted*,

64

quoted later, he refers to boat imagery in the "Skyscrapers" section.) Nevertheless, although the city had been compressed into a symbol, and its general features had been described, it had not been approached as a totality in itself, characterized for its own sake, in terms of its unique quality, as had been, for example, the human figure or the nonurban landscape.

Beginning with the Renaissance, scenes representing urban environments became popular, but the city did not become a major theme in art until well after the middle of the nineteenth century. By the twentieth century it was well established as pictorial subject matter, and in 1912, when Robert Delaunay exhibited his newly completed *La Ville de Paris* for the first time at the Salon des Indépendants, Guillaume Apollinaire pronounced it the most significant work of the Salon.[2] Delaunay's painting is a semi-abstract "portrait" of a city rather than a cityscape. Paris is compressed into a symbol, not of static power as in the Middle Ages, but of dynamic creativity — the home of the Graces that dominate the foreground. It is not a place so much as it is an idea of a place, the ideated domain of Joy, Vitality, and Brilliance. Departing from the city-as-a-frame concept, *La Ville de Paris* is a monumental portrait of a city whose general appearance is expressed by means of its most readily recognizable features. The painting's great size, approximately 10½ by 15½ feet, helped impress it on those who saw it at the Salon, among whom was unquestionably Joseph Stella. It is easy to imagine him seized with the inspiration to portray New York, as he stood before Delaunay's painting of Paris.[3]

Italian Futurists found the city the ideal symbol for their art theory. In 1909 Marinetti had written in his "Initial Manifesto of Futurism," "We shall sing of the great crowds in the excitement of labour, pleasure and rebellion; of the multi-coloured and polyphonic surf of revolutions in modern capital cities; of the nocturnal vibrations of arsenals and workshops beneath their violent electric moon; of the greedy stations swallowing smoking snakes; of factories suspended from the clouds by their strings of smoke; of bridges leaping like gymnasts over the diabolical cutlery of sunbathed rivers."[4] Between 1911 and 1912, houses and figures interpenetrated in paintings by Boccioni, Carrà, Russolo, and Severini. Some motifs from these Futurists do appear in *New York Interpreted*, such as Russolo's curving meanders and V-shapes and the use of diagonal beams of light like those in Boccioni's *The Laugh*, which Stella had already de-

veloped in *Battle of Lights*. Stella's contact with Futurism must be considered when we take into account the sources of his art, but it should be emphasized that the dissimilarities are at least as important. His concept of New York reflects the imagery of Marinetti's poetry and the program of the Futurist painters (and even that only in its positive, constructive terms) rather than their total visual effect.

Stella never felt a strong identification with the *mene freghista* * Italian movement. He never exhibited with any of the group, and as early as 1913 he is quoted as saying that one must "paint sincerely without trying to please the Futurists or the Post-Impressionists or to displease the Academicians."[5] As time went on he became more explicitly anti-Futurist, stressing the fundamental importance of tradition and the old masters (anathema to the Futurists) and the original and chief importance of modern French art. In 1925 he wrote: "Italian, and proud of the great artistic past of Italy, I consider France the only nation today to possess the sacred fire of art. Without France, true modern art, art that remains free and pure, like that of the past, without the help of official praise, would not have been able to exist, and I consider that it is the duty of the sincere modern artist from no matter where to recognize as his true country the nation-of-light: France" (I,59).[6] In an article reviewing a 1940 exhibition of Italian masterpieces at the Museum of Modern Art, Stella attacked the Futurists, comparing them to "the sixteenth-century Neapolitan painters, led by Massimo Stanzione, [who] painted over the Giotto frescoes in the church of Santa Chiara. I could cite other examples, to goad to action the seditious self-seeking of those postfactum latecomers who call themselves Futurists" (I,14).[7]

Stella's reverence for Italian art and artists of the great past was passionate and devout. In "The Beacons" he writes:

> Today, here in America after ominous black days in which in June the lugubrious winter returned with its terrible fiendish sneer, the sun burst out like a flash of lightning and spread over all creation like a Hosanna of Resurrection. All my thoughts rose with the vigorous assertiveness of virgin stalks and my memory intoned, loud and clear as the bells at Easter, a hymn to the golden art, the triumphant art of Italy.
>
> On the slopes of the incorruptible Olympus that is Art, in the

* Loosely translated, "to hell with everything."

66

heavens, there appeared the glorious vision of the glorious army of all the prodigious artists of Italy, guided by a diamondlike Giottesque brilliance. . . . Giotto, the standard bearer of every illustrious virtue of the race that was raised to heaven in order to dispel the darkness in which poor humanity struggles, torn to shreds by the savage harassments of everyday life.

And as a guardian angel, an inflexible sentinel standing at the Sanctuary of this artistic patrimony, the most valuable estate that Jove has bequeathed to humanity, for its salvation, I place on this proud pure throne the effigy of Mantegna. The face of Mantegna, his hair tumbled like a Medusa of Art, his features lit as if by the thunder and lightning of biblical wrath. . . . Mantegna ripened and formed in purest steel . . . that face with the severity of its Godlike gaze drives out of the temple of Italian art all the jealous, howling barbarians with their evil plots, all those barbarians belonging to those races of gnomes that in all periods, livid with rage and jealousy because of their base spiritual slavery, because of the misery that crushed them and holds them in subjection, spur themselves on to befoul in various ways the ever-glittering golden stairway of the glorious art of Italy. (I,15)

The distance between the Futurists and Stella, although narrow enough for him to be able to see across, was too wide to leap. The Futurists, believing speed the dominant characteristic of the new century, set about to solve the problem of depicting movement. Stella, by contrast, conceived strength and energy, steel and electricity, as characterizing modern life and achieved his effects through the use of dramatic, sometimes garish color and symmetrical composition. The dynamism of the Futurists has been characterized as "cinematography" by both Wyndham Lewis and Pierre Francastel,[8] a harsh but not completely unjustified description. It is this very quality that Stella rejects in *New York Interpreted*, straightening axes and balancing oblique and right angles, so that instead of the plunging interpenetration of lines and forms in continuous space, he produces an interplay of these elements in overlapping planes. In this he is closest to Balla, who, however, was not represented in the Futurist exhibition at Bernheim-Jeune in 1912. Despite a city-based philosophy, the Futurists produced, not a portrait *of* the modern city, but rather, a Bergsonian projection of flux and interpenetration of human sense experience *in* the city.[9] Their contribution to Stella's inspiration for his painting of New York came mainly from the word-images of their manifestoes.

In the United States, New York had found in Robert Henri and his followers, the city realists of the first decade of the century, artists responsive to its multifaceted spectacle. As early as 1910 John Marin painted the watercolor *River Movement — Downtown*, followed in 1912 by *Movement — Fifth Avenue*. After the Armory Show, Abraham Walkowitz executed many *Improvisations* of New York. But Max Weber was the first American artist to paint a truly abstract image of the city; in *New York*, 1912, and in *Rush Hour, New York*, 1915, he infused a heightened dynamism into a type of Cubism that owed much to the Futurists.[10] But it was neither Weber's idea nor Marin's nor Walkowitz' to create a portrait of the city in the comprehensive sense of Delaunay, and the French artist must be credited with the original concept, the springboard from which Stella's imagination could leap.

The problem Stella faced was first to find the symbols that would express his insight, and then to create the forms that could embody those symbols.

> In 1920 I gathered all my strength to assault with the theme that for years had become an obsession: The Voice of the City of New York Interpreted.
>
> For years I was dreaming of this tremendous subject and many times I feared that my idea was impossible to be realized in painting. The prism was composed of so many facets and above all what to begin with was the most difficult problem to solve. The idea of finding the right approach was keeping me hesitating and so desperate of this hesitation. But in spite of all the difficulties to vanquish I felt sure that some day I would grasp what I was looking for. My faith sprung from my full knowledge of the subject. In fact I had witnessed the New York's growth and expansion proceeding parallelly to the development of my own life and therefore I was feeling entitled to interpret the titanic efforts, the conquests already obtained by the imperial city in order to become what now she is, the center of the world.
>
> Continually I was wandering through the immense metropolis, especially at night, in search of the most salient spectacles to derive from the essentials truly representative of her physiognomy. And after a long period of obstinate waiting, while I was at the Battery, all of a sudden flashed in front of me the skyscrapers, the port, the bridge with the tubes and subways.[11]

The sources of a single painting are many and varied. One of the most formative influences for *New York Interpreted* was Stella's early dramatic exposure to the industrial life of Pittsburgh. Renewed contact with American industry in 1918 revitalized those impressions. The drawings made for this series reveal a number of ideas incorporated into *New York Interpreted*: the patterning of architectural elements and the wiry linearity in *The Garment Workers* (Figure 42) are the general characteristics of the five sections; the boat-prow form and winged composition of *The Shipbuilders* (Figure 45) play the central role in the polyptych (Figure 75a).

Another source can be conjectured from Stella's connection with Frederick C. Howe, Commissioner of Immigration at the Port of New York. In 1916, Howe's article, "Turned Back in Time of War," appeared in *The Survey*, with illustrations by Stella of immigrant figures similar in style to his 1908–1910 drawings. In a book published a year earlier, Howe had quoted from *Emancipation of the Medieval Town* by A. Giry and A. Reville: "The cities hummed like bees, the streets were still narrow, irregular and unsanitary, but they were teeming with life. . . . It was a new civilization bursting into bloom. Splendid monuments arose . . . and churches lifted toward heaven their domes, campaniles and spires. . . . The town bell was the *public voice of the city* as the church was the voice of the soul." [12] Stella's alternate title for *New York Interpreted* is *Voice of the City*; that, plus Stella's connection with Howe and the fact that the imagery in the quotation bears striking resemblances to the imagery in Stella's painting makes it seem likely that he had read and been impressed by this passage.

The polyptych form of the New York painting can be attributed to Stella's Italian origins and his reverent, passionate admiration for the early Italian masters, whose altarpieces were regularly composed of multiple panels with predelle. [13] The mystical leaning, through which his sense of the material power of steel and electricity was transformed into a spiritual experience, also contributed to his envisioning the city in this form, and led him to project it in conceptual terms that link him to the simplified representations found in medieval imagery. The altarpiece character of *New York Interpreted* is implied by the fact that Stella used the five sections to illustrate the privately published edition of his essay on the Brooklyn Bridge in which he describes the bridge as a shrine, and speaks of

feeling himself in the presence of a new divinity; elsewhere he writes, "from arks and ovals darts the stained glass fulgency of a cathedral." [14]

The religious content is further suggested by the five-part format, with the center canvas taller than the other four, and by the use of the predella, as Stella referred to the lower border. The quotation from altarpiece art is most explicit in the central work, "The Skyscrapers" (Figure 75a), with the central vertical axis moving upward on wings supporting a fantastic image that recalls the cloud-borne upper section of Renaissance paintings. The vertical rising shafts, narrowing as they ascend, terminate in a church-like spire, which sends out radiant spokes of light from behind its apex, surmounted by a halo. And commenting on "The Port" (Figure 75d), he explains how "Pure vermilion is lighted up at the vertex of a pyramid of black cords . . . as the burning offer of human labor, while telegraphic wires rush to bind distances in armonic whole of vibrating love." [15]

Among the important sources that found plastic expression in the imagery of *New York Interpreted* must be included poetry. Stella had a love for poetry and an extraordinary gift for reciting long passages from memory.[16] Stephan Bourgeois recalls the evening a group of artists gathered at an Italian restaurant in Greenwich Village for a bon voyage party. In the midst of the excitement and gaiety someone called out, "Play something for us, Stella; Stella, play something!" The artist, big, bulky, arose and recited a passage from *Othello*, playing the role of Desdemona. The audience was spellbound, seeing the large man transformed before its eyes into a beautiful woman, and hearing the part played with tenderness and grace.

In the "Brooklyn Bridge" essay, Stella counterposes "Poe's granitic fiery transparency revealing the horrors of the maelstrom" to "the verse of Walt Whitman . . . soaring above as a white aeroplane of help." A similar image is present in *New York Interpreted* in the horizontal tunnels and subways of the predella that suggest the dark imagination of Poe in contrast to the soaring Whitmanesque optimism of the vertical, reaching forms, above. On one hand, the work, painted at the height of Stella's powers, in his early forties, reflects his capacity for hope, his faith in the future. World War I was over, the Allies victorious, and the new world ready to move onward and upward. "Unexpectedly, from the sudden enfolding of the blue distances of my youth in Italy, a great clarity announced Peace . . . proclaimed the luminous dawn of A NEW ERA." [17]

On the other hand, *New York Interpreted* also reflects Stella's anxieties as expressed in several essays which will be discussed later.

Stella thought of *New York Interpreted* as a symphony in five movements, "a symphony that is free in the vastness of its reverberations yet sharp and precise in its development: abstract with certain carefully worked out representational references" (I,17). He wished to create "a drama of contrasts well calculated to bring out both the highly spiritual and crudely materialistic aspects . . . derived from the Basic Elements, truly new: *The Skyscrapers, White Ways* (Hymn to Electric Lights), *The Bridge, The Port*" (I,17).

The plan for *New York Interpreted* developed during the course of many preparatory pencil, crayon, and watercolor sketches, examples of which may be seen in Figures 67 and 68. Judging from a watercolor and gouache study of the five sections (Figure 66), the work was to have been unified by an arc extending across all five canvases. Early painting on the canvas must have retained that plan, for on close study very faint traces of the arc are still visible. Stella eventually abandoned this design in favor of the narrow arc across the "Skyscrapers" only. He then united this center painting with forms in the adjacent sections by means of lights and darks and linear continuities. The over-all unity of the work is produced by the greater height of the central canvas, to which the other four are equally subordinate, and the plan of alternating light and dark scenes so that the outer ones accord with that of the center. The general idea of each canvas remained in the final version substantially unchanged from the stage reached with the watercolor and gouache study but the detailed working out of the panels was still a formidable task to face.

By far the greatest number of sketches I have seen refer to "The Bridge." Several freely brushed watercolors of tall buildings probably served as notations for parts of the background of "The Skyscrapers," and a pastel, *Orange Bars* (Figure 64), seems related to "White Way II" (Figure 75c), but only in sketches for "The Bridge" can motifs incorporated in the final painting be positively recognized. To understand the development of Stella's thinking about "The Bridge" we must go back to *Brooklyn Bridge* (Figure 50), in which his attention was first claimed by the motif of the receding roadway leading to the climactic tower. Accordingly, he had taken his viewpoint at some distance from the arches, and for a time the receding roadway plunging between the tall wings created by the cables

and crisscrossed wires dominated his thinking completely, as the *Study* (Figure 66) shows. Eventually the tower began to assume greater importance (Figure 70), and in the finished painting the viewer is actually at the tower, standing in the center of the bridge looking up through the arches, his view of the roadway partially blocked by the center pier directly in front of him (Figure 75e).

In approaching the actual work of *New York Interpreted*, Stella drew the entire design on the canvases in pencil; a few remaining pencil marks can still be seen. The great height of these panels required working on a ladder with a maulstick; and the many fine lines that are such a significant part of the design were drawn with a long soft brush against a ruler.[18]

The dominant character of the painting is its insistent parallel verticalism, just as it is a dominant characteristic of the city itself. "For the Artist, New York is like a huge steel bolt flashing with streaks of lightning. The vertical line dominates, triumphs; the whole image of whipped up, rising, climbing movement is summed up in this line" (I,17).

"The skyscrapers . . . the giants of modern architecture dominate in the central canvas, purposely made the highest to break the rectangular monotony, and, induced by electricity blazing at their base with the outburst of two wings ready for flight, embark in adventurous sailing guided by the luminous edge of the flatiron building acting in the middle as the opportune prow." [19]

The composition of "The Skyscrapers" is curiously deceptive. It is symmetrical around its vertical axis, but absolute symmetry has been avoided: the wing tip at the right margin is higher than at the left, and the spacing and design of the verticals in the light area above the predella vary on each side of the center. Monotonous symmetry has further been avoided by rendering the skyscrapers in tall, generalized blocks of different heights and widths, creating an effect of staggered rhythm. At first one seems to be looking at a series of buildings receding into the distance. This impression comes partly from a feeling that there should be a considerable distance between the lower V-shaped beam of light that can be read as converging toward a distant point and the repetition of this motif in the beams emanating from the center near the top of the canvas, "behind" the skyscraper. The fact that in real life we expect to see such a scene in depth adds psychologically to the impression that this is indeed a painting in which the illusion of deep space is created. When we free ourselves of

expectations, however, we see that instead of converging toward a distant point, the lower V-shape can be read equally as diverging from a point on the surface, remaining on the surface where its branches are cut off by the frame; furthermore we are actually persuaded to read it in this way by the very element that at first led us to read it in depth: the small beams radiating from the upper center. These beams *must* be read as diverging, and the parallel position of the outer beams relative to the lower V-shape thus reinforces the divergent effect. Moreover, the weightless, floating architectural elements are stacked up behind one another like thin sheets of glass reflecting light and color; their weightlessness contradicts any concept of them as solid buildings existing in three-dimensional space. In the end it is possible to see that Stella has created a relatively shallow space, which I believe was done deliberately in order to suggest the visionary aspect of the city.

Although "The Skyscrapers" is primarily angular and rectilinear, there is a secondary, curvilinear movement in this painting. A triple belt of shadows, more clearly visible on the left than on the right, encircles the buildings at about the horizontal center, while an arch of light bends across the sky and a corresponding crescent of light extends across the lower section, as if from behind the predella. This latter section of the painting, a wide horizontal, is dominated by verticals massed into blunt wedge shapes that are variations on the V motif of the main part of the painting. But here the forms move inward according to the laws of perspective, giving a sense of solidity to the base that emphasizes the visionary quality of the upper section. The color in this painting is dominated by blacks and whites, applied with a dry brush and a scumbling technique, similar to that of the Yale *Bridge* (Figure 50). Touches of red, green, and yellow serve as expressive accents, producing an atmosphere of drama.

To the left and right of "The Skyscrapers" are "White Way I" and "White Way II," both executed in brilliant high pure color — with reds and yellows predominating — making a strong contrast to the center and outer panels. A variety of techniques is evident, with scumbling, glazing, blended strokes, broken strokes, and pointillist dots used to apply the pure colors so as to create a garish, carnival imagery. *White Way I* is composed in depth, with forms resembling theater wings overlapping and receding toward the center, as if toward a doorway. While a certain flattening of space is produced by the stabbing diagonals that cross in the

central area, the dominant pull is inward. A bewildering variety of rhythms, hatchings, crosshatchings, convergences, and divergencies are held in balance by this central pull, and by the uncompromised verticals. The central motif of the arched doorway is taken up as the dominant element of the predella, which, composed in overlapping arches, is held to the surface in front of its upper section, opposite to the plan noted for "The Skyscrapers."

In both "White Ways" Stella has inserted small representational motifs, as he did in *Battle of Lights*, with its similar carnival theme. In the deep blue sky of "White Way I," powdery with dots, one can discern a pair of facing peacocks, possibly referring to the Yin and Yang of Chinese iconography, and a small figure that seems to represent a piece of primitive sculpture. Stella's interest in Oriental and Primitive art is easily understood: we know from De Fornaro that he attended lectures on Oriental religion and philosophy, and his friend Marius de Zayas was one of the first dealers in New York to exhibit African and pre-Columbian sculpture in the gallery of modern art which he opened in 1914. A fragment of Stella's writing, entitled "The White Way," seems to refer to this sky area, although the rest of the piece does not, and is thus somewhat puzzling. "The boundless, star-paled indigo of the night weighs down over the port city like a nightmare. Faded mirage of distant splendors, it overhangs with heavy slate-gray iciness the sharp black silhouettes of the huge square-bulking factories rising everywhere like gloomy prisons with their soundless, sinister echoes. Through the silent streets, darkness, punctuated by the flashing metal of tracks, fans out its funereal, batlike wings in alternate bands that disappear like fantasies into the infinite" (I,18). Parts of this description fit various sections of all the canvases, but no one part seems to correspond with the imagery entirely. It does seem, however, that the "faded mirage of distant splendors" alludes to the sky area of "White Way I."

The lettering in this painting, like that of "White Way II," seems to be without literal meaning, alluding in a general way to the theatrical billboard signs on Broadway, the "White Way" of the title; I have spent a considerable amount of time puzzling over it, to no avail. The sequence of S-curves that writhe upward from the lower area in "White Way I" slightly resembles Russolo's *Perfume* of 1910 and *Music* of 1911, and may be a symbol of the rising sounds and smells that permeate the air of the city.

"White Way II" is composed in shallow space with depth in the pre-della. It balances its three-dimensional companion by greater weightiness, making up on the surface what it loses in depth. It is dominated by the vertical bars in the surface plane played off against the radiating spokes in the background plane. The interaction creates the effect of a revolving kaleidoscope, a motif picked up along the lower area of the painting, just above the predella. In this section it is more apparent that the spirals are meant to convey the idea of sound, for Stella has even painted music notes on the slender reedlike lines between the heavy orange-red bars.

"The Port" (Figure 75d) occupies the outer position at the left of *New York Interpreted*. Its general tonality is dark, dominated as it is by the large blue-black sky area, with substantial amounts of black, gray, and beige used throughout. The green sea under the dark sky produces a certain spaciousness and expansiveness that the other panels lack. The composition is divided horizontally into equal halves by a band of beige that widens at the left margin and narrows to a point at the right margin. At the exact vertical center, and precisely one-quarter of the length from the upper margin, a small red dot gleams with extraordinary strength: "at the vortex of a pyramid of black cords . . . hanging like the ropes of a scaffold . . . the burning offer of human labor," according to Stella.[20] The predella is a flat border of circular motifs, each circle separated by a downward narrowing arching form and marked with a diagonal cross.

Some of the details and expressive intentions of this painting are manifest in Stella's description:

> In the Port, a series of horizontal lines extend through a kind of infinite latitude. Oblique lines intersect them violently, slashing out zones of color bounding forth in a glaring light or lying quiet in slits of shadows . . . against the deep blue-green that dominates the sky and water like a triumphant song of a new religion, there rises the pure cylindrical forms of the smoke stacks . . . the trees of the ship-and-factory-forest . . . while the black telegraph wires dart like needles through space, knitting together the far and the near in harmonious unity, vibrant with love. (I,17)

The most famous, and most frequently reproduced, of the five paintings is "The Bridge" (Figure 75e), at the far right. Its popularity derives from the combination of drama, abstraction, and representation that captures the essential nature of the Brooklyn Bridge as it has probably been felt by millions of people who have seen it. Stella's "view," arbitrary and

synthetic, is taken from a vantage point on the Brooklyn side, looking through the great arches toward Manhattan. The tonality is dark, like the center and opposite outer sections, dominated by the heavy black framing structure of the pointed arches. As in "The Skyscrapers," and "The Port," the color is applied with very little oil or turpentine, the dry brush scumbling the pigment to create the effect of shifting light. With the associative value of the gothic arches, the blues, greens, reds, and yellows seem to shimmer like stained-glass windows. The composition is similar to "The Skyscrapers," with the succession and repetition of linear motifs in different planes unifying the subordinate recessive movement with the stronger surface design: the upper cables lie on the surface; the lower cables recede, but end at either side of the center axis, which belongs to the surface design, thus flattening what seems to be a recessive movement. Again, the heavier verticals that lie across the lower area on the surface are repeated in the lines of the structures in the distant planes, but touching the rim of the pointed arches, the lines cannot be read in the degree of depth that is at first implied. Once more an effect of floating is produced. Furthermore, the distant arches seen behind the center axis are placed high in the composition, tilting the background up and reinforcing the flattening tendencies. One is struck by this recurrent device of blunting the lines of recession in order to give precedence to the surface pattern.

As in the central work, the vertical axis divides the painting almost symmetrically, while the "wings" of light are inverted here and transformed into the great tusklike cables that swing out to the side margins from the top center accompanied by another set of cables that parallel them and yet emerge from out of the pictorial depth. The architecture is rendered as in "The Skyscrapers," tall, shallow, overlapping vertical forms that fill the entire area of the sky, extending the vertical bars of the bridge up to the top of the painting, where they are framed in arches. The predella is similar to that of "The Port," the circles flattened into tall ovals, enclosing a diagonal cross. The composition is held in rhythmic balance through the counterposing of the constraining, static arches against the dynamic expanding thrust of the cables. Of course, the rhythm of the cables can be thought of as upward and narrowing as well as of downward and expanding. As far as the pictorial rhythm is concerned, the relation between the dynamic and the static remains the same; the cables are like a con-

tracting and expanding diaphragm that suggests the life of the breathing giant city, while the "towers of the bridge, with the majesty of their arches, dominate the flaming delirium of the skyscrapers thrusting upward to reckless heights, and look down triumphantly upon the conquered, subjugated, light-studded abysses flowing below. All the flux of metropolitan life — pulsating, unceasing in the subterranean, subaqueous channels — streams through the predellalike base, and carries through arches and ovals the reverberations of the city, the scintillating light of cathedral windows" (I,17).

New York Interpreted expresses not only Stella's admiration for the city but the anxiety that it stirred in him. The rising movement and the large forms presented with majestic frontality convey the "courage and heaven-scaling audacity" of New York to which he responded.[21] But there is another meaning in those lines and forms. I see the repeated verticals as prison bars, the crammed space, bristling with razor-edged spokes, as a prison. Stella's New York is a city closed off from the sky, except in "The Port," where the sky is heavy and black with storm; it is a city impaled on bull-like horns and slashed with dagger beams of light, brooding in darkness and lit with a garish, pitiless, artificial light. Hidden behind the thin wiry cables in the harp-shaped form framed in the right side arch, disguised as dots representing the windows of a building arranged vertically, are the letters PAID (Figure 75f). They are difficult to see, but there is no doubt that they are there. In the collage *Study for Skyscraper* (Figure 77), reproduced in *The Little Review* for Autumn 1922 [22] and contemporary with *New York Interpreted*, the same letters, PAID, perforated on a fragment of what seems to be a canceled check, are easily read. It is as if Stella has branded the city with the image of materialistic greed.

Stella's mixed emotions, as reflected in the painting, are confirmed in one of his strongest prose-poems.

> New York . . . monstrous dream, chimeric reality, Oriental delight, Shakespearian nightmare, unheard of riches, frightful poverty. Gigantic jaw of irregular teeth, shiny black like a bulldozer, funereal gray, white and brilliant like a minaret in the sunlight, dull, cavernous black, like Wall Street after dark. Clamorous with lights, strident with sounds — that's Broadway, the White Way — at night, blazing and mad with pleasure-seeking. Imperial metropolis, childish Babel — sometimes flimsy, derisory, ephemeral, insignificant as a child's tracing

in the sands, sometimes grotesque and common, bulky with middle-class heaviness, the skyscrapers like bandages covering the sky, stifling our breath, life shabby and mean, provincial, sometimes shadowy and hostile like an immense prison where the ambitions of Europe sicken and languish, sinister port where the energies drawn from all over the world become flabby and spent, enemy of every effort, ferocious with its enormous blocks of buildings, barring one's way like the Great Wall of China, with its dreadful, closed windows, barren of flowers. Oh, Smiling One, friend, benefactress, Alma Mater of the derelict of all the world, your houses, your factories like great treasure chests of booty, your streets like new furrows through fields newly fertilized and tilled, your bridges hang like aerial highways through the chimeric fortunes of the future.

It is an immense kaleidoscope — everything is hyperbolic, cyclopic, fantastic. From the domes of your temples dedicated to commerce one is treated to a new view, a prospect stretching out into the infinite. The searchlights that plow your leaden sky in the evening awaken and stimulate the imagination to the most daring flights. And the multicolored lights of the billboards create at night a new hymn of praise. Far away on the horizon, they radiate a silvery, daybreak clangor, or ring out in deep tones the hour of royal sunset.

When fog obliterates the bases of the skyscrapers they seem suspended in air, like brilliant jewel cases of destiny, like flaming meteorites held momentarily motionless in their tracks, like stars flung into the darkness of a tempestuous sky. And wide, geometric bands of shadow, moving like an invisible procession, mass, deepen, form and unform, float into view and disappear, while the metallic skeleton of the gigantic metropolis flashes with sparkling light that breaks out suddenly like the foam of a wave, like the flight of seagulls in a storm.

A constant roar from the subterranean depths of the sleepless city, marking its deep breath and rhythm, is a ceaseless commentary and setting for this poem. (I,16)

If Stella said, as Charmion von Wiegand reported, "New York is my wife — I always come back to her," [23] the marriage was surely not a happy one. The metaphor is far more revealing than Stella intended. Although he would have been the last to admit it, his paintings and his writings reveal his ambivalence with regard to women. It is no accident

that he saw the city not only as Mammon, but as a cyclopic female who aroused in him an overwhelming sense of suffocation, a desire to feel admiration, love, even veneration, that was frustrated by conflicting emotions of fear and hatred. The city was at once the Virgin of a new religion and at the same time the Amazon that drained his energy and his talent. Woman and Mammon are fused in an image of liberating hope and enslaving greed. Edgard Varèse remembered that Stella at times sneered at love-making and women, saying, "Do you think I'm going to tire myself just to give them their pleasure?" [24]

New York Interpreted was not an unqualified success. The painting was exhibited for the first time in the galleries of the Société Anonyme for one month beginning January 10, 1923. In *The Dial* that April Henry McBride began his monthly article:

> So far, more people have asked me what I thought of Joseph Stella's new work at the Société Anonyme than have inquired into any other event of the season: and I have been more puzzled by the inquiries and have been more evasive in my replies than usual. I had set myself, upon first seeing the pictures, the task of having a clear opinion of them, but without first-rate results; and it occurred to me that others had some uncertainties, too, and hence the questioning. There was no insinuation anywhere of opposition . . . but . . . no loud shout of joy reached the heavens when the pictures were shown. They were impressive, they were interesting, they were undoubtedly sincere, but . . . were they what we were all waiting for?
>
> Maybe they were. Perhaps we'll simply have to get used to them. But part of the yearning, when we heard that Stella was doing a big New York picture, was that it might be a crashing success; and this it cannot truthfully be said to have been. When asked, I have generally said, I like them very much. There is an enormous amount of aspiration, an enormous amount of intellectual energy in them and generalship in the execution — but also a lot that offends.[25]

McBride's reservations reflect a critical reservation that has persisted to the present. In Baur's judgment, Stella's "great accomplishment,"

> lies in his creation of an immensely complex structure to match, in pictorial terms, the complexity of his theme. And if he has not succeeded in imbuing his vision with quite the sense of mystery and personal response that he has achieved in *Brooklyn Bridge*, if he has

tended to emphasize the garishness and the engineering miracles more than his own romantic perceptions, he can scarcely be blamed. The panoramic sweep of his concept, the sheer variety of his subject, imposed a certain impersonality on its treatment. The wonder is that he achieved in so vast, involved and programmatic a canvas a design of such sustained vitality.[26]

Part of whatever failure there is in *New York Interpreted* lies in a certain degree of pictorial incoherence. The horizontal and diagonal links between the canvases and the other unifying devices are not strong enough to integrate with sufficient force the five individually powerful paintings. It is hard to understand why Stella abandoned his earlier concept of the single embracing arc seen in the preliminary watercolor (Figure 66). Without it the contrast between the bright, high-keyed color of the "White Ways" and the somber tone of the center and outer sections is too sharp, and the unity is weakened. Then, too, as McBride observed, there is the "ferocious amount of parallelism." [27] Stella's triumphant vertical line, his symbol of "whipped up, rising, climbing movement," tends to defeat him with its own realistic truth. New York is a vertical city, but aesthetically the repetition does not work; it becomes rhetorical.

Despite these weaknesses, one is moved, stimulated, even inspired. The city is seen as the artist wanted us to see it: evil and sublime, a prison-altar. In American art in the first half of the twentieth century no single painting more successfully combines great imaginative scope, skill of execution, and dramatic power of expression. *New York Interpreted* deservedly brought Stella considerable fame (see Appendix III, Figure 75). It stands today as a unique attempt to express the overwhelming grandeur and vulgarity, mystery and banality that New Yorkers and visitors alike feel about the city. One wants to tell it all. That Stella told so much is his great artistic achievement.[28]

It is the myth of creation, of joyful,
ardent creation, blowing its divine breath
into the wind and sun.
— The Myth of Leda (I,26)

Nature Lyrics and Junk Art 1916–1922

It was part of Stella's aesthetic theory that an artist should "not confine himself to any schools or representation," but must "try his hand at the various styles and in his own manner and . . . paint every phase of life and every conceivable conception. This principle Stella . . . carried out all through his long and active life as an artist."[1] This must account for the fact that, during the very years when his attention was gripped by the industrial scene and while still composing such near-abstract paintings as *Spring* (Figure 46), Stella was working simultaneously with a subject matter and style as far removed from the steel and concrete forms and dramatic lighting of the modern world as from the faceted surfaces of Cubism. Around 1916 he started to produce the works referred to earlier: nature lyrics in pastel that fall into two general groups — *Nocturnes*, characteristically dark and silvery in tonality; and *Serenades*, *Prayers*, and related subjects, usually pale, sometimes pervaded by a golden light.

A typical example of a nocturne is *Night*, with its sharply silhouetted forms and slow cadenced, long curvilinear rhythms (see Appendix III, Figure 40). *The Song of the Nightingale* (see Appendix III, Figure 46) shares this mood, though it is more abstract. In a silent countryside that looks like a lunar world, the "song" is expressed through the rising and bending forms of the reeds, recalling again Russolo's Futurist intentions to translate sensual experience into line and color. *Moon Dawn* (Figure 55)

81

offers a slight variation of the style; it has close affinities with the industrial compositions in the geometrically designed space, yet belongs to the nocturne group in the expression of silence and loneliness, in the use of dark, silvery tones, and in subject matter.

"Nocturne," a poem found among Stella's papers, groups these three compositions together, and reveals their emotional source.

> The emotions, incense-misty with the memories of
> his native land,
> Bedew his nights:
> Trembling in the silvery radiance of the Moon Dawn
> They pervade with fragrance the velvety depths of
> the waters;
> Rippling with the silent rustle of the Swans,*
> They surge, rising on the stalk of the Song of
> the Nightingale,
> An aerial hymn, pouring forth from the heart of
> the mountain,
> Sacred shrine of youthful dreams.
> Oh mountains white with snow over which ascends
> waveringly
> The naive sound of the bag-pipe at Christmas . . .
> Sound that enfolds, as in a cradle,
> All our first emotions,
> All the winged dreams flying hither and yon
> Through the soft blue morning of our childhood. (I,19)

The second group contains compositions like the *Nativity* (Figure 56), whose illusionistic gold-painted trefoil frame deliberately evokes associations of the *trecento* and reveals for the first time the probable influence of Odilon Redon, particularly such works as his *Andromeda*.[2] The light floral hues are strikingly similar, but more important is the character of the abstract shapes that Stella creates, irregular patches of shaded colors and ragged forms that bear notable resemblance to the shapes created by Redon. Also suggestive, in terms of influence, is the fact that Redon's device of decorating the illusionistic frame of *Andromeda* with flowers is used by Stella in *Spring* (Figure 36), and later in *Green Apple*. August Mosca recalls Stella's speaking of his "discovery" of Redon in Paris in

* *Swans* is another title for *Night* (Figure 40).

82

1911–12. He may have been led to this through his acquaintance with Matisse, who greatly admired Redon, and his interest had very likely been increased at the time of the Armory Show, when Redon was featured so prominently.[3]

Further insight into the religious-symbolic content of the Bridge paintings can be gained from *A Child's Prayer* (Figure 51) with its pointed arch and bridge form, manifestly religious in its title. Here, completely removed from an industrial setting and associated with natural shapes, executed in light gray and pale blue, the arch and bridge forms take on an expression of tender nostalgia and delicate longing instead of the dramatic striving and struggling of *New York Interpreted* and *Brooklyn Bridge*. The composition of *A Child's Prayer* is peculiar in the way it is divided along the vertical center with the right half seeming to stand in a forward plane like a screen pulled aside to reveal a scene behind it. This right side is relatively more naturalistic and its forms looser than the left half, which is dominated by the bridge form with its smoothly rising contours and the curving sweep of the pathway. The graceful shapes and the soft tones create an atmosphere of vague and dreamy yearning that expresses Stella's sense of exile.

The current of feeling running through these works is summed up in the major oil, *Tree of My Life*, of 1919 (Figure 59), which stands to this series as the *Brooklyn Bridge* (Figure 50), its exact contemporary and twin in size, stands to Stella's industrial works — not the last word in date, but the fullest statement of the particular expression.

At the end of "Brooklyn Bridge, A Page of My Life," Stella describes how the work on the bridge painting was proceeding, "rapid and intense with no effort," when suddenly,

> brusquely, a new light broke over me, metamorphosing aspects and visions of things. Unexpectedly, from the sudden unfolding of the blue distances of my youth in Italy, a great clarity announced PEACE . . . proclaimed the luminous dawn of A NEW ERA.
>
> Upon the recomposed calm of my soul a radiant promise quivered. And one clear morning of April I found myself in the midst of joyous singing and delicious scent, the singing and the scent of birds and flowers ready to celebrate the baptism of my new art, the birds and the flowers already bejeweling the tender foliage of the newborn tree of my hopes, "The Tree of My Life."

Among his unpublished writings is the following description of the painting:

> The pure cobalt with which our sky is covered lovingly protects and encloses, at the upper part of the canvas, the whiteness of the flowers that close off the last arduous flight of the Spiritual Life. And the pure beauty of our homeland . . . transformed, ennobled by the nostalgia of memories, flows all around like healthful air, joyfully animating the sumptuous floral orchestration that follows the episodes of the ascension with appropriate resounding chords: the clanging of silver and gold, signifying the first triumphs, and the deep adagio, played by the charged, rich greens and reds, loosened from the sudden searing cry of the intense vermilion of the lily, placed as a seal of generative blood at the base of the robust trunk twisted, already twisted by the first fierce struggles in the snares that Evil Spirits set on our path. (I,20)

Tree of My Life, exhibited at the Bourgeois Galleries in March 1920, offers a number of familiar compositional features. At the center is a tall vertical axis, with subordinate vertical parallels distributed over the surface of the painting. Branches and tendrils move out at various tangents from these verticals, knitting together far and near so that although a deep distance is implied, one's strongest impression is of the decorative surface. The design is crammed with blade-shaped leaves, clawlike clusters, spidery tendrils, daggerish petals, saber-beaked birds, and a profusion of oversized, out-of-scale butterflies and blossoms and undersized out-of-scale birds. Several self-contained scenes are worked into this arabesque screen: at the lower right, a pond on which floats a swan; above this an arched bridge; still a bit higher a group of peasants at the foot of the amphitheater-shaped hill on which Muro Lucano is built. To the right of Muro Lucano there is a strange, fairy-tale gothic ruin, a rickety version of the arches in *Nativity* (Figure 56), whose spire penetrates what might be a rainbow but resembles much more a spider web. To the left of the vertical axis another viaduct form similar to that in *A Child's Prayer* (Figure 51) is placed, large and in the foreground, suggesting a continuity with the arched bridge in the background at the right. The "tree" of the title rises at the center to embrace a circular form which, with its inner concentric and radiant lines, suggests a monstrance.

The painting is heavy with symbolism. Ironically, its amazing vitality and

fascination evolve not from the rather banal allegory that Stella intended to represent, but from a deeper truth about himself that guided his hand in shaping those curling tentacles, those fantastic proportions, the writhing, slithering forms that filled his secret life.

Stella's ambivalence about New York is present also in the description and painting of *Tree of My Life*. He remembers his homeland tenderly as the scene of his first triumphs, and painfully as the setting of his early suffering. He represents his fantasy in forms that are ordinarily harmless and pretty — flowers and birds — but he renders them in such aggressive shapes and peculiar proportions that their ordinary meaning no longer fits; they take on an aspect of troubling strangeness. The thickness of the web of stems and leaves further contributes to the impression that we are glimpsing a world whose idyllic appearance is deceptive, a snare for the innocent. It is not the least of the irony that Stella himself was deceived.

For I believe that this would-be Garden of Eden is, again, thinly masked, the barred prison, the suffocating inferno Stella found in New York, in Coney Island, and in Pittsburgh. This was the geography of hell, however much he wanted to believe it was heaven: the "robust" trunk is Stella's wish for himself; its deformed base, "twisted by the first fierce struggles," the reality he would not accept.

It may have been in connection with *Tree of My Life* that Stella began the innumerable drawings of flowers that constitute such a large part of his *oeuvre*, many hundreds of sheets. Certainly flowers began to play a more and more important part in his art about this time; although we have learned not to take the appearance of dates on Stella's works literally, a large number of crayon and pastel flower studies are dated 1919. That these studies were much more than artistic "finger exercises" is clear from Stella's writings, which contain such comments as "that all our days may glide by serene, sunny, each must begin with the study of a flower" (I,21), or "my devout wish, that my every working day might begin and end . . . as a good omen . . . with the light, gay painting of a flower" (I,22).

He remembers how, in Assisi, "all the places where St. Francis and St. Clare performed the most significant of their sublime deeds are marked by flowers, kept perennially fresh by the faithful and devout. Thus, in the course of centuries, the lives of the most glorious artists appear like miraculous flowers, luminous, lucky stars lighting up the darkness for succeeding generations" (I,21).

Although the flower drawings are carefully observed studies and ac-curate renderings, here, as in *Tree of My Life*, a peculiar other-life ani-mates the long, sinuous roots and stems, the spiky, sharp-edged petals. *Lupine* (Figure 54), for all the delicacy and precision of its natural forms, is like an Indian dancer, a multiple-armed Siva, and dozens upon dozens of sunflowers, lilies, flowering cactus, and so on are similarly anthropo-morphized or zoomorphized. Among the most amusing and characteristic transformations are those in which Stella has metamorphosed zucchini into serpentine-bodied swans.

Stella's awareness of the animate qualities in his flower drawings is made clear in his poem, "Gardenia," which describes a "silverpoint drawing with color added" (not located).

> It is of a snowy whiteness,
> The petals open out sinuously, curled white blades
> like curved sabers.
> Of an airy lightness, they seem to have alighted
> on the opal cavity of the cup
> Like a miraculous butterfly in the calyx of a
> flower.
> Two dark green leaves, veined and sharp, are opened
> up at the sides
> Like wings poised, ready for flight.
> One has almost the feeling that, touching it, it
> would fly away.
> A vision so near, and so far away! (I,23)

Almost as prominent as the flowers in *Tree of My Life* are the countless birds that perch on arching stalks like buds or sprays of blossoms. Unlike the flowers, Stella seems to have made very few studies of these small birds, judging from the catalogue titles and from the fact that I have seen so few. What interested him far more were the large-bodied birds with rapier beaks, like the one in the right foreground of this painting; or scythe-shaped beaks like the pelican, center right; or those with long, serpentine necks, like swans, storks, and herons, that appear repeatedly in his works from this time on.

Stella's major bird painting is *The Heron* (Figure 44). According to a letter to Katherine Dreier (July 7, 1939), it was painted in 1918; accord-ing to another (January 22, 1942), in 1919.[4] However, as the painting was

not included in Stella's retrospective in 1920 or in the large show of his work at the Whitney Studio Club in 1921 but appears in a catalogue for the first time in 1922 in a group show at the Bourgeois Galleries, it was probably painted a few years later than he recalled. The style, with its static space and rigid, knife-edged forms, is closer to what is to come than what has already been seen as characteristic of the work around 1918–19. Certain features, however, are adumbrated in the compressed abstraction of the swans in *Night* (Figure 40), the irrational proportions in *Tree of My Life*, and the repeated concern with parallel verticals, the interest in floral forms, and the taste for certain shapes that we have been observing. We see here particularly the pointed-arch shape of the space formed between the two fantastically oversized leaves behind the heron at the right, and a variation of the arch formed by the space between the heron and the tall vertical flower at the left; the character of its irregularity is strikingly like the "fairy-tale" arch in *Tree of My Life*.

Stella's studies of fruits, which also begin to appear in these years, reveal overtones of meaning that relate them closely to the themes just discussed. As in the flower pieces, Stella's closeness of observation, the precision of the details, and the intensity of the focus produce a realism so charged with emotion — the desire of the artist to possess the objects utterly — that the effect is more than real, anticipating the visionary aspect of Surrealism by a few years. *Pomegranate* (Figure 57) reminds us of Stella's youthful feverish nocturnal visions, of the "virgin breasts" that he cut with the "knife of his violent desire."

It was during these same splendidly productive years that Stella painted the first of the exotic tropical subjects which represent such a large part of his *oeuvre*. *Tropical Sonata* (Figure 76), dramatic and diabolical with an orange-red fiery glow silhouetting the forms, immediately reminds one of the industrial scene paintings of this period despite the vastly different subject; and the analogy with music, present in *New York Interpreted*, is reintroduced in the title. There does seem to be something musical in the rhapsodic expression, as well as in the variations of rhythms and the contrast of dark and vivid tones. The composition of *Tropical Sonata* is built on the central vertical axis which Stella returns to so often that we begin to be convinced that his choice was compulsive. The tree is compressed into an abstract funnel shape, solid and rigid, in contrast to the slender, curvilinear, rhythmically spaced spears of the foliage at the

center waving upward and outward like the tentacles of a giant octopus. Two thick knobby shapes crawl up along the bottom of the trunk, and the lower foreground is filled with tropical growths, long, pincerlike leaves, and a plump, long-beaked bird. In its blend of mystery and savagery and its explosive dynamism, *Tropical Sonata* differs widely from the tropical paintings of Gauguin with their static monumentality, but evokes a sense of kinship with Gustave Moreau, in his sketches, and once again, with Redon, especially in the quality of the color applied in blotches and streaks. What is unique in Stella, however, is the sense of menace that arises from the repeated use of knife-edged and stabbing forms.

The war years had seen the rise of the Dada movement, officially born and named in 1916 in Zurich. In the United States the foremost adherents of the new anti-aesthetic were Marcel Duchamp and Man Ray, both of whom Stella knew well as can be seen from Man Ray's photograph of Stella and Duchamp taken at this time. It was undoubtedly his association with these men that led Stella to take up in a limited way certain aspects of Dada: painting on glass and collage.[5]

Stella's paintings on glass are Dada only in the marginal sense that the technique implied an attack on the sacredness of traditional material; his designs on glass were abstract, semi-abstract, or representational and do not differ from similar works executed contemporaneously with brush on canvas (see Appendix III, Figure 60). But it was probably the rebellious, Dada-sensitive streak in him that led him to paint on glass in the first place, and it was certainly this trait that responded with such delicacy, originality, and paradoxically aesthetic delight to the possibilities in collage.

It is not possible to establish a chronology for Stella's collages, although we know from the reproduction of two — *The Bookman* (Figure 78), probably a reference to the periodical of that name, and *Study for Skyscraper* (Figure 77) — in *The Little Review* of Autumn 1922 that he was working in the medium by that year. Very likely he was stimulated by the collages of Schwitters he had seen at the Société Anonyme in November–December 1920 when his own paintings were exhibited in the same show. Both of *The Little Review* collages are highly structured and in that differ from the more casual type that is exemplified by *Head* (Figure 112). This title was given to the work by the dealer, Robert Schoelkopf, whose sensitive understanding of Stella's work led him to see the accidental imagery here which Stella could very well have meant to exploit, as he

did with similar pieces such as collage *Number 21*, *Graph*, and *Profile* (Figures 110, 111, 114). Another kind of collage that Stella liked to make included the use of natural objects; an example is *Leaf* (Figure 113), a dirt-stained rectangle of cardboard surmounted by a reddish-brown leaf.

Among Stella's effects, along with his writings and letters and notebooks, are many pieces of dirty cardboard of different sizes showing the marks of footprints and tireprints, grimy and crusty with dried mud, as if they had been picked up from the streets. They call to mind Lawrence Alloway's observation that "Junk culture is city art." [6] It seems particularly significant that Stella was successful in creating beauty out of New York's debris, just as he had derived his best figure drawings from the crippled and sick poor, sketched, according to Mosca, as they waited for medical attention in Antonio Stella's office (Figure 14). It is perhaps partly because the material was so thoroughly consonant with the artist's sense of being an unvalued castoff that these collages reveal Stella's sensibilities at their most delicate and refined. Furthermore, the liberation he constantly sought — a yearning often expressed in his writings — was offered in this art form where he was free of the challenge of Italian masters of the past and the concepts he brought to traditional art. The materials and aesthetics of collage, with values placed on the disdained and discarded and on the random and unpolished — and possibly its quality as an anti-art — released Stella from these inhibiting bonds and allowed spontaneous play to his feeling for form and texture.

Kurt Schwitters' collages may have been the catalyst for Stella's art in this form, but comparison shows their work to be quite different. Stella more than Schwitters makes of collage a unique art. Schwitters' collages are extensions of paintings; many could actually have been painted without losing their brilliance or beauty, because these qualities are in the design, that is, in the interplay of shapes, of directions, and of movement. There is texture, to be sure, but the textual variations are not radically different from those used in painting. Stella's collages have an object quality that belongs entirely to that art form. It is the reality of the crumpled bit of paper or the torn, dirty cardboard as an object found and put into place as an artistic act that is asserted, rather than the act of picture-making. Schwitters' collages are over-all designs, many of which strongly resemble contemporary styles in painting; Stella's are like mounted reliefs and do not resemble contemporary painting.

Again according to August Mosca, Stella continued to collect pieces

of cardboard and fashion collages of them until the end of his life. What he apparently liked in these dirt-covered pieces was the accidental, random shapes, the irregular, rubbed, highly textured surfaces catching and reflecting light so that it shifted across the plane, yielding images that force the imagination into multiple levels of association and bring the spectator into active participation with the work of art. He probably also liked the reversal of middle-class values which this art implied in its preference for the old and battered over the new, the random over the orderly, the manhandled over the machine-made. That middle-class values were not eternal and universal was a liberating hope for a man weighed down with a sense of uncertainty in the world where such values prevailed. "Life rushes on in a tumult of uncertainty and worry. Bad luck runs alongside us, menacing our path with the most insidious traps. In vain our every entreaty, in vain every attempt to combat Destiny. Our only comfort, Art, the Magic Flame. May it burn forever inextinguishable!" (I, 22).

There seems yet another meaning for Stella in these dirty cardboards. He speaks of himself when he says: "The ugly, ponderous life of America weighed on him like a nightmare. In vain he turned his gaze inward, as if seeking relief. Everything was gray, squalid, monotonous. Frightened, he felt the nearness of death. Days followed each other with depressing sameness, *mud-caked with all the cares of petty life*" (I,24; italics mine).

Stella appears never to have exhibited his collages. None are listed in the catalogues of his shows that I have seen, nor is there any mention of them in the articles and critical notices that appeared from time to time. The only public notice of them seems to be the two reproductions in *The Little Review*. The weathered nature of the surface appealed to very few dealers and patrons before World War II. After 1945, this very quality began to play a prominent role in the art of some of the more progressive painters who matured at about this time — Jean Dubuffet, Antonio Burri, and Antonio Tapies — and Stella's collages began to be greatly admired and collected. The Zabriskie Gallery's exhibition of Stella's collages in October 1961 was financially and critically successful. The *New York Times* critic, Stuart Preston, considered the show "a magnificent little collection of collages that transform oddments into art with such abrupt and unfailing alchemy that one is made witness to the inventive act." [7]

One more aspect of Stella's art in the years around 1920 remains to be touched on: a series of silverpoint portraits of a number of important art figures, including Edgard Varèse, Marcel Duchamp, and Louis Eilshemius.

This is an extremely challenging technique for an artist because the silver-point mark, once made, cannot be erased or corrected. The medium demands the highest degree of manual control in order to elicit the special effects of subtlety, delicacy, and precision it affords. Some apparently early drawings by Stella are executed in silverpoint, but he did not begin to use this medium regularly until around 1920.

Stella's identification with Italy and with the tradition of Italian art was always strong, and his use of silverpoint is explicitly related to it. "In order to avoid careless facility, I dig my roots obstinately, stubbornly in the crude untaught line buried in the living flesh of the primitives, a line whose purity pours out and flows so surely in the transparency of its sunny clarity. Rivaling the diamondlike block fashioned by the free, generous hand of the sovereign art of Tuscany, prodigious pollinator of life, I dedicate my ardent wish to draw with all the precision possible, using the inflexible media of silverpoint and goldpoint that reveal instantly the clearest graphic eloquence" (I,25).

Among the best of the portraits is the *Profile of Marcel Duchamp* (Figure 65), drawn with chiseled stoniness. The image is enclosed in a single fine outline that thickens and thins, darkens and lightens as it traces the contours of the features, the high ridge above the eyes, the bony, not quite straight nose that develops surprisingly into a flaring fleshiness around the nostrils, the soft yet tight mouth, and again a fleshy underlip, a small, beautiful space between the underlip and the rounding of the chin, flowing in a graceful curve into the neck. The contour of the back of the head, darkly silhouetted against the light ground, focuses on the small peak at the base that interrupts the regularity of the flow of the form, a characteristic device that frequently occurs in Stella's drawings. The forms are lightly modeled to bring out the convexities and concavities of the face, stressing the eye socket and the wide, heavy-lidded eye that seems to look more inward than outward, and the large, receptive ear. The characterization is self-contained, withdrawn, and idealized, and the drawing is slightly eerie in the way the three-dimensional head develops out of the flat area of the neck. It is like relief sculpture of the kind seen sometimes on portrait metals. But in sculpture, to vary the depth of relief is conventional; to render this impression on a sheet of paper produces a peculiar effect.

The meticulous clarity of the outline, the delicate shading, and the placement of the Duchamp portrait on the sheet without any base line or background indicated are characteristics that appear singly or in com-

bination in Stella's drawings at this time. They occur in a variety of subjects, such as the silverpoint and crayon *Flower Study* (Figure 52) or the *Fruit, Flower and Cat* (Figure 53) in pencil and crayon.

Stella's reputation as a significant figure in American art was established with the exhibition in 1914 of *Battle of Lights, Coney Island*, and in the years immediately following he was recognized as one of the foremost progressive artists in the United States by critics as well as fellow painters. He frequented the Walter Arensberg home, a meeting place for American and European artists and writers who were making important contributions to modern cultural life. In 1920 when the Société Anonyme was founded, galvanized by the idealistic energy of Katherine Dreier with the guidance of Marcel Duchamp and Man Ray — the three formed the directorship of the organization with Marsden Hartley as secretary — Stella became a charter active member. His paintings hung in the first exhibition (April 30–June 15, 1920) of this pioneering organization alongside works by such masters as Juan Gris, Brancusi, Picabia, and Van Gogh, and again in November–December 1920, with Hartley, Schwitters, Derain, and Kandinsky. With Katherine Dreier and Duchamp, Stella participated in the educational programs of the Société, in lectures held at various schools and clubs in the Metropolitan area. After the gallery had closed for the year 1921–22, it reopened in 1923 with the one-man exhibition of Stella's work featuring *New York Interpreted*.[8]

Despite these marks of respect and recognition, Stella was unable to earn enough money from his painting to live and work in relative peace, security, and self-respect. Katherine Dreier helped him by buying some of his work, and Stella expresses his gratitude warmly and repeatedly in a number of letters. Miss Dreier bolstered Antonio Stella's less than stalwart confidence in his brother's abilities, writing that Joseph was "a true poet, with a true vision" who "ought to have sufficient backing to go quietly at his own gait, without interference, and really ought not to have to think of *earning* money." To this the doctor replied generously with a contribution of fifty dollars to the Société Anonyme, and a letter of thanks for Miss Dreier's interest in his brother.[9] Stella's was a hand-to-mouth existence, cold both materially and spiritually. The image of his homeland was constantly in his mind, a symbol of warmth and peace and welcome, the place where he could feel a sense of belonging.[10] In 1922, Stella returned to Naples.

Creative energy is clean and
chaste.
— The Myth of Leda (I,26)

IX

Nudes and Madonnas 1922–1929

Some of Stella's least attractive work was done during a period of intense
happiness. In 1922, visiting Pompeii, Herculaneum, and Paestum, spell-
bound for hours and days studying the Greek sculpture, "the [H]ellenic
marvels" in the Naples Museum, he was "in heavenly ecstasy, in a state of
grace, painting from morning to night, living a life of complete bliss." [1]

Among the paintings born of this solitary joy were *Undine* (Figure
80) and *The Birth of Venus* (Figure 79), ushering in a series of nudes
(extremely rare in Stella's *oeuvre*) whose lack of sexuality is matched only
by the overcharged eroticism of the paintings as a whole. *Undine*, more
dead than chaste, lying in a harsh bed of abrasively irregular coral, is yet
strangely yielding, vulnerable to the repellent shapes above her. In the
background stands a heron, whose presence recalls the theme of Leda and
Swan, a subject Stella actually did undertake, probably about the same
time, in a quite similar painting. Stella's description of his *Leda* reveals
something of the emotional quality contained in all these classical nudes.

> It is the myth of creation, of joyful, ardent creation, blowing its
> divine breath into the wind and sun. The act is pure and simple, with-
> out pretext or pretense . . . and it is sanctified, raised high, as a spur
> and example to human beings. The urgent need of fecundation, a kind
> of christening from which we are born in new splendor, arises, as-
> cends, and is framed, set in the purest realms of the clearest blue

93

heaven. Creative energy is clean and chaste, symbolized by the shimmering white of the swan which flings itself upon her as if upon an altar, to perform its rite upon the full, golden, incorruptible body of the goddess of fertility, Leda . . . the act of world creation. (I,26)

The attempted sublimation of sex onto a plane composed of one part classical mythology and one part religious mysticism is unconvincing both visually and verbally. It arouses the same uneasiness undoubtedly felt by *The New Yorker* critic who, when these paintings were first exhibited, commented: "Why Stella, of all painters, refuses to idealize the human form we cannot understand. If he insists on even his fish being things of beauty, why not his women? An interesting analytical study could be made of Stella and his interpretation of the female form. There is a spot of fear there that to us mars an otherwise perfect execution." [2]

The major painting of this series, *The Birth of Venus* (Figure 79), is almost as large as the sections of *New York Interpreted*. Reading Stella's account of his preparations for the painting and his description of it, one is again struck by the sexual imagery with which he relates his pursuit of art.

> The first idea of painting Venus suddenly occurred to me when I was struck by this verse of Anacreon: Who did sculpt the blue sea? Instantaneously a terse blue sea expanded in front of me. It arose in an apotheosis culminating in the radiant form of Venus. I was shaken with joy as if I had suddenly discovered a treasure long sought for. Thrilled by the idea of possession, I was assaulted by a violent desire quickly to realize this idea in a painting for my joy, and for the joy of others. But long and difficult is the road leading to conquest. . . .
>
> With the painstaking zeal of the true lover I tried every means to render my artistic ability worthy of the arduous task. I went to the sea. I breathed its free air. I watched and questioned every ripple of the waves. I went to the Museum of Natural History to be initiated by my ardent curiosity into the strange lore of the marine Flora. . . . To refresh and rebuild my chromatic vision I went to the flowers to learn the secret of the vibration of their colors, and having gathered a harvest of material fit for the background and surroundings of my picture, I unfolded before me all these wonders as appealing gifts for the Advent of the Goddess.
>
> And Venus arose in all the glory of her prime as the culminating point of the spiral forces of the shell . . . the essence of a miraculous lotus. I selected the lotus as the source of Beauty (the myth of Venus

is the myth of Beauty) because its color, so intense at the point where . . . its petals converge, is the true echo of the rosy birth of dawn . . . I gave her a distant look, a dominating attitude, and I put two birds (symbols of the flight and the singing of Love) upon her arms poised on a forehead which I tried to endow with the holy purity of an altar or a shrine.

I divided my composition into two main colors: the blue of the sky and the green sea. My sky was drawn from the serenity of my youth in Italy, displaying a cloudless purity of blue and arched as a protecting benediction pouring flowers from its celestial gardens. And in rivalry I gave the sea a terse crystalline transparency for a clear definition of the shells . . . shells opening at the bottom, at the corners, as the winged phrases of the untold poem of the sea. And as ministers presiding and officiating at the festa, I imagined the fishes — those stars and flowers of the sea — as seraphs playing the music of their gliding movements in an oblique ascentional rhythm of joy on both sides of their Goddess. (I,60)

The *Venus* and related works introduce a new quality in Stella's painting, that is, a greatly heightened tendency to primitivize which becomes characteristic of his work in the middle twenties. The forms are placed forward in the picture plane, simplified and rigid in the manner of *The Heron* (Figure 44), and the color is laid on in flat, sharply contrasting, homogeneous areas, a light pale pink beside a brilliant, saturated green, "gay to the point of garishness." [3]

By early 1923 Stella was back in New York.[4] He probably timed his return to coincide with the opening of his exhibition at the Société Anonyme where *New York Interpreted* was shown, and the following year he had a one-man show at the Dudensing Galleries. Despite their reservations, McBride and *The New Yorker* critic both agreed that Stella was a major figure in the city's art life "and everything he does must be seen by all those who wish to keep in the current of modern feeling." [5]

For the next few years Stella led the typical life of an artist in New York's Greenwich Village bohemia, working extravagantly and playing extravagantly. Robert Chanler had bought a house on 19th Street and his studio there became a rendezvous for artist friends. There were held the fabulous parties, "when two orchestras played, one on the top and the other on the ground floor, while the couples danced all the way from the

roof to the sidewalk. Two thousand dollars a month were spent on pro-
hibition booze while his dining room was always crowded at breakfast,
lunch, dinner and late supper." At Webster Hall, the famous Artists and
Models balls were crowded with serious men and women who danced
and sang and shouted in an uproar of hysterical abandon, freed behind
their costumes and masks from their ordinary inhibitions. Stella was a
part of it all, "invariably urged to climb upon platforms to serve on juries
composed of artists to pass upon the prettiest figure or costume of the
evening." [6]

Stella's marital arrangements are confused; and efforts to investigate
them have added little to what was generally, and hazily, known. He is
supposed to have married Mary Geraldine Walter French, a young woman
from Barbados. Mary French, born in 1882, came to the United States
while in her teens, and settled in Philadelphia with a sister (or sisters) and
a younger brother. Where and when she met Stella is not known, al-
though his family has the impression it was around 1916, when he lived in
Brooklyn and taught at the seminary. None of the family ever met her;
even her name was unknown to them. Stella's friends of early years with
whom I talked did not even know of her existence. He told his friend of
later years, August Mosca, that he married the girl from Barbados when
he was twenty-five years old, which would be in 1902. However, on his
application for American citizenship, which was granted on August 30,
1923,[7] he stated that he was not married; whatever the facts, Stella and
Mary were in effect separated by this time. They did live together again
for a few years in the mid-thirties, going to Barbados in 1937, where Mary
was known as Mrs. Stella. The artist left her to go to Europe the follow-
ing summer. Mary French Stella died in Barbados on November 29, 1939,
and was buried there under the name of Stella. August Mosca remembers
a deeply moved Stella sorrowing at the news of his wife's death.[8]

In the early twenties Stella established a ménage with Helen Walser,
a young woman with two children. In an undated letter from Stella to
Katherine Dreier, whose contents show it to have been written in 1923,
there is a perplexing postscript exclaiming, "I really don't know which
Mrs. Stella communicated with Paul!" The second "Mrs. Stella," Helen
Walser, acted as Stella's manager in some of his art dealings. She was a
large, forceful woman, a capable social worker connected with Grosvenor
House.[9] Apparently they lived together for four or five years, and Stella

did a number of portraits of her (Figure 83). She must have been known as Mrs. Stella, for a letter from her to Katherine Dreier, August 3, 1926, saying that her husband had left for Italy, is signed Helen Stella. Whatever the legal status, Stella's arrangement with both women was obviously not binding, and he lived most of his life freely coming and going, settling alternately in Europe and the United States as though he were unmarried.

During the mid-twenties, Stella continued working in the primitivizing style of *Undine* and *Birth of Venus*, in colors of high brilliance and saturation, painting a number of nudes similarly charged with symbolic meaning, such as *The Vision*, described as "a human form closely held within a rich contour line of dark orange and thinly veiled; as much like a tulip-bud as like a vision of budding womanhood." [10] The visual metaphor is completed with two sharp spears standing parallel to the figure on either side, terminating in a flame-shaped bulbous bud. At the same time and in an analogous style he also executed a series of female heads — *The Amazon*, *Ophelia*, and *Sirenella* (Figures 82, 86, 90) — highly stylized and rigid, close to the picture plane and looming large over its surface, with contrasts of hues at a high level of intensity, and with a blockiness of form and sharpness of contour that sometimes suggests wood carving.

The painting entitled *The Amazon* was intended by Stella as a tribute to American womanhood, for whose "conquests in every domain," he expresses keen admiration.

> To celebrate her beauty and efficiency, I employed precious chromatic attributes: blue, gold, silver, ivory, vermilion. I lavished gold with fiery reverberations upon the royal mass of her hair winding down the intact ivory of her face — clean-cut profile of cameo — and at the base of her long imperial neck I did spread a silvery ethereal veil, veined of rose and smiling with spring flowers, in the shape of wings opened for flight. To uplift her PRESENCE in a legendary realm, for her background I painted a rich ultramarine blue sea, compact as crystal, containing the elongated carved image of CAPRI, THE ETERNAL SIREN, and to proclaim her a GODDESS, with vermilion I rendered her bust, a volcanic pedestal refulgent of power as an OREFLAMME. [11]

The huge head thrust diagonally across the airless, static space, the large-featured, aggressive contours of the profile, contrasted with the shallow profile of the island hills in the background, and the steely expression, to-

gether with the strident contrasts of warm hues, combine to produce a strangely powerful image, with something of the compelling quality of a billboard poster, blaringly penetrating, that anticipates Pop art.[12]

Around 1925 Stella met Carl Weeks, who became an important patron. Weeks was a self-made drug and cosmetics multimillionaire from Iowa, who, when Stella met him, was in the process of building his mansion in Des Moines. Salisbury House, based architecturally on a Gothic-Tudor structure in Salisbury, England, known as King's House, incorporated surviving parts from a sixteenth-century home which possibly belonged to Weeks's ancestors. In addition to buying *The Birth of Venus* and *Tree of My Life*, as well as some smaller works, the Iowan commissioned for one of the rooms in his new home a panel based on a poem by William Morris, giving Stella complete freedom to carry out the work. "You are to do what I told you . . . do it your way," he wrote from aboard the S.S. *Belgenland*, probably in 1925. "You know where it goes, you have the symphony of it in your soul and it will come out through your finger-tips . . . a masterpiece." [13]

The commission and the patron allowed Stella to give free play to the combination of mysticism, symbolism, and love of decoration that was so deep in his nature. The result, *The Apotheosis of the Rose* (Figure 84), evokes a sense of kinship with the kind of Victorian taste that found such satisfaction in the mixture of spiritual and exotic qualities of the *Rubaiyat*. Although this painting contains many of Stella's characteristic devices of composition, formal shapes, and relations of objects, its lacy delicacy gives it a unique place in Stella's art. The rose, radiating an aureole of light, rises along a strongly accented vertical axis supported at either side by a heron. Smaller birds perch like buds on the delicate branches that writhe like the Siva-armed *Lupine* (Figure 54), and the vertical movement is reinforced by repeated verticals at left and right. The radiating rose occupies the center space, which is given an archlike appearance by the curving shape of the bird at the left and the lupine bud stalk at the right. The fantastic proportions of the figurative elements and the fine mesh of interlaced stems, stalks, and tendrils make it difficult to distinguish them from the long curving necks of the birds. An assortment of flowers softens the rigidity of the plan but also fills in a large proportion of the space in the design; even the sky is blocked off at the top by large-bodied blossoms (see Appendix III, Figure 84). At the center of the fore-

ground pond, sharing the vertical axis with the mystic rose, is a lotus, the flower which Stella identifies with Venus in his notes on *The Birth of Venus.*

For Stella to have related the rose and the lotus symbolically in a single painting is of particular interest because, along with the symbolic nudes of the twenties, he painted a series of Madonnas. His dual image of woman as a Mother-Venus representing both sacred and profane love seems to have been a major concern of these years. In a one-man show at the Valentine Gallery in 1928, he exhibited three large paintings on the Madonna theme: *The Virgin* (Figure 81), *Mater Dei* and *Purissima*. His description of *Purissima* is applicable to the entire group; every form and every color was carefully chosen as much for symbolic content as for formal design.

Purissima

Blue	White
Violet	Silver
Green	Rose

Yellow

Clear morning chanting of Spring.

BLUE intense cobalt of the sky — deep ultramarine of the Neapolitan sea, calm and clear as crystal — and alternating with zones of lighter blue, the mantle multicolored (an enormous lily blossom turned upside down).

SILVER quicksilver of spring water, quilted with the rose, green, and yellow of the gown — greenish silver, very bright — mystic DAWN-white — of the *Halo.*

WHITE as snow for the two herons, whose gleaming white necks enclose, like a sacred shrine, the prayer of the VIRGIN.

YELLOW very light — for the edges of the mantle — to bring it out clearly with diamond purity, and reveal the hard firm modeling of the virginal breast. The lines of the mantle fall straight over the long hieratic folds of the gown, forming a frame [14] — and the full, resonant yellow of unpeeled lemons at both sides of the painting like echoing notes of the propitious shrill laughter of SPRING.

VIOLET mixed with ultramarine for the zigzag motif in the panel along the edge of the mantle, and bright, fiery violet at the top

of Vesuvius, near the white fountainhead of incense — light violet tinged with rose, for the distant Smile of Divine Capri.

GREEN soft, tender, like the new grass — intense green for the short pointed leaves that enclose the lemons — and a dark green, both sour and sweet, for the palms that fan out at the sides like mystic garlands.

PINK strong — rising to the flaming, pure vermilion borders — of the Rose, brilliant as a jewel, in contrast to the waxy pallor of the hands clasped in prayer — and infinitely subtle, delicately modulated rose for the small flowers that with the others of various colors weave of dreams and promises the splendid bridal gown of the *"Purissima."* (I,29)

Purissima exhibits some of the primitivizing qualities to which I have referred, and is quite consciously archaic and hieratic. But the tonality is more subtle, the contrasts seem less sharp and the over-all luminosity glowing in comparison to the flat raw color of the nudes. Although Henry McBride, however sympathetic to Stella's uncompromising spirit, still found it difficult to cope with what he saw as the "quite untempered use of raw, bright color, applied with the simplicity of a peasant to the glorification of the Madonna," [15] a shift to greater richness is apparent, and presages a group of rich, dark paintings of the years around 1929–30. *Purissima* must have been painted toward the end of the Madonna and nude series, probably in 1927.

Stella went to Italy in the summer of 1926, and, except for a brief period in 1928 — probably at the time of his one-man exhibition at the Valentine Gallery — spent the next eight years in Europe, living mostly in Paris, but with frequent trips to Italy and one or more to North Africa. A letter to Carl Weeks of June 1, 1929, gives news of his activities, his whereabouts, and his confident, optimistic mood.

Dear Mr. Weeks:

When I came here from Paris last December, I never thought that I would have in Italy, so soon, a one-man show. Well, I have been working from morning to night, with a great enthusiasm, and the result has been an exhibition of 89 pictures. . . . All the authorities of Naples were present at the opening of my show . . . and the success has been really great. I have taken Italy by storm. . . . Seeing what is done by the best artists in Europe, I feel more than confident in my strength. Everybody here was astonished at the novelty and origi-

nality of my work and many could not believe that in America Art can be developed along such purity of style. But I have told them that America is going to be in the lead, in Art, too, pretty soon. Only the young nations that have strength and will and daring in business enterprises can be entitled to a rich Art. So it happened with Venice, Florence and all the great Italian cities when their financial strength was at high tide.[16]

Stella did not exaggerate his critical success, although we cannot know how many paintings he may have sold. Every Neapolitan newspaper carried long, appreciative articles on the exhibition, and *Emporium* for June 1929 commented that "the great event of May in Neapolitan art circles was the one-man show of the painter Joseph Stella, arranged in the galleries of the review, *Italiani pel Mondo.* . . . A great and enthusiastic success, publicly and critically."

The new paintings shown in Naples indicated a long step forward in the direction of richer tonality and a kind of incandescent radiance. From the high, brilliant color range of the previous few years, Stella's palette changes to the lower ranges, reintroducing black, and using the bright hues as accents or focuses in a context of much darker shades, although at first there are only a few bright areas. There is some indication that the artist was preoccupied with thoughts of death, for in the Naples exhibition there were four oils titled *Souls in Purgatory*, and another is listed as *The Swan of Death*. Antonio Stella had died in 1927, and it seems reasonable to assume that these paintings were related to that event, although I do not know exactly when they were painted. Initially exhibited in the May 1929 show, they are the first of Stella's paintings that I know of on the theme of death.

The Swan of Death features a black swan at the center, its body largely concealed behind a large, wide-spreading water lily whose outer petals, next to the black, range from a middle lavender to dark purple, with inner petals of lighter to darker blue and a flame-shaped center of brown and orange. The rest of the foliage is dominated by a dark green tonality, with touches of red in the spiky petals of the lotus on the vertical axis behind the swan. A screen of closely placed verticals, like a bamboo forest, reaches across the entire background, forms familiar to us now, along with the blade-shaped claw, beak, and pincers.

Of the four paintings of *Souls in Purgatory* I have seen only one. The palette is similar to that in *Swan of Death* although there are more areas

of bright color. Dark-clothed figures are placed at either side of a tabernacle in front of which are a brown skull and crucifix. A brilliant red monstrance, half-visible behind and above the tabernacle, stresses the vertical axis which begins its ascent with a light green votive candle at the base and passes through shades of lavender, purple, and dark blue accented here and there with orange and red. All but two of the figures are in profile, with only the upper part of the body rendered. Men and women of various nationality types are represented, suggesting that suffering is universal, and recalling Stella's early studies of immigrants and mine workers.

As in *The Heron* (Figure 44) and some paintings of the twenties, the style suggests carving; but here it is a different *kind* of carved look. In the earlier pieces the rigidity of the forms and their smooth outlines, composed in a static design, give a carved effect, but the term is more metaphoric than realistically descriptive of them. In *Souls in Purgatory* and a number of paintings of this time closely related in style, now in the warehouse, there is actually the look of carved wood. The idea for this woodcarving effect could have come from a book found in Stella's effects, *La Ville des Santons*, an account of the history of objects that comprise Holy Manger scenes used for decoration at Christmas time.[17]

One of the most interesting paintings in the dark style accented with brilliant areas of color is *Green Apple*, which focuses on a huge, glowingly green fruit placed against a medium light sky suspended over a brilliant, incandescent blue sea. A garland of rich dark green foliage with bright red flowers and yellow fruits frames the apple,[18] while two black birds touched with brilliant plumage fly down from the upper corners and eerie, wing-shaped leaves flutter above the apple. A peculiar effect is realized by the contrast between a flat, decorative "frame" around the apple, and the deep, glowing space behind it, and golden radiance illuminates the painting with a strong mystic light. Stella's vision, leading to the strange proportions and symbolic forms encountered so often, suggests something of the quality of the Surrealist; in particular, *Green Apple* recalls Magritte's hallucinatory images. I believe, however, that Stella arrived at his own surrealism through his private avenue, independently and even earlier in time.

In the same style is the exceptionally fine *Still Life with Yellow Melon* (Figure 95), an extremely dark painting with the central motif executed

in yellow-orange of extraordinary intensity. A kerosene lamp at the left, so dark it almost merges with the black ground, is brought into relief with a few touches of dark green and blue, while the fish bowl at the right is modeled in blues and greens, with touches of red introduced in its fish. The family resemblance of Stella's shapes, whether solids or voids, is remarkably consistent: the melon in this painting, for example, resembles the void surrounding the lotus and apple in *Green Apple.*

A number of landscapes dated to the twenties show stylistic analogies with the figure and still-life works of the period. Representative examples are the symbolic *The Little Lake* (see Appendix III, Figure 87), in which we see the melon shape noted in *Still Life with Yellow Melon* and *Green Apple*, recognizable now as the familiar arched opening, this time inverted, and the nudelike *Cypress Tree* (Figure 85), sharp-edged like *The Vision*, with curvilinear forms placed in striking juxtaposition to rectilinear forms, all severely reduced. Rather different is the dark, moody, blocky *Muro Lucano* (Figure 89) thinly painted in the lower area and around certain of the forms in such a way as to suggest that it might be unfinished. Its strong design and expressiveness give it importance in Stella's landscape painting of this time. It was also during this decade that Stella experimented with a technique that he called "encaustique." Exactly what this technique was I do not know, but it seems probable that he found some way of adding wax to his pigment in order to produce the high gloss surface of certain paintings, notably *The Amazon* (Figure 82).[19] Stella seems to have abandoned this "encaustique" after a few years.

Before the close of the twenties Stella returned to the Bridge theme with *American Landscape*, his third and last variation on this theme (see Appendix III, Figure 91, note 1). Although he shifted the tower to one side to create an asymmetrical composition held in balance by the parallel curves of the heavy cables anchoring the surface to the right-hand margin, in many other respects the painting is like the earlier bridge paintings. Stella again contrasts the curving, moving white cables with the static black towers, employs repeated verticals, and assimilates into one plane elements that lie in different planes: the vertical black bars in the lower foreground lead into the vertical edges of the buildings in the background. Nevertheless, this Bridge is less interesting than the earlier ones. It lacks the drama and the emotion of both the Yale painting (Figure 50), with its labyrinthine weavings of darks and lights, and the *New York Interpreted*

panel (Figure 75e), with its straining linearity. The cutting off of the cables at the right-hand margin implies a continuation of the scene that makes the painting more literally a view. *American Landscape* gains a degree of freshness, however, from the cruder color applied on an unprimed canvas (see Appendix III, Figure 74).

The decade between *Brooklyn Bridge* and *American Landscape* brought to realization all of the formal tendencies and the full range of subject matter to which Stella's art would address itself. Extraordinarily large for the period, decorative in treatment, dramatic in expression, and highly symbolic, with a fusion of sexual and religious meaning, the paintings of these years include many of his best works as well as those that today seem awkward in concept and execution. These were the years of his maturity, of his forties and early fifties.

It is curious that Stella does not refer to his financial success during this postwar boom. Charmion von Wiegand writes that in those ten years, "Stella's shows were always crowded with admirers. His paintings were eagerly sought by private collectors and his income was impressive. One New York art dealer is said to have made over thirty thousand dollars handling his work." [20] The crash of 1929 put an end to such prosperity. But Stella had money in the bank, and he had achieved an international reputation as a leading American artist. There seemed good cause for optimism as he found himself on the threshold of the thirties: he could not know that at the age of fifty-three he had reached the apex of his success.

When, in 1946, the last year of his life, he looked back on that decade, he forgot the weariness and loneliness and despair, the disappointments and frustrations that drove him to sudden outbursts of terrible anger,[21] and remembered only the delight, the thrill, and the joy that he had found in his work.

> From 1921 on I was swinging as a pendulum from one subject to the opposite one. With sheer delight I was roaming through different fields, spurred by the inciting expectation of finding thrilling surprises, especially going through the luxuriant garden of the Bronx, I was seized with a sensual thrill in cutting with the sharpness of my silverpoint the terse purity of the lotus leaves or the matchless stem of a strange tropical plant. Innumerable visions of pictures were storming around me like chimeric butterflies.[22]

Giotto's art goes hand in hand with those
emotional flowerings that have framed with
bright morning laughter the dawn of mankind.
— The Art of Giotto (I,32)

<div style="text-align: center;">

X

Italy, France, and North Africa 1929–1934

</div>

In contrast to the drama of the industrial paintings and the exoticism of
Tree of My Life or *Tropical Sonata*, many of Stella's paintings in the
1920's and 1930's are cool and sedate, and characterized by certain de-
liberate crudities which I have termed "primitivizing." His interest shifts
to Italy and Italian subjects, themes from classical mythology appear, and
even *The Amazon*, Stella's strange homage to the American woman, is set
against a background of Capri. Some of these years were actually spent in
Italy, and the Italian landscape and architecture in his paintings are classi-
cally airless and quiet (Figures 92, 97); but even in the French capital,
where he lived from 1930 to 1934, this Italian style shaped his view of
Paris Rooftops (see Appendix III, Figure 98), composed of broadly de-
signed interlocking horizontal and vertical forms. Although a number of
factors influenced it, the fundamental stimulus for this style derived from
his reawakened interest in the art of Giotto.

Stella was not alone in feeling this influence. In Italy, the drive to re-
establish the Italian tradition of form which the dynamism of Futurism
had destroyed created various kinds and degrees of archaizing idealism
stimulated by the rediscovery and new understanding of Giotto, Masaccio,
Uccello, and Piero della Francesca.[1] Werner Haftmann claims that Carlo
Carrà, "more than anyone else, was instrumental in developing this state

of mind. More than a leader, he became a moral authority, because he succeeded in combining the constructive ideas of modern French painting with the great traditional values of Italian art, the old masters' solid definitions of the objective world. It was through Carrà that the Italian painting of the years from 1920 to 1940 took on its characteristic classical-archaic realism." Carrà took his point of departure from Giotto, "in whose conception of objective form he recognized the true *principio italiano*, 'the inner image' of the thing in the simplest and most precise form." Stella's letter to him in 1920 [2] provides a clue that accounts for this particular direction his art took and suggests the origins of his devotion to Giotto, of whom he writes often and at length and in that special tone that suggests an identification with his subject. Two examples help reveal the quality of his passionate reverence.

> There is a corner in our souls that remains forever like a clear mirror . . . in which we find intact, fixed forever, the purity of our first sensations. It is a sacred shrine, kept by us . . . to draw on for new energy . . . in order that we may continue the harsh trial of Art. Opening it, there appear the propitious smiles of all the Good Spirits who at baptism set us on our first footsteps along the difficult path of art. And among them all, the most familiar and beneficent . . . is Father Giotto. Giotto, luminous and smiling name like a miraculous flower blooming out of the green fresh knowledge of our early school days . . . (I,31)
>
> Giotto's art is of a unique simplicity and spontaneity . . . It has the freshness of dawn. Free of all allurements, it has the smell of the newly plowed earth, and it bestows an everlasting woody perfume . . . Contemplating his creations that stand forth with the spontaneous charm of flowers, visions and inexpressible memories hover in the heaven of our soul: . . . the white of the oxen brilliant against the deep brown of the earth furrowed by the plowshare; the yellow ocher of bread on the silvery gleam of pure water; . . . the friendly chirping, at dawn, in the nests clinging to the gutters of my father's house; [3] the thundering forth of spring waters in July, quenching the trembling trees shaking like virgin limbs quivering with the burning taste of love. (I,32)

Considering himself a part of the Italian artistic tradition, Stella shared with Italian contemporaries the burden of the heroic past and sought now

as they did to revitalize his art by returning directly to its source in Giotto. The abstraction of form, the solemnity, the immobility, the trancelike suspension of reality that characterized so much of Stella's work in the twenties and thirties — *Undine, Ophelia, The White Swan*, the *Portrait of Helen Walser, Green Apple, The Little Lake, Cypress Tree, Muro Lucano, The Holy Manger* are representative — have clear analogies with similar qualities in such works by Carrà as *Pine Tree by the Sea* of 1921 and *The Boatman* of 1930; with Ottone Rosai's *Women at the Fountain,* 1921 and Giuseppe Cesetti's *Shepherds,* 1936.[4]

Nevertheless, there are important differences between Stella's painting and that of the Italians, arising in part from his temperament with its natural kinship to visionaries in art of any country, and in part from the fact that his emotional and intellectual vision was not purely Italian. By 1923 he had lived more than half his life in the United States, with a significant period in Paris, and his view encompassed a wider segment of the artistic landscape; as a result the single-minded devotion to *disegno* on which Carrà insisted was undermined by a subversive love for expressive color. While Carrà finds in Matisse's painting a lack of "constructive dignity and seriousness," this French artist was Stella's favorite among modern artists.[5] Matisse's brilliant high color was a siren song for Stella, whose strength was in line but whose heart was in color.

Living in the United States, Stella had been exposed to an Orientalizing taste that is particularly apparent in the sculpture of his friend Gaston Lachaise, whose own thought seems to have come under the influence of *his* friend, Coomaraswamy. It is possible that some of the hieratic flatness and decorativeness of Oriental design, and perhaps even some of the mysticism that animates Oriental forms, found its way into Stella's art by way of his natural responsiveness to the symbolic and the exotic. A number of minor American artists manifest such a tendency in the twenties, Stella's friend Robert Chanler among them, and this taste found its way prominently into applied art and interior decoration. De Fornaro remarks that "Stella's decorations had the flavor of Persia and Cashmere . . . One feels the Oriental breath emanating from his fantastic, stylized arabesques."[6]

In the United States, the art of the twenties shows a tendency toward classical idealism analogous to the French, German, and Italian movements, but the American emphasis is on a greater degree of naturalism. Although the art of the Precisionists was based on "an underlying

geometrical framework" and has "the clarity, the serenity, and the ordered beauty of the classical vision"[7] that relates it to Léger and the Purist movement in France, it is closer to a simplified description of reality based on representation than to an arrangement of objects taken from modern life and composed according to aesthetic considerations such as governed the French painters. The Romantic Realists[8] worked toward a style that, in its breadth of treatment, amplitude of volumes, suppression of details, balanced composition, and monumentality, is analogous to the work of Derain, to German painters such as Carl Hofer and George Schrumpf, and to the Italian followers of Carrà in the *Valori Plastici* and the *Novecento* groups.

In considering Stella's painting of the twenties and thirties in relation to contemporary art, Derain and the Germans of the *Neue Sachlichkeit* may be left aside, since any qualities in common were the result of a common source in the widespread movement toward classical form rather than with direct contact. Comparisons of Stella's art with the American Precisionists and Romantic Realists and with the Italians of the same period are meaningful, however, and show that he was more closely related to the latter. Sheeler, with his photographic realism and Shaker functionalism,[9] and Demuth, with his Cubist faceting and Futurist dynamism expressed through lines of force, were both concerned with the American scene, as was Niles Spencer. Stella lost interest in this material after *New York Interpreted* and the industrial paintings of 1918 to 1924.[10] Georgia O'Keeffe's Precisionist-related forms are instinct with her perception of process in the structure of living things. For all their classical austerity, they express a nonclassical, lyrical identification of the artist with nature.[11]

An air of introspection and individual characterization pervades the work of even the most traditional of the Romantic Realists. Kenneth Hayes Miller may pose a solid, weighty 14th-Street shopper against an equally solid, weighty department store column, but the effect is sentimental rather than classical. The art of Bernard Karfiol, Eugene Speicher, Walt Kuhn, and many of the younger painters of the following generation who came to maturity in the twenties produces a similar impression.

In Italy, underlying the individual variations of *italianità* — Carrà's stillness and solemnity, Rosai's naive realism, and Cesetti's lyrical primitivism — the balance of classicism and naturalism is weighted on the side of objectivity and restraint. Despite the unevenness of the artistic quality

of these painters, one feels the atmosphere of stately serenity in their work that is characteristic of the Giottesque tradition.

Stella's awareness of himself as Italian, and of Italian art as a primary source of inspiration appears frequently in his writing.[12] That he felt some identification with the United States is also evident at times. Because we cannot date the writings, we cannot chart these feelings, but it seems likely that during the period of the twenties and early thirties his Italian feelings were particularly strong. In 1928 he wrote Ferdinando Santoro: "Italy is my only true inspiration. The artist is like a tree: growing older, bent under the weight of its fruit, it presses always closer to the maternal womb that gave it birth. Despite everything, thirty years and more of America have succeeded only in making more solid and firm the latin structure of my nature" (I,57).

Although classicizing and primitivizing tendencies appear in Stella's art from the time of his 1922 trip to Naples, at the beginning of the thirties a more overtly Giottesque quality can be seen in the heavier, bulkier, more generalized and simplified forms created. Even without the confirmation in his writings about Giotto, we feel this in *The Ox* (Figure 93), a painting reproduced in *Le Mont-Parnasse*, August 13, 1932, accompanying a long article on Stella. A similar Giottesque quality is felt in the Goldstone *Self-Portrait* (see Appendix III, Figure 94), Stella's finest self-portrait, beautifully drawn with great simplicity and honesty of concept, free of the theatricality found in some of the others.

The most conspicuous example in Stella's *oeuvre* of his effort to apply and at the same time modernize Giottesque forms can be seen in his largest painting of the period, *The Holy Manger* (see Appendix III, Figure 100). This was the central, major work he sent to Rome, with a number of smaller paintings, for an exhibition of religious art, as reported by *Il Popolo di Roma*, February 25, 1934. A recapitulation of his work of the European years, it contains a number of recognizable motifs and forms, like the tree from *The Little Lake*, the cubic houses from *Muro Lucano*, two groups of figures arranged around a religious motif as in *Souls in Purgatory*, the small toylike figures suggested by *La Ville des Santons*, found in *Marionettes*. But here, as a result of Stella's desire to infuse *The Holy Manger* with the spirit of Giotto, the forms are more squarely built and more austerely stylized, with the figures arranged in isocephalic rows. They are seen in profile, with a few in fuller view, and they are placed

outdoors against a rocky landscape, as in Giotto's *Joachim and the Shepherds* and the *Pietà* in the Scrovegni Chapel at Padua, or in his St. Francis cycle at Assisi.

St. Francis is invoked in a number of Stella's writings, and, since Franciscan literature was found among his paper, the saint appears to have been of special interest to him.[13] Some details in *The Holy Manger* suggest specific relationships with the frescoes of the St. Francis legend, although there is no direct copying, nor have I found among Stella's drawings any sketches that can be identified as studies after Giotto. The pose of the right foreground figure in *St. Francis Being Honoured by a Simple Man* is similar to the right foreground figure in *The Holy Manager*. The houses climbing the steep mountain at the left of *St. Francis Giving His Mantle to a Poor Knight*[14] resemble the cluster of houses clinging to the rocky cliff at the left of Stella's painting. The drapery on the figures in both frescoes is rendered in distinct, careful, quiet folds, like the folds in the clothing of Stella's Muro Lucano peasants. There is even a general resemblance of composition between the *Simple Man* and *The Holy Manger* in the way two groups of figures supported by architectonic masses confront each other over a space dominated by a triangular-topped rectangular element. We can also attribute to Giotto's spiritual presence the subdued tonality of this and related works that accentuates the mass of the forms.

The complex interplay of curves and straight lines in Giotto, however, is reduced in Stella's painting, where the interlocking of horizontals and verticals is more rigid and the resulting rhythm moves with more abrupt starts and stops. Compared with Giotto's arrested movement which conveys the rhythm of the moment before and the moment to come, Stella's static poses seem detached from any sequence. Moreover, one of the most interesting features of *The Holy Manger* is quite unlike Giotto. In what might be called a Mannerist play with scale, the "real" figures, which are large, are juxtaposed to the small figurines in the manger scene, and are placed against the background of toy-sized houses, with the whole set against a deep, implied valley convincingly hidden behind the grotto. A spatial ambiguity is created by that daring white expanse in the center of the painting that is set in a plane behind the villagers. This cloth hides the support on which the grotto scene rests, preventing us from knowing exactly where the nativity group is located, and suggesting that it may be

quite far back in space, so that the figurines are in fact "real," and simply seen as small because of their recessed position. In this case, the villagers of Muro Lucano would be participating in the real Adoration instead of a Christmas re-enactment. Yet the crude "woodcarving" style of the small figures reveals that they are only figurines, so we move back and forth on two levels of reality, through two systems of scale, which I believe is precisely what Stella intended. Had he wished to clarify the situation, he would have decorated the large cloth as he did the small cloths in the foreground, instead of leaving it a white block for our eyes to relate to the white blocks of houses in the distance. The system of two realities is further elaborated by the use of two techniques for applying the paint. The foreground figures and the background houses and mountains are rendered with a smooth, blended, brush stroke, while the grotto is painted with a dry brush and thick pigment which possibly contains a grainy additive, producing a highly textural, rough surface.

The Holy Manger fails to achieve what its artist wished it to achieve. Its eclecticism just does not work.[15] Despite their immobility and stylization, the figures retain a degree of naturalism that creates a disparity between them and the conceptual context in which they are placed. They are not so much generalized as typified. The even spaces between the figures on each side are monotonous, and the monotony is not overcome by the wide space at the center, which should hold the composition together, but which functions only in creating ambiguous space. The lack of spatial tension undermines the possibility of emotional tension, and the figures are seen grouped but separate, not fused into an emotional unity as if participating in a meaningful rite. We do not feel the intensity of involvement of *Brooklyn Bridge* or *Tropical Sonata* or the flower studies that writhe with controlled energy; we have the impression of a concept applied rather than realized.

The smaller works that Stella painted for the 1934 Rome exhibition included some heads of religious figures, among which is the *Head of Christ* (Figure 99). This painting recalls the early drawings of immigrants and steelworkers, also rendered with stark dramatic contrasts of light and dark areas. A taste for sharply swerving and irregular contours was present in those early works, but in the *Head of Christ* and related paintings Stella accentuates the curves and uneven edges to the point where the shapes become almost abstract.

In 1930 Stella made one of possibly several trips to North Africa; "Algeria, 1930" is written on the back of a painting I have called *Forest Cathedral*.[16] Keeping in mind the religious tendencies in Stella's art, together with his fondness for visual analogies like the fantasies with zucchini, the tree may be seen as a praying figure with head thrown back and arms raised in supplication. This impression is heightened by the way a large, bright, pointed leaf is set in an area surmounted by an arch formed by a bending stalk and leaf, suggesting a church niche or portal in the dense verticals of the forest. The over-all tonality of the painting is green, ranging from very dark, almost black, to a pale, nearly white celadon shade. The pigment is scumbled to give a rich textural surface to the tree, and smoothly applied in the background shoots and the leaf.

Stella may have been in North Africa in 1929, for an exotic *Red Flower* seems to have tropical inspiration.[17] This is of course not conclusive evidence, for he could well have worked from sketches done in botanical and zoological gardens, and in fact the painting carries an inscription on the back "Paris, November 1929." At the center of the canvas an enormously enlarged red orchid type of blossom with widespread petals is supported by a heavy stalk and two gigantic leaves that rise to cup the space under the flower. Two exotic birds, resembling peacocks, stand guard, like the herons flanking the *Apotheosis of the Rose* (Figure 84). The dark tonality surrounding the vivid blossom places the work in the context of the dark paintings of this period.

After the dark palette of the years between 1928 and 1930, Stella's color brightened again. In the thirties we find him using strong lemon yellow contrasted with brilliant, saturated green, intense orange with equally strong blue, and unusual colors like cerise and chartreuse, with bright decorative borders and floral ornament. A characteristic example is *Self-Portrait as an Arab*, painted in Stella's massive, heavy style of the thirties, with the forms sharp-edged and carved-looking. But the color differs from the earthy tonality of *The Ox* and related works, the acid green of the overblouse vibrating with fluorescent intensity. Stella used these colors for a number of portrait figures during his Paris years — at the same time that he worked in the lighter, blander tonalities.[18]

While living in Paris, Stella was one of a group of American painters and sculptors closely associated with the *New Review*, a short-lived avant-garde literary journal edited by Samuel Putnam, which carried art

news, reviews, and criticism. The artists exhibited together at the Galerie de la Jeune Peinture, 3 rue Jacques Vallot. In June 1931 Stella shared a two-man show there with the painter Don Brown. He participated the following January in a group exhibition that included Abraham Walkowitz, Hilaire Hiler, and George Seldes, among the painters, with sculpture by Oronzio Maldarelli. Although the other names in the exhibition, as listed by Samuel Putnam,[19] are forgotten today, they were looked upon then according to him as belonging to the progressive wing of the American artists in Paris at that time, with Stella their acknowledged leader.

The rivalry between Stella's friends and a group of conservative artists led by Boris Aronson was not at all friendly, and on one occasion erupted into violence. Piecing together several accounts, it appears that Aronson had organized an exhibition, held in January 1932, that purported to represent American art, the first all-American show in Paris. Stella was not invited. One morning, while the conservative show was in progress, a friend came to his studio in rue Boissonade and reported certain slanderous remarks allegedly leveled against him by Aronson. His easily stirred temper thoroughly aroused, Stella rushed off to the Café du Dome, where both groups of American artists tended to congregate, and ran straightway into Aronson himself whom he grabbed by the lapels and shook, while shouting accusations at him. Ary Stillman, another conservative, came out of the cafe and tried to separate the pair. Stella turned on him with his cane, which he always carried, and Stillman fended off the attack with his own cane. In the ensuing duel, Stillman was knocked off his feet, and another painter, Albert Chollet, entered the fray against Stella, crashing a chair down over his head, drawing blood. The fighting grew bloodier as Aronson and Stillman re-entered the conflict. Finally, according to the account in the Paris *Tribune*, "The Dome's flying squadron of waiters came rushing up and . . . saved the day — and maybe some lives." This last was an exaggeration, for the injuries were treated at a nearby pharmacy, the combatants refused to go to a hospital, and Stella was taken to the commissariat where Aronson, Stillman, and Chollet filed complaints.[20]

Interviewed by the newspaper, Stella denied that he was disgruntled at being excluded from the "representative" exhibition of American art and insisted that he had been goaded into action because Aronson "had been leading a campaign of propaganda" against him personally. But Stella's partisans admitted their own grievance at being left out of the big show,

at the same time attacking it for *not* being representative; they used Stella as their main argument: " 'How can the show be representative if Stella, who's one of our best moderns, is left out?' they ask." Feeling in the Quarter ran high, and the *Tribune* observed that "no one would be surprised to see new fisticuffs in Montparnasse."

It is unlikely that there were "new fisticuffs" between the rival groups of American artists in Paris, for one reason if for no other: there were soon no Americans left to fight or paint or write or play in Paris. By the mid-thirties, the Depression had sent practically all of them home.[21]

The sense of freedom makes of life
a festival of flowers and fruits.
— The Poinsettia (I,27)

XI

Paintings of the Last Years 1935–1946

From 1935 to 1937 Stella lived unhappily in the Bronx with Mary French
Stella.[1] He seems to have done little painting except for some still-lifes.
A fragment in his writing that seems to be a plan for an exhibition lists
twenty-four works, fourteen of which are fruit and flower pieces, two
self-portraits, two religious titles, one of which is probably the *Head of
Christ* of 1933 (Figure 99), a portrait of Samuel Putnam [2] (listed as the
translator of Rabelais) noted as having been done in Paris, and five paint-
ings dating from the twenties or earlier. The list is datable to the middle
thirties because it postdates Stella's return to New York in 1934 (clear
from the reference to the Putnam portrait) and probably predates the trip
to Barbados, since it includes no Barbados subjects. A great number of
silverpoint drawings and pastels of flower, fruit, and bird subjects were
done, as well as sketches of human figures and heads. Rabin and Krueger,
the New Jersey dealers who represented him at this time, had well over
two thousand works in this category; although a substantial number of
them were done years earlier, Bernard Rabin believes, I think correctly,
that many belong to the middle thirties. Further evidence that Stella did
not paint a great deal in oil at this time is indicated by the retrospective
show at the Newark Museum in 1939; the catalogue lists only a few paint-
ings that can be identified as new work.

One landscape from these years, *Spring in the Bronx*,[3] shows Stella sud-

denly working in small broken strokes, with pointillist dots here and there, in an Impressionist palette of leafy greens and blues, with a touch of cerise for the roof of the building in the background. An arched halo of foliage crowns the otherwise barren tree, and its trunk is divided, like two long legs, fusing into a "torso," suggesting the kind of mystic symbolism which the artist favored. Since he often identifies with trees, notably in his description of *Tree of My Life* but in numerous other passages as well, this tree may be a self-image, and it seems likely that the painting expresses Stella's experience of his own vitality as a power that weakens at times and then is "miraculously" restored. The ebb and flow of vitality — of creative energy — is a constant preoccupation and runs like a leitmotiv through many of Stella's writings. How often he exclaimed about it: "All my green hopes reawakened" (I,9); "At last the sun of art has appeared, lighting up the horizon of my soul. Gone the cruel dark melancholy" (I,33); "Our youthful confidence miraculously restored gives us a deep awareness of our energy, of our power, of our daring to attempt everything, to use to the utmost all the gifts at our command" (I,3).

After three rather unproductive years in New York, Stella experienced another moment of exaltation and liberation on shipboard en route to Barbados the morning of December 9, 1937, as St. Thomas came into view:

> The darkness becomes lighter . . . The fresh, balmy air and the clarity of the dawn full of young joy, open up the portal of our soul, lighting it up within, chasing away the shadows thickened during the horrible time in ugly America. It comes as the Resurrection of all our Being. There resounds once more the song of Hope and Joy. The blood rushes through our veins; truly young and with full confidence in our skill, facing the most arduous challenges, our artistic powers rise, magically reawakened in the presence of unexpected natural wonders, ready for the highest flights. We have left behind the stinking slough of America. That place, compared to the Great Light that surrounds us now like a true halo, . . . appears very distant, like a rough outline of shapeless mud. (I,34)

Anyone who might be offended by the bitterness of Stella's references to the United States should remember that the strength of his feelings about everything and anything was exceeded only by their ambivalence. The only exception was art. America, for Stella, was New York, and the man and the city were like a couple who cannot live together and cannot

live happily apart. In Paris, sitting in the bright sunshine in front of the Café du Dome, he had reflected on the city of steel and electricity and skyscraping towers with admiration, gratitude, and affection, avowing that it had made him what he was. "New York is my town. My belief in the artistic future of America is not based on sentimentality or patriotism. I know that America can produce and have faith in what it will produce." [4] But after three depression years Stella's emotions had reached a low point. The climate was harsh to one from southern Italy; life in a Bronx apartment was dull and constricted in contrast to that of bohemian Montparnasse; having to work on a W.P.A. art project was distasteful.[5] And Stella was never one to express his feelings in moderate language.

Stella must have been happy in Barbados. A local reporter found him a man "who simply exudes good cheer, and whose eye twinkles with contagious mirth." [6] He had always loved the tropics, the eternal summer, the rich colors and varieties of exotic flowers and plants. Holger Cahill, Director of the Federal Art Project, wrote to him in July 1937 that, when projects for Puerto Rico and the Virgin Islands were being considered, Stella's name had occurred to him immediately because he had often heard him speak of the tropics. The letter goes on to express the pleasure with which Cahill had listened to Stella's poetic description of his trip from Paris to Italy and into Africa and to the artist's extraordinarily vivid metaphors.[7] Stella hated darkness and loved the sun. His close friend, the sculptress Clara Fasano, tells how "once, traveling on a train from Paris to Italy, a fellow passenger started to pull down a window shade against the sun that was streaming into the car. Stella shouted at the poor man, 'You don't know how fortunate you are to live in this beautiful, sunny Italy! I come from gray, foggy countries, and now that I am blessed with the beautiful sun you want to deprive me by pulling down the shade!' Stella went to the window, raised the shade, and left the young man standing there speechless at the sudden attack." [8]

Once again in the tropics, he describes his renewed energy in a lyrical love letter addressed to a Poinsettia.

> It was wintertime when I arrived in the tropics, and your high-flaming greeting filled my soul with a start of sudden elation. My drowsing energy, tortured by the cold of northern countries, was reawakened as if by magic, set aglow by the radiance of gold and purple light. All the ardor of youth surged through me, with the

overflowing, stinging, demanding desire for new conquests in the virgin lands of art. (I,27)

Stella was revitalized by the sunny warmth and balmy air of the island, and several paintings inspired by his brief six months' stay are almost as glowing with vigor and richness as the early *Tropical Sonata* (Figure 76). *Full Moon, Barbados* (Figure 105) is a static, symmetrical composition holding in tense balance the kind of strange writhing shapes, sharp, spiny spears, and wing-shaped leaves remarked so often before. *Song of Barbados* (Figure 103), which Stella considered the major work of the series, displays again the application of color in blotches that run together like watercolor, as well as the theme of rising sound (this time represented by a palm tree) used in several versions of *The Song of the Nightingale* (Figure 46). The tropical paintings of Barbados differ from the North African work in their lighter colors and less dramatic exoticism. In addition, this later group includes a number of nudes.

During June and July of 1938 a large exhibition of American painting, Three Centuries of American Art, arranged by the Museum of Modern Art, New York, at the invitation of the French government, was held in Paris at the Jeu de Paume. Stella's bridge painting of 1929, *American Landscape*, was included in the show, which may account for his leaving Barbados to go to Paris that summer (see Appendix III, Figure 91, Note 2). After a few weeks in France he left for Italy. In Milan, in July, he arranged for an exhibition at the Galleria del Milione, leaving there a group of seven paintings, probably from Barbados; in Venice he visited the Ca'd'Oro and the Museo Orientale. By September he was again back in his beloved Muro Lucano and almost equally beloved Naples, sitting in the shadow of the dome of the Galleria Umberto, polemizing on art and literature, his voice resounding under the echoing dome, a voice as "muscular as his two arms, with their large ample gestures: his words sparkled and spiraled like fiery arabesques of every imaginable color, reverberating sonorously in a style of speech that was both majestic and hyperbolic" [9] (II,16).

By December 1938 he had returned to New York and was settled in a studio at 322 East 14th Street. Charmion von Wiegand describes him at this time.

> . . . large and capacious; he has the head of a Roman senator with piercing eagle eyes. His language is studded with poetic images. He

can quote endlessly from Walt Whitman and Edgar Allan Poe, his favorite poets. He has a keen relish for a good anecdote and his delight in the things of the senses is as joyous as a child's. Something of the spacious days of the Renaissance infuses him with reckless energy and creative prodigality. He not only creates constantly but he inspires others to create. Such diverse personalities as Georgia O'Keeffe and Diego Rivera have felt the impress of his work.

A visit to Stella's studio is an event. He lives at the moment in an old brownstone house on East 14th Street near the river. If you climb the stoop and knock on his door, you are admitted to an old Victorian parlor piled high with paintings, books, mementos, and stacked with portfolios and statues. In the center of the room, serenely unconscious of confusion, sits the painter at a small easel, putting the last touches on the svelte curves of a tulip. Flower studies of all kinds litter the floor and turn it into a growing garden.[10]

Miss von Wiegand confirms the impression that Stella turned more and more to flower and still-life in the last decade of his life (Figure 109). Occasionally he executed a large subject picture, and the warehouse contains a few figure studies of Italian peasants from the 1938 trip to Italy, in addition of course to the tropical subjects of Barbados. August Mosca recalls that sometimes he and Stella would work from a nude model on Saturdays when the young artist went to Stella's studio to paint. But Stella was almost never satisfied with the model sent by the agency, and, after a short time at the easel, he would jump up, inveigh angrily against the agency, and send the model away. More often the two artists would go to the Bronx botanical garden, where Stella would spend the day drawing flowers in silverpoint or pastel. The catalogues of the last three one-man shows Stella was to have — the Associated American Artist Gallery in 1941, Knoedler Galleries in 1942, and the A.C.A. Gallery in 1943 — list few new subject compositions, showing that the exhibitions had much of the quality of retrospectives.

Between 1936 and 1942 Stella painted three more versions of his favorite American subject, the Brooklyn Bridge. The first two (Figures 101, 104) are variations based on the "Bridge" panel of *New York Interpreted* (Figure 75e), the last is a close copy of the Yale *Bridge* (Figure 50), titled *Old Brooklyn Bridge* (Figure 107). These are all smaller than the original works. In the San Francisco painting (Figure 101) the palette is very dif-

ferent from the earlier work, dominated by grays and blues that impart a foggy atmosphere to the scene. The illustration in this book is somewhat misleading in the degree of contrasts between lights and darks, giving the impression of greater drama than the design actually possesses. The composition is greatly simplified, with almost all the details of the forms eliminated. In Figure 104, on the contrary, the details of the forms have been increased, showing the stepped-back design of some of the architecture. The pattern of indentation is repeated in the outline of the towers visible on either side of the central pier. The broken contours give a more decorative aspect to this work compared to the *New York Interpreted* canvas. Another difference in the later painting is the addition of a small scene of the bridge and skyscrapers silhouetted in profile in the upper section of the predella. Although I have not seen Figure 107, the photograph shows that it is almost an exact copy of the design of Figure 50. There are differences, however: the web of thin lines in the upper right and left sections of the early work is not present in the late one, and these fine lines are missing here and there in other parts of the painting. Furthermore, the edges of the forms seem harder and I have the impression that the paint handling is smoother in the California work.

Looking back over Stella's career one characteristic with regard to subject stands out: Stella thought in terms of major and minor statements of a theme that interested him. The pattern of that thinking was repeated over the years with paintings like *Battle of Lights, Brooklyn Bridge, New York Interpreted, The Birth of Venus, Purissima,* and *Holy Manger,* each summarizing on a large scale ideas with which he was concerned over a period of time both before and after the painting. Nevertheless, it is startling to discover that in the final period of his creative life he turned to a theme that had been gestating for almost forty years, with the plan of creating the *magnum opus* of his life.

Bernard Rabin remembers finding among Stella's papers an old postcard with a picture and a descriptive legend, "The Cathedral of the Underground." He recalls that the printed date on the card (now lost) was either 1905 or 1909, because at the time he commented on the early date when pointing it out to his partner, Nathan Krueger. In 1944, Mr. Rabin, home on furlough, had seen in Stella's studio a huge drawing which, the artist explained, was in preparation for a large canvas he planned to do "soon"; he called the work *The Underground Cathedral.* The drawing

was done on a roll of brown wrapping paper, about 40 inches high and perhaps 9 or 10 feet long. Executed in charcoal and possibly ink wash, the composition showed many figures arranged along the lower half of the field, seated as if in a church. The upper part of the field was black. The figure style was similar to that in the study discussed below.

Among the paintings stored in the warehouse is what I believe to be another, earlier, preparatory version of this subject. In this oil study the figures are arranged across the lower half of the canvas with only the upper portions of the bodies given, as if they were standing in a deep declivity. The forest background against which they are placed occupies the upper portion of the canvas; a strange figure in an opening at the center hangs from a tree, reminding us of the red dot in "The Port" section of *New York Interpreted* (Figure 75d) which Stella describes as "at the vertex of a pyramid of black cords — hanging like the ropes of a scaffold — the burning offer of human labor." A pencil and wash drawing of a group of figures (Figure 108) is probably a later sketch for *The Underground Cathedral*; as in that work the faces are all in profile and overlap, with merging contours, but here Stella includes his own likeness, an idea that I believe developed in the course of preparing for the final work, an allegory of the human condition, which was never executed.

Around 1940 Stella developed heart trouble. The last four years of his life tell a moving story of intermittent illness, ebbing vitality, terrible loneliness, and fear of death amounting to panic. Always superstitious, as Varèse remembered from the early days of their friendship, his morbid anxieties deepened, especially with regard to his health. According to Mosca, Stella "feared intensely his declining physical powers. And death or the thought of it would literally terrify him."

During periods of relatively good health he was, as he had always been, seemingly aggressive, confident of his own artistic power, and certain of his opinions which he handed down to listeners like pronouncements. His court was often the Waldorf Cafeteria on Eighth Street and Sixth Avenue (now Avenue of the Americas) — no longer there — where he discoursed to Milton Avery, Aristodemus Kaldis, Max Schnitzler, Vincent Spagna, the Soyers, Clara Fasano, Jean de Marco, and many other artists, on religion and politics occasionally, but most often on the stylistic particularities and relative greatness of Italian masters. "His eloquence on art . . . [was] truly poetic and his knowledge of painters of the Renaissance . . .

phenomenal. He loved to talk about Raphael, Pisanello, Piero della Francesca, Botticelli, Mantegna, . . . Giotto, Masaccio. . . . He had a special feeling about the major-minor masters such as Melozzo da Forlì, Antonella da Messina, Fra Angelico, Lippo Lippi. His love for Titian, Giorgione, Uccello, Donatello, Pollaiuolo, Bellini, was boundless. . . . Among the moderns he rated Cézanne the highest and Matisse was his especial love. He admired Gauguin but seldom talked about him. Also Rouault, Van Gogh, and Seurat." All judgments were final and closed to rebuttal.

In April 1942 illness forced Stella to give up his studio at 13 Charlton Street, where he had moved from East 14th Street, and he took an apartment adjacent to that of his sister-in-law and nephew in Astoria, Long Island.[11] A characteristic letter (one of many) to Mosca the following September reads:

> I cannot tell you how terribly I feel in being confined to the bed. . . . I cannot sleep: I feel at night horribly nervous, and I do not know why, a real terror. To be all day practically all alone — and not have any more the comfort of Art. . . . I wish I was there in Charlton Street, working very hard. I will die working all the time, although in minor style. I can still pay some homage to Beauty. . . . My nephew and my sister-in-law are like angels to me. . . . Without them I do not know what would have become of me. I expect your visit this coming Saturday with great anxiety. . . . I have a scheme about my studio — and I will reveal it to you when you will be here.

The scheme he mentions was to start a Stella workshop, having in mind something of Chase's teaching methods learned years ago at the start of his career. Half humoring him and half believing in the possibility of realizing the plan, Mosca, led by his great devotion to the older artist, helped him to draw up a list of what would be needed for the workshop, how much money would have to be invested, and other details. The tone of the list has something of the mixture of reality and fantasy found in children's projects. But Stella was fighting ferociously to hold on to his life as an artist, for no other life was possible for him. "I work every day," he wrote Mosca in December, still ill, "because only with work can we keep permanent the youth of our spirit."

In 1942 Stella's last version of the Brooklyn Bridge was shown at the

Artists for Victory exhibition at the Metropolitan Museum. He felt it as a great blow that his painting was not awarded the prize he believed it deserved. "Your words of praise about my picture at the Metropolitan did me a lot of good," he wrote Mosca in January 1943. "I was robbed — I do not deny it. It has been a terrible blow for me, this robbery — one shall not forget that after all that picture of the *Bridge* epitomizes all my efforts to celebrate the new civilization of America." But he had the courage to add, "Let us forget and try to paint all the time."

Finally he was well enough to leave the care of his sister-in-law. Once again he took a studio in the Village, this time at 104 West 16th Street. After about five months he suffered a thrombosis in his left eye and was obliged to return to Astoria, early in 1944. But later in the year, stubbornly refusing to give up, Stella rented another studio, on West 14th Street. Clara Fasano remembers that he moved in late in the evening and did not notice a church and funeral parlor directly across the street. When he looked out of his window the following morning and saw them, he panicked and telephoned Jean de Marco to come immediately. De Marco found him shaking with fear, insisting that he help him move from that place as soon as possible. (Either his fright abated or was not so great as it seemed, for he remained at the West 14th Street address for some time; a number of artist friends remember him there.)

Mosca's memories of Stella provide vivid descriptions and insights. He recalls with fond amusement Stella cleaning his studio, "which meant only that he would sweep the central section of the studio floor, never moving any furniture or paintings to clean behind or around them." He speaks with an artist's respect of Stella's understanding of paint and brushes. "He selected his color tints at the art supplier very carefully after a great deal of testing. His knowledge of color chemistry and permanence was exceptional and he always was careful about the laying on of pigment. . . . He was very concerned about the longevity of his works — if they showed any cracks in the paint he would volubly deny their existence, and then lose a night's sleep over them." Favorite memories are of Stella painting, intense and deeply absorbed, his materials around him, preparatory drawings at hand. Mosca remembers Stella's dislike of shaking hands, for fear of being contaminated by some skin disease, and his use of "a string or rope for a belt." *

* A life-long habit, for Varèse recalled this detail of Stella's dress from the early days.

Sometimes he would wear suspenders, but only when going to a formal reception or party. . . . He always . . . wore a muffler except for the two hot summer months. Jammed his beaten up fedora squarely on his head, ate prodigiously . . . never drank much liquor except wine or beer. His cane was his constant companion; he used it expertly both as a help in walking along and as a weapon. I can still see him now walking along slowly and suddenly stopping leaning both hands on his cane and going into a monologue on Degas. Or swinging it threateningly at someone who said something he became angry at. He was subject to sudden rages where he would roar so that he could be heard a couple of blocks away. And just as suddenly he would get sentimental, and croon like a mother over her child. One had always to choose his words when talking to him or else become the object of his sudden rage.

In 1945 Stella was selected as a judge for the third Portrait of America Show, sponsored by the Pepsi-Cola Company. While at a warehouse to look at some paintings, he stepped into an open elevator shaft and fell about twenty feet, breaking his arm and shoulder. Mosca recounts that in the hospital, despite his pain, Stella was able to joke. "Well, all my artist friends who begged me to vote for their paintings are still my friends. Imagine how many enemies I would have made if this hadn't happened." [12] He recovered from these injuries, but he did not return to the studio; he lived, until his death, in the Astoria apartment.

For a while he was well enough to be up and about, and Aristodemus Kaldis remembers Stella coming to one of his lectures on art in the spring of 1946 at the Penthouse Club on West 59th Street. Kaldis showed a slide of Mantegna's *Dead Christ* and Stella rose from his chair and cried out in great agitation that the figure was of himself. His fear of death lay always close to the surface of his mind in these last years, erupting easily into moments of uncontrollable fright.

At other times he tried to reconcile himself to dying, sensing that he had not long to live. The gentleness and resignation of a piece called "Thoughts" suggests that it may have been written toward the end of his life.

Today, the sky cloudy and infinitely soft, there is in my room a kind of murmuring, a whispering of words not quite clear that seem to be full of honey, the aromatic honey of the rose dawn of our life.

124

Everything is filmy, subdued, veiled: colors are softened like a fresco dulled with time.

The sound of words would strike us as a sacrilege. We recall the monk gesturing to silence over the gate of the convent of San Marco, the convent of Beato Angelico. And we close our eyes, absorbed, anxiously following this tenuous thread that leads into depths, into the recesses of our soul. Familiar, tremulous visions of dear ones stand out in relief against the remote blue distance of our childhood — they come closer, in a glow of feeble rays; they make a gesture of bene-diction, accompanied and sanctified by a ghostly smile. It is as if a perfume-laden breeze rocks with a gentle caress the cradle of our life, soothing it, drawing it into the abyss of oblivion where all misery is forgotten. (I,36)

Joseph Stella died of heart failure on November 5, 1946. The funeral mass at the church on Carmine Street in Greenwich Village was crowded with the artists who had made up his world, the world of the artist. "*You need to be in contact with people that fight and work* happens what may," he had underlined in a letter to Mosca during his illness in 1942. "In the great periods of art, the best artists were always in contact. To isolate oneself and be only with people that are not interested in art, like the majority of people, is the worst thing to do. Our artistic faculties need to be stimulated all the time. Association with exceptional people gives the best results. You have to understand that we do not work only when we handle the brushes. In talking sometimes about the work that we cherish, great ideas flash in our mind — ideas that can give birth to real works of art." Mosca rode in the cortege with Milton Avery and James Johnson Sweeney to Woodlawn Cemetery where Stella was buried.

For the last three years of his life Stella had been bedridden. Never-theless, he never stopped working, and every day he made three or four silverpoint and colored pencil drawings of flowers and fruits. To the very end of his life he was faithful to the motto he had chosen: *Nulla dies sine linea.*

Oh that this enchantment might endure
forever! That this enchantment might be like
a silent passage through which our life fades
away, to sink into the immensity of immortality.
— Thoughts (I,36)

XII

Conclusion

My threefold concern in this book has been to analyze Stella's painting
style, his personality, and his relation to the movements and tendencies of
his time. A survey of the assembled material leads to a number of con-
clusions that reveal the essential nature of this artist and his art. Stylisti-
cally, Stella shifted from naturalistic representation to abstraction and
then back to representation, this time shaped by a primitivizing taste. His
early style, in oil painting, is characterized by a dark palette, with the
centralized principal subject — either figure or landscape motif — brought
out by a golden or silvery light. *Tarda Senectus* and *The Italian Church*
are representative. A large proportion of the work of these years was exe-
cuted in pencil and charcoal, in a variety of formal treatments that ranged
from the naturalistic figures of *The Stokers* (Figure 20) to the near-
abstract dark shapes silhouetted against the light, as seen in *Before the
Furnace Door* (Figure 18), and which also included landscape.

Stella's position with regard to abstract art was moderate. Only rarely
did he abandon all reference to the object as he did in the Nebraska *Battle
of Lights* (Figure 37). His first abstract style depended on the particolored
shapes, varied in size, that he laid on the canvas like pieces of appliqué in
quilting designs (Figure 30). The shift to this style was accompanied by a

bright palette which appears to be one of its consistent characteristics. As representational elements regained importance, the small chips of color tended to disappear and the abstract quality of the paintings was derived mainly from the arbitrary arrangement and reduction of forms of recognizable motifs, as in *New York Interpreted*. This later type of abstraction was accompanied by another shift of tonality, a return to a predominantly dark palette, although exceptions are readily noted in the two bright "White Way" canvases of the New York painting. While in both kinds of abstractions the design elements are distributed over the field so that there is little distinction made between figure and ground area, the distinction is clearer in the later ones. The later also contain the more strongly emphasized vertical axis and the symmetrical design that remains as a dominant characteristic when Stella returns to representation. Stella's subject matter in both abstract styles is scenic, typified in the earlier manner by the *Battle of Lights* group, in the second by the bridge and factory paintings. There are no abstract still-lifes, and the individual human figure as a principal motif, so important in the first period of his career, disappears completely. Most of the abstract work seems to have been executed in color media. Except for a few drawings related to the *Bridge* or *New York Interpreted*, I have seen no work in either of Stella's abstract manners done in pencil or charcoal. While the forms in the industrial drawings published in *The Survey* of 1924 are severely reduced, they are still representational, and belong more to the artist's postabstract development.

With his return to representational painting, Stella's preference for the vertical axis and symmetrical composition becomes even more pronounced as a result of the greater distinction between figure and ground made in representational painting. Large, generalized figures are sharply delineated against a flattened screen which may be highly simplified as in *The Vision* or decorated as in *The Virgin* (Figure 81), but which usually combines both solid and decorated areas, the former in the upper section, the latter below, as in *The Birth of Venus* (Figure 79). A horizon line or some other horizontal is frequently chosen as a device to flatten the composition. The shapes continue to be elongated and enclosed within hard-edged curvilinear or rectilinear contours that tend to narrow and come to a point, but the new figure-ground relationship increases the effect of the hard-edged shapes, creating a more static image. A more uniform application of color and the elimination of *sfumato* also contribute importantly to

the heightened formality of this style in which the dignified sadness of the early Rembrandtesque paintings or the operatic drama of *Brooklyn Bridge* gives way to the hieratic tension of *The Little Lake* (Figure 87).

Stella's greater artistic gift was his draftsmanship rather than his sensitivity to color. Some of the early pencil, crayon, and charcoal studies of Pittsburgh, of the steelworkers and coal miners, of immigrants, and of cripples may be counted among the master drawings of American art. Even in his paintings the greatest satisfaction is derived from the precision and inventiveness of the shapes created by his line. Nevertheless, as shown in many exquisite flower and still-life pastels and crayons, he could be a sensitive and interesting colorist. It is strange that his color in oil paintings was less satisfying, and one may believe that the sometimes garish brightness was in fact due to Stella's conviction, stated to Mosca, that the paintings would fade, as the old masters had faded, and that by the time the world was ready to understand his true worth as an artist, the color would have reached the softer tones that represented the real image he intended. His art, he felt, was in partnership with time.[1]

Those who knew Joseph Stella invariably remarked on his dual personality. He was gentle and aggressive, friendly and hostile, refined and vulgar. He was stingy, habitually carried very little money and that in a wallet inside another wallet tied with a string, and suspicious that people wanted to cheat him. Occasionally, according to Mosca, "He seemed to want to act generously." He was eloquent, lyrical, but also coarse, physically bulky, yet graceful in his movements. He was bellicose, but all agree that he had a "persecution complex" — a term, along with "mercurial," used repeatedly by those interviewed. Although contrasting traits exist in everyone, in Stella they were more evident than in most. Despite the difficulty in coping with his unpredictable behavior, he was able to inspire deep friendship, his company was sought, and his opinions on art respected.

Writings of and about Stella permit some insight into the unresolved conflicts that produced his divided personality. Stella consistently expresses anxiety about his artistic powers, relief as his self-confidence is intermittently renewed, and a sense of imprisonment, nostalgia for his homeland, and a desire for spiritual liberation. The imagery consciously and unconsciously indicates feelings of fear and timidity, as well as of aggressiveness and struggle, and produces an impression of sexual preoccupation that he was unwilling to recognize.

Conclusion

Stella's painting is more developed artistically than his writing yet some characteristics are common to both; the overelaboration of his written imagery is sometimes a fault in his painting as well; both tend to be florid; the repetition of images and ideas in his writing has its counterpart in the repeated use of certain motifs, shapes, and compositional devices in the paintings. Since these similarities exist in both forms of expression, despite their difference on the technical level, I am led to believe that the paintings reflect the same sexual imagery, anxiety, confidence, timidity, violence and aggressiveness, oppressiveness, and happy relief found in his writings.

Stella's greatest works are those created in an atmosphere that heightened his tensions. Dr. Edward Gendel, a psychiatrist who has been particularly interested in the emotional problems of artists, points out that, while increased tension may contribute to greater expressive power, Stella's unresolved conflicts could well account for the obsessive repetition of forms, and produce images in which contrasting attitudes were represented.[2] *New York Interpreted* is a celebration of and homage to the power of a great city and a response to its symbolic meaning. For Stella, New York was the highest embodiment of man's achievement and promise. But there is also in this painting an expression of his feeling of being imprisoned in an alien world, which he verbalizes in the pieces about New York and in a number of others dealing with the city as a generality. *Battle of Lights, Coney Island* (Figure 30) expresses on its surface the gaiety and festivity of the amusement park. Beneath that surface, however, is the sense of struggle and the anxiety awakened in Stella by crowds of people. He wrote of this painting:

> I felt that I should paint this subject upon a big wall, but I had to be satisfied with the hugest canvas that I could find. Making an appeal to my most ambitious aims — the artist in order to obtain his best results has to exasperate and push to the utmost his faculties — I built the most intense arabesque that I could imagine in order to convey in an hectic mood the surging crowd and the revolving machines generating for the first time not anguish and pain but violent, dangerous pleasures. I used the intact purity of the vermilion to accentuate the carnal frenzy of the new bacchanal and all the acidity of the lemon yellow for the dazzling lights storming all around.[3]

Many painters have wanted to cover walls with their paintings and have

painted enormous canvases. But remembering Stella's hatred of feeling closed-in and observing how densely packed this large painting of Coney Island is, noting how he associated violent and dangerous pleasures with hectic, bacchic, carnal frenzy, one feels that *Battle of Lights* imparts not only the chaos and confusion of the park but reveals the artist's inner anxieties as well. If I am correct in seeing as Stella's self-portrait the masked image at the lower right (Figure 30a), pushed to the side and almost lost as it merges with the similar fragments of color around it, this interpretation adds significance to the word "Battle" in the painting's title.

In assessing the effect on Stella's art of the various physical environments in which he lived and worked, and the influences with which he was in contact, it appears that Italy and Italian artists were of prime although by no means exclusive importance. The earliest influences were the seventeenth-century Neapolitan Baroque paintings to which he had been exposed during his youth, together with the "Neapolitan School" of the nineteenth century, and the Italianized form of the international Rembrandt-Hals-Velásquez taste of the end of the century. The influence of Rembrandt then became dominant through his contact with the paintings in the Metropolitan Museum. The second decade of his career is marked by French influence, modified by Italian Futurism. In the 1920's and 1930's Stella's art reflects the general preference for larger, more monumental forms and static compositions, as well as a reassertion of the object, that characterizes the principal movements in Italy, France, Germany, and the United States, showing the closest affinity to that of Italy.

Stella was not touched by the regionalism of the American Scene painters in the thirties, nor can the eerie effects in some of his tropical paintings be attributed to an interest in Surrealism which gathered increasing strength in those years. This quality appears in his work as early as 1922, with *Tropical Sonata*, and probably even earlier in some flower studies. But Stella's surrealist tendencies had no programmatic base; neither the automatism that produced the odd juxtaposition of objects nor the conscious application of Freudian concepts had any place in his work. And he remained aloof from the abstract movement that began to revive in the United States in the late thirties and early forties. According to Moses Soyer, who knew him well at this time,[4] Stella felt that abstract art was debased by the younger American artist. He admired Picasso and Marcel

Duchamp, but considered that Gorky did not understand the principles of abstraction, although he conceded that he was a talented painter, as was Jackson Pollock who, unfortunately, "had gotten on the wrong track." When August Mosca asked why he had abandoned the Cubist-Futurist style, Stella replied that he found the old masters more nourishing, that abstraction was a limitation when practiced as a style. Abstraction was properly a function, he held, and that function was to support the painting, not to substitute for it. He had learned abstraction, he told Soyer, from Michelangelo's *Last Judgment* and Tintoretto's San Rocco paintings.

By the late thirties Stella's interest in the old masters was no longer predominantly directed to the Florentine *trecento*. Mosca and others remember him speaking more often about the Venetians, who had attracted him so strongly in 1909–10. The 1936 *Cathedral of the Underground* displays a more coloristic effect and a slight slackening of severity, as compared to the paintings of the earlier thirties, that can be attributed to this shift of interest. The change, however, was not great. Stella owned a large collection of reproductions of masterpieces, and his studio was a gallery of everchanging exhibitions in which Giotto and Masaccio continued to be featured along with Giovanni Bellini, Titian, Tintoretto, and Veronese. Almost always on view was Giorgione's *The Concert*.

Although born in Italy and deeply indebted to Italy and Italian art, Stella is known as an American Artist. Beyond the fact of his citizenship, how and to what degree is this description justified? Such a question requires a definition of American art, and, although the subject resists the limitations of a single definition, a number of writers have found characteristics that do appear with a significant degree of consistency throughout the history of our art. Among those who have dealt with the question, Lloyd Goodrich emphasizes "dynamism," "freshness," and "power" as dominant traits, at the same time cautioning against an oversimplified view of the American artistic temperament.[5] John Baur, while pointing out the insufficiency of generalizations, observes the unanimity of judgment that has prevailed for one hundred and fifty years: "the commonest attempts to isolate the American quality in our art have centered on such adjectives as simple, naive, vigorous, matter of fact, ingenious, realistic, independent and the like."[6] Both writers note that romanticism has a continuing tradition from Washington Allston through Quidor, Ryder, and into contemporary art.

Conclusion

Acknowledging the diversity of traits in American art, scholars in general agree that it has a flavor that is recognizable, though tantalizingly elusive when we try to describe it.

One part of that flavor reflects the peculiar circumstance that our population has been composed of immigrants — people who had the initiative to leave an unfavorable social situation in the belief that they could create, or find, a favorable one. In such men and women there seems to be a combination of practicality and romanticism that has been manifested in many aspects of American society in which the vulgar and refined, the prosaic and poetic maintain a shifting but working relationship. In American art, these traits have been reflected in the preference of painters and their patrons for careful observation (of Americans and the American scene, most often) modified by a taste for expressive effects and symbolic content.

The combination of observation and aspiration, literalness and interpretation, brashness and delicacy, that seems so typically American is one of the most characteristic qualities in Stella's art, producing such semiabstractions as *Battle of Lights, Coney Island* (Figure 30) and *New York Interpreted* and the kinds of subjective interpretations seen in *The Amazon, Factories*, and *Song of Barbados* (Figures 82, 71, 103). On the other hand, Stella despised the commonplace, unlike many American artists who have seen in everyday life the virtues of the unheroic, the poetry of the prosaic. The middle-class atmosphere is totally absent in Stella's painting, just as the mixture of Mediterranean mythology and Catholicism in his art is absent from American painting. Looking at *Tree of My Life, The Birth of Venus*, and *The Virgin* (Figures 59, 79, 81), we feel an Italian atmosphere. Stella's color sense seems to belong to his Italian background; his taste for bright colors used in an elaborately ornamental manner recalls the gay decorations of folk festivals in southern Italy.

There is more to put into the balance. Stella's most significant work was inspired by his response to American subject matter and life. The early drawings of the Pittsburgh scene, the paintings of the industrial milieu, and those of New York were executed in the United States. Furthermore, he contributed importantly in helping American art make the leap into the front ranks of the modern movement. For these reasons, and despite his stylistic affinities with Italian art, Stella may justly be claimed as an American artist. Because he was the only significant Futurist of the

United States; because no exhibition surveying American art can be complete without including one of his Futurist-related paintings; because in range of style and expressive power he was among the best of his American contemporaries, Joseph Stella must be accounted a major American artist: with his unique cultural and personal characteristics he not only enriched the American heritage but made a significant and lasting contribution to the twentieth century.

APPENDIX I

*Texts of Writings by Stella**

1 Autobiografia: Muro Lucano (Autobiography: Muro Lucano)
 One sheet, 11 x 8½, faded gray; handwritten in black ink, recto and verso.

Ringrazio il Signore per avere avuto la fortuna di nascere in un paese
montano. La luce e lo spazio sono i due elementi essenziali della pittura,
e la mia arte trepidando ha spiccato i primi voli nello spazio libero, investita
dalla luce più radiosa. Il mio paese natìo, Muro Lucano, nell'aspra Basi-
licata, incunea le sue radici testarde nelle viscere tormentate di una rocciosa
collina. Le sue solide case sono costrutte dalla pietra viva e dalle selci. E,
tratte dalle rocce scaglionate all'intorno, s'elevano a forma di anfiteatro
addossate le une sulle altre in atteggiamento di scolte raccolte e pronte per
un attacco come ubbidienti al ciglio severo protette in alto e vigile dalle
torri merlate del castello medioevale che racchiude nelle sue fosche e cupe
mura il mistero dell'orrendo delitto della Regina Giovanna. Al suo fianco
la Chiesa madre eleva il suo corto e tozzo campanile, ed il rimbombo della
sua campana che suona inondando lo spazio di fragore gioiosa a Pasqua,
sgrana, segna il rosario delle ore del paesello, martellando con accordi
speciali gli avvenimenti lieti e tristi delle vicende della vita, tintinnando, squil-

* The quotations in the text and chapter epigraphs are excerpted from these writ-
ings. Nos. 13, 14, and 59, although not manuscripts, are included because they are direct
statements of the artist in a language other than English which are translated in the
text.

lando, accendendo lo spazio di faville nunziatrici di lieti sponsali alla vigilia di feste grandiose o accompagnando di lamenti, di sospiri ampi straziati, le salmodie intonate per le vie alla morte che passa. Un'immensa vallata le si stende ai piedi, perdendosi all'infinito nelle lontananze più vaghe ed azzurrine.

2 La casa paterna (My Birthplace)
One sheet, 10½ x 7¼, faded gray; handwritten in black ink, recto and verso.

Appena in cospetto del paesaggio natìo, come tenui i fili che ci avvincevano alla vita d'esilio durata per anni. Più tenui dei voli di nebbia si dileguano al vento e balza, d'improvviso, intatto, netto e preciso il paese natìo, inciso dallo memoria precisa. È incisione netta, dalla forma piena integra sonora, senza volume alcuno, il suo profilo a punte aguzze intagliate sull'azzurro immacolato dell'Alba della nostra vita. E con il volo agilissimo del gridio delle rondini salutanti la luminosità del mattino, siamo attorniati, presi, avviluppati, circondati, dalle carezze calde e suadenti delle memorie delle visioni prime che levarono e tennero sospeso nelle altitudini celesti il nostro animo incantato, come la stretta spasimante, delirante di gioia di mia madre che d'un balzo ritrova il figlio suo smarrito e lo stringe violentemente al seno quasi per conficcarselo nel cuore, per non perderlo mai più. Tutta la natura all'intorno sorride amica, saluta festosamente il ritorno, e pare che sia pavesata, fiorita, per l'occasione come i davanzali delle finestre di maggio, alla festa del Corpus Domini.

Il paese natìo s'eleva ad anfiteatro su di una roccia aspra — e da questa pare che sia sgorgata nelle striature delle sue case scolpite nel masso roccioso, striature trasversali e diagonali che con i segni della tormentosa fecondità segano, tagliano, dividendoli gli abituri aggruppati [unfinished].

3 Nostalgia: L'esule (Nostalgia: The Exiled)
One sheet, 11 x 8½, faded ivory; handwritten in blue ink, recto and verso.

Ogni cima di monte è come un viso familiare che s'affaccia sul balcone della nostra anima. Tutto all'intorno ci sorride dell'assicurante sorriso della Divina Amicizia. I muri della casa che ci hanno visto crescere ci cingono come le braccia materne che ci serrano protettrici, ed in ogni angolo di esse dorme un ricordo che si sveglia e sorge dinanzi a noi come persona amica sbalzata all'improvviso all'apertura della cortina del passato. Alle gronde dei tetti, con i nidi cinguettanti delle rondini, noi ritroviamo allacciata intatta, pura, di un verde primaverile incontaminato, tutta la nostra età prima, e come dai nidi al mattino le rondini scattano per rigare di ilari giri tortuosi l'aere rorido, le nostre sensazioni prime sciamano fuori al sole, appaiono iridescenti intessute di sogni ed attorniano il nostro animo con

clamore infantile spumeggiante di gioia, come onde verdi frementi coronanti lo scoglio scuro della nostra età matura. Noi ritroviamo il vero asilo, la vera pace augusta dei nostri lari. La voce dei grandi classici latini risuona chiara e ferma fugando tutti i dubbi, le ansietà dateci dal nostro pellegrinare nel mondo. La nostra compagine fisica pare che d'un tratto si sia riaffermata, irrobustita, come per magia. La nostra prima sicurezza, ritrovata per miracolo, ci da la coscienza piena della nostra forza, del nostro potere, della nostra audacia di tutto tentare, di usare appieno tutti i tesori che potrà elargirci la nostra volontà determinata — [e rinsaldata sull'incudine salda e lucente come adamante della casa paterna]. Ci ergiamo, al mattino, al cospetto dell'immensa vastità dell'orizzonte che ci sovrasta, come benedizione, [lo sguardo teso come ad una promessa] all'azzurro luminoso in cui si sprofonda tutta la lussureggiante ubertosità della vallata, e la piena massiva austerità dei monti che ci attorniano, azzurra lontananza verso cui corre per perdersi la musicalità argentina delle campane delle chiese tintinnanti osannanti all'alba (o spirito divino di San Francesco, apparenti le braccia immense tese sullo zenit) ed abbiamo d'un tratto la sensazione che i nostri piedi affondino nelle viscere del suolo materno. Questo ci reclama e ci ripossiede con gelosia materna e noi ci lasciamo serrare dalle sue spire calde, con ebbrezza, come quando piccini ci addormentavamo sul seno materno per sognare di tutti i sogni intessuti di rubini e di celeste, intessuti intorno a noi come ghirlande di verde, con cherubini rosei danzanti all'intorno.

4 La casa paterna, II (My Native Village)
Three sheets, 7⅞ x 5⅝, lined notebook paper, yellow; handwritten in black ink, three recto, two verso; second sheet badly torn.

La mia casa paterna è posta in alto, nel mezzo delle rupi, su cui s'erge il paese. La camera in cui dormo s'apre su di una terrazza ampia, che, campata in aria, mi dà la sensazione di un pallone inamovibile, da cui sospesa nell'aria, ho la vista infinita vertiginosa di un'immensa valle che si sprofonda all'infinito, per montare nella cerulea lontananza in un addentato di groppe di monti — monti che con le loro moli cerulee tengono sospeso incantato lo spirito d'avventura. Quando io m'abbandono a questa terrazza, mi pare di prendere un bagno salutare, un lavacro d'acqua santa, di battesimo nuovo verginale. Ogni senso di stanchezza sparisce per incanto — ed io riprendo lena, forza, energia novella per nuovi lavori. Una catena maestosa di monti s'allunga dirimpetto ed infinito è il mio compiacimento; io mi attardo, come per carezzare con l'occhio acuto e vigile tutte le ondulazioni varie dei loro profili sul cielo. La mia casa, sospesa in aria si riempie, s'anima, come un istrumento musicale, di tutte le vibrazioni, di tutti i rumori grandi e piccoli che s'avvincendano, che punteggiano i lunghi

periodi di pace del piccolo paese. Ed ogni piccolo rumore, remotamente conosciuto, conosciuto dall'infanzia prima, che dormono e riposano in tutti i ripostigli della casa. Io sento intorno la presenza affettuosa dei parenti lontani, spariti; la mia anima ha la sensazione come se cinta d'una collana soffice e morbida, come d'una blanda suaditrice carezza. È forse il ritorno dell'affettuoso fiato materno che proteggeva e custodiva la nostra infanzia? Tutte le immagini candide che corsero lungo l'orizzonte lontano della nostra anima appena schiusa, come promesse ridenti di letizie a venire, ritornano e svariano nel cielo dalla nostra anima divenuta d'incanto pura come il terso cielo che vi si schiude in alto. E come le macchie azzurre dell'orizzonte velato, per i suoni vari che improvvisi sorgono all'intorno, appaiono episodi, frammenti della vita prima vissuta tanto remotamente. Il suono metallico suona alterno dello zoccolo ferrato dell'asinello sul selciato, e ci si vede svelti ed ilari. . . . con la gioia di rondinelle, per i prati verdeggianti a primavera, per i filari delle viti colme dell'uva matura. Le stagioni si avvicendano, si amalgamano e si. . . . Lunghe file di asinelli carichi di frutte e d'uva si dilungano innanzi ai nostri sguardi, campeggianti bruni su immensi cieli sfolgoranti d'oro nei tramonti gloriosi del primo autunno, e tintinnano, garriscono come saluti ai rosei chiarori mattutini. . . .

Gli asini ed i muli passano per la strada ripida, a scalini che discende lungo la casa. Il suono acuto e metallico degli zoccoli ferrati che stridono sulle pietre dure e levigate del selciato (pare che mandino scintille musicali) pare che sia come una musica primitiva, derivata da strumenti che s'indovinano fatti di pietra dura, risonante in cave di monti. Dalla lontananza della campagna che s'allunga infinita, giungono voci di giovani paesani. La lontananza verde e cristallina spoglia d'ogni asprezza le voci e ne tramanda soltanto la trama irreale sottilissima d'argento del suono.

4a Il nuovo conato in arte (The New Effort in Art)
Two sheets, 7⅞ x 5⅝, lined notebook paper, yellow; handwritten in black ink. The first page is the verso of the third sheet of no. 4.

Il nuovo conato in arte, lampeggia e appare d'un tratto, come alla svolta d'un sentiero di montagna, improvviso, intento, ma per realizzarsi, maturarsi ed essere spiccato dall'albero ha bisogno di tempo. Esso albeggia, come promessa mattutina in cima all'albero delle nostre promesse—e la nostra anima d'un tratto s'alza improvvisa [spicca il volo subitaneo all'alba del volo dell'uccello che esce dal nido nell'ardente desiderio del possesso]. Ma bisogna avere pazienza. . . .

In silenzio, nell'ombra, acquista ogni giorno più forza e forma—ed un bel mattino, in cui nel cielo della nostra anima svaria calma la nostra forza pronta al cimento dell'opera, il fiore divenuto frutto sboccia e sgorga fuori all'aperto, luminoso, a nostra grande sorpresa di gioia.

5 Casa paterna, III (Homeland)
One sheet, 11 x 8½, faded gray; handwritten in black ink, recto and verso.

I monti sono una perenne fonte di sentimenti profondi d'idee eccelse. Su i loro inamovibili profili, disegnati con fermezza e precisione, tagliante dalla possanza di una deità discesa dal cielo a miracolo — l'agilità aerea delle nubi corre ininstancabile come a carezzarli, a tenerli, rinnovantesi raffigurazione di sogno e chimere, sull'immenso telaio azzurro del cielo.

E da essi viene a noi come un rivolo, discende da essi, il gregge argenteo delle mandre che rallegrarono la nostra infanzia, tenendola giuliva, come dinanzi una processione di fate, apportatrice di tutti i sentori della madre terra, di tutti profumi silvestri. L'anima s'irraggiò a tutte le bianche luci.

6 L'arte (Awareness of Art)
One sheet, 11 x 8½, faded gray; handwritten in black ink, recto and verso.

Io ricordo l'irrompere dell'arte nella mia acerba puerizia. Fu come lo schiudersi repentino di una luce, fragore come cascata celeste — e la mia povera anima invasa da essa tremò come uno di quei teneri virgulti all'impeto dell'esplosione d'oro di un tramonto autunnale in cima ad uno dei miei monti. La mia anima sussultò di gioia, come all'inaspettata scoperta di un vero tesoro, il tesoro dell'Amica Divina consolatrice che sempre avrei amato e che sempre m'avrebbe arriso, che avrebbe sempre cosparso di rosa il cammino della mia vita. E traboccante come vaso colmo io godetti della segreta delizia di chi sa che per lui solo esiste una fonte perenne di gaudio celeste, di colui che tiene nascosta per il sommo godimento dei suoi sensi un'amante insperata, ignorata da tutti. Il segreto del godimento quale possessione cui si resta avvinti con gelosa tenacia.

7 La mia autobiografia in italiano (My Autobiography in Italian)
Three sheets, 5¾ x 4, tan; handwritten in black ink, recto and verso.

SINOSSI

Fortuna di essere nato nel paese.

Primi anni di scuola.

Pubertà acerba, incosciente.

Risveglio d'arte.

L'amore per l'ordine della geometria;
 odio per l'ambiente chiuso, il collegio;
 amore per la vita solitaria, dei campi, sui monti, sulle colline,
 al vento, al sole, nei torridi meriggi d'estate, alla voce
 eclatante [sic] delle cicale.

Arte e primo amore.

Le prime visioni — l'acerbo bisogno di sfogare.

Il. . . .

Il profilo di San Francesco.

Le visioni mistiche nate e realizzate nel granaio.

La sera tutti i lumi accesi ogni giovedì — al passaggio del Cristo in cielo — Fare luce al Suo passaggio — I fuochi crepitanti alla vigilia d'ogni festa — Il suono di tamburo all'alba, appena aperti gli occhi — Le processioni — Blu, bianco niveo, il rosso fiammante — Gli alti stendardi spiegati dinanzi al sagrato. La visione di Bella, il giorno di festa, macchie di vermiglione e nero intenso, un campo di strani papaveri. I ricordi dell'Egitto e della Grecia nelle nicchie, nelle gonne discendenti a pieghe diritte, ieratiche, arcaiche. Il passaggio delle bare aperte — La morte sorridente delle vergini coronate di fiori simili alle immagini viste ed adorate nelle cattedrali. La festa di Natale, il suono delle campanelle — Le immagini ingenue con la creta tratta dalle balze montane insieme con il musco.

8 Puerizia acerba di voluttà (Budding Passion)
One sheet, 11 x 8½, gray; handwritten in black ink, recto and verso.

Dall'albero della mia vita fiorita fragrante di fiori e canora d'augelli candidi intonanti il salmo di gaudio spirituale, d'un tratto spuntarono inattesi, puntiti e mordenti di spini, le prime frutte rosse di sensualità acri, acerbe, amare, ma cariche di profumo, silvestre, delizioso. All'azzurro ed al giallo tenero di tutte le delizie altamente spirituali, esse innestarono con violenza, d'un rosso carico, denso, sanguinante, e tutto il mio essere fu investito come da una raffica, fremette a lungo, s'agitò, si torse come fusto tenero a marzo, alla violenza all'impeto della sorpresa d'una volata nuova di temporale. Molti fiori caddero. . . .

Il desiderio balzò imperioso, d'una esigenza che diveniva di giorno più acuminata e tagliente. Esso reclamò l'esigenza pronta subitanea di tutti suoi bisogni. E d'un tratto la conquista della preda, per la spinta della fame e della sete, divenne l'oggetto odierno della mia vita. E nel tormento dell'affanno della corsa muta ed ostinata, alla ricerca della femmina, una sosta muta avveniva in cui tutto il mio essere si coloriva violentemente di rosso. E nelle notti insonne, come esca, come fuoco eternamente acceso mi ardeva dinanzi la visione di poppe di vergini, sodi come globi lucenti di cristallo, dalle punte erte, rosse, tentatrici mi s'allineavano dinanzi, su per un tavolo di marmo, ed io con l'immaginazione eccitata, maneggiandole segnando con le dita frementi il modellato pieno e vellutato delle loro sagome, affilavo in segreto un coltello, il coltello del mio desiderio violento che le tagliavo ed aprivo come frutte misteriose ed ciò facendone provavo una voluttà spasmodica di sgravio e liberazione.

9 La casa paterna, IV (My Birthplace)
Two sheets, 11 x 8½, gray; handwritten in black ink, recto and verso.

Con ansia sempre crescente durante un lungo periodo d'esilio, ho aspettato questo ritorno al paese natìo. La mia attesa negli ultimi tempi addirittura dilaniava il mio animo [tormentato] dalle torture delle pene continue di un soggiorno forzato fra gente nemica, in nera regione funerea, su cui pesava, come punizione suprema, la maledizione d'un clima crudele. Quale sussulto di gioia proruppe alfine! E come il mio animo scattò in alto nella luce radiosa di questo gaudio supremo. Come urna riboccante di miele, il mio cuore s'empì d'un tratto di bontà. Tutto dinanzi ai miei occhi estatici s'asperse di rosa. Visioni [sorridenti?] si levarono con il candore di nubi fulgenti di riso e tutto un coro festante di voci, affinchè, di suono familiari, intonò il peana del mio ritorno ai patri lari, e tutto il verde di speranza ridente, tutte le lusinghe d'oro e di porpora che mi balenarono dinanzi nel panorama d'incanti disigillatomi dalla magia della vigilia di questa festa, tennero incantato il mio animo sospeso. Mi sentivo, intanto, così umile: vera umiltà francescana vestiva il mio animo. Mi pareva per la prima volta, sgravato d'ogni gravame inutile d'ambizione e di preoccupazioni alla madre terra, di sentire per la prima volta il respiro, il pulsare, di questa come bimbo in cui si sveglia la consapevolezza della propria madre, tutta la grazia del divino poverello d'Assisi, fluì, si versò, con tutti i suoi aromi silvestri, nel profondo del mio cuore e dette vita a tutti tesori di bontà unica, dormenti, sopiti negli angoli più riposti, più ignoti della nostra anima.

10 Lettera a Carlo Carrà (Letter to Carlo Carrà)
Three sheets (first, 9¾ x 7¾, second and third, 8 x 10¾), gray; handwritten in black ink, recto and verso.

Ci siamo conosciuti nella Galleria Bernheim, a Parigi, alla prima esposizione futurista — e forse lei non si ricorderà di me, perchè non ci siamo più visti.

Malgrado lontano, qui, a New York (dove risiedo da anni), ho sempre seguito con interesse e viva simpatia il suo lavoro alacre di artista novatore ed ho sempre sperato, per l'amore che porto alla mia patria d'origine, in una mostra a New York delle audacie e delle conquiste ultime in Arte compiute da lei e dai suoi compagni a gloria d'Italia.

È da anni che l'America conosce ed apprezza l'opera degli artisti più ardimentosi di Francia e di Spagna, ma, malgrado la parola futurismo sia quì, come altrove, di dominio pubblico, essa ignora o meglio ha conoscenza imperfetta dell'opera loro. V'è stata, due anni fa, un' esposizione di Severini, ma questa a parte i meriti, non può essere, come lei ben sa, rappresentativa appieno dell'arte moderna italiana. Con gioia quindi ho accettato l'incarico datomi dalla "Società Anonima" d'invitare lei e tutti gli artisti che crederà

opportuni a tenere una mostra, ai principi dell'anno venturo, nelle sale di detta Società. La "Società Anonima" è sorta ad iniziativa di Miss K. Dreier, pittrice e scrittrice, e facoltosa, con lo scopo precipuo d'aiutare ed incoraggiare qualunque manifestazione genuina d'arte moderna (tutte le audacie accette) senza tener conto di nazionalità o di pregiudizi di scuole. Va senza dire che sono scartate a priori tutte le pseudo-novità e tutte le marachelle secessioniste. Detta Società non percepisce alcunche sulla vendita dei lavori, ma pone il compratore in comunicazione diretta con l'artista — e ciò per debellare il sozzo strozzinaggio dei mercatanti. Per l'artista lontano, come nel caso suo, essa appresta i fondi necessarî per l'invio dei quadri e per l'assicurazione.

Le invio intanto dei manifesti e delle fotografie illustranti la prima mostra.

In Autunno vi sarà un'esposizione Archipenko, seguita da quella dei Dadaisti.

Sono sicuro che avrò una pronta risposta.

Augurandole un mondo di bene,

cordialmente
Giuseppe Stella

P.S. La prego di scrivere dietro ogni quadro il prezzo.

Amerei che per l'occasione scrivesse.

11 Lettera a Alfredo Schettini a proposito di Antonio Mancini (Letter to Alfredo Schettini about Antonio Mancini)
Four sheets, 8⅜ x 6¾, lined notebook paper, yellowing; handwritten in blue ink, recto and verso.

Caro Schettini,

Eccomi a te con le mie note su Mancini, tirate così alla buona.

Ho conosciuto Mancini a Roma nel 1910, quando egli aveva lo studio a Via Margutta. A New York, avevo inteso un certo Olivotti ebreo fiorentino sedicente pseudo commerciante d'arte dipingere Mancini a neri colori: capriccioso vivente per pose e per follia, dipingente in ambiente fetido fra luridi stracci policromi. Anche che teneva lo studio chiuso ai visitatori ed aveva posto fuori, con piccola grazia, Lady Curzon, la moglie dell'inglese Viceré dell'India raccomandata dal pittore Sargent allora protettore di Mancini. L'idea di carpire al maestro in voga un quadro per venderlo ad un carissimo prezzo era fallita. È questa la ragione precisa del vilipendio emanato dal sozzo ebreo. Io ho conosciuto Mancini di sera alla modesta trattoria Volpacci a [in] Via delle Vite.

Ero a desinare con pochi amici artisti, quando apparve inaspettato un ometto rotondo, dall'aspetto roseo e sorridente. Caro il nostro Don Antonio, fu il grido unanime di tutti ed il famigerato artista con l'aria più naturale di questo mondo, umile come il più modesto degli operai, si sedette fra di

noi ed ordinato le sue pietanze favorite, intavolò conversazione con noi tutti indistintamente, come un camerata di lunga data.

La nostra conoscenza sorse spontanea, senza presentazione di sorta, e l'artista e l'uomo si rivelarono di botto, destando in me la più viva simpatia e la più grata sorpresa. Sorpresa perchè di tutto quello che io avevo letto ed inteso, non riscontravo dato alcuno nell'artista che mi sedeva accanto.

Il suo inestinguibile sorriso, che spesso s'apriva in vero scrosciante riso, attestava un formidabile grazioso temperamento. Avendo raggiunto più che confortevole agiatezza, era pulitamente vestito, da innato signore, senza pretenzione alcuna di eleganza.

L'Artista

Io ebbi la ventura di vederlo spesso per uno o due anni di mia residenza, sia nel suo studio a Roma, sia quasi assiduamente di sera, in detta trattoria e posso dire d'avere gradito la sua intimità. Egli era un pittore nato, d'istinto. Mancava completamente d'ogni cultura in fatto di storia d'arte; ignorava completamente perchè i suoi giudizi che zampillavano, detti nel puro gergo napoletano riguardo qualunque opera che l'avesse colpito, sia moderna che antica, erano interessanti, perchè spontanei ed originali.

"L'arte greca è na [una] gran macchia janca [bianca] su un cielo veramente chiuso è sole senza una maronna [madonna] e nuvole. Perchè avete sapè [dovete sapere] una cosa; i greci non conoscevano i pidocchi — erano tutti signurini [signorini] — mangiavano e vestivano bene. Che c---- ha da combinà' [combinare] un povero Dio d'oggigiorno con li pirucchi [pidocchi] da [con la] miseria che lo magnano [mangiano] vivo?"

Aveva un orrore della pittura tirata a sciaboloni dallo stile colante, come la definiva il baggiano Vittorio Pica — pittura che trionfava allora alle biennali veneziane.

"A chillu signore dà una pennellata e se ne fine. . . ." ["Quel signore dà una pennellata e se ne va."]

A tu per tu con i problemi più vitali della pura pittura, aveva un riso spasmodico, dinanzi le produzioni che risentivano delle imitazioni.

"Va truove chi sa magnati." Per l'arte celebrale, egli aveva un orrore. "Botticello io l'aggio ditto tanta vota, chillo non è un pittore, chiamatelo ingegnere invece." ["Botticelli io l'ho detto tante volte, quello non è un pittore, chiamatelo invece ingegnere."]

La preoccupazione sua più assillante era la riproduzione più esatta del vero. Con minaccie continue d'inchiodare il modello se si movesse, egli cercava di dare la misura esatta del vero. Quando si espandeva, come egli diceva, e dimenticava di fare il suo dovere rispetto al vero, egli usciva in invettive contro sé stesso. "Mancini fesso, Mancini incretinito, Mancini carognone," andava ripetendo, mentre cessava e s'allontanava e riveniva

al cavaletto per avere la giusta prospettiva e ripigliare le giuste proporzioni.

Un giorno lo trovai preoccupatissimo dinanzi ad una testa ad olio.

"Lo aggio lavorato tutta la matina per fa na testa di bue come chilla carugnone è Michetti. . . ." ["Ho lavorato tutta la mattina per fare una testa di bue come quella del carognone di Michetti. . . ."] Di questi non aveva storia alcuna. "A chillu mancava l'essenziale in arte, della decenza." ["A quello mancava l'essenziale in arte, la decenza."]

Parlando del "Voto": "Maronna, chillu quatte fetiente e cafune che strisciano a lingue su un pavimento chino è merda. L'ariano mattere scuorno. Ed io direi a stu c---- è Michetti: 'Neh, ricchiò, va . . . ai mortacci tui. Tu mi à veni a sfottere u pasticciollo. Tu a chi c---- vuò va vurruacà." ["Madonna, quei quattro sciocchi che strisciano la lingua sul pavimento pieno di porcheria. Si dovrebbe vietarlo. . . . Ed io direi a questo stupido di Michetti: 'Neh, vattene via, non seccarci. . . ."]

Egli era un grande lavoratore: dalla mattina alla sera dipingeva. Spesso veniva stanchissimo, tardi, alla trattoria a mangiare. Appena ristorato un po', cominciava subito a ridere, dimenticando noia e fatica. E sorbito un caffè si levava la giacca — e con il lapis e la carbonella sempre a portata di mano, cominciava a disegnare furiosamente con la foga e l'entusiasmo di un giovane di venti anni.

Umettava la carbonella ed il lapis e sfregava con. . . . [unfinished]

12 Ricordi (Memories)
One sheet, 8½ x 6¾, lined notebook paper, faded ivory, torn edges; handwritten in black ink, recto and verso.

Nel 1910, a Parigi, dopo essere stato spettatore ed attore nella rivoluzione dell'arte moderna (esplosione del fauvismo e del cubismo) feci rotta per l'America del Nord. New York, alla cui espansione io avevo assistito in previa dimora, mi si rivelò come miniera miracolosa di motivi veramente straordinari per l'avvento di un'arte nuova.

Sbendati gli occhi di tutti i vieti pregiudizi, rotte le pastoie d'ogni scuola, io ero in possesso pieno di una grande libertà di movenza per lo slancio e la corsa nei campi nuovi che mi si aprivano innanzi, per l'inseguimento ed il possesso d'ogni nuova avventura che mi si offriva [illegible].

13 Incontro con Bruno Barilli (Interview with Bruno Barilli) Published in *L'Ambrosiano*, Milan, September 8, 1929.

Una sera ero in quella orrenda città che è Brooklin: l'inferno industriale. Badate — un luogo da fuggire a gambe levate.

La neve dura copriva tutto. Una neve che il carbone anneriva: tutta ghiacciuoli taglienti e croste pericolose c'era ad ogni passo da rompersi le ossa.

Insomma vetro in terra e vetro nell'aria. Nessuno fuori in quell'ora. Neanche un cane in giro.

Le case e le botteghe di quel quartiere anonimo erano chiuse e sprangate. E sopratutto un buio morto, un silenzio spietato.

Aspettavo il tram che non veniva. Avevo freddo. Ero solo.

Per riscaldarmi cercai di muovere qualche passo su quel difficilissimo cammino.

Vedevo proiettarsi laggiù sulla neve una luce folgorante. Meno male, pensai, c'è un bar aperto, un caffè, o forse un ristorante.

Andai avanti incantato verso quella zona di neve che sotto la luce vivissima sembrava sollevarsi leggera nelle tenebre.

Adagio adagio raggiunsi l'angolo e nel voltarmi rimasi quasi acciecato da una specia di forno elettrico.

Era una terribile vetrina delle pompe funebri che vomitava il fuoco bianco di cento dinamo su tutta la neve della strada. In mezzo alla vetrina c'era una bara di smalto bianco, foderata di seta bianca. Su quella bara un cartello: As you like it? che vuol dire, "come vi piace?".

Questa è l'America dai pugni di ferro e dai nervi d'acciaio.

14 *Corriere d'America*, February 18, 1940.

Noi sappiamo che proprio nel seicento i pittori partenopei con a capo Massimo Stanzione, nella Chiesa di Santa Chiara, dipinsero sugli affreschi di Giotto. Potrei citare altri esempi di simile genere per stuzzicare all'azione l'onanismo sedizioso di qualche sedicente futurista in ritardo.

15 I fari (The Beacons)
Two sheets, 11 x 8½, faded gray; handwritten in black ink, recto and verso.

Oggi, qui, in America, dopo giornate nere e sinistre, in cui a giugno il lugubre inverno è riapparso con il suo ghigno terribile d'Iddio del Male, è scoppiata, come folgore la luce solare e si è diffusa per il creato come l'osanna della Risurrezione. Tutti i miei pensieri si sono elevati con il vigore assertivo di fusti vergini ed il ricordo dell'arte aurea, trionfale dell'arte italiana ha intonato l'inno suo più alto come campana a Pasqua. Sugli spalti dell'Olimpo incorruttibile dell'arte, nelle sfere [illegible] è apparsa la visione gloriosa della schiera gloriosa di tutti i prodigiosi artisti d'Italia capitanati dalla chiarezza adamantina giottesca — Giotto il vessillifero di tutte le virtù preclari della razza elevata al cielo per fugare le tenebre in cui la povera umanità, lacera a brandelli delle atroci vessazioni quotidiane, si dibatte. E come nume tutelare, come guardia integra, inflessibile del Santuario di questo patrimonio artistico, il più prezioso e vistoso che Giove ha donato per salvarla all'umanità, erigo sul trono più puro e fiero l'effige di Mantegna. Il viso di Mantegna dai capelli spioventi

di Medusa dell'arte, dai lineamenti in corruccio per i lampi ed i tuoni che si susseguono con alterno fragore biblico. . . . Mantegna [maturato] e foggiato nell'acciaio più schietto che allontana con la severità del suo sguardo d'Iddio tutte le malevoli intenzioni dei barbari rumoreggianti gelosi fuori del tempio dell'arte italiana, di tutti quei barbari appartenenti a tutte le razze di gnomi che, in tutti i tempi, lividi per rabbia e gelosia della loro bassa schiavitù spirituale, per la miseria che li schiaccia e li tiene soggetti, con verbi poveri e. . . . variamente s'affannano ad insozzare l'oro sempre rilucente delle scale della gloriosa arte italiana.

16 New York
Two sheets, 13¼ x 8⅝, folded and stapled to form a booklet, 8⅝ x 6⅛; yellow graph paper.

New York — sogno mostruoso, realizzazione chimerica, delizie orientali, incubi Shakespeariani, ricchezze inaudite, miserie spaventevoli. Enorme mandibola dai denti ineguali, lucida e nera, come macchina stritolatrice, grigia e funerea, bianca e squillante come minareto al sole, cupa e nera come nei quartieri d'affari, di sera fragorosa di luci e stridente di suoni come per Broadway (Via Bianca — White Way) di notte, quando al piacere s'accende ed impazza — Metropoli imperiale, Babele infantile — alle volte dall'apparenza cartonacea, irrisoria, effimera, insignificante come figurazione sull'arena tracciata da bambino, alle volte grottesca e volgare, piatta, massiccia, borghesemente pesante, i grattacieli come strettoie, il cielo quasi celato, il respiro mozzo, la vita piccola e meschina di provinciale, alle volte cupa ed ostile come immensa prigione, in cui vengono a patire e languire le ambizioni europee, porto sinistro in cui s'afflosciano e si spengono energie accorse da tutte le parti del mondo, come nemica d'ogni tentativo, feroce con i suoi enormi caseggiati sbarranti il passo come enormi muri cinesi, con le sue finestre chiuse ed orridenti, prive di fiori — o sorridente, amica, benefattrice, L'Alma Mater dei derelitti di tutto il mondo, le sue case, i suoi opifici come immensi scrigni da conquistare, le sue strade come i cammini nuovi per i campi nuovi da fecondare e dissodare, i suoi ponti sospesi come le vie aeree per le fortune chimeriche da avvenire.

È un immenso caleidoscopio, tutto è iperbolico, ciclopico, fantastico. Dalle cupole dei suoi tempi dedicati agli affari si gode una prospettiva nuova — una prospettiva campata nell'infinito. I riflettori che di sera solcano perennemente il suo cielo plumbeo, destano e provocano la fantasia per i voli più audaci. E le luci variopinte e mobili delle reclame creano, di notte, un peana nuovo. Di lontano esse irraggiano sull'orizzonte un clangore argentino albale, e suonano cupe l'ora di tramonti imperiali. Quando la nebbia oblitera le basi dei gratacieli essi appaiono sospesi in alto, come scrigni folgoranti di fati, come bolidi rattenuti, come costellazioni proiettate sul cupo di un

cielo in tempesta. E zone d'ombra, larghe, geometriche, mobili, come al passaggio di processioni non viste, si agglomerano, s'addensano, si fanno, si disfanno, vagolano, nascondono e l'ossatura metallica della metropoli mostruosa ha balenii di folgore, comme immensa sbarra di acciaio, stride, sfavilla di bianchi, inattesi come di schiume d'onde, come di voli di gabbiani nella tempesta. Un fragore continuo, cupo e sotterraneo della vita insonne, commenta ed inquadra questo poema, segnandone il largo respiro ed il ritmo.

17 New York, II
Three sheets, 11 x 8½, faded gray, pasted together along left edges; typed, recto.

Il voto di usare tutto il fuoco suo per foggiare un'arte gigantesca, illimitata, lontana dalle insignificanti frivolità del quadro da cavalletto, procedente severamente su matematica precisione d'intenti, animata solo da essenziali elementi, si realizza nelle cinque grandi tele componenti "NEW YORK."

Esse sono state definite come i cinque movimenti di una grande sinfonia. Una sinfonia libera nelle sue vaste risonanze, ma precisa e tagliente nel suo sviluppo: l'astratto con opportuna saggezza innestato a rappresentazioni precise e vive. Ne risulta un contrasto dramma appropriato al carattere altamente spirituale e crudamente materialista, insieme, dei fattori di questa sinfonia. Fattori desunti da Elementi Essenziali, nuovi veramente: I GRATTACIELI, LE VIE BIANCHE (Peana della luce elettrica), IL PONTE, IL PORTO.

La notte appresta la profondità del MISTERO, la severità del carattere geometrico dell'intero si veste opportunamente di tonalità metalliche. Per l'artista New York è come mostruosa sbarra d' acciaio stridente in bagliori di folgore. La linea, perchè il tutto s'esaspera, s'aderge ed ascende con impeto.

In alto riflettori tracciano l'augurio di VIE DELL'AVVENIRE, mentre alla base delle costruzioni ciclopiche, convergenti nel centro in prua, il clangore d'una luce d'argento scatta veemente, con la violenza subitanea di ali scoccate per volo. Le vie bianche, ai lati, turbinano di fulgori: appaiono come mostruose ali di chimeriche farfalle. Le torri del Ponte, con la maestà dei loro archi, dominano il delirio infierente, all'intorno, delle altezze temerarie dei grattacieli e sovrastano, trionfatrici, i vinti e soggiogati baratri fluviali constellati di luci.

Nel PORTO linee orizzontali si susseguono, esse corrono per smisurata latitudine. Linee oblique le intersecano, con violenza. È un frastaglio di zone, di colori balzanti clamorosi in luce cruda o giacenti muti in ombra fitta. Vermiglione puro arde sul cupo azzurro di cielo in tempesta, al ver-

tice di un'aerea piramide di cordami, e sul profondo bluverde che governa cielo ed acqua, come canti trionfali di religione novella, s'innalzano le pure forme cilindriche dei fumaioli, degli alberi di fattorie e di bastimenti, mentre i neri fili telegrafici si avventono nello spazio per allacciare le distanze in vicinanza armonica e concorde, vibrante di amore. Tutto il flutto della metropolitana vita — pulsante, ininterrotta, nelle vie sotterranee e subacquee — fluisce per la base foggiata a predella, ed in archi ed ovali tramanda riverberi, fulgori da vetrate di cattedrali.

18 The White Way (La via bianca)
One sheet, 9⅜ x 7⅜, faded ivory, two-hole notebook paper; handwritten in ink, recto and verso.

L'indigo sconfinante della notte preme la città oceanica come incubo. Lievemente soffuso di albore astrale — Pallida Fata Morgana di splendori lontanissimi sormonta con pesante grigia glacialità di lavagna il nero affilato tagliente delle immani moli quadre delle fattorie chiuse, elevantesi all'intorno fosche con sorde risonanze sinistre di prigioni. Per le vie mute, in cui l'oscurità dipana le sue funeree ali di pipistrelli in zone alterne, punteggiate dai fulgori metallici dei binari, che sconfinano fantastiche nel vuoto.

19 Notturno (Nocturne)
One sheet, 11 x 8½, faded beige; typed, recto.

Le emozioni — vaporanti come incenso dalle esperienze prime
del paese natale — irrorano i suoi notturni:
tremolano nell'irradiazione d'argento
dell' "ALBA LUNARE" —
pervadono di fragranze il velluto fondo
delle acque deste dal fruscio serico
dei
"CIGNI" —
sorgono, s'adergono con lo stelo
del
"CANTO DELL'USIGNUOLO"
inno aereo scaturente dall'imo della
cuna montana, reliquario sacro
dei sogni primi.

20 L'albero della mia vita (The Tree of My Life)
Two sheets, 11 x 8½, faded beige; typed, recto.

Dallo schiudersi repentino delle cerulee distanze della giovinezza prima trascorsa in Italia, chiarità irrompe — e si tramutano aspetti e visioni di

cose. Ed una mattina d'aprile egli si trova fra canti gaudiosi e profumi deliziosi di uccelli e fiori ingioiellanti già il tenero fogliame dell'appena nato albero delle speranze sue: "L'ALBERO DELLA MIA VITA."

Il cobalto puro, di cui s'ammanta il cielo nostro, cinge amorevole, protegge, al sommo della tela, il candore dei fiori sigillante gli ardui voti ultimi della Via Spirituale, e la bellezza pura di luoghi nostrani — trasfigurati, sublimati dalla lontananza e dalla nostalgia dei ricordi — circola quale aura benefica, vivifica di gaudio l'orchestrazione floreale sontuosa che segue le vicende dell'ascensione con risonanze appropriate: il clangere di argento e d'oro, per i primi trionfi, e l'adagio profondo suonato dai verdi e rossi carichi lussuosi, che si snoda dal brusco repentino grido tagliente del vermiglio intenso del giglio, posto come Sigla di sangue generatore alla base del tronco — tronco robusto, ma contorto — contorto già dalle prime fiere lotte impegnate con quelle insidie che i Genii del Male tendono sul nostro cammino.

21 Pensieri (Thoughts)
One sheet, 10½ x 7, faded ivory; handwritten in black ink, recto and verso.

Perchè la nostra giornata scorra serena e lucida, bisogna iniziarla con lo studio di un fiore.

In Assisi, ricordo, tutti i posti dove San Francesco e Santa Chiara svolsero le loro gesta serafiche più significative, sono segnate di fiori, mantenuti perennemente freschi dal ricordo più devoto e fedele.

Così, per il corso dei secoli, le vite degli artisti gloriosi appaiono come fiori miracolosi, come costellazioni propizie e luminose rischiaranti il buio in bene delle susseguentesi generazioni.

22 Pensieri, II (Thoughts, II)
Three sheets, 11 x 8½, faded gray; typed, with several handwritten insertions, recto.

La vita scorre rapida ed incerta in tumulto d'affanni: alle sue sponde di continuo accorre la masnada dei geni del male per funestare dei più insidiosi tranelli il nostro cammino.

Vano ogni scongiuro, vano ogni conato per debellare il Destino.

L'unico conforto, l'Arte, Fuoco Magico. Che esso arda
 inestinguibile!

Che la nostra vita s'illumini del suo oro e della sua porpora, in eterno, e che cullata dal suo fragore gaudioso, dimentica di tutti i mali, possa essa cadere come incenso nelle sue fiamme purificatrici, per vaporare quale profumo in alto verso il celeste

e

l'immacolato.

Ad Assisi — ricordo — ogni luogo dove si compì un miracolo di San Francesco e Santa Chiara è sigillato dalle tinte festose di fiori freschissimi, di continuo rinnovati.

Mio Voto: che la giornata d'ogni mia fatica d'arte s'inizi e si chiuda — per lieto auspicio — con la pittura ilare ed aerea d'un fiore.

23 Gardenia

Two sheets, 11 x 8½, faded gray, formerly glued together along left edges; typed, recto.

(disegno colorato a punta d'argento)

È d'un candore Niveo.
I petali s'irraggiano con sinuosità di chiome albine, arricciolate, a punte ricurve di lame orientali.
Leggerissima aerea pare che sosti nel cavo d'opale della coppa quale miracolosa farfalla nel calice d'un fiore.
Due foglie, venate ed aguzze, d'un verde fondo, le s'aprono ai lati con lo slancio di ali pronte per il volo.
Si ha quasi il timore che, toccandola, debba involarsi.
Prossima e lontanissima apparizione!
Chiara definita eppure evanescente visione.
Immacolato bianco, suono puro d'arpa angelica!
Innumeri visioni corrono fulgenti per
L'orizzonte purificato della nostra anima.
E si resta assorti, come allo
Spettacolo delle cime dei monti natali
Bianche di neve sull'oro del tramonto,
la
Vigilia di Natale.

24 Sensazioni livide (Dark Moods)

One sheet, 5¾ x 5⅛, ivory; handwritten in black ink, recto.

La lurida vita americana pesante, premeva su di lui come un incubo. Invano egli girava gli sguardi intorno, come alla ricerca di un sollievo. Tutto era grigio, squallido, uniforme. Egli sentiva, spaventato, l'approssimarsi della morte. I giorni si susseguivano uguali, fangosi di tutte le piccole vicissitudini della vita bassa e col grigiore. . . .

25 Confessione (Confession)

Two sheets, 9 x 7¼, faded gray; handwritten in black ink, recto and verso.

Per sfuggire alla facilità sciatta, m'abbarbico ostinato e testardo al segno

rude immerso nella carne viva tanto dei primitivi, la cui purezza sgorga e
procede così sicura nella trasparenza della sua chiarezza solare. In rivalità
al blocco d'adamante foggiato dalla mano libera e generosa della sovrana
arte toscana — prodigioso polline datore di vita, io affido la brama mia
ardente di precisare con la integra mia visione alla inflessibile della punta
d'argento o d'oro che pronunzia subitaneo l'eloquenza grafica più chiara
e ritorno all'espressione rapida. . . .

26 Il mito di Leda (The Myth of Leda)
One sheet, 11 x 8½, yellow; handwritten in black ink, recto and verso,
badly torn edges.

È il mito della creazione, della creazione gaudiosa, ardente, spiegante al
vento ed al sole il suo alito divino. L'atto è netto e chiaro, senza velame —
ed è santificato, lanciato in alto, come sprone ed esempio agli umani. Il
bisogno urgente della fecondazione, lavacro da cui ogni cosa rinacque,
vita e splendore nuovo s'eleva, s'innalza e s'inquadra, s'incastona nelle
zone più pure del più puro celeste divino. La forza creatrice ha candore
e virginità simboleggiata dal bianco fremente del cigno e si scaglia per
compiere il suo rito come su di un altare sulla dorata piena incorruttibile
formosità del corpo della Dea della fecondità, Leda, atta a creare un mondo.

27 La poinsettia (The Poinsettia)
One sheet, 11 x 8½, faded gray; handwritten in black ink, recto and verso.

Quando d'inverno arrivai nel paese tropicale, il tuo alto saluto di fiamma
investì il mio animo con sussulto — il subitaneo saluto d'esultanza.

La mia energia sopita, martoriata dal gelo degli orridi paesi del nord si
ridestò come per incanto. S'irraggiò di porpora ed aurea luce. Tutto
l'ardore della giovinezza sorse più in alto e con le sue cupidigie di granato,
con gli straripanti desideri acri e pungenti di nuove conquiste nei vergini
domini dell'arte. Il tuo alto canto fu il grido di Bacco erettosi di nuovo
a nuovo nume tutelare della mia arte. E dinanzi i miei occhi attoniti io vidi
con trepidazione svolgersi l'ondante processione bacchica per le verdi
plaghe della gioia sensuale. E questo tripudio mi fu come simbolo del mio
nuovo svolgimento artistico. Gioia irrefrenabile, entusiasmo e lena con-
tinue, desiderio insonne di gaudio continuo. La vita libera da tutte le dis-
cordie, festa continua: una lunga teoria di fiori e frutta — da incastonare
e rendere memorabile ogni momento della nostra esistenza. Il sogno dio-
nisiaco avverato, il trionfo del peana fulvo della Letizia aurea e fecondatrice.

O, Poinsettia, le tue foglie lanceolate si diramano dal tuo cuore intessuto
d'acini d'oro stretti le fibre inalterabilmente verdi come la speranza con
la mobilità di fiamme. Quale artista possente le trasse dal fuoco sacro del-
l'Olimpo e foggiò, le intagliò, con tale, inaudita perizia? Fu Prometeo?

28 L'apoteosi della Rosa (The Apotheosis of the Rose)
Two sheets, 11 x 8½, faded gray, typed, recto.

Il Maggio, lucido e garrulo, proclama il suo
avvento con la vermiglia GIOIA che irrompe dalla
ROSA
raggiante dal centro del quadro come
CUORE,
La tersa serenità del Cielo le offre, come
per altare
tutta la purezza immacolata del suo azzurro —
e santifica
La
GLORIA DELLA REGINA
con
AUREOLA D'ARGENTO,
CANTO AUGURALE D'ALBA MISTICA.
E dalla base del quadro s'eleva, trepido,
— propizia offerta votiva —
un cespuglio rorido di roselline e
d'umili fiori,
incastonato di niveo,
il niveo dei due AIRONI sorgenti, come
per incanto, dal terso ruscello
echeggiante della risonanza celeste —
ruscello presso cui accorrono, per abbeverarsi d'azzurro e di luce, onde
trarre lena per le loro voci gioiose, nuovi uccelli venuti a rafforzare, rendere
più alto squillante il CORO delle LAUDI
celebrante il divino connubio
del CIELO e della TERRA
Cantanti all'unisono.

29 Purissima
Three sheets, 11 x 8½, faded beige; typed, recto.

Azzurro	Bianco
Viola	Argento
Verde	Rosa

Giallo

Intonazione chiara, mattutina, di Primavera.

AZZURRO cobalto intenso del cielo — oltremare profondo del mare partenopeo, calmo e lucido come cristallo — e celeste di bande varieganti il manto vario-pinto (calice capovolto di giglio enorme)

ARGENTO vivo, d'acqua sorgiva, trapunto di rosa verde giallo della gonna —

argento verdolino, chiarissimo — mistica bianca AURORA — dell'AURE-
OLA.

BIANCO niveo dei due Aironi, che con il candore fulgente dei loro lunghi colli
chiudono, come in un reliquario immacolato, la preghiera della VERGINE.

GIALLO chiarissimo — per gli orli del manto — che intaglia, con purezza
d'adamante, e ne rileva l'acerba soda plastica del petto verginale, e cade
con linee rigide, dirette di cornice, su per le lunghe pieghe ieratiche della
gonna — e giallo pieno e sonoro dei limoni, musicalmente sgranati, d'ambo
i lati del quadro, come le squillani note del propizio riso acre della PRI-
MAVERA.

VIOLA intinto d'oltremare delle bande a zig-zag lungo il manto e viola acceso,
di fuoco, a sommo del Vesuvio, presso la bianca polla d'incenso — viola
tenua, appannato di rosa, del Sorriso lontano di Capri Divina.

VERDE soffice, tenero, dell'erba minuta novella — verde denso delle brevi foglie
acuminate che serrano i limoni — e verde aspro e tenero insieme, cupo,
delle palme, che s'irradiano ai lati come mistici serti.

ROSA intenso — saliente verso i bordi infocati del vermiglione puro — della
Rosa, vivida come gemma, in contrasto al pallore cereo delle mani con-
giunte per la preghiera — e rosa ad infinite modulazioni di tenerezza e di
languore dei diversi fiorellini, che insieme con gli altri di vario colore,
tessono di sogni e di promesse la sontuosa veste da sposa di "PURISSIMA."

30 Il piccolo lago (The Small Lake)
One sheet, 11 x 8½, faded beige; typed, recto.

| BLU | GRIGIO |
| ARGENTO | VERDE |

BLU di cobalto del cielo, intenso in alto, verso lo zenit, digradante in
chiarità, soffusa di rosa, verso la base —

ARGENTO MISTICO della LUNA PIENA, con tremule irradiazioni albali all'in-
torno.

GRIGIO OPACO CARICO PLUMBEO, striato di viola acre, alle rocce, e GRIGIO
APERTO E CHIARO dei muri delle case —

VERDE INTENSO DI SMERALDO del PICCOLO LAGO, e VERDE AD INTONAZIONI
MULTIPLE, dense lussuose d'alcove — l'alcova dei boscosi recessi
ombrosi — dell'albero —

e VERDE SCURO, d'acciaio patinato, nel centro del quadro, della pianta
laminata, che dallo squarcio del tronco generatore prorompe ad elevare,
nella chiarità vespertina, l'intaglio netto del suo CANTO FERMO!

31 Giotto
Two sheets, 11 x 8½, faded gray, glued along left edge together with
no. 32; typed, recto.

Vi è un angolo della nostra anima che resta come specchio limpido —
mai appannato dalle vicissitudini della vita — specchio dove ritroviamo
intatto fissato per sempre il candore delle nostre sensazioni prime.

È il reliquario più sacro da noi custodito come amuleto per debellare
i più difficili momenti e trarre nuova lena incitamento nuovo alla continu-
azione dell'aspro cimento d'arte.

Disigillandolo s'affaccia — come da verone fiorito d'un vermiglio d'aurora
— il sorriso propizio di tutti i Geni del bene che tennero a battesimo il
passo nostro primo per l'arduo cammino dell'arte.

E fra tutti — il più familiare e benefico che per aiutarci, e proteggerci ci
corre allato — è Padre GIOTTO — GIOTTO nome luminoso ridente
come FIORE MIRACOLOSO in cima al verde delle cognizioni primo
appreso in iscuola — NOME SACRO il cui suono si profonda nel nostro
animo e lo scuote con gaudio festoso d'OSANNA intonato da campane
pasquali.

32 L'arte di Giotto (The Art of Giotto)
Two sheets, 11 x 8½, faded gray, glued along left edge together with no.
31; typed, recto.

L'arte di GIOTTO è d'una semplicità ed istantaneità uniche. Nessun
sforzo e nessuna preoccupazione di voler ottenere effetto. Essa rampolla,
fluisce con impeto d'acqua sorgiva — ed ha freschezza albale.

Monda d'ogni lenocinio ha il sentore della terra appena smossa e peren-
nemente tramanda profumi silvestri. Non stanca, sazia giammai come la
terzina dantesca — simile al blu immacolato del cielo alla terra in ger-
moglio.

Essa s'accompagna e si sposa al fragrante schiudersi di quelle fioriture
emotive che hanno inquadrata di fulgido riso mattinale la nostra età prima.

Contemplando le sue creazioni che s'ergono con la spontanea grazia dei
fiori, visioni e ricordi ineffabili svariano nel cielo della nostra anima.

Visioni ed emozioni virgiliane s'affacciano, s'illuminano:
 — il bianco dei buoi fulgido sul bruno profondo della terra franta dal
 vomere —
 — l'ocra del pane sul lustro d'argento dell'acqua pura raggiante nel cris-
 tallo come Adamante —
 — il raccolto sommesso intimo pigolio all'alba dei nidi agganciati alle
 gronde della CASA PATERNA —
 — l'irrompere fragoroso dell'acqua sorgiva dissetante a luglio le piante
 frementi sussultanti come membra virginee percosse dai roventi assaggi
 dell'AMORE.

33 Elevazione (Elevation)
Four sheets, 10½ x 7, faded gray; handwritten in black ink, four recto,
three verso.

Finalmente il sole dell'arte è apparso per illuminare l'orizzonte della mia anima. Non più la truce ombrosa malinconia. L'azzurro più puro inquadra la flora più candida tremolante di rugiada, dei miei sogni d'estate!

Gli uccelli più propizi intrecciano ininstancabili le loro canore "carole." E le visioni paradisiache d'arte sbocciano immense come costellazioni, si schiudono, aprono i loro scrigni colmi d'oro e di luce radiosa. E l'anima spicca i voli più ardui d'aquila, d'allodola libera nello spazio.

Alleluia, Alleluia!

— PENSIERI — SENSAZIONI

Per il cielo d'azzurro profondo sfilano, corrono nubi candide, dalle creste fulgenti d'oro, della tua luce radiosa, o Sole. E in rivalità i miei sogni d'arte s'innalzano per la vastità libera della mia anima, si rincorrono e cantano, il peana dell'anima risorta, elevantesi per le zone più alte e pure.

GIOTTO

GIOTTO per l'arte grafica è quello che Dante rappresenta per la letteratura. Con Giotto la vera arte italiana, fiore miracoloso annunziato e preparato dai succhi più vitali dell'arte più gloriosa greca, la vera prima fioritura della primavera artistica italica schiude i suoi primi e più fulgidi tesori cromatici dal verde tenero e soffice su cui svaria la flora miracolosa, dai canti propizi e nunziatori dell'oro e dell'argento albale. E tutti i segni generatori vermigli s'inquadrano dell'azzurro più ricco e profondo, come costellazioni propizie fulgenti per gli spazi infiniti delle notti serene primaverili.

Il verbo nuovo corre libero ed ilare per i freschi cespugli fioriti magicamente (si realizza una fiaba miracolosa), si delinea e fulge in tutta la sua pienezza e purezza il volto dell'arte italiana, come nella terzina Dantesca il verbo italiano s'integra e risuona in tutta la sua ferma schiettezza. Giotto è il vero genio che nel suo pugno creatore aduna tutti gli sforzi degli artisti primi che hanno preparato e generato il suo avvento e li fonde in unità assoluta, legandoli con inscindibile plasticità, compatta dell'ineluttibilità delle forze naturali.

———

Tintoretto con tutti i suoi titani Veneziani abbaglia e fulge di tutti i tesori di tramonti regali, intessuti di porpora e d'oro. Giotto ci avvince e ci soggioga estatico con l'argento vivo albale. Egli ci commuove per la novità del suo verbo mistico; la sua voce fatidica annunziatrice di nuove meraviglie si disigilla dalle zone più pure, ed è fragrante di profumi e di freschezza, come acqua sorgiva, come fiore appena sbocciato, come selva magica, schiudendosi improvvisa dinanzi ai nostri occhi attoniti. La sua arte ha il fascino fulgido di tutto ciò che è nuovo, di tutto ciò che è imbevuto di quella prima freschezza che dà brividi nuovi ai nostri sensi inattesamente svegli.

34 Viaggi, Idee, Sensazioni, Impressioni (Verso BARBADOS) (Travels, Ideas, Sensations, Impressions [on the way to Barbados])
Three sheets, 11 x 8½, faded gray; typed, recto.

9 dicembre 1936

Il mare è d'oltremare carico, ma fulgente: trasparente e leggero malgrado l'intensità. Agitato, sussultante si sgrana in multipli bianchi sorrisi di spuma — all'apice l'ascesa d'ogni onda si schiude in calici e petali nivei trasformantesi in filamenti arabeschi di trine nuziali. Alle volte è percorso da bagliori d'argento — bagliori di fuochi pirotecnici.

È l'oltremare del manto della Madonna istoriato da ricami trapunti da Arcangeli.

Il fulgore della scia, che accompagna il candido bastimento, dà come l'apparizione del fausto passaggio delle Divine Grazie munifiche di Gioia.

MATTINO

L'oscurità diviene sempre più leggera. D'un tratto il Mare Sacro s'innalza dinanzi il nostro occhio attonito come una Divina Apparizione sorta dagli abissi della Notte — il verso d'Anacreonte risuona: Chi scolpì il mare? — ed il primo verbo della Terra è scandito dalle oscure remote ondulazioni delle montagne dell'isola St. Thomas. Il grigio del cielo s'inargenta, schiarendosi, e di repente, è corso dal brivido di un tenue sorriso rosa, Araldo Propizio del prossimo avvento del Grande Trionfo della Piena Luce. Bande di sole — le prime — disigillano il verde tenero di colline dolci, qua e là ombre dense ancora avvolgenti con gelosa tenacia il bianco pudico di case disseminate come le mucche di un Presepe. L'aria freschissima come balsamo e la chiarità albale colma d'infantile letizia disserrano il portale della nostra anima e villaggiano dentro, fugando le tenebre addensatesi per l'atroce soggiorno nell'America laida. Avviene come la Risurrezione di tutto il nostro Essere. Risuona ancora una volta il canto della Speranza e della Gioia. Il nostro sangue corre nelle vene con impeto veramente giovanile e con piena fiducia nella nostra efficienza, a tu per tu con i cimenti più ardui, la nostra possanza artistica, ridestata per incanto al cospetto d'inattesi incanti naturali, si solleva per i più alti voli. Si è fuori dalla funesta gora d'America. Questa, in paragone alla Gran Luce che ci cinge ora come di una vera e propria aureola, dell'Aureola della RIVELAZIONE del nostro Io più intimo, appare remotissima, un informe abbozzo di fango.

35 Sole, almo sole (Oh Sun, Great Sun)
One sheet, 11 x 8½ yellow; handwritten in black ink, recto and verso, badly torn edges.

Sole, Almo Sole. Febo Divino. Appena la mattina appare, il suo raggio

magicamente schiude il mio animo come un'arnia e tutti i fiori d'idee e sentimenti volano, mi svariano dinanzi, come rondini gioiose, osannanti alla vita. Sole almo, solo tu percuoti con violenza il mio animo e come il ferro battuto, il mio animo tramanda scintille alla tua Luce di Risurrezione. Il gaudio della vita s'agita, fermenta, irrompe e batte su la finestra della mia anima, come flora miracolosa lanciata su i vetri da una bufera di aprile.

36 Pensieri, III (Thoughts, III)
One sheet, 11 x 8½, faded gray; handwritten in black ink, recto and verso.

Oggi il cielo è velato ed infinitamente dolce; v'è nella mia camera come un sussurro, un bisbiglio, di parole ancora non chiare, ma che si indovinano piene di miele — il miele aromatico di tutto quello che schiuse con dolcissima rosa l'alba della nostra vita. Non definite, sorridenti visioni passano, ma lontanissime, in un presagio di sogno. Tutto è tenue, sommesso, velato; sono le tinte languide d'un affresco che ci fa restare muti.

Il suono della parola ci colpirebbe come sacrilegio. Ci ricordiamo del frate invitante al silenzio sulla porta del Convento di San Marco del Beatico Angelico. E chiudiamo gli occhi, assorti, seguenti con ansia questo tenue filo di lene. . . . che scorre nelle profondità, nei recessi della nostra anima. Familiari tremolanti visioni di cari si distaccano dall'azzurro remotissimo della nostra infanzia — s'avanzano, s'illuminano, d'un fievole raggio, fanno un gesto di benedizione, accompagnato, santificato da un sorriso lieve irreale di visione. E come una brezza carica di profumi, carezza blanda, la nostra vita, l'addolcisce, l'attrae in un gorgo di oblio di tutte le miserie. È una trama di luce blanda su per cui fluisce, come su di una corda di violino, la musica deliziosa, d'intimità, rosa ed azzurra di quest'ora deliziosa, apprestataci dalle grazie.

E che questo incanto duri eterno! Che questo incanto sia come un passaggio cheto per la nostra vita di lentamente perdersi, naufragare nell'immensità dell'immortalità.

37 Mattino (Morning)
Four sheets, 11 x 8½, faded beige; typed, recto, several handwritten insertions.

Le campane suonano l'Ave: suoni cristallini, suoni argentini, voci limpide e nivee augurali di Angeli.
Il cielo si schiude alle prime luci, con tenerezza, trepidante, come fiore alla rugiada. Il cielo — terso — d'un azzurro verginale, trasale all'oriente d'un pudore di sposa — tremola d'un rosa asperso d'oro dalla promessa insistente nunziatrice dell'imminente Apparizione dell'Amante Sole.
E per l'aura corrono bisbigli, murmuri arcani: per l'immensa valle pro-

fonda come si dilaga il coro misterioso di corrente lontana sotterranea — coro suonante nell'intimo dell'Anima — il Preludio del prossimo lieto Evento.

La terra, avvolta nel suo manto bruno arabescato di verde profondo, freme nel suo primo risveglio di fremiti d'amante voluttuosa richiamata alle giostre d'Amore — e veli di nebbia, azzurrini come frammenti caduti dal gran manto celeste o dal passaggio di angeli, spoglie donate, vagolano qua e là come aeree carezze.

Cominciano le prime voci del Coro festante degli uccelli: sono spunti, accenti brevi, i primi tintinnii di prova delle arpe celesti, i primi gorgheggi serafici preludianti allo scoppio pieno finale dell'Osanna. Ed il rossore verginale ed argente diviene sempre più intenso al dilagare dell'oro vivo che arde sempre più per l'approssimarsi dell'Amore del Dio.

Gli uccelli si levano, si slanciano, corrono impetuosi all'incontro dello Sposo. Le rondini, ebbre, tessono per l'etere le loro fantasie circolari punteggiate dagli aculei dei loro gridi secchi rivelanti l'ansia della loro attesa.

E gli alberi si levano, scagliano in alto la verde musica delle loro chiome lussureggianti.

Le nebbie azzurrine svaniscono a poco a poco: la terra se le beve. Il bruno s'accentua sempre più ed il verde s'intensifica sempre più profondo nei suoi toni scuri, squilla più limpido nei chiari. Nella chiarezza le sagome si stagliano piene e nette con precisione geometrica. Innumeri forme, poco prima appena intraviste, sorgono piene, integre, ed arricchiscono della loro presenza inattesa il peana delle Apparizioni all'intorno.

E l'oro invade sempre più il cielo. L'azzurro, allo zenit, diviene più compatto, più intenso. Il cielo è ora come un immenso altare in cui s'accende il fulgore del grande Rito. — Il cielo è divenuto il grande reliquario della Dea Luce, e la dispensa all'intorno come Benedizione feconda.

Gli uccelli ora guidati dall'infallibile chiaroveggenza della Dea Luce levano alto come il loro volo, il loro coro d'Esultanza punteggiato di tratto in tratto da pause che permettono il murmuro d'assentimento e d'approvazione alla folla rapita in estasi delle piante.

D'un tratto scattano come saette dietro il monte ripieno d'azzurro le frecce d'oro lanciate dall'arrivo dello Sposo dalla vibrante Aureola — Serto del Dio dell'Amore.

Il cielo scosso da brividi d'oro, è pronto con tutto il disordine delle sue vesti scinte azzurre alla completa dedizione.

E lo Sposo, tratto dalla sfrenata corsa del piacere, appare sfolgorante di fulgore divino.

Un uragano di gioia si scatena e corre per la trasfigurazione e la sublimazione d'ogni cosa.

Tutto scatta e balza in alto come alla voce di richiamo delle sfere celesti.

E per la Terra tutta s'intona, tumultuoso, il gran fragore fecondo d'**ogni** bene dell'Alma Aurea Luce.

———

Pensieri

Lo scritto deve sgorgare come sangue e come questo, inatteso, con i lampeggiamenti forieri del Dramma che s'annunzia, deve folgorare l'animo avvinto del lettore con indelibile impressione. All'inizio deve balzare **con** veemenza dalla polla d'acqua prorompente dalla sorgente per come **questa** poi fluire libera e piena.

Il treno corre con sbuffi d'ansia e grida di gioia come verso convegno **di** GAUDIO PURO.

Gaudio Spirituale già balenando come iride risplendente. Scossi nel pro-fondo dal susseguirsi incessante di emozioni vive, ci abbandoniamo **con** voluttà a questa corsa magica per contrade miracolose, che ci avvincono con continue sorprese d'incanti. Ed, all'improvviso, i ricordi aurei dell'arte intima e profonda, che in questa plaga felice rampollò con purezza argen-tina d'acqua sorgiva e nel suo lungo corso serbò nelle sue acque **chiare** l'immacolato celeste delle altitudini paradisiache, si levano, canori **come** uccelli all'alba, ed ai loro canti tutto s'inciela e s'imparadisa di rosa.

Cinti da luce soprannaturale, restiamo trasfigurati e rapiti, come **da** Rivelazione, allo spiergarsi in immensità d'oro e d'argento, di teorie **di** figure d'angeli in file interminabili di candori incastonati da candori **di** gigli, dilungantisi con murmure profondo — il murmure della preghiera sommessa, che sale diritta e cheta come l'esigua fiamma dalla lucerna **rustica**, sempre accesa nell'ombra delle tue Chiese abbandonate,

O Umbria Divina!

38 **Umbria**

Two sheets, 11 x 8½, faded gray; glue-stained at left margins, typed, recto.

Azzurro, azzurro, azzurro . . .

Azzurro, intenso, eppur tenerissimo, di questo cielo di gennaio disigillato da tersita d'adamante, incarcantesi con fresca soavità di corolla **appena** schiusa — azzurro tenue liliale — fluida celestrina trasparenza luminosa per monti lontani, tremula scia albale di coro d'angeli — azzurro d'oltre-mare puro, balzante vivo dal luccichio di rivi in lena, picchiettanti **di** letizia con fresco tinnulo riso l'adagio grave suonato da paralleli **ritmi** di verde e d'oro cupo onduleggianti alterni per l'ampia pianura.

39 **Orvieto**

One sheet, 11 x 8½, faded beige; typed, recto.

Innanzi il Duomo — 11 gennaio 1927

O Orvieto Divina! Io mi prostro davanti al tuo Duomo

URNA IMMENSA DEL SILENZIO MISTICO,
e verso lagrime di gioia — lagrime simili a quelle
 dei mistici puri, dei SANTI — lagrime della
serafica letizia di SANTA CATARINA DA SIENA ravvisando
nel sangue del condannato il sangue di Cristo.
 Tutte le descrizioni, udite e lette, cadono come
 vacue appendici verbali.
 TU, OPERA IMMORTALE,
ti snudi e ti concedi libera a piena alla travolgente
 passione mia artistica
 che aduna e lega in fascio ardente
la mia vita avanti che cada e si perda nell'infinito del
 MISTERO donde ESSA levò le ali alla LUCE.

40 Casa paterna, V (My Father's House)
One sheet, 11 x 8½, faded gray; handwritten in black ink, verso of no. 50.

Sul bianco di calcina dei tuoi muri, o, casa paterna, scendevano sus-
seguendosi alterne profilandosi retti quali con piene sagome di portentosi
corimbi di frutta saporose, visioni fiammanti di vermiglione aperto e schietto
di chiarori alpini fulgenti su azzurro immacolato, vermiglione di visioni
aspre di sensualità acre fustigante la mia carne perennemente desta nella
tesa continua della sua piena espansione e chiarori di visioni alate elevando
la mia anima per liberarla a lungo nell'etere puro delle alte sfere celesti.

41 Sul terrazzo (On the Terrace)
One sheet, 10 x 8, faded ivory; handwritten in blue ink, recto.

La luce fresca, brilla e suona alta, clangore argentino di fanfara gioiosa.
Sono come nel mezzo d'un gorgo di luce radiosa e tutto s'irraggia all'in-
torno cingendomi come d'un splendente di carezza. M'affondo e m'attardo,
con delizia da questo gorgo di luce.

———

Solo chi ha l'anima pura, profondamente buona, può sillabare la bellezza
superba dei fiori.

42 Su Napoli (Naples)
One sheet, 9 x 6¾, yellowed; handwritten in blue ink, recto and verso.

Il sole scende la plastica, e ne incide e taglia il suo blocco sull'azzurro
mondo, rivelando chiara e lucide il risalto della sua architettura di granito,
sontuosa ed opulenta, cesellata dal mare.
L'artista scosso da queste multiple sensazioni è come quei teneri virgulti,
in cima a colline fiorite, mossi dal vento. La sua sensibilità è fiamma in

continua vibrazione, come fiamma obbedisce, rapida, foggia le sue ali per l'occasione a tutti quei richiami del bello, che spunta come fiore da tutti i lati, che canta come uccello da tutti i rami in fiore i canti di una vergine foresta canora. Striscia, s'attorce, all'intorno ed assale, morde, punge, fustiga le nari, l'aria carica di profumi.

43 Pensieri, IV (Thoughts, IV)
One sheet, 11 x 8½, faded gray; handwritten in blue ink, recto and verso.

Nella vita dell'artista vero, arriva il momento decisivo, presto o tardi, in cui tutto il mondo suo occulto, riposto negli abissi della sua anima, domanda di venire fuori alla luce per essere rivelato. L'artista si contorce come è squassato da un sussulto di terremoto, [come] la madre per il dolore del parto che squaderna tutte le compagini del suo essere.

Passato il momento della luce della rivelazione, la luce folgorante sulla strada di Damasco, cala come una cortina pesante sul suo essere che asconde tutto il fulgore delle sue visioni come se lo scrigno si richiudesse. Ma il suo spirito d'avventura che non dorme, la fede sua alerte, brandisce la sua volontà come l'arma più adatta per procedere imperterrito, il badile più affilato ed appuntato per dissodare il terreno alla ricerca del tesoro della sua personalità.

E per la prima volta ancora egli s'avvede, è cosciente di tutto il peso, di tutto lo spessore del grande materiale incombente, ingombrante, insondabile, che educazione, abitudini, rispetto, convenzioni, pregiudizi hanno accumulato nella sua anima e tiene sotterrato il proprio io. Il lavoro di questo sterro deve essere assiduo, ostinato, nella sua esasperazione d'arrivare a toccare lo strato vergine della sua anima. Durante questo lavoro, come per animarlo e tener accesa la sua lena, s'illuminano lampi nelle fosche tenebre dei sotterranei in cui egli penetra, e visioni precorritrici, fiammanti, istantanee di mondi nuovi, saltano ai suoi occhi ansiosi della grande luce esasperando ed affilando sempre più il suo spirito di ricerca insonne.

44 Idee — sensazioni (Ideas — Sensations)
One sheet, 11 x 8½, faded ivory; typed, recto.

Il grido, lo strido, che accompagna il volo della rondine corre per l'azzurra concavità dell'orizzonte tortuoso come i guizzi del razzo.

Il malanno della città è questo: chiusi come si è fra le case — ostrutti il cielo e la campagna — si resta assediati da mane a sera dalla folla multipla, che preme su di noi, soffocandoci, come ossessione, come incubo. Da qui il desiderio imperioso, assillante di tutti gli spiriti alacri di fuggire, come da peste, da questi alveari umani infetti per andare a rifugiarsi in un eremo e, dinanzi la vastità dell'orizzonte libero, poter agganciare l'anima al cielo. Perchè la vita spicciola quotidiana è gretta e bassa. Per poter vivere bisogna

coprire le sue apparenze tragiche e laide con il velario dei sogni e delle chimere, a noi concesso dalle Grazie che vegliano benefiche sul nostro destino.

45 Il mio sogno (My Dream)
One sheet, 11 x 8½, yellow; handwritten in black ink, recto, badly torn edges.

Il mio sogno, la mia brama d'artista è di pormi al centro della vita e che questa da tutti i lati corra verso il mio Io, per svegliarlo, scuoterlo, come albero carico di frutti, per divellere il mio animo da tutte le pene passeggere che lo tengono soggiogato, confinato, per schiantarlo dalla roccia della vita quotidiana e lanciarlo per sempre su per le altitudini terrestri.

46 La vita quotidiana (Petty, Everyday Life)
One sheet, 10⅝ x 8¼, yellowed ivory; handwritten in black ink, verso; recto, "French Line" and "a bord Le" imprinted in red.

La vita quotidiana, spicciola, ci apporta fastidio, è come un sipario calato sul bello, la sua cura. . . Per non essere oscurato e preservare acceso, fino agli ultimi giorni il nostro entusiasmo, bisogna lavorare costantemente, ininterrottamente. Solo il lavoro opera il miracolo dell'avvento della Luce e della gioia. Come si dorme bene dopo avere spesa una bella giornata, così si muore tranquilli dopo avere spesa una bella vita. Tale l'insegnamento del Maestro divino Leonardo.

47 Paesaggio americano (American Landscape)
Two sheets, 11 x 8½, faded gray, glued along left edge; typed, recto.

È un mattino chiuso gelido come cassa mortuaria. Per il rettangolo di luce dubbia del rettangolo della mia finestra — speco schiarentesi appena — le cime degli alberi nudi rigano di un intrico di vene il plumbeo compatto velario del cielo.

Una morsa agghiacciante tiene serrato l'animo. La nostalgia intensa accenna con languido sorriso al ricordo tremulo di rosa e di azzurro del cielo remoto natìo — cielo schiudentesi all'alba con purezza di fiore allo scampanio festoso delle chiese che proclamano ed annunziano l'avvento della luce come benedizione.

D'improvviso sulla morta gora dell'orizzonte s'illumina un triangolo di un chiaro acuto giallo — scia fulgida di costellazione ascosa. Riti remotissimi si svolgono per le altitudini celesti. Il triangolo s'accende sempre più, brilla come l'occhio di Dio.

Poi lentamente il fulgore inatteso si vela, s'ottenebra, si chiude come l'occhio di moribondo — e di nuovo la cenere del cielo riguadagna il tutto, di nuovo si distende gelida come immenso sudario.

48 Pensieri — sensazioni, II (Thoughts — Feelings, II)
 Two sheets, 10 x 8, faded beige; typed, recto.

La campagna è spoglia, brulla. Gli alberi, vedovi di foglie, si profilano
neri sul cielo velato, da cui qua e là traspare tenuissimo azzurro — tenue
come il ricordo d'amore sognato nell'adolescenza acerba.

V'è sospesa nell'aria una tristezza infinita, tristezza che sosta con l'ondu-
lare lento, con il fluttuare lento della nebbia d'argento che vela l'asprezza
delle cime irte dei monti.

L'alto silenzio fa pensare all'abbandono di uno strumento musicale cui
l'Invidia abbia spezzate le corde.

I rami, schiantati dal vento, pendenti come membra stronche, non sono
forse le corde rotte dall'immensa lira muta della campagna?

Qualche volo basso d'uccello sperso s'aggira incerto, come per sotter-
fugio, e qualche foglia, all'improvviso, brilla d'oro ai furtivi raggi del sole.
Luce d'oro, ultimo ricordo di amore che fu — luce d'oro, scia luminosa
vibrante della lussuosa porpora creata dal fasto di gloriose civiltà tra-
montate — luce d'oro, murmure di coro eroico dilungantesi nella lontananza,
murmure raccolto e tenue sospeso dall'Eco inconsolabile per la perdita
della MUSICA DI TRIPUDIO che piena risuonava nei suoi antri — luce
d'oro, vestigio, indice eloquente scritto sul muro superstite di scomparso
tempio vetusto — luce d'oro su statua tronca compiuta dall'attività stimo-
lata della nostra immaginazione a ricostruire le linee imperiose dell'eterna
Dea della Bellezza.

49 Virgo Purissima
 One sheet, 11 x 8½, faded gray; typed, recto.

È l'apparizione Attesa che schiude, tra la fioritura albale della NASCENTE
PRIMAVERA, la sua COROLLA DI PUREZZA.

50 O, San Francesco (Oh, St. Francis)
 Two sheets, 11 x 8½, faded gray; handwritten in black ink, two recto,
 one verso.

La mia anima si strugge di tenerezza al suono del tuo nome, cero votivo
dinanzi la tua imagine [sic] sacra.

Cerco di radunare le parole più schiette, polite [sic] e belle — e le allineo
dinanzi sul [sic] tuo altare, O, San Francesco, queste parole umili ed
odoranti come fiori campestri, come quei piccoli fiori ignoranti, tremanti
di tenerezza come timidi saluti di persone care su di un ciglio rupestre con-
tro il bianco rugiadoso d'un tenero velato cielo d'aprile — fiori umili, ma
dotati d'un profumo forte, sferzante come quello del mentastro dai piccoli
fiorellini d'un sonora viola tenera.

La musica alata di Bach e dei nostri gloriosi primitivi sale schiudente all'anima miriadi di gorghi, di visioni di luce radiosa, su per le infinite altitudini celesti. La voce tenera dei fanciulli s'eleva trepidante come il calice rugiadoso d'un fiore portentoso schiuso dal tocco creatore portentoso, magico, datore di vita d'uno dei primi raggi del sole nascente.

Al suono ondulante d'una musica sommessa e profonda, sgorgante, cheta ed inesausta da remotissime caverne mi flutta dinanzi una vastissima messe di visioni candide come lo sciamare incessante di cherubini le cui ali candide fremono come creste spumeggianti di onde interminabili nell'attesa della celebrazione radiosa del tuo verbo, O, San Francesco.

Da profondità inesplorate misteriose, mai sospettate, previste prima, sgorga ininterrotto inesauribile un radioso fluire di onde mistiche al richiamo solo del tuo nome, O, San Francesco, onde accorrenti come sciame di uccelli intonanti l'Ave.

51 Mater Dei
One sheet, 11 x 8½, faded beige; typed, recto.

<div align="center">

ORO

VERMIGLIO

VERDE

AZZURRO

</div>

Circondata dall'ORO denso dell'Aureola irradiantesi all'intorno con tonalità di tramonto, la porpora del manto — ricamato d'ORO, per i lati, ed arabescata di fiori violacei nel mezzo — diviene VERMIGLIA intorno il VERDE profondo del busto, inquadrando di sangue mistico il GESTO MATERNO DI DEDIZIONE E DI PROTEZIONE delle mani, snudato il seno a FONTE VIVA.

Ed ombrando di DRAMMA la sorte del BAMBINO — il cui fausto schiudersi alla VITA è annunziato dal coro gaudioso dei fiori cinguettanti per l'AZZURRO, constellato e rigato di bianco, delle fasce che lo serrano come in un talismano.

52 Piero della Francesca
One sheet, 11 x 8½, faded gray; handwritten in black ink, recto and verso.

Sono oggi al cospetto della duchessa d'Urbino. Una fotografia comprata a Parigi anni fa riproduce con fedeltà la pittura famosa. L'ho ritrovata stamane fra vecchi disegni miei ed il mio animo è balzato come ad una inattesa rivelazione. L'immagine è divenuta Apparizione. Il mio animo è stato attratto, magnetizzato dal gorgo del mistero.

È apparizione d'uno dei volti del Grande Mistero. La testa abbigliata con sontuoso eppure sobrio adornamento — una corona di gioielli, emblematica di dovizie favolose, domina al sommo della testa, e fa pensare ad una strana vegetazione fiorita sul dorso d'una collina. Ed il viso, bianco

<div align="center">

164

</div>

d'un biancore evanescente di fantasma, si staglia netta d'una precisione d'adamante incastonato nell'azzurro con candore d'ostia. La linea del cranio e della fronte è curva, perfetta e fluisce senza interruzione, cola calma verbalmente ma in silenzio per decifrare con esulta eloquenza il carattere del naso lievemente adunco ed il taglio della bocca meditativa di male, un po' colorata di fiele per arrotondarsi nel mento, rimasto infantile e rattenere, adunare con orli saldi la piena della solidità del collo lungo e rotondo, giovanile. L'abbigliamento s'agglomera intorno l'occipite di contornati su le orecchie, obliquamente aguzzo al sommo con un viluppo di pieghe rassomiglianti visceri attortigliati, cadente con bande diritte spiegate come protezione sul collo. Pupille nere, d'una . . .

53 La casa di Poe (The House of Poe)
Handwritten on the back and unprinted pages of a two-sheet exhibition catalogue of the Cooperative Gallery, Newark, N.J., March 1939.

La vita di Poe come quella di tutti gli artisti rivelatori di mondo inaspettato, è martirologia continua. Il suo corso rapido è di repente arrestato dalla morte — da questa è come strozzata nel suo pieno fiorire. Rilevando i drammatici eventi di questa vita tronca come singulto, ricorrono alla mente i versi dell'Albatros di Baudelaire. Tutti gli spiriti del male pare che si siano dati l'intesa per debellare e strozzare in sul nascere lo spirito di creazione.

La malignità più atroce di maligni e degli invidiosi in lega con la povertà più assillante tengono stretta e genuflessa la volontà del volo e dell'espansione. Ma questa essendo di natura divina insorge e spezzando ogni legame, come piena prorompe ed invade distruggendo gli argini vani come agguati tesi dall'iniqua impotenza.

La sua prosa serrata e compatta è precisa e lucida come materia preziosa. Mai titubante, rigida e rigorosa, procede inflessibile come se imposta dal fato. Luminosa dal buio fitto, dissigilla alle sagome misteriose e con nettezza ne incide i contorni. Questa precisione, come di fatto reale, vissuta, accentua e rafforza le virtù rappresentative delle sue visioni, e appaga derivando il fascino e la suggestione di esse.

54 Tramonto (Sunset)
Two sheets, 11 x 8½, faded ivory; handwritten in blue ink, recto and verso.

L'ora è presso il tramonto. Il Sole che discende lentamente, in questo caldo giugno, tramanda una luce aurea, d'un oro d'ambra e di miele, insieme. Una grande calma sovraneggia nella campagna, una calma tarda e succosa come frutto maturo, in cui l'anima, come uccello in sosta, raccoglie le sue ali e posa come corolla colma, tremula di rugiada. La cam-

pagna si distende come coppa traboccante di beatitudine per questo soave aureo tesoro vivo. Gli alberi vi s'imperlano e vi s'imbevono e le foglie palpitano, fremono di voluttà, s'accendono d'argento su l'ombra fonda tralucente d'oro.

La pace celeste è discesa dalle sfere celesti. Immagini diafane sfilano lente ed una musica aurea fluisce per segnarne il ritmo, vi si strugge di tenerezza.

Il cielo, poi, s'intinge di viola tenue (agli orli splende dell'oro) e profilo più acuto e tagliente l'arabesco del ricco fogliame di velluto che diviene sempre più denso. O chiome sottili aeree in cima ai sottilissimi fusti delle giovani piante tremante d'acerba verginità, cantate dalla purità del pennello di Perugino.

L'anima si raccoglie in una preghiera. S'apre il libro che raccoglie come in un reliquario d'oro il fulcro migliore della nostra vita e tutto il nostro essere s'illumina come l'ostia sull'altare.

Discendere così alla Beata Riva, al Gran Mistero che ci attende come in sogno.

55 Ravenna
One sheet, 13 x 9⅜, folded to 9⅜ x 6½, ivory, probably drawing paper; handwritten in pencil, recto and verso.

Il silenzio di Ravenna, alto, solenne, ieratico come la processione d'oro e di bianco lungo muro di purezza proteggente la vera Santità grave della Vergine. Case, chiese, campanili, gli alti cilindri dei campanili si elevano con semplicità, naturalezza nel silenzio su un fondo di staticità vivente, lungo cui si sente, s'intravede una vita profonda dilungarsi per i meandri del Mistero, ma presente e viva come nei fondi animati dalla muta e tanto raccolta eloquenza delle figure di Piero della Francesca. Nel silenzio la tomba di Galla Placidia — notturno soffuso . . .

Suoni di campane ansimano brevi come richiami flebili di moribondi. Cuori che si aprono nel dolore e sul dolore si chiudono, palpebre appena sollevate e presto cadute su sguardi dolorosi.

La sera cade lentamente, ma il cielo è chiaro, il blu del cielo divenuto d'un pallore soffuso di riflesso sugli orli neri delle case.

Appena qualche lieve rumore — fuochi passanti si perdono nelle ombre inavvertite. E sul cielo, non campeggia che il campanile e la facciata del duomo, che impallidendo nella sera ha una dolce chiarità soffusa di tenerezza ed amore come di moribondo.

56 Quadri da fare (Paintings to be Done)
One sheet, 11 x 8½, yellow; handwritten in black ink, recto.

(According to Mosca, these plans for future paintings were made by Stella during his final illness and were never executed.)

1. Tra due guerre la Cattedrale dell'*underworld*.
2. La Vergine e Santa Anna (Inno alla Primavera).
3. L'uccello lira.
4. Ondine e il loto e i gigli d'acqua.
5. La foresta vergine (Africa divina).
6. Coro di Barbados (Torso nudo ed il tronco gigantesco del Sambo) — Coro di tronchi d'alberi, canti fermi.
7. San Francesco (Tripudio degli uccelli osannanti).
8. Les nuits de New York (il canto dello spazio libero).
9. Due annunciazioni.
10. Il muro (di notte).

57 Letter to Ferdinando Santoro
Quoted in *Italiani pel Mondo*, August 1928.

L'Italia è l'unica mia vera ispiratrice. L'artista è come l'albero: invecchiando, s'incurva sotto i frutti, si fa sempre più presso il grembo materno che lo ha generato. Malgrado tutto, trenta e più anni di America non sono riusciti che a rendere più compatta e decisa la mia compagine latina.

58 Idee (Ideas)
One sheet, 6⅜ x 4⅞, faded ivory; handwritten in black ink, recto and verso.

Il gran danno della città è questo. Chiusi come si è fra le case degli umani, il cielo e la campagna ostruiti si è assediati da mane e sera dalla folla. Perchè la vita quotidiana è gretta e bassa. Per avere la forza di vivere, bisogna stendere sulle piaghe crudeli il velario di tutti i nostri sogni, dei desideri nostri più intensi per le alte plaghe di beatitudine che lasciarono e tennero assorta, sospesa la nostra anima nelle blu altitudini celesti. La casa paterna è il solo congiungitore con il passato. È il ponte solido, fermo. . .

59 Letter from Stella to the Editor, *Courrier des Etats-Unis*, published April 21, 1925.

Italien et orgueilleux du grand passé artistique de l'Italie, je considère la France comme la seule nation qui possède aujourd'hui le feu sacré de l'art. Sans la France, le vrai Art Moderne, l'art qui reste pur et libre, comme celui du passé, sans l'assistance des louanges officielles, n'aurait pu exister et j'estime que c'est le devoir du vrai artiste moderne de n'importe quelle race de reconnaître comme sa vrai patrie la Nation-Lumière: la France.

60 The Birth of Venus
Ten sheets, 11 x 9½, faded ivory; typed, recto.

[This passage is the introduction to a piece written in English. The major portion, quoted in the text, is not repeated here.]

A true artist in order to create the work which shall live as a "joy forever" in many ways resembles the ascetic who selects as an altar for his profound devotion the green remoteness of the woods.

After having removed himself from the sordid doings of the common daily life and having broken all evil contacts with infesting crowds liable to contaminate, he feels uplifted into superior regions where everything appears transfigured, spiritualized by supernatural light. It is the atmosphere of fire, the state of grace, the moment for the miracle, the moment encircling with a glorious halo the life of St. Francis.

Suddenly the solitude is struck by the lightning of REVELATION and the artist is seized with ecstasy — ecstasy at a whole [series] of visions unfolding inexhaustible wealth of forms and colors through unlimited blue of Heaven. It is then that Inspiration begins to sing with vehemence, it is then that all the energies of the artist — unorganized before — arise linked in a superb effective unity prompted to action by the same law of inevitability of the natural forces.

———

Various and dissimilar are the visions. Some gleam afar, starlike tokens of incomparable treasures to be some day unsealed in their plenitude; some appear and disappear at the same time, but leaving in our memory an ache forever quivering with the music of their passage, and some reveal themselves in fragments to reappear in their fullness, to be pursued and seized little by little by a patient, obdurate daily practice: *Nulla dies sine linea* (not one day without a line) (GIOTTO). But some, in a vivid precise definition of the whole, remain for days as hunting marvels, tyrannical in their dominion of the soul, imperatively exacting an immediate translation into the eternal idiom of Art.

It is the vision like the fruit falling while ripe; the Vision born — undetected — at the bottom of the unconscious, secretly fed for years by the ardent pursuit of Art and showing itself at the opportune moment at the full growth of the artistic faculties. Sometimes it is the word of fire by a cherished poet or a painting portraying some of our dreams that acts as the magic voice of appeal generating this miracle: for real Art has force of expansion of continuity into future harvests. The work of Art, the artist — carrier of fire — is a seed of perennial fecundity confided to the GODDESSES OF JOY presiding at the CELEBRATION OF BEAUTY in the ever green fields of ART.

61 Autobiographical Notes
Fifteen sheets, 11 x 8½, faded ivory, glued along left edges; typed, recto. Covered with blue gift wrapping paper, also glued, like a binding. A red

strip of paper is pasted on the cover, diagonally, upper left to lower right. Page 15 is signed: Joseph Stella/Gennaio/Astoria January 1946.

62 Notes about Joseph Stella
 Four sheets, 11 x 8½, faded beige; typed, recto.

Writings about Stella

1 "Joseph Stella" Carlo de Fornaro
 Foreword by Benjamin de Casseres.
 Eighty pages plus five, 11 x 8½, faded gray; typed, recto. In gray paper binder. Title page dated by hand, l.l.: New York/ November 26. 39; also, by hand, across upper margin: Original copy, before corrections and deletions, i.e., unexpurgated. Also, by another hand, across upper part of page: Property of/ Hazel Hotchkiss/ 593 Riverside Drive/ N.Y.C. – 31 –. Clipped to cover, a letter to "My dear girls" (the Hotchkiss sisters), signed in red crayon, Carlo de Fornaro.

2 "Joseph Stella – Painter of Brooklyn Bridge." Charmion von Wiegand.
 Nine pages, 11 x 8½, yellow; typed, recto, c. 1940.

3 "Memories of Joseph Stella." August Mosca
 Sixteen pages, 11 x 8½, onion skin; typed, recto; 1961.

4 Joseph Stella. A poem by Louis M. Eilshemius
 Two sheets, cut approximately 9 x 7¼, beige, mounted on yellow poster paper; handwritten in brown ink, recto. Second sheet dated, l.l., July 22/21. Signed, in lower right, Louis M. Eilshemius. Scroll designs are drawn in the spaces separating the stanzas.

APPENDIX II

Texts of Foreign-Language Quotations

1 Agostino de Biasi, *Il Progresso Italiano*(?), April 1913
Stella che trovò docile la mano a disporre i suoi colori . . . come può
essere oggi un post-impressionista? . . . Non si può, non si può rinunciare
al passato. . . . Un artista che operi come gli altri fanno, perchè gli altri
fanno, deforma il suo carattere e contorce la sua dirittezza. Siamo prevenuti
contro questo orientamento pittorico? No. Diamogli libero passo. Ad un
patto. Che lo si senta e chi lo esprime sia sincero.

2 Ernesto Valentini, *Bollettino della Sera*, April 26, 1913
Io spero ed auguro a Peppino Stella che presto o tardi trovi la espressione
definitiva della sua anima artistica, la quale dorme, evidentemente, nel sub-
cosciente e che . . . non attende che d'essere svegliata.

3 Antonio Aniante, *L'Italia Letteraria*(?) c. 1932
Partito giovanissimo, con l'anima latina imbevuta di studi classici, ritorna
al vecchio continente, pittore americano. Biforme, sdoppievole, egli guarda
e fissa la grandezza americana con occhi di europeo e la dolcezza del Mare
di Napoli con occhi di smaliziato straniero. Qui sta il segreto dell'arte di
Stella. Due istinti cozzano in lui, due contrasti, due passioni, due patrie
fanno ressa nel suo pensiero creativo; Europa e America lo tormentano
e lo piegano alla fatica quotidiana e notturna. Il gigantesco ponte di Brook-
lyn e il minuscolo ponticello di Capo di Giano del suo paese nativo Muro

Lucano gli fan trascorrere notti di insonnia. Assiso fra un fulgore di luci, dinanzi alla Withe Way [*sic*] di Broadway, con tavolozza e cavalletto, il vento della sera porta fino a lui la canzone di Posillipo di un organetto sperduto nella Little Italy del Bronx. Ciò che manca nello spirito pragmatista, il sentimento, è forte nel pittore emigrato.

4 Fernando Santoro, *Italiani pel Mondo*, August 1928
Chi osa più oggi ammantare Madonne nelle grazie dell'arte? Stella. E forse lui solo. È un suo speciale stato di fervore puro. E da tale stato di animo del pittore musico e poeta nasce Virgo Purissima.

5 Antonio Porpora, *Italiani pel Mondo*(?), September 1926
E ancora l'artista ritrova in Italia l'afflato dei nostri antichi Iddii indigeni. La tradizione gloriosa dei nostri affreschi rifulge ancora. Il paganesimo delle nostre contrade soleggiate risorge.

6 Agostino de Biasi, *Il Progresso Italiano*(?), April 1913
La prima sala contiene i lavori che Stella ha eseguito, parte in America e parte in Europa, nel suo periodo accademico. Sono figure che denotano la padronanza in lui del colore, la sicurezza del tocco, la proprietà di esprimere l'anima del soggetto. Ciò che colpisce è la varietà dei tipi che balzano, dai fondi scuri sotto il pennello dell'artista, che ama indugiarsi in dettagli minuziosi sui visi e sulle mani. *La vecchia che prega* (Esposizione Internazionale di Roma, 1911) si fa notare per la solidità ed efficacia rappresentativa, per la giustezza di toni e l'evidenza del carattere psicologico.

7 Ernesto Valentini, *Bollettino della Sera*, April 26, 1913
Se domandate però quali tele sono migliori, quelle della prima sala o quelle della terza, sarei tentato rispondere con un paragone paradossale ed esagerato, dicendo che fra i quadri della vecchiaia, gli interni, il notturno della prima sala ed il post-impressionismo della terza, corre la stessa differenza che passa fra Rembrandt e Matisse.

8 Agostino de Biasi, *Il Progresso Italiano*(?), April 1913
Il giovane aveva veduto le notti avvampate delle "collieries" di Monongahela e per affrancarsi del cupo malessere di quelle impressioni aveva pensato ad una umanità vestita d'una luce meno sanguigna. Dove trovar la luce soleggiata e vivificatrice se non in Italia?

9 Alfredo Schettini, Italian newspaper, September 24, 1938
Giuseppe Stella fu dapprima a Roma in grande dimestichezza con Antonio Mancini che lo chiamava "il selvaggio."

10 Agostino de Biasi, *Il Progresso Italiano*(?), April 1913
Nella terza sala, in piena orgia di tinte. Cos'è questa trasformazione? Chi ha trattato anzi ha maltrattato così tele, pennelli e colori? Stella? No, perchè Stella lo ritroviamo dotato di raziocinio e di soda preparazione artistica nel quadretto, "La finestra"; lo ammiriamo nella carezza che dà

alle "Vecchie case in un giorno di nebbia." Vi sono frutta, fiori, foglie, vasi. Sono forti pennellate, violente come il sole che avvolge il paesaggio. Ma troppo, troppo verde!

11 Ernesto Valentini, *Bollettino della Sera*, April 26, 1913
Uno dei quadri . . . rappresentante un tavolo con dei bicchieri, delle frutte, ed un vaso nel centro su di tenue sfondo color rosa.

12 Ario Fiamma, *Il Giornale Italiano*, April 24, 1913
Egli non cade nelle esagerazioni cervellotiche di effetti cromatici dei divisionisti imitatori, ma fonde insieme le qualità degli uni e degli altri, prende dal passato e dal presente tutto ciò che è bello ed educatore, e poi vi aggiunge tutta la gamma delle sue visioni di luce, di impressioni, di sentimenti, espressi con realtà, con plasticità immediata e di effetto simpatico e sincero.

13 "L'Ex-Turco di Ritorni," Italian-American newspaper, April 1913
Non cadono nel "fumisteries" fra il pazzesco e il cretino, che vedemmo testè sciorinate in New York e che ci hanno tutta l'aria di atroce burle giuocate agli occhi e al gusto della gente tuttora nel pieno possesso del senso comune.

14 Italian language newspaper (Published in France?), 1932
Non sai dove cominciare a fissare lo sguardo . . . un quadro alla maniera dei maestri bizantineggianti . . . uno che ricorda la pittura giapponese nel quadro accanto . . . la sala ha girato come un carosello . . . gli olii di tutte le dimensioni, di tutte le sfumature, di tutte le scuole . . . di tutte le tendenze e di tutte le techniche. Ci sono dei quadri della migliore maniera classica Italiana, altri inconfondibilmente surrealisti, altri di tendenza astratta, qualche accennno alla scuola futurista . . . altre composte alla maniera dei primitivisti si può riscontrare la presenza di temi e di toni car alla scuola fiamminga . . . il visitatore si domanda: dov'è Stella? . . . Stella rimane inafferrabile: è in tutte le opere variatissime e non è in alcuna di esse.

15 Michele Biancale, *Il Popolo di Roma*, February 25, 1934
Se smontate le soprastrutture trovate indifferentemente Ghirlandaio e il Greco, se togliete i lunghi manti alle oranti, scoprite il Giotto. Ma ciò non ha importanza, è il risultato che conta. E questo è bello: Stella s'è posto a pregare pittoricamente in tutte le lingue. . . . E ci sembra che Stella sia il più esteticamente sorvegliato in tale difficile faccenda.

16 Alfredo Schettini, Italian newspaper, September 24, 1938
. . . la voce di Stella rintronò sotto la cupola [della Galleria Umberto, Napoli]. Divenne una voce muscolosa come le sue braccia dai gesti ampii e irruenti: le parole scintillavano a forma di spirali ed arabeschi di fuoco dai colori più variati, riverbero sonoro di un linguaggio maestoso e insieme iperbolico.

17 Frank E. Washburn Freund, *Der Cicerone*, October 1924

Wer kann New York schildren: Wer sein eigentliches Sein so zur Darstellung beingen, dass der Beschauer fuhlt: dies ist die Stadt. . . .

Wer kann das tun: Ein Einheimischer kaum, fahlte das Moment des Wunderns, das Moment des Stellungnehmens, er wurde Einzelheiten sehen . . . Ein Fremder . . . Joseph Stella aber, New York darzustellen, war der rechte Mann dazu. . .

APPENDIX III

Catalogue with Notes about Works Illustrated

This catalogue gives the title, date, medium, size, and present collector of the works illustrated, and includes, for works exhibited or published in Stella's lifetime, the earliest known appearance of the work in an exhibition or publication. Exhibition in the important Whitney Museum of American Art retrospective in 1963 is also shown. I have not indicated "signed" because I have reservations about many of the signatures having been actually inscribed by the artist, although I have no doubts whatever about the authenticity of the works cited. The catalogue also provides notes relative to some of the works; these often concern problems of date or identification, but sometimes contain supplementary information that seemed too interesting to leave out but not critical enough to place in the text.

Because of the difficulty of dating Stella's works, I have followed certain guidelines in assigning dates to works listed here and in Appendix IV. If unqualified, the date is either sufficiently supported by documents and style or appears on the work and can be accepted as reliable by reason of style (e.g., 30. *Battle of Lights, Coney Island*, 1913; Checklist 149. *The Red Flower*, 1929). Short (en) dashes are used for works executed over a period of years (e.g., 75. *New York Interpreted*, 1920–1922). Dates preceded by "between" are assigned to works whose style is characteristic of a period, with no evidence to support a specific year (e.g., 37. *Battle of Lights, Coney Island*, between 1914–1918). Question marks indicate that the date appears on the

work but that I doubt its reliability (e.g., 1. *Head of an Old Man, V*, 1898?). I have ignored the date that appears on a work in a few instances where I have discussed the problem in the text or illustration notes and explained the reasons for the date assigned (e.g., 69. *Telegraph Pole*, 1920). Dates qualified by *circa* (c.) signify one or a combination of the following: the style is characteristic of the years around the date given; documentary evidence suggests the approximate date; or I have not seen the work and am giving the date assigned by the collector or in the catalogue that is the source of my information about the work (e.g., 34. *Abstraction, Garden*, c. 1914; 72. *Factories*, c. 1921; Checklist 74. *Man in the Elevator*, c. 1922). If a title is followed by n.d., I have not seen the work and lack sufficient documentary evidence to date it; or I have seen the work but have had insufficient time to study it; or I have seen the work but have no evidence for dating it (e.g., Checklist 244. *Nocturne*, n.d.; 113. *Leaf*, n.d.). Measurements are given height before width. All addresses are in New York City unless otherwise indicated, excepted the frequently cited Rabin and Krueger Gallery, which is in Newark, New Jersey. The works are listed in chronological order, arranged alphabetically within the chronology.

1 *Head of an Old Man, V*, 1898?
 Pencil; 8 x 5⅞. Collection: Rabin and Krueger Gallery.

2 *Bark*, 1900?
 Crayon; 4¼ by 9⅞. Collection: Rabin and Krueger Gallery.

3 *Head of a Man with a Hat*, 1900.
 Crayon touched with white; 9 x 8¼. Collection: Rabin and Krueger Gallery.

4 *Head of an Old Man, VIII*, 1900.
 Crayon; 7⅞ x 5⅞. Collection: Rabin and Krueger Gallery.

5 *Old Man, XI, Seated*, c. 1900.
 Pencil, crayon, and charcoal; 9½ x 7. Collection: Rabin and Krueger Gallery.

6 *Standing Young Girl*, 1900?
 Pencil; 10⅞ x 4¾. Collection: Rabin and Krueger Gallery.

7 *Americans in the Rough: The Gateway*, 1905.
 Pencil. Illustrated: *The Outlook*, 71: 967.

8 *Americans in the Rough: A German*, 1905.
 Pencil(?). Illustrated: *The Outlook*, 71: 970.

9 *Americans in the Rough: A Russian Jew*, 1905.
 Charcoal(?). Illustrated: *The Outlook*, 71: 973.

10 *Nude*, c. 1902.
 Oil; 27 by 15. Collection: Sergio Stella, Glen Head, N.Y. Exhibited: Whitney Museum of American Art, *Joseph Stella*, illustrated in catalogue.

11 *Face of an Elderly Person*, 1907(?)
 Charcoal and chalk; 9½ x 7½. Collection: Rabin and Krueger Gallery. Exhibited: Whitney Museum of American Art, *Joseph Stella*, illustrated in catalogue.

12 *Monongah: Morning Mist at the Mine Mouth*, 1907.
 Pencil and charcoal(?). Illustrated: *The Survey*, 19: facing 1313.

13 *Monongah: Rescue Workers*, 1907.
 Pencil and crayon(?). Illustrated: *The Survey*, 19: facing 1328.

14 *The Cripple*, c. 1908.
 Pencil; 11½ x 7⅞. Collection: Dr. and Mrs. Franklin Simon, Millburn, N.J. Exhibited: Whitney Museum of American Art, *Joseph Stella*.

15 *Pittsburgh II: Italian Leader*, 1908.
 Conte crayon; 23½ x 19. Collection: Zabriskie Gallery. Exhibited: Whitney Museum of American Art, *Joseph Stella*. Illustrated: *The Survey*, 21: facing 880; now dated and signed Joseph Stella, although no date or signature appears on the reproduction in *The Survey*.

16 *Pittsburgh II: Painter's Row: Dark Bedroom*, 1908.
 Charcoal; 12½ x 16½. Collection: Sergio Stella, Glen Head, N.Y. Exhibited: Whitney Museum of American Art, *Joseph Stella*. Illustrated: *The Survey*, 21: 910.

17 *Pittsburgh II: Painter's Row: Workers' Houses*, 1908.
 Charcoal; 12 x 18¼. Collection: Mrs. Angela Gross, Maplewood, N.J. Exhibited: Whitney Museum of American Art, *Joseph Stella*. Illustrated: *The Survey*, 21: facing 899.

 Workers' Houses now bears the date 1910 at the lower left; actually it belongs to the 1908 series, for it is reproduced in *The Survey*, February 6, 1909, with no date at all.

18 *Pittsburgh III: Before the Furnace Door*, 1908.
 Charcoal and pastel(?). Illustrated: *The Survey*, 21: facing 1050.

 Although this has a strong resemblance to some of Seurat's drawings, it is unlikely that Stella had ever seen a drawing by the French artist at this time, for his work had not yet been exhibited in the United States, and the De Hawke catalogue indicates no Seurat drawings in American collections at this early date. (See C. M. de Hawke, *Seurat et Son Oeuvre* [Paris: Grund, 1961].)

19 *Pittsburgh III: Four Miners*, 1908.
Charcoal; 18¼ x 34⅜. Collection: Mr. and Mrs. Caesar P. Kimmel, Livingston, N.J. Exhibited: Whitney Museum of American Art, *Joseph Stella*, illustrated in catalogue. Illustrated: *The Survey*, 21: facing 1175.

20 *Pittsburgh III: The Stokers*, 1908.
Charcoal and pastel(?). Collection: Alexander Bonci, Italy. Illustrated: *The Sun*, May 25, 1913.

This drawing was apparently one of those most highly appreciated when the Pittsburgh series was exhibited at the Circolo Nazionale Italiano in New York in April 1913. The *Sun* ran it across an entire page, above the article about Stella quoted at the beginning of Chapter III. Bonci was an Italian singer who lived for a while in New York.

21 *Pittsburgh, Winter*, 1908.
Charcoal; 17⅛ x 23 (sight). Collection: Rita and Daniel Fraad, Scarsdale, N.Y. Exhibited: Whitney Museum of American Art, *Joseph Stella*, illustrated in catalogue.

Stella did several versions of this view in the same impressionistic style, featuring a large spire at the center.

22 *Head of an Old Man, I*, 1910?
Crayon; 10⅞ x 8⅞. Collection: Rabin and Krueger Gallery.

23 *Back of a Woman, Sleeping*, c. 1910.
Pencil; 5½ x 8¼. Collection: Mr. and Mrs. Raymond J. Horowitz. Exhibited: Whitney Museum of American Art, *Joseph Stella*, illustrated in catalogue.

24 *Italian Church*, c. 1910.
Oil; 22¼ x 28¾ (oval). Collection: Joseph H. Hirshhorn Foundation. Exhibited: Bourgeois Galleries, March–April 1920(?). Exhibited: Whitney Museum of American Art, *Joseph Stella*.

A painting entitled *The Village Church*, probably *Italian Church*, was exhibited at Stella's retrospective at the Bourgeois Galleries, March–April 1920, under the heading in the catalogue "Paintings, 1907–1909." However, this group also includes the *Portrait of the Architect Berchet, Florence* (Figure 25), which must date to 1910–11; thus we are not bound to accept the earlier date for *The Village Church*.

25 *Venetian Architect (Voce del Passato)*, c. 1910.
Oil; 48½ x 40. Former collection: Brooklyn Museum (destroyed by fire, 1956). Exhibited: Bourgeois Galleries, March–April 1920(?).

This is almost certainly *Portrait of the Architect Berchet, Florence* (Stella, "Discovery," p. 3; also alluded to in "Notes About Stella"). I

am informed by Axel von Saldern, former Curator of Paintings and Sculpture at the Brooklyn Museum, that *Venetian Architect* "while on loan was destroyed by fire in 1956" (Letter of March 5, 1964). A reproduction of a painting by Stella with the title *Voce del Passato* was published in an Italian language newspaper, probably the New York *Il Progresso Italiano*, with the legend, "exhibited and admired in the Brooklyn Museum of Art and acquired by that Museum." Since the Brooklyn Museum never owned a *Voce del Passato*, this title must refer to the *Venetian Architect*. The painting came into the collection of the Museum in 1929 as a gift from Stella in memory of his brother, Antonio Stella.

26 *Man Seen from the Rear*, c. 1912.
Crayon; 8 x 6⅞. Collection: Gallery 6 M.

27 *Rocky Landscape with Trees*, 1912.
Pencil and crayon; 11¾ x 7⅝. Collection: Rabin and Krueger Gallery.

28 *Still Life*, 1912.
Oil; 23¼ x 28¼. Collection: Charles Silber, Newark, N.J. Exhibited: The Armory Show, February 1913(?); Whitney Museum of American Art, *Joseph Stella*.

Stella originally submitted five paintings to the Armory Show, listed in the domestic committee ledger as *Nature Morte*, $200; *Nature Morte*, $600; Liseuse, $100; *La Montagne*, $500; and *L'Été*, $500; only the $600 *Nature Morte* was accepted. In Milton Brown's revised catalogue of the show, two other Stella paintings are entered, a *Still Life* and a *Landscape*, which Brown suggests must have been invited later. Since these titles are in English, they were probably selected by Arthur B. Davies for the Chicago show because William M. R. French, Director of the Chicago Art Institute, had requested "that the Chicago catalogue be all in English — no foreign titles" (Brown, *Story of the Armory Show*, p. 166). This does not mean, however, that the *Still Life* was not in the New York exhibition. According to the catalogue of the anniversary exhibition of 1963, this painting, lent by Charles Silber, "appeared on the Juried list in the Kuhn papers." (Exhibition Catalogue, *The Armory Show — 50th Anniversary Exhibition, 1913–1963*. Henry Street Settlement, New York, and Munson-Williams-Proctor Institute, Utica, 1963, p. 182.) The Brown catalogue carries the legend that *Nature Morte* was catalogued but not received. However, Ernesto Valentini in the *Bollettino della Sera* describes the painting in the show as "A table with glasses, fruit and a vase in the center, against a pink background," which does not correspond to the Silber *Still Life*. Therefore, if the Silber *Still Life* was in the show, and if Valentini is correct about the painting he describes, Stella must have had two paintings in the exhibition in New York — the

Nature Morte described by Valentini and the Silber *Still Life* — with the *Landscape* added in the Chicago Show. This tallies with Stella's own statement: "In 1913 I contributed three pictures to the famous Armory Show, that memorable exhibition which remains epic as the resurrection of modern art in this country" (Stella, "Discovery," p. 6).

29 *Study of a Woman,* c. 1912.
Oil; 18 x 14. Collection: Dr. and Mrs. Marvin Kantor, Whittier, Calif.

30 *Battle of Lights, Mardi Gras, Coney Island,* 1913.
Oil; 75 ¾ x 84. Collection: Société Anonyme, Yale University Art Gallery. Exhibited: Montross Gallery, February 1914; Whitney Museum of American Art, *Joseph Stella,* illustrated on catalogue cover. Illustrated: *The Century,* April 1914.

Note 1. Page 182 of the catalogue of *The Armory Show — 50th Anniversary Exhibition, 1913–1963,* lists *Battle of Light* (sic), *Coney Island,* with an asterisk that indicates works "which are believed to have been included in the 1913 exhibition, but which were not listed in the original catalogue; they are included in the present exhibition." *Battle of Lights,* in fact, was not in the show, as is correctly shown in Brown's catalogue (Brown, *Story of the Armory Show*) and in Baur's manuscript, where he explains the source of the error. In "Stella," Baur explains that "The often published story that [*Battle of Lights*] hung in the Armory Show is traceable to an error by Miss Katherine Dreier in the catalogue which she compiled of the Société Anonyme collection when it was given to Yale University." (Information from George Heard Hamilton, former Chairman of the Department of Art History, Yale University, in a letter to John Baur, May 22, 1963; Artists Files, "Joseph Stella," Whitney Museum of American Art.)

Note 2. A problem arises in connection with the several versions of *Battle of Lights* referred to by De Fornaro. Stella claims that "Arthur B. Davies gave this painting the place of honor in the exhibition of the first American modern art (organized by him) in 1914 at the Montross Gallery" and that "*The Century Magazine,* the leading periodical of the time, with great praise reproduced in color the acclaimed picture" (Stella, "Discovery," pp. 6–7). There would seem to be no difficulty, for this painting is actually the one reproduced in *The Century,* April 1914. However, the New York *Sun,* February 9, 1914, at the time of the exhibition at the Montross Gallery, contains a cartoon which was drawn by De Fornaro. It is extremely interesting and amusing in the way the artists are depicted, clothed in the styles of their painting, and for what it tells about their unsophisticated understanding of the new art styles; but what concerns us most sharply in this drawing is the rendering of Stella's paint-

ing. Besides being cut off so that we cannot see the whole composition, the cartoon version differs in a number of ways from the Yale *Battle of Lights* (the one reproduced in *The Century*) which Stella seems to indicate was that exhibited at the Montross Gallery. Note particularly the streamer undulating across the upper section, the straight line extending from side to side a little below the upper margin, and the regularity of the light beams emanating from the central area of the cartoon; none of these features exists in the Yale painting.

In Autumn 1922, *The Little Review* issued a "Stella Number," in which a number of his works were reproduced. Among them (printed by error on its side) is one entitled *Mardi Gras* (Figure 32). Turning the magazine so that the signature, "Joseph Stella," and the date, the final numbers of which are illegible, are in the lower right-hand corner, right-side up as here shown, similarities between this work and the cartoon rendering by De Fornaro can be seen: the undulating streamer; the straight line across the top; and some indication of rather regular beams of light emanating from a central area. However, the lettering in *Mardi Gras* corresponds to that of the Yale painting, showing "Felt," "Com," and "Park," although painted in different relationships and proportions. Furthermore, there is doubt about the medium; from the reproduction one might think it is pencil. A work called *Coney Island (Mardi Gras)* was exhibited at the Whitney Studio Club, November 1921, which by its title suggests this *Little Review* illustration, but there is no further identifying or descriptive note and no dimensions are given.

We may speculate, from De Fornaro's letter to the Misses Hotchkiss stating that he prefers his sketch to the "large and second painting of which there are two copies in different museums" (see text), that there were possibly three large versions in all — the first one exhibited in February 1914 at the Montross Gallery, present location unknown; a second one reproduced in *The Century* in April of that year, now in the Yale collection; and a third, reproduced in *The Little Review*, which has also disappeared.

Stella, however, never mentions any other versions of this painting and leaves us unsure how to interpret the evidence at hand. In a letter to Katherine Dreier, dated July 7, 1939, Stella wrote that *Coney Island* was painted "right after the Armory Show towards the end of 1913 and it was exhibited in 1914 in New York (Montross Gallery), in Philadelphia, Chicago, Boston, San Francisco." In a letter of January 22, 1942, clearly in answer to her inquiry, he wrote that *Coney Island* was bought by her sister, Dorothy Dreier, in 1922. I am inclined to believe that *The Little Review*'s *Mardi Gras* (Figure 32) was a preparatory drawing for the Yale *Battle of Lights*, and that De Fornaro based his cartoon on this drawing. Attempts to turn up another copy of the large painting have failed,

and I doubt that there was one. Another painting with the title *Battle of Lights, Coney Island*, is at the University of Nebraska (Figure 37). Although this cannot be considered another version of the Yale *Battle of Lights*, it is certainly related to it, making use of primary colors and spears of color representing darting beams of light.

30a *Battle of Lights*, *Coney Island*, detail, self-portrait, masked.

31 *Study for Battle of Lights, Coney Island*, 1913.
Oil; 20¼ diameter. Collection: The Museum of Modern Art, New York, Elizabeth Bliss Parkinson Fund.

Hazel and Ruth Hotchkiss brought this painting to the Peridot Gallery, which sold it to The Museum of Modern Art. It bore two dates, 1914 and 1915, and the Museum, recognizing that stylistically the piece seemed earlier, dated it 1913–1914? This *Study for Battle of Lights, Coney Island*, can now be assigned with certainty to 1913, for the large finished *Battle of Lights* (Figure 30) was exhibited at the Montross Gallery in February 1914 (New York *Sun*, February 9, 1914), indicating that it was at least begun, and probably finished, in 1913.

32 *Mardi Gras*, c. 1913.
Pencil(?). Illustrated: *The Little Review*, Autumn 1922, following p. 16.

33 *Der Rosenkavalier*, 1913.
Oil; 24 x 30. Collection: Whitney Museum of American Art. Exhibited: Montross Gallery, February 1914.

34 *Abstraction, Garden*, c. 1914.
Pastel; 18⅛ x 24 (sight). Collection: Rabin and Krueger Gallery. Exhibited: Whitney Museum of American Art, *Joseph Stella*.

35 *Composition*, 1914.
Pastel; 25 x 19. Collection: Mrs. Edith Gregor Halpert.

36 *Spring*, c. 1914.
Oil; 20⅜ x 14¼. Collection: Mr. and Mrs. Harry L. Koenigsberg. Exhibited: Whitney Museum of American Art, *Joseph Stella*.

37 *Battle of Lights, Coney Island*, between 1914–1918.
Oil; 39 x 29½. Collection: F. M. Hall, University of Nebraska Art Galleries. Exhibited: Whitney Museum of American Art, *Joseph Stella*.

The treatment is completely abstract, the brush stroke is broader, and the paint thicker in many places than in the Yale *Battle of Lights* (Figure 30), recalling the *Still Life* (Figure 28). The stroke is considerably varied, compared to that in the Yale work in which the paint is laid on smoothly and evenly throughout, except for the dots that translate into colored light bulbs.

38 *Ellis Island: A Bearded Bulgarian,* 1916.
Pencil; 8⅞ x 3⅞. Collection: Rabin and Krueger Gallery. Illustrated: *The Survey,* 36: 152.

This is now signed "Joseph Stella" at the lower left; no signature appeared on the original illustration.

39 *Ellis Island: Young Woman Reading,* 1916.
Pencil; 9 x 7. Collection: Rabin and Krueger Gallery. Illustrated: *The Survey,* 36: 155.

40 *Night,* 1917.
Pastel. Exhibited: Bourgeois Galleries, November–December 1918 as *Night.*

We can identify this work, despite the nondescriptive title, because it was reproduced in the New York *Herald,* Sunday, November 17, 1918, with the credit "Courtesy of the Bourgeois Galleries." Although mentioned by Stella in a fragment of a list of collectors of his work as being in the collection of John Quinn, it is not listed in the catalogue of the Quinn collection. In *The Little Review,* Autumn 1922, facing p. 24, it is illustrated under a different title — *The Swans.*

41 *Bethlehem: The "Insides" of the Clock of War,* 1918.
Charcoal(?). Illustrated: *The Survey,* 41: 615.

42 *The Garment Workers: In a New York Loft Building Workshop,* 1918.
Charcoal(?). Illustrated: *The Survey,* 41: 450.

43 *The Gas Tank,* 1918.
Oil; 40½ x 30. Collection: Mr. and Mrs. Roy R. Neuberger. Exhibited: Bourgeois Galleries, May 1919; Whitney Museum of American Art, *Joseph Stella.* Illustrated: *Der Cicerone;* October 1924.

Der Cicerone for October 1924 published this painting with the title *Amerikanische Landschaft,* showing that was its title at the time; it is probably the *American Landscape* listed in the catalogue of the *Annual Exhibition of Modern Art,* held at the Bourgeois Galleries May 3–24, 1919. The catalogue has a preface by Albert Gleizes. This painting should not be confused with *American Landscape,* 1929, Figure 91.

44 *The Heron,* c. 1918.
Oil; 48¼ x 29¼. Collection: Société Anonyme, Yale University Art Gallery. Exhibited: Bourgeois Galleries, May 1922, as *White Heron.* Illustrated: *International Studio,* February 1926.

45 *The Shipbuilders: The Launching,* 1918.
Pencil and charcoal(?). Illustrated: *The Survey,* 41: 259.

46 *The Song of the Nightingale*, 1918.
Pastel; 18 x 23½. Collection: The Museum of Modern Art, New York.
Exhibited: Bourgeois Galleries, May 1919; Whitney Museum of American
Art, *Joseph Stella*. Illustrated: *The Arts*, October 1921, p. 26.

A work with the same title, executed in 1930 (according to a letter
from Wallace Baldinger to Stella in which he thanks the artist for the
information), was exhibited in Paris at the Galerie Sloden in 1931, repro-
duced in the Paris *Tribune* on June 28, 1931, and again in 1937 as part of
The Metropolitan Museum's Living American Art series. A third paint-
ing with this title is in the collection of the Dallas Museum. A letter of
April 1, 1965, from Miss Carol Robbins, secretary to the director, in-
forms me that "the painting illustrated in the newspaper clipping which
you enclosed (Paris *Tribune*, June 28, 1931) is not the Dallas Museum
painting. To provide a rough comparison, the Dallas version is a more
abstract concentration on what is the center of the illustrated painting."
An unexpected insight into the influence of Modigliani on this aspect
of Stella's work is provided by Luigi Servolini in "Modigliani Vero"
(*Le Venezie e l'Italia*, no. 2, June 1962, p. 39), where he reports that
Modigliani was always speaking about doing a painting called *Il Canto
del Cigno* (The Song of the Nightingale). The elongated, curvilinear
forms in Stella's nature lyrics at this time possibly reflect a delayed re-
action to his close contact with Modigliani in Paris in 1911–12.

47 *Spring*, c. 1918.
Oil; 75 x 40⅛. Collection: Société Anonyme, Yale University Art Gal-
lery. Exhibited: Whitney Museum of American Art, *Joseph Stella*, illus-
trated in catalogue.

The error in the catalogue which dates this painting 1914 (*Collection
of the Société Anonyme*, New Haven: Yale University Art Gallery, 1950,
pp. 6–8) is explained by George H. Hamilton, who writes that the cata-
logue was prepared by Katherine Dreier two years before Yale acquired
her letters. (See also Figure 30, Note 1.)

48 *Study for Brooklyn Bridge*, c. 1918.
Watercolor(?). Photograph found among Stella's papers.

49 *Study for Brooklyn Bridge*, c. 1918.
Pastel; 12¾ x 16. Collection: Zabriskie Gallery.

50 *Brooklyn Bridge*, c. 1919.
Oil; 84 x 76. Collection: Société Anonyme, Yale University Art Gallery.
Exhibited: Bourgeois Galleries, March–April 1920; Whitney Museum of
American Art, *Joseph Stella*, illustrated in catalogue. Illustrated: *The
Arts*, October 1921, p. 27.

A detailed, exact pencil drawing of this *Bridge* in the collection of Dr. Hilda Mosse, is signed and dated 1917. It may be a complete study for the work or a drawing after the work; in either case the date on the drawing (which I do not believe correct) cannot be a guide to dating the painting.

51 *A Child's Prayer*, 1919.
Pastel; 23½ x 18¼. Collection: Estate of Isabel Lachaise. Exhibited: Bourgeois Galleries, May 1919. Whitney Museum of American Art, *Joseph Stella*. Illustrated: *The Little Review*, Autumn 1922, following p. 24.

52 *Flower Study*, c. 1919.
Silverpoint and crayon; 12⅞ x 6½. Collection: Rabin and Krueger Gallery.

53 *Fruit, Flower, and Cat*, 1919.
Pencil and crayon; 8⅝ x 8⅞. Collection: Rabin and Krueger Gallery.

54 *Lupine*, c. 1919.
Pastel; 27½ x 21½ (sight). Collection: Mr. Robert Tobin, San Antonio, Texas. Exhibited: Whitney Museum of American Art, *Joseph Stella*, illustrated in catalogue.

55 *Moon Dawn*, c. 1919.
Pastel. Exhibited: Bourgeois Galleries, March–April 1920, as Moonrise(?). Illustrated: *The Little Review*, Autumn 1922, facing p. 40.

56 *Nativity*, c. 1919.
Pastel; 37 x 19⅛. Collection: Whitney Museum of American Art. Exhibited: Bourgeois Galleries, March–April 1920.

57 *Pomegranate*, 1919.
Crayon; 14 x 18. Collection: Rabin and Krueger Gallery. Exhibited: Whitney Museum of American Art, *Joseph Stella*.

58 *Sunflower*, c. 1919.
Crayon; 28½ x 21¾. Collection: Sergio Stella, Glen Head, N.Y. Exhibited: Whitney Museum of American Art, *Joseph Stella*, illustrated in catalogue.

59 *Tree of My Life*, 1919.
Oil; 83½ x 75½. Collection: Iowa State Education Association, Des Moines, Iowa. Exhibited: Bourgeois Galleries, *Joseph Stella*, 1920; Whitney Museum of American Art, *Joseph Stella*. Illustrated: catalogue, Bourgeois Galleries, 1920.

60 *Untitled*, c. 1919.
Oil on glass. Collection: Rabin and Krueger Gallery. Exhibited: Bourgeois Galleries, May 1919(?).

 Stella's paintings on glass can be assigned to the years between 1918 and 1926 at the latest, when he exhibited eight at the New Gallery Art Club: flower pieces, two *Rose Windows*, and a *Butterfly Motif*, all related to his flower mystique.

61 *By-Products Storage Tanks*, c. 1920.
Charcoal; 22 x 31 (sight). Illustrated: *The Survey*, 51: 568. Collection: Santa Barbara Museum of Art, Gift of Wright Ludington.

62 *Coal Pile*, c. 1920.
Charcoal; 20 x 26. Collection: The Metropolitan Museum of Art, Whittlesey Fund, 1950. Illustrated: *The Survey*, 51: 564.

63 *Crusher and Mixer Building*, c. 1920.
Charcoal; 34⅛ x 22¾ (sight). Illustrated, *The Survey*, 51: 565. Collection: Santa Barbara Museum of Art, Gift of Wright Ludington.

64 *Orange Bars*, c. 1920.
Charcoal and pastel; 24½ x 19. Collection: Mr. and Mrs. Emanuel M. Terner. Exhibited: Whitney Museum of American Art, *Joseph Stella*.

65 *Profile of Marcel Duchamp*, c. 1920.
Silverpoint; 28¼ x 22¼. Collection: The Museum of Modern Art, New York. Illustrated: *The Arts*, October 1921, p. 24.

66 *Study for New York Interpreted*, c. 1920.
Watercolor and gouache; 10½ x 19⅝. Collection: Yale University Art Gallery.

67 Three Studies for *New York Interpreted*, c. 1920.
(a) *City Buildings*. Pen and wash; 11¾ x 8¼.
(b) *The Bridge*. Crayon and watercolor; 12⅜ x 9¼.
(c) *The Bridge*. Crayon; 13¾ x 9¾.
Collection: Rabin and Krueger Gallery.

68 Three Studies for *New York Interpreted*, "The Bridge," c. 1920.
(a) Crayon; 7 x 4½.
(b) Pencil; 7⅞ x 4⅞.
(c) Crayon; 7 x 4½.
Collection: Rabin and Krueger Gallery.

69 *Telegraph Pole*, c. 1920.
Gouache; 24½ x 19½. Collection: Mr. and Mrs. M. P. Potamkin, Philadelphia, Penn. Exhibited: Whitney Museum of American Art, *Joseph Stella*, illustrated in catalogue.

70 *Sketch for New York Interpreted, "The Bridge,"* between 1920–1922. Pastel; 23 x 17. Collection: The Downtown Gallery. Exhibited: Whitney Museum of American Art, *Joseph Stella.*

71 *Factories,* c. 1921.
Oil; 56 x 46. Collection: The Museum of Modern Art, Lillie P. Bliss Bequest. Exhibited: Whitney Studio Club, November 1921(?); Whitney Museum of American Art, *Joseph Stella,* illustrated in catalogue. Illustrated: catalogue Angiporto Galleria, Naples, May 1929.

72 *Factories,* c. 1921.
Oil; 24 x 24. Collection: The Art Institute of Chicago.

73 *Factories at Night–New Jersey,* c. 1921.
Oil; 28⅞ x 36½. Collection: The Newark Museum, Newark, N.J.

74 *Smoke Stacks,* c. 1921.
Oil; 36 x 20. Collection: Art Department, Indiana State University, Terre Haute, Indiana. Exhibited: Whitney Museum of American Art, *Joseph Stella.*

A letter to John Baur from Indiana State University suggests that *Smoke Stacks* might have been painted in the thirties, as the college acquired it through the W.P.A. However, there is no reason to suppose that Stella would not have felt he was discharging his obligation to the W.P.A. by giving them a painting that he had actually done much earlier. The style and technique accord with the earlier work more closely than with the later period: it is printed on a prepared ground similar to that of *Brooklyn Bridge* and of *New York Interpreted* of 1920–1922, whereas in the thirties, and as early as 1929, Stella painted directly on the canvas. (One can see the white canvas showing through the paint in *American Landscape,* Figure 91, for example, whereas in *New York Interpreted* the ground can be seen to be a beige-gray priming, as in *Smoke Stacks.*) The very ragged character of the smoke from the steelmill furnaces is rendered with extreme care to avoid any harshness of contour, while in later works Stella uses a more viscous paint yielding a harder outline.

75 *New York Interpreted,* 1920–1922 (see 75a-e).
Oil; 99¾ x 270. Collection: The Newark Museum, Newark, N.J. Exhibited: The Société Anonyme, January 1923; Whitney Museum of American Art, *Joseph Stella.* Illustrated: *Stella,* pamphlet, Société Anonyme, undated but doubtlessly January 1923. The five-panel spread first illustrated, *The Survey,* 51: 142; the individual panels were reproduced on pp. 143–147.

It was Stella's hope that *New York Interpreted* might be bought by a

patron who would install it in a prominent public building, and a number of possibilities were explored. For a time it appeared that Rodman Wanamaker might be interested, and Katherine Dreier tried to influence Lawrence Langner to buy it for the projected new Theatre Guild building (YUSL, "Stella"). Nothing came of these attempts, however, and the work was unsold until July 1937, when it was acquired by The Newark Museum.

75a *New York Interpreted*, "The Skyscrapers."
Oil; 99¾ x 54. Illustrated: *The Little Review*, Autumn 1922, following p. 16; catalogue, Whitney Museum of American Art, *Joseph Stella*.

75b *New York Interpreted*, "White Way, I."
Oil; 88½ x 54.

75c *New York Interpreted*, "White Way, II."
Oil; 88½ x 54.

75d *New York Interpreted*, "The Port."
Oil; 88½ x 54.

75e *New York Interpreted*, "The Bridge."
Oil; 88½ x 54. Illustrated: *The Arts*, February 1923, p. 127.

75f *New York Interpreted*, "The Bridge," detail, "PAID."

76 *Tropical Sonata*, c. 1921.
Oil; 48 x 29. Collection: Whitney Museum of American Art. Exhibited: Bourgeois Galleries, May 1922; Whitney Museum of American Art, *Joseph Stella*, illustrated in catalogue. Illustrated: *The Little Review*, Autumn 1922, following p. 40.

77 *Study for Skyscraper*, c. 1922.
Collage. Illustrated: *The Little Review*, Autumn 1922, following p. 32.

78 *The Bookman*, c. 1922.
Collage; 7 x 4½. Collection: Joseph H. Hirshhorn. Exhibited: Whitney Museum of American Art, *Joseph Stella*. Illustrated: *The Little Review*, Autumn 1922, following p. 32.

79 *The Birth of Venus*, 1922.
Oil; 85 x 53. Collection: Iowa State Education Association. Exhibited: Dudensing Galleries, 1925; illustrated in the exhibition catalogue.

80 *Undine*, 1922.
Oil; Former collection: Stephen C. Clark? Exhibited: Dudensing Galleries, 1925, illustrated in the exhibition catalogue.

81 *The Virgin,* 1922?
Oil; 39⅜ x 38¾. Collection: The Brooklyn Museum. Exhibited: Valentine Gallery, April 1928. Illustrated: *New York Times,* July 15, 1928.
 Stella's "Discovery" (p. 13) states: "In 1922 I went to Naples and I was so happy to paint there the Vergin [*sic*] donated by Adolphe Lewisohn to the Brooklyn Museum." The style is closer to c. 1926.

82 *The Amazon,* 1924.
Oil; 27 x 22. Collection: Lester Avnet. Exhibited: Valentine Gallery, April 1928, as *Amazonian;* Whitney Museum of American Art, *Joseph Stella.* Illustrated: *Italiani pel Mondo,* August 1928.

83 *Portrait of Helen Walser,* c. 1925.
Oil. Present location unknown. Illustrated: *Italiani pel Mondo,* August 1926?, p. 228.

84 *The Apotheosis of the Rose,* 1926.
Oil; 84 x 47. Collection: Iowa State Education Association. Illustrated: *International Studio,* July 1926.
 Stella's poem on *The Apotheosis of the Rose* underlines the visionary, ecstatic context of the painting:
May, shining and filled with the sounds of warbling,
Proclaims its arrival with the vermilion joy bursts from the Rose
Radiating from the center of the canvas like
A Heart.
The clear serenity of the sky offers as an altar
The Queen of Heaven
With a silver Halo, the song that foretells the Mystic Dawn.
And from the base of the canvas arises, fluttering — propitious votive
 offering —
A dewy thicket of small roses and field flowers
Set in snowy whiteness,
The whitness of two herons springs as if by magic out of the shining brook
 that echoes with heavenly resonance,
The brook toward which rush other birds, to bathe themselves
In the blue and the light,
To draw fresh energy for their joyous voices that they may strengthen,
 render more fully,
The ringing Chorus of Praise
Celebrating the divine union of
Sky and Earth
As they sing in unison. (I,28)
 The *Art Digest,* November 15, 1943, states that the idea for the *Apotheosis of the Rose* was based on a poem by William Morris.

85 *Cypress Tree*, c. 1926.
Watercolor and gouache; 41 x 27. Collection: Joseph H. Hirshhorn. Exhibited: Angiporto Galleria, Naples, May 1929(?); Whitney Museum of American Art, *Joseph Stella*.

86 *Ophelia*, c. 1926.
Oil. Exhibited: Angiporto Galleria, Naples, May 1929, and illustrated in exhibition catalogue.

87 *The Little Lake*, c. 1927.
Oil; 36 x 31½. Collection: Montclair Museum, Montclair, N.J. Exhibited: Valentine Gallery, April 1928. Illustrated: catalogue, Angiporto Galleria, Naples, May 1929.

This was possibly done in Italy in 1927, at the beginning of the period of darker tonalities. The coloring, according to Stella, comprises the "blue of the sky, intense at the top towards the zenith, diminishing in brilliance, tinged with rose at the base, Mystic Silver of the Full Moon, with the tremulous vibrations of the dawn all around. Opaque, acrid-violet-streaked lead gray of the rocks, and Clear Bright Gray of the wall of the houses. Deep Emerald Green of the small lake, and different tonalities of rich green for the alcove of the tree, a shady, woody recess. And in the center of the painting, the Dark Green, like patina'd steel, of the foliated plant that burst from the torn trunk of the life-giving tree, to offer up, in the vesper light, its clear sharp chorale" (I,30).

88 *Morning*, c. 1927.
Oil. Exhibited: Angiporto Galleria, Naples, May 1929, and illustrated in exhibition catalogue.

89 *Muro Lucano*, 1928.
Oil; 32 x 25¾. Collection: Lawrence H. Bloedel, Williamstown, Mass. Exhibited: Whitney Museum of American Art, *Joseph Stella*, illustrated in catalogue.

90 *Sirenella*, c. 1928.
Oil. Exhibited: Angiporto Galleria, Naples, May 1929, and illustrated in exhibition catalogue.

Stella also exhibited a painting titled *Sirens* in this show. According to Homeric legend, sirens were singers of the dirge for the dead and were often depicted on funeral monuments. Dr. Antonio Stella had died in 1927 and possibly this and other paintings of the period reflected Stella's sense of loss.

91 *American Landscape*, c. 1929.
Oil; 78½ x 39 (sight). Collection: Walker Art Center, Minneapolis. Ex-

hibited: Galerie Sloden, Paris, May 1930; Whitney Museum of American Art, *Joseph Stella*, illustrated in catalogue. Illustrated: *New York Sun*, May 13, 1939.

Note 1. In the thirties, Stella painted three Bridge pictures but none represents a new type (see Chapter XI). It seems certain that he painted *American Landscape* in the latter months of 1929 or early in 1930, in Paris, as a substitute for one of the earlier Bridge paintings which he was not able to have shipped abroad in anticipation of a Paris exhibition. For in his letter to Carl Weeks of June 1, 1929, Stella expressed his eagerness to show his "best pictures done in America" (among which he counted *Brooklyn Bridge* and *New York Interpreted*) at an exhibition he hoped to have in Paris that year. In December 1929 he was still working to realize that hope, as we find him writing to his patron: "Although I have a number of paintings that brought me great success in my exhibition in Italy, I pursue my efforts with all my strength, thinking rightly that an exhibition in Paris is the proof of fire." By February 22, arrangements had been finally made for a show at the Galerie Sloden, and in April he writes to Weeks: "I regret that I will not be able to put in the exhibition any of my biggest paintings achieved in America, like your *Tree of Life*, *The Rose*, *Venus*, or *New York, the Brooklyn Bridge* . . . my show will be composed, between drawings, watercolors, and oils, of 87 works done in Italy and Paris" (I.S.E.A., "Correspondence, Weeks-Stella"). The first mention of *American Landscape* appears in the catalogue of the exhibition in May 1930 at the Galerie Sloden.

Note 2. American Landscape had an enormous public and critical success when it was exhibited at the Jeu de Paume in Paris 1938. Negotiations were begun as early as July 1938 to purchase it for the permanent collection of the Jeu de Paume, as we learn from a letter to Stella from A. Conger Goodyear (found in Stella's papers), then president of The Museum of Modern Art, informing him that M. André Desarrois, director of the French museum, had expressed interest in such a purchase. The following year The Museum of Modern Art released an announcement to the press of the acquisition of Stella's painting by the Jeu de Paume through the gift purchase of Arthur F. Egner, then president of the Newark Museum. Why this acquisition was never finally made does not seem to be known; perhaps the outbreak of the war had something to do with it. The Walker Art Center, which acquired this work in 1957 from two private owners, has been unable to trace its history.

92 *Neapolitan Song (Canzone Napoletana)*, 1929.
Oil; 34¼ x 28. Collection: Rabin and Krueger Gallery. Exhibited: Galerie Sloden, Paris, May 1930. Illustrated: *Town and Country*, August 15, 1932, cover.

93 *The Ox*, c. 1929.
Oil; 18⅞ x 18⅞. Collection: Rabin and Krueger Gallery. Exhibited: Washington Palace, Paris, February–March 1932. Illustrated: *Le Mont-Parnasse*, August 13, 1932, front page.

94 *Self-Portrait*, c. 1929.
Watercolor and wax; 20 x 15½. Collection: Mr. and Mrs. Herbert A. Goldstone. Exhibited: Angiporto Galleria, Naples, May 1929; Whitney Museum of American Art, *Joseph Stella*, illustrated in catalogue. Illustrated: *Emporium*, June 1929.

I have revised the date of this painting from c. 1925, as it appears in the catalogue of the Stella retrospective exhibition at the Whitney Museum. The first mention of the work is in *Emporium*, June 1929, where it is illustrated in a review of the Naples exhibition at the Angiporto Galleria. It is again illustrated in the news bulletin of the Academia Latinitatis Excolendae, February–March 1932, in connection with Stella's exhibition at the Washington Palace, in Paris, held under the auspices of this Academy. These documents, together with the style of the work, its simplicity, light color, and bulky forms have led me to change the date which had been assigned to it by the Rabin and Krueger Gallery. The medium of this *Self-Portrait* is watercolor and wax, a variation of what I believe to be the medium of Stella's "encaustique"; it produces a peculiar textural effect, as if the pigment clotted as it spread across the sheet.

95 *Still Life with Yellow Melon*, 1929.
Oil; 15 x 18⅞. Collection: Rabin and Krueger Gallery. Exhibited: Whitney Museum of American Art, *Joseph Stella*.

96 *Marionettes*, c. 1930.
Oil; 25½ x 32¼. Collection: Rabin and Krueger Gallery. Exhibited: Galerie Sloden, Paris, May 1930. Illustrated: Catalogue, The Newark Museum, *Joseph Stella*, 1939.

97 *Impression of Venice*, c. 1931.
Oil; 20¾ x 16½. Collection: Mrs. Joanna Davanzo, Essex Fells, N.J.

98 *Paris Rooftops*, 1931.
Oil; 39¼ x 33⅜. Collection: Mr. and Mrs. Samuel Halpern, East Orange, N.J. Illustrated: *Chantecler* (Paris newspaper) 1931?.

This could be *View from Paris Studio*, exhibited Valentine Gallery, November–December 1931.

99 *Head of Christ*, c. 1933.
Oil; 9½ x 7½. Collection: Mr. and Mrs. Herbert A. Goldstone. Exhibited: Exhibition of Sacred Art, Rome, 1934?

100 *The Holy Manger*, c. 1933.
Oil; 60 x 76. Collection: The Newark Museum, Newark, N.J. Exhibited: Exhibition of Sacred Art, Rome, 1934. Illustrated: *Il Popolo di Roma*, February 25, 1934.

This work is dated 1929 in the Newark Museum catalogue of Stella's retrospective held there in 1939, while in the Newark newspaper, *The Sunday Call*, May 7, 1939, it is illustrated with the legend, "painted in 1930." I believe, however, that it was painted in 1933, in preparation for the Exhibition of Sacred Art in Rome the following year, for there is no mention of the painting earlier in catalogues or newspaper notices of Stella's exhibitions during 1930, 1931, and 1932.

101 *Bridge*, c. 1936.
Oil; 55½ x 35½. Collection: San Francisco Museum of Art.

102 *Self-Portrait*, c. 1937.
Oil. Illustrated: *Corriere D'America* (New York), August 14, 1939.

103 *Song of Barbados*, 1938.
Oil; 58 x 37. Collection: Rabin and Krueger Gallery. Exhibited: The Newark Museum, February 1939, Whitney Museum of American Art, *Joseph Stella*. Illustrated: *New York Times*, February 5, 1939.

104 *Brooklyn Bridge: Variation on an Old Theme*, 1939.
Oil; 70 x 42. Collection: Whitney Museum of American Art. Exhibited: Knoedler Galleries, *Joseph Stella*, 1942; Whitney Museum of American Art, *Joseph Stella*.

105 *Full Moon, Barbados*, 1940.
Oil; 36 x 25. Collection: Sergio Stella, Glen Head, N.Y. Exhibited: Whitney Museum of American Art, *Joseph Stella*, illustrated in catalogue.

106 *Self-Portrait*, c. 1940.
Silverpoint; 13¾ x 13¾. Collection: Mr. and Mrs. Moses Soyer.

107 *Old Brooklyn Bridge*, c. 1941.
Oil; 76 x 68. Collection: Wright Ludington, Santa Barbara, Calif. Exhibited: The Metropolitan Museum of Art, *Artists for Victory*, 1942.

108 *Figures, including Self-Portrait*, c. 1944.
Pencil and wash; 7¾ x 13⅛. Collection: Rabin and Krueger Gallery.

109 *Still Life wtih Small Sculpture*, 1944.
Pencil and crayon; 14 x 13½. Collection: Mr. and Mrs. John D. Frisole, Short Hills, N.J. Exhibited: Whitney Museum of American Art, *Joseph Stella*.

110 *Number 21*, n.d.
Collage; 10½ x 7½. Collection: Whitney Museum of American Art. Exhibited: Whitney Museum of American Art, *Joseph Stella*, illustrated in catalogue.

111 *Graph*, n.d.
Collage; 13 by 9⅞. Collection: Robert Schoelkopf Gallery. Exhibited: Whitney Museum of American Art, *Joseph Stella*, illustrated in catalogue.

112 *Head*, n.d.
Collage; 12 x 9. Collection: Mrs. Frederick Arkus, Yorktown Heights, N.Y.

113 *Leaf*, n.d.
Collage with natural leaf; 11 by 8½. Collection: Zabriskie Gallery. Exhibited: Whitney Museum of American Art, *Joseph Stella*, illustrated in catalogue.

114 *Profile*, n.d.
Collage; 10¾ x 7. Collection: Schoelkopf Gallery.

APPENDIX IV

Checklist of Works by Stella

Most of these works have been publicly exhibited or published or were considered for exhibition in connection with the Joseph Stella retrospective at the Whitney Museum of American Art in November 1963; exceptions are indicated with (‡). A list of some 785 paintings and drawings is far from being a complete catalogue of works done by an artist whose professional career spanned forty years; I have already mentioned that the Rabin and Krueger Gallery alone has a collection of over 2000 pastels, crayons, and watercolors, only a fraction of which is included here. The information will help round out the account of the range of Stella's subjects, and his preferences concerning media, sizes, and format, so far as they can be generalized. The list may also serve as a basis for a future critical catalogue, and as a convenience for locating works. Dates, measurements, and addresses follow the system used in Appendix III and explained in the headnote there. "Reference" signifies that I have not seen the original and that the reference given is the source of my knowledge of the work.

Oils

1 *Laughing Man*, 1900. Oil. 26½ x 20¼ (sight). Estate of Joseph Stella. Reference: Catalogue, Whitney Museum of American Art, *Joseph Stella*, 1963. Illustrated: Jaffe, "Stella."

2 *Child in Blue*, 1902. Oil. Collection, Rabin and Krueger Gallery, Newark, N.J. Reference: Catalogue, Seton Hall University, South Orange, N.J., November–December 1964.

3 *Girl, Chin on Hands*, c. 1902. Oil. 24½ x 18½. Collection, Sergio Stella, Glen Head, N.Y.

4 *Nude*. See Figure 10.

5 *A Scholar*, c. 1905. Oil. 48 x 39. Estate of Joseph Stella.

6 *Mural*, c. 1905. 35 x 83. Collection, Dr. Adrian W. Zorgniotti.‡

7 *Old Man with Turban and Beard*, c. 1905. Oil. 28¼ x 17¼. Collection, Samuel Denberg, Newark, N.J.

8 *Serb*, 1905. Oil. Collection, Rabin and Krueger Gallery. Reference: Catalogue, Seton Hall University.

9 *Tarda Senectus*, c. 1906. Oil. 29 x 21. Estate of Joseph Stella. Exhibited: Society of American Artists, 1906. Illustrated: *Italiani pel Mondo*, August 1928, p. 805; Jaffe, "Stella."

10 *The Beggars*, c. 1908. Oil. Reference: Catalogue, Bourgeois Galleries, *Joseph Stella*, March–April 1920.

11 *The Widow*, c. 1908. Oil. 39½ diameter. Estate of Joseph Stella.

12 *Young Miner*, c. 1908. Oil on paper. 11⅛ x 8⅜. Collection, Mr. and Mrs. Harry L. Koenigsberg.

13 *Italian Church*. See Figure 24.

14 *Man's Head*, c. 1910. Oil on paper. 8¾ x 6. Collection, Mr. and Mrs. Walter Fillin, Rockville Centre, N.Y.

15 *Portrait of Walter Damrosch*, c. 1910. Oil on paper. 13 x 10¼. Reference: Catalogue, Zabriskie Gallery, September–October 1959.

16 *Venetian Architect (Voce del Passato)*. See Figure 25.

17 *Girl with Parasol*, c. 1912. Oil. 31 x 12½. Collection, Mrs. Edward Patterson, Glen Head, N.Y.

18 *Mediterranean Landscape*, c. 1912. Oil. The Howard S. Wilson Memorial Collection, The Sheldon Memorial Art Gallery, The University of Nebraska, Lincoln, Neb. Reference: Catalogue, The Sheldon Memorial Art Gallery, October–November 1966, illustrated.

19 *The Shepherd's House*, c. 1912. Oil. Estate of Joseph Stella. Illustrated: *The Trend*, June 1913, p. 894; Jaffe, "Stella."

20 *Still Life*. See Figure 28.

21 *Still Life, Apples*, c. 1912. Oil. 12⅞ x 18. Collection, Rabin and Krueger Gallery.

22 *Still Life with Grapes*, c. 1912. Oil. 10½ x 11½. Collection, Mr. and Mrs. Herbert A. Goldstone.

23 *Study of a Woman*. See Figure 29.

24 *Battle of Lights, Coney Island*. See Figure 30.

25 *Der Rosenkavalier*. See Figure 33.

26 Study for *Battle of Lights, Coney Island*. See Figure 31.

27 *Untitled* (Nude with Bottle), c. 1913. Oil. 30 x 20 (approximately). Collection, David Joyner.

28 *Battle of Lights, Coney Island.* See Figure 37.

29 *Coney Island,* between 1914–1918. Oil. Collection, Mrs. E. A. Speiser, Philadelphia, Pennsylvania.

30 *The Hippodrome (Ballet),* between 1914–1918. Oil. Reference: Catalogue, The Whitney Studio Club, *Joseph Stella and Henry Schnakenberg,* and *Art News,* November 1921.

31 *Madonna of Coney Island,* between 1914–1918. Oil. 41¾ diameter. Collection, The Metropolitan Museum of Art. Catalogue, Whitney Museum of American Art, *Joseph Stella,* illustrated.

32 *Spring.* See Figure 36.

33 *Spring Procession, Italy,* between 1914–1918. Oil. Reference: Catalogue, The Whitney Studio Club, *Joseph Stella and Henry Schnakenberg,* and *Art News,* November 1921.

34 *Study for Spring* (?), between 1914–1918. Oil. 11 diameter. Collection, Mr. and Mrs. Herbert A. Goldstone.

35 *Mountain Abstract,* 1916. Oil. Collection, Rabin and Krueger Gallery. Reference: Catalogue, Seton Hall University.

36 *Old Man Sleeping,* c. 1916. Oil. 3 x 4½. Reference: Catalogue, Zabriskie Gallery, April–May 1958.

37 *Chinatown,* c. 1917. Oil on glass. 19¼ x 8⅜. Collection, Philadelphia Museum of Art. Illustrated: *The Little Review,* Autumn 1922.

38 *Early Morning (Landscape),* c. 1917. Oil. Reference: Catalogue, Bourgeois Galleries, October–November 1917.

39 *Evening (Landscape),* c. 1917. Oil. Reference: Catalogue, Bourgeois Galleries, October–November 1917.

40 *Night,* c. 1917. Oil. 19 x 25. Collection, Wright Ludington, Santa Barbara, California.

41 *Southern Italy (Landscape),* c. 1917. Oil. Reference: Catalogue, Bourgeois Galleries, October–November 1917.

42 *Abstract with Vertical Bars,* c. 1918. Oil on glass. Collection, Rabin and Krueger Gallery.

43 *Aquatic Life,* c. 1918. Oil. Reference: Catalogue, Bourgeois Galleries, March–April 1918.

44 *The Gas Tank.* See Figure 43.

45 *Gas Tanks,* c. 1918. Oil. Collection, Rabin and Krueger Gallery. Reference: Catalogue, Seton Hall University.

46 *The Heron.* See Figure 44.

47 *La Fusée,* c. 1918. Oil on glass. Reference: Catalogue, Bourgeois Galleries, March–April 1918.

48 *The Machine,* c. 1918. Oil. Reference: Photograph, The Museum of Modern Art.‡

49 *Man in Elevated*, c. 1918. Oil. Reference: Catalogue, Whitney Museum of American Art, *Pioneers of Modern Art in America*, 1946. (Possibly No. 74.)

50 *The Sanctuary*, c. 1918. Oil. Reference: Catalogue, Bourgeois Galleries, March–April 1918.

51 *Song of the Nightingale*, c. 1918. Oil. 16 x 9⅞. Collection, Dallas Museum of Fine Arts, Dallas, Texas.

52 *Spring*. See Figure 47.

53 *Brooklyn Bridge*. See Figure 50.

54 *Pittsburgh*, c. 1919. Oil on glass. Reference: Catalogue, Bourgeois Galleries, May 1919.

55 *Sonata Rusticana*, c. 1919. Reference: Catalogue, Bourgeois Galleries, May 1919.

56 *Tree of My Life*. See Figure 59.

57 Untitled. See Figure 60.

58 *Aria (Canto Paesano)*, c. 1920. Oil on glass. Reference: Catalogue, Bourgeois Galleries, *Joseph Stella*.

59 *By the Sea*, 1920. Oil. Collection, Rabin and Krueger Gallery. Reference: Catalogue, Seton Hall University.

60 *Melon*, 1920. Oil. Collection, Rabin and Krueger Gallery. Reference: Catalogue, Seton Hall University.

61 *New York Interpreted*. See Figure 75a–e.

62 *The Stork*, c. 1920. Oil. Reference: Catalogue, Bourgeois Galleries, *Joseph Stella*.

63 *The Sun Through My Window*, c. 1920. Oil. Reference: Catalogue, Bourgeois Galleries, *Joseph Stella*.

64 *Water Lily*, c. 1920. Oil on glass. Reference: Catalogue, Bourgeois Galleries, *Joseph Stella*.

65 *Factories*. See Figure 71.

66 *Factories*. See Figure 72.

67 *Factories At Night – New Jersey*. See Figure 73.

68 *Smoke Stacks*. See Figure 74.

69 *Tropical Sonata*. See Figure 76.

70 *Birth of Venus*. See Figure 79.

71 *Dance of Spring*, 1922. Oil. Reference: *Stella*, "Discovery," p. 14. Illustrated: New York *Times* Magazine, October 12, 1924. Catalogue, Dudensing Galleries, 1925, illustrated.

72 *Fish (Ricordo Marino)*, c. 1922. Reference: Catalogue, Angiporto Galleria, *Giuseppe Stella*, Naples, 1929, illustrated.

73 *Leda and the Swan*, c. 1922. Oil. 42½ x 46½. Estate of Joseph Stella. Illustrated: Jaffe, "Stella."

74 *Man in the Elevator (Man on the Elevated)*, c. 1922. Oil on glass. Refer-

ence: Catalogue, Whitney Museum of American Art, *Abstract Painting in America*, 1935. (Possibly No. 49.)

75 *Study for Undine*, 1922. Oil. 20 x 22 (approximately). Collection, August Mosca.

76 *Undine*. See Figure 80.

77 *The Virgin*. See Figure 81.

78 *The Amazon*. See Figure 82.

79 *The Palm*, c. 1924. Oil. Reference: Catalogue, Angiporto Galleria, illustrated.

80 *The Swan*, c. 1924. Oil. 45 diameter. Estate of Joseph Stella. Catalogue, Whitney Museum of American Art, *Joseph Stella*. Illustrated: Jaffe, "Stella."

81 *Lyre Bird*, c. 1925. Oil. 54 x 38. Collection, Addison Gallery of American Art.

82 *Portrait of Helen Walser*. See Figure 83.

83 *Sunrise*, c. 1925. Oil. Reference: *International Studio*, July 1926.

84 *Three Swans*, c. 1925. Oil. 44 x 44. Collection, Sergio Stella.

85 *Tropical Landscape*, c. 1925. Oil. Reference: Dreier, *Modern Art*, illustrated.

86 *The Vision*, c. 1925. Oil. 78¾ x 10¾ (sight). Estate of Joseph Stella. Illustrated: Jaffe, "Stella."

87 *Apotheosis of the Rose*. See Figure 84.

88 *Arabesques*, c. 1926. Encaustique. Reference: Catalogue, New Gallery Art Club, *Joseph Stella*, April 1926.

89 *Bird*, c. 1926. Encaustique. Reference: Catalogue, New Gallery Art Club, *Joseph Stella*.

90 *Birds*, c. 1926. Encaustique. Reference: Catalogue, New Gallery Art Club, *Joseph Stella*.

91 *The Cats*, c. 1926. Oil. Reference: Catalogue, City Library Gallery, Des Moines, Iowa, *Joseph Stella*, May 1926.

92 *Denise and Dog*, c. 1926. Encaustique. Reference: Catalogue, City Library Gallery, Des Moines, Iowa, *Joseph Stella*.

93 *Elevation – Flower* (3), c. 1926. Encaustique. Reference: Catalogue, New Gallery Art Club, *Joseph Stella*.

94 *Gladiolas*, c. 1926. Encaustique. 13⅝ x 10⅜. Collection, Mrs. Dorothy Omansky. Reference: Catalogue, New Gallery Art Club, *Joseph Stella*.

95 *Mater Dei*, c. 1926. Oil. 38¾ x 38¾. Estate of Joseph Stella. Illustrated: Jaffe, "Stella."

96 *Nude*, c. 1926. Encaustique. Reference: Catalogue, New Gallery Art Club, *Joseph Stella*.

97 *Nude*, c. 1926. Encaustique. Reference: Catalogue, New Gallery Art Club, *Joseph Stella*.

98 *Ophelia*. See Figure 86.

99 *Pastoral*, c. 1926. Tempera. 57 diameter. Estate of Joseph Stella.

100 *Pelican* (2), c. 1926. Encaustique. Reference: Catalogue, New Gallery Art Club, *Joseph Stella*.

101 *Persian Lady*, c. 1926. Oil. Collection, Rabin and Krueger Gallery. Reference: Catalogue, Seton Hall University. (Possibly Nos. 112, 160.)

102 *Portrait of Artist's Father*, c. 1926. Encaustique. Reference: Catalogue, New Gallery Art Club, *Joseph Stella*.

103 *Portrait of Carlo de Fornaro*, c. 1926. Encaustique. Reference: Catalogue, New Gallery Art Club, *Joseph Stella*.

104 *Portrait of Helen Walser Wearing a Shawl*, 1926. Oil. 29¼ x 23. Collection, Mrs. Nathan Krueger, Newark, N.J. Illustrated: *International Studio*, July 1926.

105 *Portrait of Kathleen Millay*, c. 1926. Encaustique. 28½ x 22. Collection, Rabin and Krueger Gallery. Illustrated: Porpora, "Stella."

106 *Portrait of a Lady*, c. 1926. Encaustique. Reference: Catalogue, New Gallery Art Club, *Joseph Stella*.

107 *Portrait of Miss Liebman*, c. 1926. Encaustique. Reference: Catalogue, New Gallery Art Club, *Joseph Stella*.

108 *Portrait of Norma Millay*, c. 1926. Encaustique. Reference: Catalogue, New Gallery Art Club, *Joseph Stella*.

109 *Scherzo*, c. 1926. Encaustique. Reference: Catalogue, New Gallery Art Club, *Joseph Stella*.

110 *Scherzo (Portrait of Woman with Bird)*, c. 1926. Oil. Reference: Catalogue, City Library Gallery, Des Moines, Iowa, *Joseph Stella*, May 1926. (Possibly No. 179.)

111 *Veiled Woman*, c. 1926. Oil. 44 x 30. Collection, Rabin and Krueger Gallery. (Possibly Nos. 101, 160.) Catalogue, Angiporto Galleria, illustrated.

112 *Water Lily*, c. 1926. Encaustique. Reference: Catalogue, New Gallery Art Club, *Joseph Stella*.

113 *Edna St. Vincent Millay*, c. 1927. Oil. Collection, Rabin and Krueger Gallery. Reference: Catalogue, Seton Hall University.

114 *Flowers (Roses)*, c. 1927. Oil. 15 x 18⅛. Collection, Dr. and Mrs. Franklin Simon, Millburn, N.J.

115 *The Little Lake*. See Figure 87.

116 *Morning*. See Figure 88.

117 *Purissima*, c. 1927. Oil. 75 x 57 (sight). Estate of Joseph Stella. Exhibited: Valentine Gallery, April 1928. Illustrated: *Italiani pel Mondo*, August 1928, p. 809; Jaffe, "Stella."

118 *Vesuvius*, c. 1927. Oil. Collection, Rabin and Krueger Gallery. Reference: Catalogue, Seton Hall University.

119 *Carolina*, c. 1928. Oil. Reference: Catalogue, Valentine Gallery, *Joseph Stella*, April 1928.

120 *Concertino*, c. 1928. Oil. Reference: Catalogue, Valentine Gallery, *Joseph Stella*.

121 *Twilight (Crepuscule Premier)*, c. 1928. Oil. 16 x 16. Estate of Joseph Stella. Catalogue, Schoelkopf Gallery, *Joseph Stella*, November 1963.

122 *Lemons*, c. 1928. Oil. Reference: Catalogue, Valentine Gallery, *Joseph Stella*.

123 *Mannequins*, 1928. Oil. Collection, Rabin and Krueger Gallery. Reference: Catalogue, Seton Hall University.

124 *Muro Lucano*. See Figure 89.

125 *Neapolitan Song (Canzone Napoletana)*, c. 1928. Oil. 15½ x 25½. Collection, Sergio Stella. Illustrated: *Italiani pel Mondo*, August 1928.

126 *Old Church*, c. 1928. Oil. Collection, Rabin and Krueger Gallery. Reference: Catalogue, Seton Hall University.

127 *Pulcinella (Addio alle Maschere)*, c. 1928. Oil. Reference: Catalogue, Angiporto Galleria. Illustrated: *Emporium*, LXIX, June 1929.

128 *Sirenella*. See Figure 90.

129 *Song of Birds*, c. 1928. Oil. Collection, Dr. and Mrs. Robert Jones, Westfield, N.J. Reference: Catalogue, Seton Hall University, illustrated.

130 *Swan of Death (Black Swan)*, c. 1928. Oil. 20¾ x 31. Estate of Joseph Stella. Catalogue, Angiporto Galleria; catalogue, Galerie Sloden (Paris), *Joseph Stella*, May 1930, listed as *Black Swan*, and so illustrated, *Herald Tribune* (Paris), June 28, 1931; catalogue, Whitney Museum of American Art, *Joseph Stella*, *Black Swan*, illustrated; Jaffe, "Stella."

131 *Three Flowers*, c. 1928. Oil. Collection, Rabin and Krueger Gallery. Reference: Catalogue, Seton Hall University.

132 *Tree at Nice*, c. 1928. Oil. Collection, Rabin and Krueger Gallery. Reference: Catalogue, Seton Hall University.

133 *Village Church*, c. 1928. Oil. 20 x 16. Estate of Joseph Stella. Catalogue, Schoelkopf Gallery, *Joseph Stella*, illustrated.

134 *American Landscape*. See Figure 91.

135 *Construction – Paris (Factories?)*, c. 1929. Oil. 33½ x 23¼. Collection, Rabin and Krueger Gallery. Catalogue, Schoelkopf Gallery, *Joseph Stella*, illustrated.

136 *Country Priest, Italy*, c. 1929. Oil. Reference: Catalogue, The Newark Museum, Newark, N.J., *Joseph Stella*, 1939.

137 *Exotic Landscape with Palm Tree*, c. 1925. Oil. 34 x 28½. Collection, Dr. and Mrs. Henry L. Kaplan, Newark, N.J.

138 *Exotic Landscape with Palm Tree and Birds*, c. 1925. Oil. Reference: Dreier, *Modern Art*, illustrated.

139 *The Fountain*, 1929. Oil. 46 x 37¼. Collection, Rabin and Krueger Gallery.

140 *Gas Tank*, c. 1929. Oil. 16 x 20. Collection, Schoelkopf Gallery. Catalogue, Schoelkopf Gallery, *Joseph Stella*, illustrated.

141 *The Ox*. See Figure 93.

142 *Lent, Italy*, c. 1929. Oil. Reference: Catalogue, The Newark Museum, *Joseph Stella*.

143 *Lily*, c. 1929. Oil. Reference: Catalogue, Valentine Gallery, *Joseph Stella*, November–December 1931.

144 *Lotus*, 1929. Oil. 21½ x 25¾. Collection, Joseph H. Hirshhorn Foundation.

145 *Lotus Flower*, c. 1929. Oil. 8⅞ x 10¼ (sight). Collection, M. Knoedler and Co. Inc.

146 *Marchande de Gargouilles*, c. 1929. Oil. Reference: *Logique*, March 30, 1934, illustrated.

147 *Neapolitan Song*. See Figure 92.

148 *Prayers for the Souls in Purgatory: Old Woman with Cat*, 1929. Oil. 34¼ x 38. Estate of Joseph Stella.

149 *The Red Flower*, 1929. Oil. 57½ x 38½. Estate of Joseph Stella. Catalogue, Galerie Sloden, Paris, 1930. Illustrated: *Art in America*, October 1963.

150 *St. Peter (Peter Anselmo)*, c. 1929. Oil. 10¾ x 8. Reference: Catalogue, Museum of Modern Art, *Twentieth Century Portraits*, 1942.

151 *Sirens*, c. 1929. Oil. Reference: Catalogue, Valentine Gallery, *Joseph Stella*, November–December 1931.

152 *Souls in Purgatory*, 1929. Oil. 38¾ x 31 (sight). Estate of Joseph Stella. Catalogue, Angiporto Galleria, illustrated.

153 *Souls in Purgatory* (3), c. 1929. Oil. Reference: Catalogue, Angiporto Galleria, *Giuseppe Stella*.

154 *Still Life*, c. 1929. Oil. 15 x 24¼. Collection, Whitney Museum of American Art. Catalogue, Whitney Museum of American Art, *Joseph Stella*.

155 *Still Life with Yellow Melon*. See Figure 95.

156 *Twilight, Italy*, c. 1929. Oil. Reference: Catalogue, The Newark Museum, *Joseph Stella*.

157 *The Village*, c. 1929. Oil. 130 x 97. Estate of Joseph Stella.

158 *Africa, Algiers*, c. 1930. Oil. Reference: Catalogue, The Newark Museum, *Joseph Stella*.

159 *African Tree*, c. 1930. Oil. 36 x 31. Estate of Joseph Stella. Catalogue, Whitney Museum of American Art, *Joseph Stella*, under title of *Banyan Tree*.

160 *Arab Woman, Algiers, Africa (Persian Woman)*, c. 1930. Oil. 44 x 30. (Possibly Nos. 101, 112.) Reference: Catalogue, The Newark Museum, *Joseph Stella*.

161 *Evening*, c. 1930. Oil. Reference: Catalogue, Valentine Gallery, *Joseph Stella*.

162 *Flowers, Italy*, c. 1930. Oil. 75 x 75. Collection, Phoenix Art Museum,

Phoenix, Ariz. Reference: Catalogue, The Newark Museum, *Joseph Stella*, illustrated.

163 *Forest Cathedral*, 1930. Oil. 46½ x 37¾. Estate of Joseph Stella. Catalogue, Whitney Museum of American Art, *Joseph Stella*, illustrated.

164 *Green Apple*, c. 1930. Oil. 30¼ x 21¼. Estate of Joseph Stella. Catalogue, Whitney Museum of American Art, *Joseph Stella*. Illustrated: Jaffe, "Stella."

165 *Green Leaf, Algiers, Africa*, c. 1930. Oil. Reference: Catalogue, The Newark Museum, *Joseph Stella*.

166 *Head of Christ*, c. 1930. Oil. 9½ x 7½. Collection, Mr. and Mrs. Herbert A. Goldstone.

167 *Lights*, c. 1930. Oil. Reference: Catalogue, Whitney Museum of American Art, *Abstract Painting in America*.

168 *Marionettes*. See Figure 96.

169 *New Jersey Smokestacks*, c. 1930. Oil. Reference: Catalogue, Whitney Museum of American Art, *Abstract Painting in America*.

170 *Nocturne*, c. 1930. Oil. 18 x 23. Reference: New York Public Library folder: Parke Bernet sale, May 4, 1945, Egner Collection.

171 *Nocturne*, c. 1930. Oil. 25½ x 32⅛. Collection, Dr. Norman Linde, Millburn, N.J. (Also titled *Christmas Eve*; illustrated: *Esquire*, July 1941.)

172 *Paesaggio*, c. 1930. Oil. Reference: *L'Italia Letteraria* (Italian newspaper), July 19, 1931, illustrated.

173 *Song of the Nightingale*, 1930. Oil. Reference: *Herald Tribune* (Paris), June 28, 1931, illustrated. See catalogue note, Figure 46.

174 *Swans and Crane*, 1930. Oil. 39¼ x 49. Estate of Joseph Stella.

175 *Bird in Tropical Forest*, c. 1931. Oil. Reference: photograph among Stella's papers.‡

176 *Impression of Venice*. See Figure 97.

177 *Pea Hen and Tropical Foliage*, c. 1931. Oil. Reference: photograph among Stella's papers.‡

178 *Pomegranate*, c. 1931. Oil. Reference: photograph among Stella's papers, inscribed on back: Joseph Stella "Pomegranade, il miglior [illegible word] alla recente eposizione della *Jeune Europe* diretta da Antonio Aniante, Montparnasse, gennaio 1932."

179 *Portrait (Girl in Black with Bird)*, c. 1931. Oil. Reference: *Il Resto del Carlino* (Italian newspaper), May 19, 1932, illustrated; Catalogue, The Newark Museum, *Joseph Stella*, illustrated. (Possibly No. 110.)

180 *Paris Rooftops* (possibly also titled *View from Paris Studio*). See Figure 98.

181 *Waterlily* (or *Lotus*), 1931. Oil. 13 x 18. Collection, Mr. and Mrs. Chiam Gross.

182 *Gray and White (Still Life)*, c. 1932. Oil. 35 x 27½. Estate of Joseph Stella.

183 *Portrait of Woman in Pink Dress*, c. 1932. Oil. 25½ x 32. Collection, Sergio Stella.

184 *Self-Portrait*, c. 1932. Oil. 16½ x 17½. Estate of Joseph Stella.

185 *Woman with Black Fan, I*, c. 1932. Oil. 36 x 36. Estate of Joseph Stella. Illustrated: Jaffe, "Stella."

186 *Woman with Black Fan, II*, c. 1932. Oil. 43 x 32¼ (sight). Estate of Joseph Stella. Illustrated: Jaffe, "Stella."

187 *Head of Christ*. See Figure 99.

188 *Head of a Woman (Madonna?)*, c. 1933. Oil. 9¼ x 7⅜. Collection, Rabin and Krueger Gallery.

189 *The Holy Manger*. See Figure 100.

190 *Portrait (A prophet?)*, c. 1933. Oil. 18 x 14⅜. Collection, Joseph H. Hirshhorn Foundation.

191 *Self-Portrait as an Arab*, c. 1933. Oil. 32 x 29. Estate of Joseph Stella. Catalogue, Valentine Gallery, January 1935. Illustrated: *Art Digest*, January 1935, p. 8.

192 *The Sparrows*, c. 1933. Oil. 36 x 24. Estate of Joseph Stella. Catalogue, The Newark Museum, *Joseph Stella*, illustrated.

193 *Still Life with Pomegranate*, c. 1933. Oil. 18¼ x 24. Collection, Rabin and Krueger Gallery.

194 *The Tree – Nice*, c. 1933. Oil. Collection, Rabin and Krueger Gallery. Catalogue, A.C.A. Gallery, *Joseph Stella*, November 1943, illustrated.

195 *Two Apostles*, 1933. Oil on wood. 9¼ x 11⅞. Collection, Sergio Stella.

196 *Two Peasants*, c. 1933. Oil. 14 x 10. Collection, Sergio Stella.

197 *Bridge*. See Figure 101.

198 *Old Couple at Prayer*, c. 1936. Oil. 23 x 17. Estate of Joseph Stella. Catalogue, Schoelkopf Gallery, *Joseph Stella*, illustrated.

199 *Spring*, c. 1936. Oil. 24 x 30. Collection, The State University College, Potsdam, N.Y.

200 *Spring in the Bronx*, c. 1936. Oil. 60 x 40. Estate of Joseph Stella. Illustrated: *Il Progresso Italo-Americano*, March 21, 1937; catalogue, The Newark Museum, 1939.

201 *Study for Underground Cathedral*, 1936. Oil. 42 x 16½. Estate of Joseph Stella. A label on the back of the canvas bears the date 1936.

202 *Christmas Fantasy* (also called *The Fountain*), 1937. Oil. 27 x 24. Collection, Rabin and Krueger Gallery. Catalogue, The Newark Museum, *Joseph Stella*, illustrated.

203 *Self-Portrait*. See Figure 102.

204 *Sergio as Arab Sheik*, 1937. Oil. Collection, Sergio Stella.

205 *The Skyscrapers*, 1937. Oil. 36 x 30. Collection, The Wood Art Gallery, Montpelier, Vt.

206 *Wine Drinker*, 1937. Oil. Reference: *Art Digest*, November 15, 1937, illustrated.

207 *Barbados, Tropical Foliage*, c. 1938. Oil. 25¾ x 21⅜. Collection, Sergio Stella.

208 *Italian Village*, c. 1938. Oil. Reference: Catalogue, The Newark Museum, *Joseph Stella.*

209 *Italian Princess*, 1938. Oil. 35 x 19⅜. Estate of Joseph Stella. Illustrated: *Esquire*, July 1941.

210 *The Joy of Living*, 1938. Oil. 43¼ x 31. Collection, Bernard Rabin, Newark, N.J. Illustrated: *Esquire*, July 1941.

211 *Nude, Barbados*, c. 1938. Oil. 40½ x 31½ (sight). Estate of Joseph Stella. Illustrated: Jaffe, "Stella."

212 *Poinsettia*, c. 1938. Oil. 16¼ x 20. Collection, Sergio Stella.

213 *Song of Barbados.* See Figure 103.

214 *Tree, Barbados*, c. 1938. Oil. 24 x 15¼. Collection, Rabin and Krueger Gallery.

215 *Brooklyn Bridge: Variation on an Old Theme.* See Figure 104.

216 *The Bread*, 1940. Oil. 53 x 42½. Estate of Joseph Stella. Illustrated: Jaffe, "Stella."

217 *Floral Garden*, c. 1940. Oil. 16 x 15⅞. Collection, Seattle Art Museum, Seattle, Washington.

218 *Full Moon, Barbados.* See Figure 105.

219 *Golden Fall*, 1940. Oil. 25½ x 20½. Estate of Joseph Stella.

220 *Green and Gold Still Life*, c. 1940. Oil. 16 x 12. Estate of Joseph Stella. Catalogue, Schoelkopf Gallery, *Joseph Stella*, illustrated.

221 *In the Jungle*, 1940. Oil. 38½ x 27½. Estate of Joseph Stella.

222 *Nocturne*, c. 1940. Oil. Collection, Dr. Norman Linde. Reference: Catalogue, Seton Hall University.

223 *Profile*, c. 1940. Oil. 25 x 18. Collection, Joseph H. Hirshhorn Foundation.

224 *St. Francis*, c. 1940. Oil. 16 (diameter). Collection, Rabin and Krueger Gallery.

225 *Self-Portrait*, c. 1940. Oil. 17 x 20⅞. Collection, Rabin and Krueger Gallery.

226 *Still Life with Eggplant*, c. 1940. Oil. 13 x 18. Estate of Joseph Stella.

227 *Zucchini and Low Urn*, c. 1940. Oil. 18¼ x 24½. Estate of Joseph Stella.

228 *Old Brooklyn Bridge.* See Figure 107.

229 *Portrait of Abraham Walkowitz*, 1941. Oil. Reference: Catalogue, Brooklyn Museum, *One Hundred Artists and Walkowitz*, 1942, illustrated.

230 *Portrait of Carol Stella* (unfinished), c. 1942. Oil. 30 x 24. Collection, Sergio Stella.‡

231 *Portrait of Clara Fasano*, c. 1943. Oil. 30 x 24 (approximately). Collection, Jean de Marco and Clara Fasano.‡

232 *Still Life with Putto and Figurines*, 1943. Oil. 20 x 15¾. Collection, Max Granick.

233 *Portrait of Moses Soyer*, 1944. Oil. 10 x 7½. Collection, The Brooklyn Museum.

234 *Portrait of Grace Price*, 1944. Oil. 23 x 20. Collection, Sergio Stella.‡

235 *Still Life*, 1944. Oil and gouache on paper. 28 x 21. Collection, Dr. and Mrs. Leonard Weinstock, Plainfield, N.J. Catalogue, Whitney Museum of American Art, *Joseph Stella*, illustrated.

236 *Crucifixion*, n.d. Oil. 21½ x 18⅛. Collection, Sergio Stella.

237 *By the Sea*, n.d. Oil. 12¼ x 21½. Collection, Stanley Ross, Maplewood, N.J.

238 *Deposition*, n.d. Oil? Collection, Helena Rubenstein.

239 *Green Hilltops*, n.d. Oil. 13 diameter. Estate of Joseph Stella.

240 *King of Beggars*, n.d. Oil. 75 x 34. Collection, Iowa State Education Association, Des Moines, Iowa.

241 *Lilies*, n.d. Oil. 38 x 18 (approximately). Collection, Jean de Marco and Clara Fasano.‡

242 *Lilies in Slender Pitcher* (unfinished), n.d. Oil. 41 x 25½. Collection, Sergio Stella.‡

243 *Muro Lucano*, n.d. Oil. 4 x 5. Reference: Catalogue, Zabriskie Gallery, April–May 1958.

244 *Nocturne*, n.d. Oil. 15 x 19. Collection, Mr. and Mrs. Mac Rabinowitz, Brooklyn, N.Y.

245 *Pomona*, n.d. Reference: Catalogue, City Library Gallery, Des Moines, Iowa, *Joseph Stella*, May 1926, spelled Pamona; also listed in catalogue of Whitney Museum of American Art, *Third Biennial of Contemporary American Painting*, 1936 (possibly different paintings).

246 *Pompeii*, n.d. Oil. 18 x 24 (approximately). Collection, Jean de Marco and Clara Fasano.‡

247 *Portrait of Artist's Mother*, n.d. Oil. 19⅛ x 14⅛. Collection, Sergio Stella.

248 *Siesta*, n.d. Oil. 8 x 12. Collection, William Clarey.

249 *Vesuvius*, n.d. Oil. 8 x 6¾. Collection, Joseph H. Hirshhorn Foundation.

250 *Voices of Spring*, n.d. Oil. 42 x 32. Collection, Dr. and Mrs. Robert Jones.

251 *Waterlilies*, n.d. Oil. 8½ x 11½. Collection, Joseph H. Hirshhorn Foundation.

252. *Woman*, n.d. Oil. 24 x 18½. Collection, Sergio Stella.

253 *Woman at Feast of Passover*, n.d. Oil. Reference: Catalogue, *Second Annual Pepsi-Cola Competition and Exhibition*, 1945.

Crayons, Gouaches, Pastels, Watercolors

254 *The Immigrants*, c. 1902. Charcoal and watercolor. Collection, Mr. and Mrs. Stanley Sadkin, Newark, N.J. Reference: Catalogue, Seton Hall University, illustrated.

255 *Old Man and Woman*, c. 1902. Pastel. Collection, Mr. and Mrs. Samuel Denberg. Reference: Catalogue, Seton Hall University, illustrated.

256 *Head of Woman*, 1908. Charcoal and pastel. 19 x 15 (sight). Collection, Sergio Stella. Catalogue, Whitney Museum of American Art, *Joseph Stella*.

257 *Abstraction*, between 1914–1918. Pastel. 11½ diameter. Collection, Mrs. Edith Gregor Halpert.

258 *Abstraction, Garden*. See Figure 34.

259 *Composition: Mardi Gras*, 1914. Watercolor and gouache. 8¾ x 11½. Collection, Mr. and Mrs. Sidney E. Cohn. Catalogue, Whitney Museum of American Art, *Joseph Stella*.

260 *Composition*. See Figure 35.

261 *Coney Island*, c. 1914. Pastel. Reference: Catalogue, Galerie Montaigne, Paris, May–June 1922.

262 *Landscape*, 1914. Watercolor. 15¾ x 20¼. Collection, Philadelphia Museum of Art, Philadelphia, Pennsylvania.

263 *Mardi Gras*, between 1914–1918. Watercolor and gouache. 8¾ x 11½. Collection, William S. Zierler, Indiana.

264 *Sunlight and Water*, 1914. Pastel. 17 x 22¼ (sight). Collection, Mr. and Mrs. Emanuel M. Terner, South Orange, N.J. Catalogue, Whitney Museum of American Art, *Joseph Stella*, illustrated.

265 *Untitled (abstraction)*, between 1914–1918. Pastel. 16 x 10½. Collection, Mrs. McCook Knox, Washington, D.C.

266 *Horizon*, c. 1916. Pastel. 18 x 24. Collection, Rabin and Krueger Gallery.

267 *Landscape*, c. 1916. Pastel. 22 x 17. Collection, Metropolitan Museum of Art. Illustrated: Henry Geldzahler, *American Painting in the Twentieth Century*, 1965.

268 *Old Brooklyn Houses*, c. 1916. Pastel. 19½ x 27. Estate of Joseph Stella. Catalogue, Whitney Museum of American Art, *Joseph Stella*.

269 *Abstract with Bird*, c. 1917. Pastel. 21½ x 17¼ (sight). Collection, Rabin and Krueger Gallery.

270 *Brooklyn Bridge*, 1917? Watercolor. 11¾ x 8½. Collection, Dr. Frederick Wertham.

271 *Brooklyn Bridge*, 1917? Watercolor. 11¾ x 8¾. Collection, Dr. Frederick Wertham.

272 *The Country Church*, c. 1917. Pastel. Reference: Catalogue, Bourgeois Galleries, October–November 1917.

273 *Landscape (abstraction)*, c. 1917. Watercolor. 10½ x 7⅝. Collection, Rabin and Krueger Gallery.

274 *Night*. See Figure 40.

275 *Study for Brooklyn Bridge*, 1917? Watercolor and gouache. 3¾ x 3 (sight). Collection, Dr. Frederick Wertham.

276 *Study, New York*, 1917? Watercolor on tracing paper with crayon. 20¼ x 16⅜ (sight). Collection, Schoelkopf Gallery.

277 *Abstraction*, c. 1918. Pastel. 25½ x 19. Collection, Zabriskie Gallery. Catalogue, Whitney Museum of American Art, *Joseph Stella.*

278 *Factories*, c. 1918. Pastel and charcoal. 21½ x 27½. Collection, Joseph H. Hirshhorn Foundation. Catalogue, Whitney Museum of American Art, *Joseph Stella.*

279 *Jungle Foliage*, c. 1918. Pastel. 25 x 18½ (sight). Collection, George Hopper Fitch. Catalogue, Whitney Museum of American Art, *Joseph Stella.*

280 *The Sacrifice. A Caproni Plane Ramming a German Balloon*, 1918. Charcoal and pastel. Reference: cover, *The Independent*, July 20, 1918, illustrated.

281 *Sketch for Brooklyn Bridge*, c. 1918. Pastel. 25 x 19. Collection, Mrs. Edith Gregor Halpert.

282 *The Song of the Nightingale.* See Figure 46.

283 *Study for Brooklyn Bridge*, c. 1918. Watercolor? Collection, Edwin Wolf, Washington, D.C.‡

284 *Study for Brooklyn Bridge.* See Figure 48.‡

285 *Study for Brooklyn Bridge.* See Figure 49.

286 *Study for Brooklyn Bridge*, c. 1918. Pastel, watercolor, and crayon. 12¾ x 22 (lunette). Collection, Mr. and Mrs. Moses Soyer.‡

287 *Abstraction with Blue Discs*, c. 1919. Gouache. 6⅞ x 3. Collection, Mr. and Mrs. Harry L. Koenigsberg.

288 *Brooklyn Bridge (New York Interpreted?)*, 1919. Crayon. 22 x 17¼. Collection, Lawrence H. Bloedel, Williamstown, Mass.

289 *A Child's Prayer.* See Figure 51.

290 *Fantasy with Zucchini*, c. 1919. Pastel 18 x 24 (sight). Estate of Joseph Stella. Catalogue, Whitney Museum of American Art, *Joseph Stella.* Illustrated: Jaffe, "Stella."

291 *Flowering Cactus*, 1919. Crayon. 13¼ x 9⅝. Collection, Sergio Stella.

292 *Flower Study*, c. 1919. Crayon, 9¾ x 11¾ (sight). Collection, Sergio Stella.

293 *Flower Study*, c. 1919. Crayon. 10½ x 12⅞. Collection, Sergio Stella.

294 *Lotus* (or *Water Lily*), c. 1919. Crayon, 13⅛ x 9⅜. Collection, Mr. and Mrs. Harry L. Koenigsberg.

295 *Lupine.* See Figure 54.

296 *Moon Dawn.* See Figure 55.

297 *Nativity.* See Figure 56.

298 *The Peacock*, c. 1919. Pastel. Reference: Catalogue, Bourgeois Galleries, *Joseph Stella.*

299 *Pomegranate.* See Figure 57.

300 *Profile of a Girl*, 1919. Gouache. 20 x 16 (sight). Collection, August Mosca.

301 *Pyrotechnic Fires*, 1919. Pastel. 40 x 29½ (sight). Estate of Joseph Stella. Exhibited but not catalogued, Whitney Museum of American Art, *Joseph Stella*.

302 *Serenade*, c. 1919. Pastel? Reference: Catalogue, Bourgeois Galleries, May 1919; illustration, *The Detroit Sunday News*, August 3, 1919.

303 *Still Life*, c. 1919. Pastel. 28 x 19¾. Collection, Joseph H. Hirshhorn Foundation.

304 *Sunflower*. See Figure 58.

305 *Tropical Plants*, c. 1919. Pastel. 19 x 25. Collection, Mr. and Mrs. John D. Frisoli, Short Hills, N.J.

306 *Abstraction: Study for New York Interpreted*, between 1920–1922. Watercolor. 9 x 7. Collection, The Downtown Gallery.

307 *Boy*, c. 1920. Pastel. Collection, Mr. and Mrs. Lewis S. Kaufman, Newark, N.J. Reference: Catalogue, Seton Hall University, illustrated.

308 *Bridge and Buildings*, c. 1920. Watercolor. 28½ x 21⅛. Collection, Mr. and Mrs. Emanuel M. Terner.

309 *Building Forms*, c. 1920. Watercolor. 24¼ x 17¾ (sight). Collection, Joseph H. Hirshhorn Foundation. Catalogue, Whitney Museum of American Art, *Joseph Stella*.

310 *City, Abstract*, between 1920–1922. Crayon, 14¼ x 19. Collection, Rabin and Krueger Gallery.

311 *New York*, between 1920–1922. Watercolor. 24 x 20. Collection, Mr. and Mrs. Alan Rosenthal.

312 *Night Fires*, c. 1920. Pastel. 22½ x 29. Collection, Mrs. Edith Gregor Halpert. Catalogue, Whitney Museum of American Art, *Joseph Stella*.

313 *Orange Bars*. See Figure 64.

314 *Sketch for Brooklyn Bridge (New York Interpreted)*, between 1920–1922. Pastel. 21 x 17½. Collection, Whitney Museum of American Art. Catalogue, Whitney Museum of American Art, *Joseph Stella*.

315 *Sketch for New York Interpreted*, "The Bridge." See Figure 70.

316 *Skyscraper, Study for New York Interpreted*, between 1920–1922. Pencil and crayon. 10⅞ x 8¾. Collection, Rabin and Krueger Gallery.

317 *Steel Mill*, c. 1920. Gouache. 17 x 12. Collection, The Downtown Gallery. Catalogue, Whitney Museum of American Art, *Joseph Stella*. Illustrated: *New York Sunday Times Book Review Section*, January 7, 1951.

318 *Study for Brooklyn Bridge (New York Interpreted)*, between 1920–1922. Ink and gouache. 6 x 4. Collection, Joseph H. Hirshhorn Foundation.

319 *Study for Brooklyn Bridge (New York Interpreted)*, between 1920–1922. Watercolor. 17 x 12. Colelction, Joseph H. Hirshhorn Foundation.

320 *Study for New York Interpreted*, between 1920–1922 (Two watercolors

framed together). 11 x 4¾ (sight) each. Collection, Mr. and Mrs. Samuel Halpern, East Orange, N.J.

321 *Study for New York Interpreted*, between 1920–1922. Watercolor and crayon. 20½ x 15½. Collection, Salpeter Gallery.

322 *Study for New York Interpreted*, between 1920–1922. Pencil and crayon. 10½ x 7⅜. Collection, Rabin and Krueger Gallery.

323 *Study for New York Interpreted*. See Figure 66.

324 *Study for New York Interpreted*, between 1920–1922. Gouache and charcoal. 21 x 16¼. Collection, Anonymous (information courtesy of August Mosca).

325 *Telegraph Pole*. See Figure 69.

326 *Telegraph Wires*, c. 1920. Watercolor. 6½ x 8⅞. Collection, Mr. and Mrs. Walter Fillin.

327 *Three Studies for New York Interpreted*. See Figure 67a-c and Figure 68a-c.

328 *Study for Brooklyn Bridge, New York Interpreted*, 1922. Watercolor. 21½ x 17½ (sight). Collection, D'Arcy Gallery.

329 *New York Interpreted* (?), 1923? Gouache and ink. 11 x 8½. Collection, The Downtown Gallery.

330 *Song of Birds*, c. 1924. Pastel. 42¼ x 32. Collection, Dr. and Mrs. Robert Jones.

331 *Apple*, c. 1924. Red pencil. 11½ x 10⅝ (sight). Collection, Schoelkopf Gallery.

332 *Christ in the Temple*, c. 1925. Reference, Catalogue, City Library Gallery, Des Moines, Iowa, *Joseph Stella*, June 1926.

333 *Kathleen Millay*, c. 1925. Crayon. 28⅛ x 22. Collection, Sergio Stella.

334 *New York Interpreted* (?), 1925? Crayon and pencil. 12 x 8. Collection, The Downtown Gallery.

335 *Cypress*, c. 1926. Watercolor. 40¼ x 27⅛ (sight). Estate of Joseph Stella.

336 *Cypress*, c. 1926. Gouache. 13 x 9. Collection, Mr. and Mrs. Herbert A. Goldstone.

337 *Cypress Tree*. See Figure 85.

338 *Still Life*, c. 1926. Oil? 15⅛ x 18. Collection, Dr. Norman Linde.

339 *Corner of Wood*, c. 1927. Watercolor. Reference: Catalogue, Valentine Gallery, *Joseph Stella*.

340 *Egg Plant*, c. 1927. Watercolor. Reference: Catalogue, Valentine Gallery, *Joseph Stella*.

341 *Flowers*, c. 1927. Watercolor. Reference: Catalogue, Valentine Gallery, *Joseph Stella*.

342 *The Haystack*, c. 1927. Watercolor. Reference: Catalogue, Valentine Gallery, *Joseph Stella*.

343 *Landscape, South Italy*, c. 1927. Watercolor. Reference: Catalogue, Valentine Gallery, *Joseph Stella*.

344 *Pomegranates*, c. 1927. Watercolor. Reference: Catalogue, Valentine Gallery, *Joseph Stella*.

345 *Red Flower*, c. 1927. Gouache. 31 x 23. Collection, August Mosca.

346 *Red Lilies*, c. 1927. Watercolor. Reference: Catalogue, Valentine Gallery, *Joseph Stella*.

347 *Sonata Rustica*, c. 1927. Watercolor. Reference: Catalogue, Valentine Gallery, *Joseph Stella*.

348 *Tropical Floral Composition*, c. 1927. Gouache. 13¾ x 10. Collection, Mrs. Ann Davanzo, Essex Falls, N.J.

349 *Water Lilies*, c. 1927. Watercolor. Reference: Catalogue, Valentine Gallery, *Joseph Stella*.

350 *Water Lilies*, c. 1927. Watercolor. Reference: Catalogue, Valentine Gallery, *Joseph Stella*.

351 *The White Plate*, c. 1927. Watercolor. Reference: Catalogue, Valentine Gallery, *Joseph Stella*.

352 *Self-Portrait*, c. 1928. Pastel. 14 x 10¾. Collection, Joseph H. Hirshhorn Foundation.

353 *Back of a Seated Man in a Blue Shirt*, c. 1929. Pencil and crayon. 10⅞ x 8⅝. Collection, Rabin and Krueger Gallery. Illustrated: Gerdts, *Drawings*, no. 151.

354 *Church and Cypress Tree*, c. 1929. Gouache. 40½ x 27½. Estate of Joseph Stella. Catalogue, Schoelkopf Gallery, *Joseph Stella*.

355 *Green and Gold (Landscape)*, c. 1929. Watercolor. 27 x 40½ (sight). Estate of Joseph Stella.

356 *Houses at Night*, c. 1929. Charcoal and pastel. 17⅜ x 24⅜. Collection, Rabin and Krueger Gallery.

357 *Italian Houses*, c. 1929. Pastel. 23¼ x 17¼ (sight). Collection, Sergio Stella.

358 *Lighted Windows*, c. 1929. Charcoal and pastel. 19 x 24¾. Collection, Rabin and Krueger Gallery.

359 *Nocturne*, c. 1929. Pastel. 38½ x 58½ (sight). Collection, Joseph H. Hirshhorn Foundation. Catalogue, Whitney Museum of American Art, *Joseph Stella*.

360 *Nocturne: Song of the Nightingale*, c. 1929. Watercolor. 24¼ x 30. Collection, William H. Lane Foundation, Andover, Mass.

361 *Self-Portrait*. See Figure 94.

362 *Still Life with Fruit*, c. 1929. Gouache. 21 x 29 (sight). Collection, Whitney Museum of American Art.

363 *Sunflower*, c. 1929. Gouache. 21⅞ x 18¼ (sight). Collection, Mr. and Mrs. Emanuel M. Terner. Catalogue, Whitney Museum of American Art, *Joseph Stella*.

364 *Two Pomegranates*, c. 1929. Pastel. 13¼ x 16½ (sight). Collection, Sergio Stella.

365 *Valley of Muro Lucano*, c. 1929. Pastel and chalk. 27 x 39. Estate of Joseph Stella. Catalogue, Schoelkopf Gallery, *Joseph Stella.*

366 *Surreal Landscape*, c. 1930. Watercolor. 5 x 7⅛. Collection, Mr. and Mrs. Walter Fillin.

367 *Self-Portrait*, c. 1932. Pencil and watercolor. 21¼ x 15¾ (sight). Collection, Sergio Stella.

368 *Landscape with Crossed Trees Reflected in Water*, c. 1935. Pastel. 16½ x 22. Collection, Sergio Stella.

369 *Park Walk Through Trees*, c. 1935. Pastel. 38 x 26. Collection, Sergio Stella.

370 *Tree Shadows on House*, c. 1935. Pastel. 29¾ x 23½. Collection, Dr. Bernard R. Goldberg, South Orange, N.J.

371 *Landscape in the Bronx*, c. 1936. Pastel. Reference: Catalogue, Knoedler Galleries, *Joseph Stella*, April–May 1942.

372 *Rocks in the Park*, c. 1936. Pastel. Collection, Miss Bridget Del Forno.

373 *Spring, Bronx*, c. 1936. Pastel. Reference: Catalogue, Knoedler Galleries, *Joseph Stella.*

374 *Study of Heads*, c. 1936. Black and blue wash. Reference: print, Shorewood Press.

375 *Woman in a Blue Hat*, c. 1936. Crayon and watercolor. 11 x 8⅜. Collection, Rabin and Krueger Gallery. Illustrated: Gerdts, *Drawings*, no. 135.

376 *Bread Trees, Barbados*, 1937. Pastel. Reference: Catalogue, Knoedler Galleries, *Joseph Stella.*

377 *Houses, Barbados*, 1937. Pastel. Reference: Catalogue, Knoedler Galleries, *Joseph Stella.*

378 *Papayas*, c. 1937. Pastel. Reference: Catalogue, Knoedler Galleries, *Joseph Stella.*

379 *Papaya and Mango (Barbados)*, 1937. Pastel. 19 x 12½. Collection, Sergio Stella.

380 *Squash*, 1937. Pastel. Reference: Catalogue, Knoedler Galleries, *Joseph Stella.*

381 *Banyan Tree*, c. 1938. Watercolor. 18¾ x 24¾. Collection, Rabin and Krueger Gallery.

382 *Barbados*, 1938. Pastel. 18 x 22¼. Collection, Salpeter Gallery.

383 *The Croton*, 1938. Pastel. Reference: Catalogue, Knoedler Galleries, *Joseph Stella.*

384 *Firebush with Bird*, 1938. Crayon. 28½ x 22¼. Collection, Sergio Stella.

385 *Old Italian Couple*, c. 1938. Pastel. 39 x 28¼. Collection, Mr. and Mrs. Samuel Denberg.

386 *Seated Woman*, c. 1938. Watercolor, 40 x 26½. Reference: Catalogue, James Goodman Gallery, Buffalo, N.Y., 1964, illustrated.

387 *Old Italian Woman*, c. 1938. Pencil, charcoal, crayon and gouache. 23⅛ x 17½. Collection, Mr. and Mrs. John D. Frisoli.

388 *The Red Leaf, Barbados*, 1938. Pastel. Reference: Catalogue, Knoedler Galleries, *Joseph Stella*.

389 *Tropical Foliage*, c. 1938. Pastel. 23⅛ x 17¾. Collection, Dr. Norman Linde.

390 *Two Trees, Barbados*, 1938. Pastel. Reference: Catalogue, Knoedler Galleries, *Joseph Stella*.

391 *Seated Italian Peasant with Mustache*, 1939. Pastel. 25½ x 18. Collection, Dr. and Mrs. Robert Jones.

392 *Three Peasants*, c. 1939. Charcoal and pastel. 25½ x 17¾. Collection, Dr. Norman Linde.

393 *Tropical Flowering Cactus*, c. 1939. Watercolor. 24⅝ x 18½. Collection, Rabin and Krueger Gallery.

394 *Basket of Fruit*, c. 1940. Pastel. 11½ x 17½. Collection, Mr. and Mrs. John D. Frisoli.

395 *Birds on Cherry Branch*, c. 1940. Pastel. 26¾ x 21 (sight). Collection, Dr. Norman Linde.

396 *Self-Portrait*, c. 1940. Pencil and Wash. 13½ x 11¼. Collection, Raphael Soyer.

397 *Still Life with Zucchini and Flowers*, 1940. Pastel. 20 x 21⅜ (sight). Collection, Sergio Stella.

398 *Tropical Bird*, 1940. Crayon. 7⅛ x 9½ (sight). Collection, Mr. and Mrs. Samuel Denberg. Catalogue, Whitney Museum of American Art, *Joseph Stella*.

399 *Lemon and Squash*, c. 1941. Pastel. Reference: Catalogue, Knoedler Galleries, *Joseph Stella*.

400 *Landscape, Study of Trees*, 1941. Pastel. 18 x 24. Collection, Salpeter Gallery.

401 *Canto Fermo (Man with Guitar)*, 1942. Pastel. 26 x 20. Collection, Sergio Stella.

402 *Green Squash*, c. 1942. Pastel. 10½ x 13½. Estate of Joseph Stella.

403 *Guitar Player*, 1942. Pastel. 25½ x 19¾ (sight). Collection, Sergio Stella.

404 *Still Life with Pumpkin*, 1942. Pastel. 14½ x 12⅜. Estate of Joseph Stella.

405 *Magnolia*, c. 1942. Pastel. 12 x 9. Estate of Joseph Stella.

406 *The Red Flower*, c. 1942. Pastel. Reference: Catalogue, Knoedler Galleries, *Joseph Stella*.

407 *The Singing Oriental*, c. 1942. Pastel. Reference: Catalogue, Knoedler Galleries, *Joseph Stella*.

408 *Tarda Senectus*, 1942. Pastel. 26 x 20. Collection, Sergio Stella.

409 *Tarda Senectus*, 1942. Pastel. 25⅝ x 19⅞ (sight). Collection, Sergio Stella.

410 *Seated Man with Cane Handle*, 1943. Medium? 29¾ x 21¾ (sight). Collection, Dr. Norman Linde.

411 *Forest Frieze*, 1944. Medium? 20¾ x 28. Collection, Dr. Robert Gross, Maplewood, N.J.

412 *Portrait Sketch of Jean de Marco*, 1944. Pastel. 11½ x 16¾. Collection, Dr. Robert Gross.

413 *Still Life with Small Sculpture*. See Figure 109.

414 *Tropical Composition*, 1944. Pastel and Oil. 13¾ x 20. Collection, William Carrington Guy.

415 *Bay of Naples*, n.d. Watercolor. 40½ x 27½. Estate of Joseph Stella. Catalogue, Schoelkopf Gallery, *Joseph Stella*.

416 *Birds*, n.d. Pastel. 30 x 23. Collection, Rabin and Krueger Gallery. Reference: Catalogue, Galleria Astrolabio Arte, Rome, December 1966, illustrated.

417 *Heads of Miners*, n.d. Pastel. Collection, Dr. and Mrs. Norman Linde. Reference: Catalogue, Seton Hall University, illustrated.

418 *Mary Dreier*, n.d. Pencil and crayon. 22½ x 10. Collection, Theodore Dreier, Schenectady, N.Y.

419 *Neapolitan Landscape*, n.d. Gouache. 27 x 40½. Estate of Joseph Stella. Catalogue, Schoelkopf Gallery, *Joseph Stella*.

420 *Nocturne*, n.d. Pastel. 18 x 24. Estate of Joseph Stella. Catalogue, Schoelkopf Gallery, *Joseph Stella*.

421 *Paris, Rooftops*, n.d. Watercolor. 21⅛ x 16¾. Collection, Jon Nicolas Streep.

422 *Seated Woman*, n.d. Gouache. 40 x 26½. Reference: Catalogue, Parke-Bernet Auction, October 29, 1964.

423 *Sphere*, n.d. Gouache. Collection, Rabin and Krueger Gallery. Reference: Catalogue, Seton Hall University.

424 *Stone Bridge*, n.d. Pastel. Reference: Catalogue, Berman and Brown, Newark, N.J., November 1938.

425 *Sunset (Factories)*, n.d. Pastel. 6½ x 9½. Collection, Joseph H. Hirshhorn Foundation.

Black and White (with occasional touches of color)

426 *Dall'America*, 1893. Pencil. 5½ x 3½. Collection, Rabin and Krueger Gallery.

427 *Three Male Figures*, c. 1893. Pencil. 6⅜ x 5. Collection, Sergio Stella.

428 *Italian Peasant: Un Murese*, 1894? Red ink. 4⅞ x 4. Collection, Sergio Stella.

429 *Italian Immigrant*, 1898? Pencil and crayon. 8¾ x 7½. Collection, Stanley Ross.

430 *Head of an Old Man V*. See Figure 1.

431 *Old Man, IX*, 1898? Pencil. 8 x 4¼. Collection, Rabin and Krueger Gallery. Illustrated: Gerdts, *Drawings*, no. 66.

432 *Head of an Old Italian*, before 1900? Crayon. 22¼ x 16¼ (as framed with *Sleeping Boy*, c. 1906). Collection, Rabin and Krueger Gallery.

433 *Peasant of Muro Lucano*, before 1900? Crayon. Reference: *Arts and Decoration*, August 1923, illustrated.

434 *Seated Man*, before 1900. Pencil. 5 x 3¼. Collection, Rabin and Krueger Gallery.

435 *Bark*. See Figure 2.

436 *Head of a Man with a Hat*. See Figure 3.

437 *Head of an Old Man, II*, c. 1900. Pencil. 9⅜ x 7¼. Collection, Mr. and Mrs. Moses Soyer. Illustrated: Gerdts, *Drawings*, no. 53.

438 *Head of an Old Man, III*, c. 1900. Crayon. 10¼ x 7¾. Collection, Rabin and Krueger Gallery. Illustrated: Gerdts, *Drawings*, no. 60.

439 *Head of an Old Man, IV*, c. 1900. Crayon touched with white. 8¾ x 8¾. Collection, Rabin and Krueger Gallery. Illustrated: Gerdts, *Drawings*, no. 61.

440 *Head of an Old Man, VI*, c. 1900. Chalk. 8 x 5¾. Collection, Rabin and Krueger Gallery. Illustrated: Gerdts, *Drawings*, no. 63.

441 *Head of an Old Man, VII*, c. 1900. Pen. 7 x 4⅞. Collection, Rabin and Krueger Gallery. Illustrated: Gerdts, *Drawings*, no. 64.

442 *Head of an Old Man, VIII*. See Figure 4.

443 *Horse and Carriage*, c. 1900. Ink. 4⅜ x 6½. Collection, Rabin and Krueger Gallery. Illustrated: Gerdts, *Drawings*, no. 1.

444 *Italian Immigrant*, c. 1900. Pencil. 14 x 9 (sight). Collection, Edgar Kaufmann, Jr. Catalogue, Whitney Museum of American Art, illustrated.

445 *Landscape*, between 1900–1909. Pencil. 7¼ x 9 (sight). Collection, Rabin and Krueger Gallery. Catalogue, Whitney Museum of American Art, *Joseph Stella*.

446 *Man, Smiling*, c. 1900. Pencil. 9¾ x 5½. Collection, Rabin and Krueger Gallery.

447 *Man's Head*, c. 1900. Crayon. 11¾ x 9. Collection, Mr. and Mrs. Walter Fillin.

448 *Old Man, X*, c. 1900. Crayon. 8¾ x 5¾. Collection, Rabin and Krueger Gallery. Illustrated: Gerdts, *Drawings*, no. 67.

449 *Old Man, XI, Seated*. See Figure 5.

450 *Old Man, XII*, c. 1900. Wash. 12 x 8⅛. Collection, Rabin and Krueger Gallery. Illustrated: Gerdts, *Drawings*, no. 69.

451 *Profile of a Girl*, 1900? Pencil. 11¾ x 8⅞. Collection, Rabin and Krueger Gallery. Illustrated: Gerdts, *Drawings*, no. 44.

452 *Rooftops*, c. 1900. Ink. 6¼ x 4⅞. Collection, Rabin and Krueger Gallery. Illustrated: Gerdts, *Drawings*, no. 2.

453 *Self-Portrait*, c. 1900. Blue pencil. 6 x 6¾. Collection, Rabin and Krueger Gallery.

454 *Standing Young Girl*. See Figure 6.

455 *Landscape with Bay*, c. 1902. Pencil and crayon. 9⅞ x 13½. Collection, Rabin and Krueger Gallery. Illustrated: Gerdts, *Drawings*, no. 84.

456 *Americans in the Rough: A German*. See Figure 8.

457 *Americans in the Rough: A Native of Poland*, 1905. Pencil? Reference: *The Outlook*, December 23, 1905, p. 968, illustrated.

458 *Americans in the Rough: A Russian Jew*. See Figure 9.

459 *Americans in the Rough: The Gateway*. See Figure 7.

460 *Americans in the Rough: Hungarian Types*, 1905. Pencil? Reference: *The Outlook*, December 23, 1905, p. 972, illustrated.

461 *Americans in the Rough: Irish Types*, 1905. Pencil? Reference: *The Outlook*, December 23, 1905, p. 971, illustrated.

462 *Americans in the Rough: Italians*, 1905. Pencil and charcoal? Reference: *The Outlook*, December 23, 1905, p. 969, illustrated.

463 *Head of a Hag*, c. 1905. Charcoal. 4 x 3. Collection, Rabin and Krueger Gallery. Illustrated: Gerdts, *Drawings*, p. 4.

464 *Man at a Shop*, c. 1905. Crayon. 2⅞ x 4½. Collection, Rabin and Krueger Gallery. Illustrated: Gerdts, *Drawings*, no. 4.

465 *Profile of a Girl*, c. 1905. Pencil, crayon, and chalk. 5⅝ x 3¼. Collection, Rabin and Krueger Gallery. Illustrated: Gerdts, *Drawings*, no. 40.

466 *Smiling Young Boy*, c. 1905. Pencil. 8¾ x 4⅞. Collection, Rabin and Krueger Gallery. Illustrated: Gerdts, *Drawings*, no. 27.

467 *Standing Young Woman*, c. 1905. Pencil. 11⅞ x 5⅞. Collection, Rabin and Krueger Gallery. Illustrated: Gerdts, *Drawings*, no. 20.

468 *Study of Heads*, c. 1905. Sanguine. 5⅞ x 8⅜. Collection, Rabin and Krueger Gallery.

469 *The Voice of the Street*, 1905. Pencil and charcoal. Reference: Poole, *Voice* (see Bibliography), six illustrations: The Voice of the Street; Lucky Jim; Dago Joe; The Romance of Roland; A New Plan: Playing Music.

470 *Wagon Before a Shop*, c. 1905. Pencil. 3¾ x 5¼. Collection, Rabin and Krueger Gallery. Illustrated: Gerdts, *Drawings*, no. 5.

471 *Sleeping Boy*, c. 1906. Pencil. 22¼ x 16¼ (as framed with *Head of an Old Italian* before 1900?). Collection, Schoelkopf Gallery.

472 *Buildings in a Landscape*, c. 1907. Pencil. 4¾ x 5¾. Collection, Rabin and Krueger Gallery. Illustrated: Gerdts, *Drawings*, no. 7.

473 *Face of an Elderly Person*. See Figure 11.

474 *Head of Old Man, Profile*, c. 1907. Silverpoint. 8 x 6 (oval). Collection, Mr. and Mrs. Herbert A. Goldstone.

475 *Head of Old Man, Profile*, c. 1907. Charcoal. 8 x 6 (oval). Collection, Mr. and Mrs. Herbert A. Goldstone.

476 *Man in a Cap, Resting on a Park Bench*, c. 1907. Crayon. 5⅛ x 7⅛. Collection, Rabin and Krueger Gallery. Illustrated: Gerdts, *Drawings*, no. 59.

477 *Monongah: A Woman*, 1907. Pencil and charcoal? Reference: *The Survey*, January 4, 1908, facing p. 1312, illustrated.

478 *Monongah: Head of a Woman Wrapped in a Shawl*, 1907. Pencil and charcoal? Reference: *The Survey*, January 4, 1908, facing p. 1329, illustrated.

479 *Monongah: Morning Mist at the Mine Mouth.* See Figure 12.

480 *Monongah: Rescue Workers.* See Figure 13.

481 *Study of a Bearded Man*, c. 1907. Crayon. 5⅞ x 7⅝. Collection, Rabin and Krueger Gallery. Illustrated: Gerdts, *Drawings*, no. 36.

482 *Three Men on a Bench*, c. 1907. Pencil. 5¾ x 8¾. Collection, Rabin and Krueger Gallery. Illustrated. Gerdts, *Drawings*, no. 37.

483 *Two Seated Men, Sleeping*, c. 1907. Pencil. 5 x 6½. Collection, Rabin and Krueger Gallery. Illustrated: Gerdts, *Drawings*, no. 35.

484 *The Apprentice in an Apron*, c. 1908. Crayon. 22¼ x 16¼. Collection, Mrs. Elizabeth Schoelkopf.

485 *Back of a Man Working*, c. 1908. Pencil. 9¼ x 6⅝. Collection, Rabin and Krueger Gallery. Illustrated: Gerdts, *Drawings*, no. 14.

486 *Bridge*, c. 1908. Charcoal. 14½ x 23½. Collection, Carnegie Institute Museum of Art, Pittsburgh, Penn.

487 *Chimney, Pittsburgh*, 1908. Charcoal. 18 x 23. Collection, Zabriskie Gallery.

488 *The Cripple.* See Figure 14.

489 *Head of a Bearded Man*, c. 1908. Charcoal. Collection, David Daniels.

490 *Head of Miner, Resting*, 1908. Pencil. 7⅛ x 8¼. Collection, Mr. and Mrs. Emanuel M. Terner.

491 *Head and Shoulders of an Old Man*, c. 1908. Crayon. 6¾ x 5⅜. Collection, Rabin and Krueger Gallery. Illustrated: Gerdts, *Drawings*, no. 56.

492 *Head of a Young Man*, c. 1908. Chalk. 12⅞ x 9¾. Collection, Rabin and Krueger Gallery. Illustrated: Gerdts, *Drawings*, no. 50.

493 *Mill Interior*, 1908. Charcoal. 13½ x 17¾. Collection, Mr. and Mrs. Herbert A. Goldstone. Catalogue, Whitney Museum of American Art, *Joseph Stella*.

494 *The Newcomer*, c. 1908. Pencil. 22¼ x 16¼. Collection, Joseph H. Hirshhorn Foundation.

495 *Norwegian Immigrant*, c. 1908. Pencil. 7 x 5¾. Collection, Rabin and Krueger Gallery.

496 *Old Italian*, c. 1908. Silverpoint and crayon. 22¼ x 16¼. Collection, Schoelkopf Gallery.

497 *Old Italian*, 1908. Silverpoint. 12½ x 9½ (sight). Collection, Rabin and Krueger Gallery.

498 *Pittsburgh*, 1908. Charcoal. 6½ x 8. Collection, Rabin and Krueger Gallery. Illustrated: Gerdts, *Drawings*, no. 78.

499 *Pittsburgh I: A Greener—Lad from Herzogovina*, 1908. Pencil. 22¼ x 16¼. Collection, Schoelkopf Gallery. Illustrated: *The Survey*, January 2, 1909, facing p. 564.

500 *Pittsburgh I: A Pittsburgh Worker (Hand on Cheek)*, 1908. Pencil, charcoal, and crayon, touched with red? Reference: *The Survey*, January 2, 1909, facing p. 499, illustrated.

501 *Pittsburgh I: A Slav*, 1908. Pencil and charcoal? Reference: *The Survey*, January 2, 1909, p. 589, illustrated.

502 *Pittsburgh I: A Slavic Laborer*, 1908. Charcoal? Reference: *The Survey*, January 2, 1909, p. 552, illustrated.

503 *Pittsburgh I: British Born*, 1908. Pencil and charcoal? Reference: *The Survey*, January 2, 1909, p. 560, illustrated.

504 *Pittsburgh I: Direct from the Fields of Mid-Europe*, 1908. Charcoal and ink wash? Reference: *The Survey*, January 2, 1909, p. 535, illustrated.

505 *Pittsburgh I: Immigrant Out of Work*, 1908. Pencil and charcoal? Reference: *The Survey*, January 2, 1909, facing p. 594, illustrated.

506 *Pittsburgh I: In the Church of the Double Cross (Man Singing, Profile)*, 1908. Charcoal and crayon? Reference: *The Survey*, January 2, 1909, facing p. 548, illustrated.

507 *Pittsburgh I: In the Light of a Five-Ton Ingot*, 1908. Pencil and charcoal? Reference: *The Survey*, January 2, 1909, facing p. 552, illustrated.

508 *Pittsburgh I: Of the Old Time Irish Immigration*, 1908. Pencil and charcoal? Reference: *The Survey*, January 2, 1909, facing p. 556, illustrated.

509 *Pittsburgh I: Old Worlds in New*, 1908. Pencil and charcoal. Reference: *The Survey*, January 2, 1909, facing p. 592, illustrated.

510 *Pittsburgh I: Russian*, 1908. Pencil and charcoal. Reference: *The Survey*, January 2, 1909, facing p. 596, illustrated.

511 *Pittsburgh I: The Strength of the New Stock*, 1908. Pencil and charcoal? Reference: *The Survey*, January 2, 1909, facing p. 598, illustrated.

512 *Pittsburgh II: An Old Slav*, 1908. Pencil? Reference: *The Survey*, February 6, 1909, facing p. 912, illustrated.

513 *Pittsburgh II: A Pittsburgh Worker*, 1908. Pencil, charcoal, and crayon, touched with red? Reference: *The Survey*, February 6, 1909, facing p. 769, illustrated.

514 *Pittsburgh II: Italian leader*. See Figure 15.

515 *Pittsburgh II, Painter's Row: Company Houses (Street in Allegheny)*, 1908. Charcoal. 12 x 8½. Collection, Schoelkopf Gallery. Illustrated: *The Survey*, February 6, 1909, facing p. 898.

516 *Pittsburgh II, Painter's Row: Dark Bedroom*. See Figure 16.

517 *Pittsburgh II, Painter's Row: Workers' Houses*. See Figure 17.

518 *Pittsburgh III: A Breathing Spell*, 1908. Pencil? Reference: *The Survey*, March 6, 1909, facing p. 1086, illustrated.

519 *Pittsburgh III: A Pittsburgh Worker*, 1908. Pencil, charcoal, and crayon, touched with red? Reference: *The Survey*, March 6, 1909, facing p. 1034, illustrated.

520 *Pittsburgh III: A Steel Worker*, 1908. Charcoal and ink wash? Reference: *The Survey*, March 6, 1909, p. 1104, illustrated.

521 *Pittsburgh III: Before the Furnace Door.* See Figure 18.

522 *Pittsburgh III: Four Miners (In the Bread Line at Wood's Run).* See Figure 19.

523 *Pittsburgh III: In the Glare of the Converter*, 1908. Charcoal and pastel? Reference: *The Survey*, March 6, 1909, facing p. 1090, illustrated.

524 *Pittsburgh III: Italian Steel Worker*, 1908. Pencil and charcoal? Reference: *The Survey*, March 6, 1909, facing p. 1082, illustrated.

525 *Pittsburgh III: Slav in Bread Line*, 1908. Pencil? Reference: *The Survey*, March 6, 1909, facing p. 1064, illustrated.

526 *Pittsburgh III: Steel Mill – Pittsburgh*, 1908. Charcoal. 14¾ x 20¾. Collection, Rabin and Krueger Gallery. Illustrated: *The Survey*, March 6, 1909, p. 1065.

527 *Pittsburgh III: The Stokers (At the Base of the Blast Furnace).* See Figure 20.

528 *Pittsburgh III: Tired Out*, 1908. Pencil. Reference: *The Survey*, March 6, 1909, facing p. 1062, illustrated.

529 *Pittsburgh, Winter.* See Figure 21.

530 *Pittsburgh, Winter*, c. 1908. Charcoal. 4½ x 5⅝. Collection, Mr. and Mrs. Harry L. Koenigsberg.

531 *The Puddler*, 1908. Charcoal and pastel. 19 x 26. Collection, Mr. and Mrs. Walter Fillin. Catalogue, Whitney Museum of American Art, *Joseph Stella*, illustrated.

532 *Sewing Lesson*, 1908. Charcoal. 22 x 14. Collection, Dr. Robert Gross.

533 *Steel Worker*, 1908. Charcoal. 23¾ x 17½ (sight). Collection, Harry Salpeter Gallery.

534 *Stoker*, 1908. Charcoal. 23¾ x 25½ (sight). Collection, Dr. Robert Gross.

535 *Stoker*, 1908. Pencil. 8¼ x 6⅞ (sight). Collection, Mr. and Mrs. Emanuel M. Terner.

536 *They Who Knock at Our Gates: Old Italian Woman*, c. 1908. Pencil? Reference: Antin, "They Who Knock at Our Gates," p. 18 (see bibliography), illustrated.

537 *They Who Knock at our Gates: Young Worker*, c. 1908. Pencil? Reference: Antin, "They Who Knock at Our Gates," p. 18, illustrated.

538 *Three Heads*, 1908. Charcoal? 25½ x 25⅝. Collection, Robert Graham. Illustrated: *The Survey*, January 4, 1919, cover. (*Note:* the drawing is dated in the lower right, but the third numeral is difficult to read and may be a "1," making the date 1918. The style, however, accords with the 1908 period.)

539 *Tired Miner*, c. 1908. Charcoal. 31 x 23¼. Collection, Mr. and Mrs. Samuel Denberg.

540 *Underpass*, 1908. Charcoal. 11¼ x 16¼. Collection, Bruce Howe, Cambridge, Mass. Catalogue, Whitney Museum of American Art, *Joseph Stella*.

541 *Working Man*, 1908. Pencil. 8 x 6. Collection, Joseph H. Hirshhorn Foundation.

542 *Profile*, 1909. Charcoal and chalk. 16¼ x 9½. Collection, Rabin and Krueger Gallery.

543 *Profile of a Woman*, 1909. Chalk and crayon. 10⅞ x 9⅝. Collection, Rabin and Krueger Gallery. Catalogue, Whitney Museum of American Art, *Joseph Stella*.

544 *Back of a Woman, Sleeping*. See Figure 23.

545 *Boy Playing Wind Instrument*, c. 1910. Charcoal and sanguine. 14½ x 19½. Collection, Mr. and Mrs. Herbert A. Goldstone. Catalogue, Whitney Museum of American Art, *Joseph Stella*, illustrated.

546 *Boy with Bagpipe*, c. 1910. Pencil. 21¾ x 16. Collection, Mr. and Mrs. Walter Fillin. Catalogue, Whitney Museum of American Art, *Joseph Stella*.

547 *Head of a Boy*, c. 1910. Crayon. 11⅞ x 7¾. Collection, Rabin and Krueger Gallery. Illustrated: Gerdts, *Drawings*, no. 52.

548 *Head of a Child*, c. 1910. Pencil. 7 x 5¼. Collection, Rabin and Krueger Gallery. Illustrated: Gerdts, *Drawings*, no. 43.

549 *Head of a Man*, c. 1910. Pencil and wash. 4⅛ x 3⅜. Collection, Rabin and Krueger Gallery. Illustrated: Gerdts, *Drawings*, no. 39.

550 *Head of a Man*, 1910. Silverpoint. 8 x 6½. Collection, Rabin and Krueger Gallery.

551 *Head of a Man*, c. 1910. Pencil. 8⅜ x 10⅛. Collection, Rabin and Krueger Gallery.

552 *Head of an Old Man, I*. See Figure 22.

553 *Head of a Woman*, c. 1910. Charcoal and pastel. 22¼ x 18⅛ (sight). Collection, Mrs. Samuel Shore. Catalogue, Whitney Museum of American Art, *Joseph Stella*.

554 *Head of a Woman*, c. 1910. Silverpoint and pencil. 11⅜ x 8⅞. Collection, Rabin and Krueger Gallery. Illustrated: Gerdts, *Drawings*, no. 42.

555 *Head of a Woman in a Large Hat*, c. 1910. Crayon. 10¼ x 7¾. Collection, Rabin and Krueger Gallery. Illustrated: Gerdts, *Drawings*, no. 55.

556 *Hooded Woman Standing*, c. 1910. Pencil and crayon. 12¼ x 4⅝. Collection, Rabin and Krueger Gallery. Illustrated: Gerdts, *Drawings*, no. 23.

557 *Immigrant*, 1910. Sepia. 11½ x 8¾. Collection, Mr. and Mrs. Samuel Halpern.

558 *Profile Head of an Old Woman*, c. 1910. Pencil and chalk. 15⅜ x 9.

Collection, Rabin and Krueger Gallery. Illustrated: Gerdts, *Drawings*, no. 15.

559 *Profile of a Man*, c. 1910. Silverpoint. 8¾ x 6¼. Collection, Rabin and Krueger Gallery. Catalogue, Whitney Museum of American Art, *Joseph Stella*.

560 *Profile of an Old Man*, c. 1910. Pencil. 5⅝ x 6. Collection, Rabin and Krueger Gallery. Illustrated: Gerdts, *Drawings*, no. 30.

561 *Rocky Landscape*, c. 1910. Pencil. 5 x 8½. Collection, Rabin and Krueger Gallery. Illustrated: Gerdts, *Drawings*, no. 8.

562 *Seated Man with Cane*, c. 1910. Pencil, crayon, and wash. 10½ x 9⅜. Collection, Rabin and Krueger Gallery. Illustrated: Gerdts, *Drawings*, no. 24.

563 *Seated Old Man, with Cane*, c. 1910. Pencil. 11¾ x 7½. Collection, Rabin and Krueger Gallery. Illustrated: Gerdts, *Drawings*, no. 10.

564 *Seated Old Man, with Staff*, c. 1910. Pencil. 11⅛ x 6¾. Collection, Rabin and Krueger Gallery. Illustrated: Gerdts, *Drawings*, no. 21.

565 *Seated Old Woman*, c. 1910. Pencil. 10¾ x 8¼. Collection, Rabin and Krueger Gallery. Illustrated: Gerdts, *Drawings*, no. 18.

566 *Study of a Young Woman*, c. 1910. Crayon. 6 x 6⅞. Collection, Rabin and Krueger Gallery.

567 *Tree*, c. 1910. Sanguine. 10½ x 4¼. Collection, Rabin and Krueger Gallery.

568 *Trees in a Yard*, c. 1910. Pencil. 5½ x 8¼. Collection, Rabin and Krueger Gallery.

569 *Two Men*, c. 1910. Sanguine. 8 x 8¾. Collection, Rabin and Krueger Gallery.

570 *Two Men Lying Down*, c. 1910. Pencil. 5½ x 8. Illustrated: Gerdts, *Drawings*, no. 11.

571 *Two Seated Men*, c. 1910. Crayon. 10⅜ x 7½. Collection, Rabin and Krueger Gallery. Illustrated: Gerdts, *Drawings*, no. 54.

572 *The Unmade Bed*, c. 1910. Pencil. 4 x 5½. Collection, Rabin and Krueger Gallery. Illustrated: Gerdts, *Drawings*, no. 10.

573 *Woman's Head*, c. 1910. Pencil. 5 x 3½. Collection, Paul Magriel. Catalogue, Whitney Museum of American Art, *Joseph Stella*.

574 *Woman Lying Down and Reading*, c. 1910. Ink. 8 x 9½. Collection, Rabin and Krueger Gallery. Illustrated: Gerdts, *Drawings*, no. 12.

575 *Man Seen from the Rear*. See Figure 26.

576 *Rocky Landscape with Trees*. See Figure 27.

577 *Young Woman Reading*, c. 1912. Pencil. 5⅜ x 4⅜. Collection, Rabin and Krueger Gallery. Illustrated: Gerdts, *Drawings*, no. 32.

578 *Mardi Gras*. See Figure 32.

579 *Albanian Mother and Child*, c. 1916. Crayon. 13¾ x 7⅞. Collection, Rabin and Krueger Gallery. Illustrated: Gerdts, *Drawings*, no. 29.

580 *Ellis Island: An Aged Roumanian*, 1916. Pencil? Reference: *The Survey*, May 6, 1916, p. 150, illustrated.

581 *Ellis Island: An Albanian*, 1916. Pencil? Reference: *The Survey*, May 6, 1916, p. 150, illustrated.

582 *Ellis Island: A Bearded Bulgarian (Bulgarian War Refugee)*. See Figure 38.

583 *Ellis Island: A Calabrian*, 1916. Pencil? Reference: *The Survey*, May 6, 1916, p. 150, illustrated.

584 *Ellis Island: An Irishman*, 1916. Pencil? Reference: *The Survey*, May 6, 1916, p. 150, illustrated.

585 *Ellis Island: A Norwegian*, 1916. Pencil? Reference: *The Survey*, May 6, 1916, p. 151, illustrated.

586 *Ellis Island: A Polish Consumptive*, 1916. Pencil? Reference: *The Survey*, May 6, 1916, p. 150, illustrated.

587 *Ellis Island: A Russian Cossack*, 1916. Pencil? Reference: *The Survey*, May 6, 1916, p. 151, illustrated.

588 *Ellis Island: A Slovak*, 1916. Pencil? Reference: *The Survey*, May 6, 1916, p. 151, illustrated.

589 *Ellis Island: A Young Negress from the Barbados*, 1916. Pencil? Reference: *The Survey*, May 6, 1916, p. 151, illustrated.

590 *Ellis Island: French Maid*, 1916. Pencil? Reference: *The Survey*, May 6, 1916, p. 155, illustrated.

591 *Ellis Island: French Woman*, 1916. Pencil? Reference: *The Survey*, May 6, 1916, p. 155, illustrated.

592 *Ellis Island: From the Campagna*, 1916. Pencil? Reference: *The Survey*, May 6, 1916, p. 154, illustrated.

593 *Ellis Island: Hungarian Lad*, 1916. Pencil? Reference: *The Survey*, May 6, 1916, p. 151, illustrated.

594 *Ellis Island: Immigrant, Seen from Rear*, 1916. Pencil? Reference: *The Survey*, May 6, 1916, p. 147, illustrated.

595 *Ellis Island: Immigrants*, 1916. Pencil? Reference: *The Survey*, May 6, 1916, p. 156, illustrated.

596 *Ellis Island: Jewish Girl*, 1916. Pencil? Reference: *The Survey*, May 6, 1916, p. 155, illustrated.

597 *Ellis Island: Listeners at an Ellis Island Concert*, 1916. Pencil? Reference: *The Survey*, May 6, 1916, p. 149, illustrated.

598 *Ellis Island: Man and Wife from South Italy*, 1916. Pencil? Reference: *The Survey*, May 6, 1916, p. 150, illustrated.

599 *Ellis Island: Mother and Child (At the Threshold of the New World)*, 1916. Charcoal and sanguine. 24⅛ x 20. Collection, Rabin and Krueger Gallery. Illustrated: *The Survey*, May 6, 1916, p. 148. Catalogue, Whitney Museum of American Art, *Joseph Stella*.

600 *Ellis Island: Russian Jew*, 1916. Pencil? Reference: *The Survey*, May 6, 1916, p. 150, illustrated.

601 *Ellis Island: The World's Tallest Man*, 1916. Pencil? Reference: *The Survey*, May 6, 1916, p. 156, illustrated.

602 *Ellis Island: Wreckage*, 1916. Charcoal and pastel? 23¼ x 30¼. Collection, Dr. Erwin R. Biel, New Brunswick, N.J. Reference: *The Survey*, May 6, 1916, p. 157, illustrated.

603 *Ellis Island: Young Woman Reading*. See Figure 39.

604 *Head of a Young Woman*, c. 1916. Crayon and chalk. 9⅞ x 10⅛. Collection, Rabin and Krueger Gallery. Illustrated: Gerdts, *Drawings*, no. 17.

605 *Old Italian Woman*, c. 1916. Charcoal and crayon. 23¼ x 15¾. Collection, The Reverend Father Heinbold, Newark, N.J.

606 *Seated Woman with a Large Hat*, c. 1916. Crayon. 7¾ x 5⅞. Collection, Rabin and Krueger Gallery. Illustrated: Gerdts, *Drawings*, no. 57.

607 *Serbian Woman*, c. 1916. Charcoal and pasted. 18 x 19 (sight). Collection, Zabriskie Gallery.

608 *City Buildings*, 1917? Watercolor. 11¾ x 9¼. Collection, Rabin and Krueger Gallery. Illustrated: Gerdts, *Drawings*, no. 107.

609 *Parade*, c. 1917. Charcoal. 16 x 18. Collection, Bruce Howe.

610 *Study for Brooklyn Bridge*, 1917? Pencil and sepia wash. 17 x 15½. Collection, Dr. Hilde Mosse.

611 *A New Race*, 1918. Pencil? Reference: *The Survey*, November 30, 1918, p. 262, illustrated.

612 *Bethlehem: The Blow*, 1918. Charcoal? Reference: *The Survey*, February 1, 1919, p. 617, illustrated.

613 *Bethlehem: The Furnaceman*, 1918. Charcoal? Reference: *The Survey*, February 1, 1919, p. 618, illustrated.

614 *Bethlehem: Handling a Shell*, 1918. Charcoal. Reference: *The Survey*, February 1, 1919, p. 616, illustrated.

615 *Bethlehem: The "Insides" of the Clock of War*. See Figure 41.

616 *Bethlehem: The Link*, 1918. Charcoal. Reference: *The Survey*, February 1, 1919, p. 617, illustrated.

617 *Bethlehem: The Night Watchman*, 1918. Charcoal. Reference: *The Survey*, February 1, 1919, p. 616, illustrated.

618 *Factory Landscape, Pittsburgh*, c. 1918. Charcoal. 21 x 16¾ (sight). Collection, Sergio Stella. Catalogue, Whitney Museum of American Art, *Joseph Stella*, illustrated.

619 *Garment Workers: A Jewish Knitter of Socks*, 1918. Pencil? Reference: *The Survey*, January 4, 1919, p. 449, illustrated.

620 *Garment Workers: An Italian Stitcher*, 1918. Pencil? Reference: *The Survey*, January 4, 1919, p. 449, illustrated.

621 *Garment Workers: British Born*, 1918. Pencil? Reference: *The Survey*, January 4, 1919, p. 448, illustrated.

622 *Garment Workers: A Slovak Machine Operator*, 1918. Pencil? Reference: *The Survey*, January 4, 1919, p. 448, illustrated.

623 *Garment Workers: A Swedish Presser*, 1918. Pencil? Reference: *The Survey*, January 4, 1919, p. 447, illustrated.

624 *Garment Workers: In a New York Loft Building Workshop*. See Figure 42.

625 *Shipbuilders: Hog Island Type*, 1918. Pencil. 9 x 11. Collection, Rabin and Krueger Gallery. Illustrated: *The Survey*, November 30, 1918, p. 261. (*Note:* This drawing is one of five *Hog Island Types* illustrated on pp. 260–261.)

626 *The Shipbuilders: The Launching*. See Figure 45.

627 *The Swarming*, 1918. Charcoal. Reference: *The Survey*, March 1, 1919, p. 781, illustrated.

628 *An Apple and Pear*, 1919. Silverpoint. 6¼ x 9¼ (sight). Collection, Mr. and Mrs. Emanuel M. Terner.

629 *Cactus*, 1919. Pencil and crayon. 13⅜ x 10¼. Collection, Rabin and Krueger Gallery. Illustrated: Gerdts, *Drawings*, no. 93.

630 *Flamingo*, c. 1919. Pencil and crayon. 14⅛ x 10⅜. Collection, Rabin and Krueger Gallery. Illustrated: Gerdts, *Drawings*, no. 105.

631 *Flower Studies*, 1919. Pencil and crayon. 13⅞ x 11. Collection, Rabin and Krueger Gallery. Illustrated: Gerdts, *Drawings*, no. 96.

632 *Flower Study*. See Figure 52.

633 *Fruit*, 1919. Pencil and crayon. 12¾ x 9⅝. Collection, Rabin and Krueger Gallery. Illustrated: Gerdts, *Drawings*, no. 99.

634 *Fruit, Flower, and Cat*. See Figure 53.

635 *Leaves*, 1919. Crayon. 13⅜ x 10⅜. Collection, Rabin and Krueger Gallery. Illustrated: Gerdts, *Drawings*, no. 97.

636 *Nature Studies*, c. 1919. Pencil and crayon. 13⅛ x 9¾. Collection, Rabin and Krueger Gallery. Illustrated: Gerdts, *Drawings*, p. 8.

637 *Seated Woman*, 1919? Ink. 7⅛ x 5⅜. Collection, Sergio Stella.

638 *Tree Trunk*, c. 1919. Crayon. 16½ x 11. Collection, Rabin and Krueger Gallery. Catalogue, Whitney Museum of American Art, *Joseph Stella*, illustrated.

639 *Three Studies for New York Interpreted, "The Bridge"*. See Figure 68.

640 *By-Products Storage Tanks*. See Figure 61.

641 *Coal Pile*. See Figure 62.

642 *Crusher and Mixer Building*. See Figure 63.

643 *The Great White Way, Study for New York Interpreted*, between 1920–1922. Pencil and crayon. 11⅛ x 8¾. Collection, Rabin and Krueger Gallery. Illustrated: Gerdts, *Drawings*, no. 108.

644 *Palm Fronds*, c. 1920. Silverpoint. 8⅜ x 10⅞. Collection, Sergio Stella.

645 *Pittsburgh Night*, 1920. Charcoal. 22 x 16. Collection, Downtown Gallery.

646 *Profile of a Bearded Man (Ezra Pound?)*, 1920. Silverpoint. 15⅛ x 14¾. Collection, Rabin and Krueger Gallery. Illustrated: Gerdts, *Drawings*, no. 125.

647 *Portrait of Eilshemius*, 1920. Silverpoint. 22¾ x 18½. Collection, Joseph H. Hirshhorn Foundation. Catalogue, Whitney Museum of American Art, *Joseph Stella*, illustrated.

648 *Portrait of Eilshemius*, c. 1920. Pencil. 28⅜ x 21¾. Collection, Whitney Museum of American Art.

649 *Portrait of Joe Gould*, c. 1920. Charcoal and pencil. Reference: *Broom*, October 1923, illustrated.

650 *Profile of Marcel Duchamp.* See Figure 65.

651 *Profile of Eva Gautier*, c. 1920. Goldpoint. Reference: *The Little Review*, Autumn 1922, illustrated.

652 *Profile of Edgard Varèse*, c. 1920. Silverpoint. 20¼ x 14⅜. Collection, Baltimore Museum of Art. Illustrated: Gerdts, *Drawings*, no. 126.

653 *Profile of a Woman*, c. 1920. Silverpoint. 5⅜ x 4⅜. Collection, Rabin and Krueger Gallery. Illustrated: Gerdts, *Drawings*, no. 41.

654 *The Quencher*, c. 1920. Charcoal? Reference: *The Survey*, March 1, 1924, p. 567, illustrated.

655 *The Traveling Pusher*, c. 1920. Charcoal? Reference: *The Survey*, March 1, 1924, p. 566, illustrated.

656 *Trees and Buildings*, c. 1920. Watercolor. 10½ x 6⅜. Collection, Rabin and Krueger Gallery. Illustrated: Gerdts, *Drawings*, no. 113.

657 *Female Nude*, c. 1922. Pencil. 7⅝ x 11⅞. Collection, Rabin and Krueger Gallery. Illustrated: Gerdts, *Drawings*, no. 47.

658 *Fish*, c. 1922. Pencil and crayon. 8 x 13⅞. Collection, Rabin and Krueger Gallery. Illustrated: Gerdts, *Drawings*, no. 106.

659 *The Immigrant Madonna*, 1922. Pencil? 13⅛ x 11½. Collection, Dr. and Mrs. Franklin Simon. Illustrated: *Survey Graphic*, December 1922, cover.

660 *Nude with Raised Arms*, 1922. Pencil and crayon. 23¾ x 19⅜. Collection, Rabin and Krueger Gallery. Illustrated: Gerdts, *Drawings*, no. 119.

661 *Pompeii*, c. 1922. Pencil and crayon. 10¾ x 8¼. Collection, Rabin and Krueger Gallery. Illustrated: Gerdts, *Drawings*, no. 83.

662 *Torso of a Woman*, c. 1922. Silverpoint. 5⅝ x 3½. Collection, Rabin and Krueger Gallery. Illustrated: Gerdts, *Drawings*, no. 45.

663 *Hands and Other Studies*, c. 1926. Pencil. 5¼ x 5⅝. Collection, Rabin and Krueger Gallery. Illustrated: Gerdts, *Drawings*, no. 34.

664 *Seated Nude Woman*, c. 1926. Crayon. 8 x 5⅜. Collection, Mr. and Mrs. Moses Soyer. Illustrated: Gerdts, *Drawings*, no. 46.

665 *Flowerpots (Study for Neapolitan Song)*, c. 1928. Pencil and crayon. 11½ x 16¾. Collection, Rabin and Krueger Gallery. Illustrated: Gerdts, *Drawings*, p. 6.

666 *Back of a Man Seated at Table*, c. 1929. Pencil and crayon. 11¾ x 9. Collection, Rabin and Krueger Gallery. Illustrated: Gerdts, *Drawings*, no. 152.

667 *Buildings*, c. 1929. Chalk. 10 x 13⅜. Collection, Rabin and Krueger Gallery. Illustrated: Gerdts, *Drawings*, no. 79.

668 *Cat*, c. 1929. Pencil. 10¾ x 13¼. Collection, Rabin and Krueger Gallery. Illustrated: Gerdts, *Drawings*, no. 101.

669 *Cat on a Chair*, c. 1929. Pencil. 5⅞ x 4⅞. Collection, Rabin and Krueger Gallery. Illustrated: Gerdts, *Drawings*, no. 38.

670 *Harlequin*, c. 1929. Silverpoint. 28½ x 22. Collection, Rabin and Krueger Gallery. Illustrated: Gerdts, *Drawings*, no. 120.

671 *The Ox*, c. 1929. Medium? 4⅛ x 5⅞. Collection, Rabin and Krueger Gallery.

672 *Reclining Woman, Sleeping*, 1929. Chalk. 5¾ x 9¼. Collection, Samuel Shore.

673 *Skirt and Feet*, c. 1929. Crayon. 15¾ x 12¼. Collection, Rabin and Krueger Gallery. Illustrated: Gerdts, *Drawings*, no. 153.

674 *Study of a Woman*, c. 1929. Pencil. 6¼ x 4. Collection, Rabin and Krueger Gallery. Illustrated: Gerdts, *Drawings*, no. 149.

675 *Two Studies of a Woman* (matted together), c. 1929. Pencil. 4½ x 6; 4½ x 3¾. Collection, Rabin and Krueger Gallery. Illustrated: Gerdts, *Drawings*, no. 149.

676 *Veiled Woman*, c. 1929. Pencil. 10¾ x 7½. Collection, Rabin and Krueger Gallery. Illustrated: Gerdts, *Drawings*, no. 73.

677 *Woman Among Ruins*, c. 1929. Charcoal. 15⅜ x 18⅛. Collection, Rabin and Krueger Gallery. Illustrated: Gerdts, *Drawings*, no. 75.

678 *Woman in a Shawl*, c. 1929. Crayon. 15⅝ x 12¼. Collection, Rabin and Krueger Gallery. Illustrated: Gerdts, *Drawings*, no. 154.

679 *Algerian Woman*, c. 1930. Pencil, crayon, and wash. 23⅞ x 18. Collection, Rabin and Krueger Gallery. Illustrated: Gerdts, *Drawings*, no. 122.

680 *Flower Study*, c. 1930. Gouache. 9½ x 5⅞. Collection, Rabin and Krueger Gallery. Illustrated: Gerdts, *Drawings*, no. 91.

681 *Head of a Dog*, c. 1930. Crayon. 13 x 9½. Collection, Rabin and Krueger Gallery. Illustrated: Gerdts, *Drawings*, no. 103.

682 *Head of a Goat*, c. 1930. Pencil and crayon. 9 x 12⅛. Collection, Rabin and Krueger Gallery. Illustrated: Gerdts, *Drawings*, no. 104.

683 *Palm*, c. 1930. Silverpoint. 9 x 11. Collection, Sergio Stella.

684 *Palm Trees*, 1930. Pencil and crayon. 17 x 12⅛. Collection, Rabin and Krueger Gallery. Illustrated: Gerdts, *Drawings*, no. 89.

685 *Portrait of Samuel Putnam*, c. 1930. Pencil. Reference: Stella "Papers." Illustrated: New York *Herald Tribune*, May 2, 1947.

686 *Study of a Tree*, c. 1930. Crayon. 12¼ x 8⅞. Collection, Rabin and Krueger Gallery. Illustrated: Gerdts, *Drawings*, no. 90.

687 *Two Sleeping Dogs*, c. 1930. Pencil, crayon, and wash. 12 x 14⅛. Collection, Rabin and Krueger Gallery. Illustrated: Gerdts, *Drawings*, p. 9.

688 *Young Woman Sleeping*, c. 1930. Pencil. 3¾ x 5¼. Collection, Rabin and Krueger Gallery. Illustrated: Gerdts, *Drawings*, no. 33.

689 *Sleeping Woman*, c. 1932. Silverpoint and crayon on pink paper. 11¾ x 9 (sight). Collection, Ira Moscowitz, Paris, France. Catalogue, Whitney Museum of American Art, *Joseph Stella*.

690 *Study for the Holy Manger*, c. 1933. Pencil and watercolor. 9½ x 15⅛. Collection, Rabin and Krueger Gallery. Illustrated: Gerdts, *Drawings*, no. 86.

691 *Crossed Hands*, c. 1936. Pencil and crayon. 6¾ x 4⅜. Collection, Rabin and Krueger Gallery. Illustrated: Gerdts, *Drawings*, no. 145.

692 *Head of a Man*, c. 1936. Pen and crayon. 11¼ x 8¼. Collection, Rabin and Krueger Gallery. Illustrated: Gerdts, *Drawings*, no. 132.

693 *Head of a Man*, c. 1936. Pencil and crayon. 11⅛ x 8¾. Collection, Rabin and Krueger Gallery. Illustrated: Gerdts, *Drawings*, no. 133.

694 *Head of a Man*, c. 1936. Silverpoint and crayon. 11⅞ x 8⅜. Collection, Rabin and Krueger Gallery. Illustrated: Gerdts, *Drawings*, no. 134.

695 *Head of a Man*, c. 1936. Crayon. 9¾ x 6⅞. Collection, Rabin and Krueger Gallery. Illustrated: Gerdts, *Drawings*, no. 131.

696 *Man in a Cap*, c. 1936. Pencil and crayon. 6¾ x 4½. Collection, Rabin and Krueger Gallery. Illustrated: Gerdts, *Drawings*, no. 148.

697 *Man in a Cap and Overcoat*, c. 1936. Pencil and crayon. 8⅞ x 5¼. Collection, Rabin and Krueger Gallery. Illustrated: Gerdts, *Drawings*, no. 146.

698 *Man in a Cap, Resting*, c. 1936. Crayon. 8½ x 5. Collection, Rabin and Krueger Gallery. Illustrated: Gerdts, *Drawings*, no. 147.

699 *Man in a Hat*, c. 1936. Pencil and crayon. 8¾ x 5¾. Collection, Rabin and Krueger Gallery. Illustrated: Gerdts, *Drawings*, no. 143.

700 *Man in a Hat, Resting*, c. 1936. Pencil and crayon. 8⅝ x 5⅝. Collection, Rabin and Krueger Gallery. Illustrated: Gerdts, *Drawings*, no. 144.

701 *Man Resting*, c. 1936. Crayon and wash. 6¾ x 4½. Collection, Rabin and Krueger Gallery. Illustrated: Gerdts, *Drawings*, no. 71.

702 *Man Sleeping*, c. 1936. Pencil and crayon. 7⅛ x 9⅝. Collection, Rabin and Krueger Gallery. Illustrated: Gerdts, *Drawings*, p. 11.

703 *Men Around a Table*, c. 1936. Pencil. 9⅛ x 11¼. Collection, Rabin and Krueger Gallery. Illustrated: Gerdts, *Drawings*, no. 150.

704 *Mrs. Stella, Seated*, c. 1936. Crayon with pencil touches. 9⅜ x 12¼. Collection, Rabin and Krueger Gallery. Illustrated: Gerdts, *Drawings*, no. 137.

705 *Mrs. Stella Sewing*, c. 1936. Pencil and watercolor. 11⅞ x 9¼. Collection, Rabin and Krueger Gallery. Illustrated: Gerdts, *Drawings*, no. 140.

706 *Old Woman in Shawl*, c. 1936. Crayon. 6¾ x 4½. Collection, Rabin and Krueger Gallery. Illustrated: Gerdts, *Drawings*, no. 72.

707 *Poplar and Rocks*, c. 1936. Silverpoint. 6⅛ x 5. Collection, Rabin and Krueger Gallery.

708 *Profile of a Man*, c. 1936. Crayon. 12 x 8⅞. Collection, Rabin and Krueger Gallery. Illustrated: Gerdts, *Drawings*, no. 134.

709 *Profile of a Priest*, c. 1936. Pencil and crayon. 10⅜ x 14⅜. Collection, Rabin and Krueger Gallery. Illustrated: Gerdts, *Drawings*, no. 128.

710 *Rocks*, c. 1936. Chalk and wash. 5⅛ x 7⅜. Collection, Rabin and Krueger Gallery. Illustrated: Gerdts, *Drawings*, no. 80.

711 *Roots and Trees in a Rocky Landscape*, c. 1936. Chalk. 19⅝ x 25⅝. Collection, Rabin and Krueger Gallery. Illustrated: Gerdts, *Drawings*, no. 87.

712 *Sleeping Figure*, c. 1936. Pencil and chalk. 8½ x 11¾. Collection, Rabin and Krueger Gallery. Illustrated: Gerdts, *Drawings*, no. 141.

713 *Study – Two Heads*, c. 1936. Crayon. 11⅜ x 9. Collection, Rabin and Krueger Gallery. Illustrated: Gerdts, *Drawings*, no. 136.

714 *Three Women*, c. 1936. Charcoal and wash. 10¾ x 14. Collection, Rabin and Krueger Gallery. Illustrated: Gerdts, *Drawings*, no. 156.

715 *Two Women Talking*, c. 1936. Crayon and watercolor. 17⅞ x 23⅜. Collection, Rabin and Krueger Gallery. Illustrated: Gerdts, *Drawings*, no. 155.

716 *Woman Lying on her Back*, c. 1936. Pencil and crayon. 9¾ x 12. Collection, Rabin and Krueger Gallery. Illustrated: Gerdts, *Drawings*, no. 142.

717 *Woman Resting*, c. 1936. Crayon. 12½ x 18. Collection, Rabin and Krueger Gallery. Illustrated: Gerdts, *Drawings*, no. 138.

718 *Woman Resting*, c. 1936. Chalk, crayon, and wash. 10⅜ x 13¾. Collection, Rabin and Krueger Gallery. Illustrated: Gerdts, *Drawings*, no. 139.

719 *Woman Under a Tree*, c. 1936. Wash. 10⅜ x 8¾. Collection, Rabin and Krueger Gallery. Illustrated: Gerdts, *Drawings*, no. 117.

720 *Christmas Theme*, c. 1937. Pencil and crayon. 10¾ x 7¾. Collection, Rabin and Krueger Gallery. Illustrated: Gerdts, *Drawings*, no. 114.

721 *Self-Portrait*, 1937. Pencil. 29 x 23. Collection, Sergio Stella.

722 *Buildings and Trees*, c. 1938. Wash. 8⅜ x 8⅞. Collection, Rabin and Krueger Gallery. Illustrated: Gerdts, *Drawings*, no. 85.

723 *Buildings in a Landscape*, c. 1938. Pencil and crayon. 9⅝ x 7½. Collection, Rabin and Krueger Gallery. Illustrated: Gerdts, *Drawings*, no. 82.

724 *Man Holding a Guitar*, c. 1938. Pen and wash. 19⅝ x 6⅞. Collection, Rabin and Krueger Gallery. Illustrated: Gerdts, *Drawings*, no. 118.

725 *Old Man in Cap and Overcoat*, c. 1938. Crayon. 4⅞ x 9¾. Collection, Rabin and Krueger Gallery. Illustrated: Gerdts, *Drawings*, p. 10.

726 *Old Man with a Guitar*, c. 1938. Silverpoint. 11 x 8. Collection, Rabin and Krueger Gallery. Illustrated: Gerdts, *Drawings*, no. 28.

727 *Peasant*, c. 1938. Pencil and crayon. 15¼ x 11½. Collection, Rabin and Krueger Gallery. Illustrated: Gerdts, *Drawings*, no. 121.

728 *Portrait of Eilshemius*, 1939. Pencil, gouache, and silverpoint, touches of chalk. 23 x 17. Collection, Mr. and Mrs. Herbert A. Goldstone.

729 *A Saint*, c. 1940. Pencil and crayon. 9¼ x 13. Collection, Rabin and Krueger Gallery. Illustrated: Gerdts, *Drawings*, no. 115.

730 *Armless Man on Bench*, c. 1940. Pencil. 8 x 11½. Collection, Mr. and Mrs. Moses Soyer.‡

731 *Birds*, c. 1940. Crayon. 9 x 11½. Collection, Rabin and Krueger Gallery. Illustrated: Gerdts, *Drawings*, no. 102.

732 *Five Heads*, c. 1940. Pencil and wash on brown paper. 15 x 22¾ (sight). Collection, Samuel Shore.

733 *Head of an Elderly Jew*, c. 1940. Crayon. 10⅜ x 8¼. Collection, Rabin and Krueger Gallery. Illustrated: Gerdts, *Drawings*, no. 130.

734 *Lotus*, 1940. Pencil and crayon. 11⅛ x 9⅞. Collection, Rabin and Krueger Gallery. Illustrated: Gerdts, *Drawings*, no. 92.

735 *Man Sleeping*, c. 1940. Ink. 7 x 10. Collection, The Corcoran Gallery of Art, Washington, D.C.

736 *Man with a Book*, c. 1940. Pencil. 9½ x 11¾. Collection, Rabin and Krueger Gallery. Illustrated: Gerdts, *Drawings*, no. 129.

737 *Self-Portrait*. See Figure 106.

738 *Self-Portrait*, c. 1940. Pencil. 29½ x 22. Estate of Joseph Stella.

739 *Portrait of Clara Fasano*, c. 1943. Pencil. Collection, Jean de Marco and Clara Fasano.‡

740 *Portrait of Jean de Marco, Resting*, c. 1943. Pencil. Collection, Jean de Marco and Clara Fasano.‡

741 *Figures, including Self-Portrait*. See Figure 108.

742 *Three Women*, c. 1944. Pencil, crayon, and wash. 17⅞ x 23⅝. Collection, Rabin and Krueger Gallery. Illustrated: Gerdts, *Drawings*, no. 157.

743 *Flowers and Leaves* (2), n.d. Silverpoint and crayon. 14 x 10½. Collection, Sergio Stella.

744 *Head of Girl*, n.d. Chalk and crayon? 4⅝ x 3⅝. Collection, Rabin and Krueger Gallery.

745 *Head of a Man*, n.d. Wash. 8¾ x 6⅜. Collection, Rabin and Krueger Gallery. Illustrated: Gerdts, *Drawings*, no. 70.

746 *Head of a Woman*, n.d. Charcoal and pastel on brown paper. 22¼ x 18⅛ (sight). Collection, Samuel Shore.

747 *Head of a Woman*, n.d. Silverpoint. 13½ x 14¾. Collection, Knoedler Galleries.

748 *Italian Accordionist with Woman*, n.d. Medium? 15⅝ x 15⅝. Collection, Stanley Sadkin.

749 *Italian Immigrant*, n.d. Pencil. 12¾ x 2½. Collection, Dr. Robert Jones.

750 *Man Carrying a Flag*, n.d. Charcoal. 15⅜ x 12⅛. Collection, Rabin and Krueger Gallery. Illustrated: Gerdts, *Drawings*, no. 74.

751 *Nature Forms*, n.d. Charcoal. 23 x 18. Collection, Sergio Stella.
752 *Peasant Couple, Seated*, n.d. Charcoal. 18 x 14. Collection, Stanley Ross.
753 *Self-Portrait*, n.d. Crayon. Collection, Rabin and Krueger Gallery.
754 *Study for Voices of Spring*, n.d. Silverpoint and crayon. 26 x 21. Collection, Schoelkopf Gallery.
755 *Study of a Hat*, n.d. Crayon. 22¼ x 16¼. Collection, Mr. and Mrs. Samuel Halpern, East Orange, N.J.
756 *Twilight Through the Trees*, n.d. Pencil. Collection, Paul Magriel.
757 *Young Woman*, n.d. Crayon and pencil. 17⅛ x 13⅝. Collection, Dr. Robert Gross.

Collages

758 *The Bookman*. See Figure 78.
759 *Brown*, n.d. Collage. 10 x 6. Collection, Zabriskie Gallery.
760 *Chicago*, n.d. Collage. 8 x 7. Collection, Zabriskie Gallery.
761 *Circle*, n.d. Collage. 12 x 9. Collection, Zabriskie Gallery.
762 *Conjunction*, n.d. Collage. 12 x 9. Collection, Zabriskie Gallery. Catalogue, Whitney Museum of American Art, *Joseph Stella*.
763 *The End of a Day*, n.d. Collage. 8⅜ x 10¼. Collection, Schoelkopf Gallery. Catalogue, Whitney Museum of American Art, *Joseph Stella*.
764 *Graph*. See Figure 111.
765 *Gray*, n.d. Collage. 12¼ x 8⅞ (sight). Collection, Rabin and Krueger Gallery. Catalogue, Whitney Museum of American Art, *Joseph Stella*.
766 *Gray and Orange*, n.d. Collage. 10 x 8⅜. Collection, Schoelkopf Gallery. Catalogue, Whitney Museum of American Art, *Joseph Stella*.
767 *Head*. See Figure 112.
768 *Leaf*. See Figure 113.
769 *Number 2*, n.d. Collage. 12 x 9. Collection, Zabriskie Gallery.
770 *Number 3*, n.d. Collage. 11 x 8. Collection, Zabriskie Gallery.
771 *Number 8*, n.d. Collage. 16⅛ x 10⅜. Collection, Carnegie Institute Museum of Art.
772 *Number 11*, n.d. Collage. 17 x 11½. Collection, Mrs. M. Baum.
773 *Number 21*. See Figure 110.
774 *Pastel*, n.d. Collage. 9 x 6. Collection, Ulrich Franzen. Catalogue, Whitney Museum of American Art, *Joseph Stella*.
775 *Pegasus*, n.d. Collage. 12½ x 9. Collection, Zabriskie Gallery.
776 *Postcard*, n.d. Collage. 6½ x 4. Collection, Zabriskie Gallery.
777 *Profile*. See Figure 114.
778 *Red Seal*. n.d. Collage. 18 x 12. Collection, Zabriskie Gallery. Catalogue, Whitney Museum of American Art, *Joseph Stella*.
779 *Red, White, and Blue*, n.d. Collage. 11 x 8½. Collection, Ulrich Franzen.

Illustrated: Catalogue, Zabriskie Gallery, *Collages, Joseph Stella*, October 1961, cover.

780 *Serenade*, n.d. Collage. 12 x 9. Collection, Zabriskie Gallery.

781 *Shovel*, n.d. Collage. 10¾ x 9. Collection, Zabriskie Gallery.

782 *Stucco*, n.d. Collage. 12 x 9. Collection, Zabriskie Gallery.

783 *Study for Skyscraper*. See Figure 77.

784 *Telephone*, n.d. Collage. 12½ x 10. Collection, Zabriskie Gallery.

785 *Tread*, n.d. Collage. 5½ x 8½. Collection, Zabriskie Gallery.

Bibliography

This bibliography is arranged in four parts: critical reviews of exhibitions, signed articles, books, and catalogues that contain more than passing reference to Stella; unsigned or routine notices and other brief references in periodicals; one-man exhibition catalogues; a guide to Stella's major work as illustrator. Newspaper notices and biographical dictionaries are not included.

I. On Stella

Antin, Mary. "They Who Knock at Our Gates," *American Magazine*, April 18, 1914, pp. 18ff. (Also published in book form, same title, Boston: Houghton, Mifflin, 1914, but with some illustrations omitted.)

Armory Show Fiftieth Anniversary, 1913–1963. New York: Henry Street Settlement, and Utica, N.Y.: Munson-Williams-Proctor Institute, 1963.

Artieri, Giovanni. "Cronache," *Emporium*, 69:377 (June 1929).

Baker, Elizabeth C. "The Consistent Inconsistency of Joseph Stella," *Art News*, December 1963, pp. 46–68.

Baur, John I. H. "The Machine and the Subconscious: Dada in America," *Magazine of Art*, 44:233 (October 1951).

——— *Revolution and Tradition in Modern American Art*. Cambridge, Mass.: Harvard University Press, 1951.

——— (ed.) *New Art in America*. Greenwich, Conn.: New York Graphic Society in cooperation with Frederick A. Praeger, New York, 1957.

——— "Joseph Stella Retrospective," *Art in America*, Nov. 5, 1963, pp. 32–37.

——— Joseph Stella. Exhibition Catalogue. New York: Shorewood, 1963.

Bibliography

Blesh, Rudi. *Modern Art U.S.A.* New York: Alfred A. Knopf, 1956.

Brook, Alexander. "February Exhibitions," *The Arts*, 3:127 (February 1923).

Brooklyn Museum. Brooklyn Bridge. *Seventy-Fifth Anniversary Exhibition.* Brooklyn, N.Y.: Brooklyn Museum, 1958.

Brown, Milton W. *American Painting from the Armory Show to the Depression.* Princeton, N.J.: Princeton University Press, 1955.

—— *The Story of the Armory Show.* The Joseph H. Hirshhorn Foundation, 1963, distributed by New York Graphic Society, Greenwich, Conn.

—— "Cubist Realism," *Marsyas*, Nos. 3–4, 1943–1947, pp. 139–158.

Cahill, Holger. *A Museum in Action.* Catalogue of American Paintings and Sculpture from the Museum's Collections. Newark, N.J.: The Newark Museum, 1944.

Chanin, A. L. *Art Guide/New York.* New York: Horizon Press, 1965.

Cheney, Sheldon. *A Primer of Modern Art.* New York: Boni and Liveright, 1924.

City Art Museum of St. Louis. *Two Hundred Years of American Painting.* Exhibition Catalogue. St. Louis, 1964.

Collection of the Société Anonyme: Museum of Modern Art 1920. New Haven, Conn.: Yale University Art Gallery, 1950.

Craven, Thomas. "Joseph Stella," *Shadowland*, 7:11 (January 1923).

Dreier, Katherine S. *Western Art and the New Era: An Introduction to Modern Art.* New York, Brentano's, 1923.

—— *Modern Art.* New York: Société Anonyme, 1926.

—— See Yale University Sterling Library.

Eliot, Alexander. *Three Hundred Years of American Painting.* New York: Time, Inc., 1957.

Field, Hamilton. "Joseph Stella," *The Arts*, 9:24–27 (October 1921).

—— "Joseph Stella, genio del color," *Social* (Havana, Cuba), July 1928, pp. 43–46.

—— "Joseph Stella." Unpublished monograph, New York, 1939.

Freund, Frank E. W. "Joseph Stella," *Der Cicerone* 16:963–972 (October 1924). (Reprinted in *Jahrbuch der Jungen Kunst*, Leipsig, 1924, pp. 310ff.)

Friedman, Martin L. *The Precisionist View in American Art.* Exhibition Catalogue. Minneapolis: Walker Art Center, 1960.

Gaylor, Wood. Untitled autobiographical manuscript transcribed from a series of tape recordings. Mimeographed copy in the library of the Whitney Museum of American Art, New York, N.Y.

Geldzahler, Henry. *American Painting in the Twentieth Century.* New York: Metropolitan Museum of Art, 1965.

Gerdts, William. *Drawings of Joseph Stella.* Newark, N.J.: Rabin and Krueger Gallery, 1962.

—— "People and Places of New Jersey," *Newark Museum Bulletin*, n.s. 15, Spring-Summer 1963, p. 36.

Goodrich, Lloyd, and Baur, John I. H. *American Art of Our Century.* New York: Frederick A. Praeger, 1961.

Goodrich, Lloyd. *The Decade of the Armory Show 1910–1920.* New York: Whitney Museum of American Art, 1963.

—— *Pioneers of Modern Art in America.* New York: Frederick A. Praeger, 1962.

Bibliography

Haftmann, Werner. *Painting in the Twentieth Century*. New York: Frederick A. Praeger, 1960.

Hunter, Sam. *Modern American Painting and Sculpture*. New York: Dell Publishing Co., 1959.

——— *American Modernism: The First Wave*. Exhibition Catalogue. Waltham, Mass.: Brandeis University, The Poses Institute of Fine Arts, 1963.

Jaffe, Irma B. "Joseph Stella: an Analysis and Interpretation of His Art," unpublished Ph.D. dissertation, Columbia University, 1966.

Kouenhoven, John A. *American Studies: Words or Things?* Wilmington, Del.: The Wemyss Foundation, 1963.

Lancellotti, A. "Un Pittore di Avanguardia: Giuseppe Stella," *Emporium*, 71:67–76 (February 1930).

Larkin, Oliver W. *Art and Life in America*. New York: Rinehart and Co., 1949.

Lenfest, Marie. "Joseph Stella — Immigrant Futurist." Unpublished Master's thesis, Columbia University, 1959.

Loving, Pierre. "Joseph Stella — Extremist," *The Nation*, 116:446 (April 11, 1923).

McBride, Henry. "Modern Art," *The Dial*, 73:423–425 (April 1923).

——— "Modern Art," *The Dial*, 80:525–527 (June 1926).

Mellquist, Jerome. *The Emergence of an American Art*. New York: Charles Scribner's Sons, 1942.

——— "Les Courants de la Peinture Americaine," *Les Arts Plastique*, February–March 1952, pp. 271–278.

Museum of Modern Art. Artists File: "Joseph Stella."

——— *Art in Progress*. New York, 1944.

New York Public Library. Artists File: "Joseph Stella."

Oeri, Georgine. "The Object of Art," *Quadrum*, Nov. 16, 1964, pp. 7–8.

Parker, Edwin S. "Analysis of Futurism," International Studio, 58:59 (April 1916).

Pach, Walter. "The Point of View of the 'Modernist,'" *The Century*, 87:851–868 (April 1914).

Poole, Ernest. *The Voice of the Street*. New York, A. S. Barnes, 1906.

Porpora, Antonio. "Giuseppe Stella: un pittore futurista di Basilicata a New York," *Italiani pel Mondo*, September 1926, pp. 226–230.

Putnam, Samuel. *Paris Was Our Mistress*. New York: The Viking Press, 1947.

Riley, Maude. "Stella in Review," *Art Digest*, November 15, 1943, p. 13.

Ritchie, Andrew C. *Abstract Painting and Sculpture in America*. New York: Museum of Modern Art, 1951.

Rosenblum, Robert. *Cubism and Twentieth Century Art*. New York: Harry N. Abrams, 1960.

Salpeter, Harry. "Stella: Art's Poetic Gladiator," *Esquire*, 16:92, 107 (July 1941).

Santoro, Ferdinando. "Giuseppe Stella," *Italiani pel Mondo*, August 1928, pp. 803–811.

——— Preview of Stella exhibition, Angiporto Galleria, Naples, 1929, *Italiani pel Mondo*, March–April 1929, pp. 333–334.

Schettini, Alfredo. *Vita di Antonio Mancini*. Naples: Editrice Rispoli Anonima, 1941.

Stella, Joseph. "The New Art," *The Trend*, June 1913, pp. 392–395.

——— "On Painting," *Broom*, 1:119–123 (December 1921).

—— "Confession," *The Little Review*, Spring 1929, pp. 79–81.

—— "The Brooklyn Bridge (A Page of My Life)," *Transition*, 16–17:86–88 (June 1929). This essay was previously printed and distributed privately by Stella, in brochure form, with illustrations of the five sections of *New York Interpreted*.

—— "Discovery of America: Autobiographical Notes," *Art News*, November 1960, pp. 41–43, 64–67 (written in 1946).

Torrey, Arthur H. "A Gift from Mr. Lewisohn," *Brooklyn Museum Quarterly*, 15:117 (October 1928).

Trachtenberg, Alan. *Brooklyn Bridge: Fact and Symbol.* New York: Oxford University Press, 1965.

Tyrrell, Henry. "New York in Epic Painting," *Il Carroccio*, 17:351 (March 1923).

Von Wiegand, Charmion. "Joseph Stella, Painter of Brooklyn Bridge." Unpublished essay, 1939.

Weber, Brom. *Hart Crane.* New York: The Bodley Press, 1948.

Whitney Museum of American Art. Artists File: "Joseph Stella."

Williams, Helen. "The Art of Joseph Stella in Retrospect," *International Studio*, 84:76–80 (July 1926).

Yale University. *Collection of the Société Anonyme.* New Haven: Yale University Art Gallery, 1950.

Yale University Fine Arts Library. "Société Anonyme."

Yale University Sterling Library. American Collection: "Joseph Stella Correspondence."

II. Unsigned or brief references in periodicals

Art Digest, 5:9 (August 1931).

—— 6:15 (December 1, 1931).

—— 9:8 (January 15, 1935).

—— 12:29 (November 15, 1927).

—— 13:11 (July 1, 1939).

—— 15:18 (January 15, 1941).

—— 16:15 (May 1, 1942).

Art News, 4:2 (March 24, 1906).

—— 20:10 (November 1921).

—— 26:9 (February 4, 1928).

—— 28:23 (June 14, 1930).

—— 30:23 (November 28, 1931).

—— 33:11 (January 12, 1935).

—— 39:13 (January 11, 1941).

—— 41:21 (May 15, 1942).

—— 42:21 (November 15, 1943).

—— 45:35 (April 1946).

—— 58:10 (September 1959).

—— 60:15 (November 1961).

—— 61:10 (February 1963).

—— 63:12 (October 1964).

Bibliography

Arts, 32:55 (May 1958).
———— 36:40 (October 1961).
———— 37:50 (February 1963).
———— 38:65 (December 1963).
———— 39:23 (October 1964).
———— 39:60 (November 1964).
Bulletin and Italiana (Italy America Society), 2:90 (May 1938).
Der Cicerone, 12:450 (1920).
———— 14:50 (1922).
Current Opinion, 64:423 (June 1918).
———— 68:832 (June 1920).
Italy American Monthly, 2:14 (April 25, 1935).
The Little Review (Autumn 1922); special Stella number.
Logique (Paris), March 30, 1934, p. 11.
The New Yorker, April 18, 1925, p. 17.
———— April 23, 1926, p. 49.
———— April 14, 1928, p. 82.
———— December 12, 1931, p. 57.
Pictures on Exhibit, October 1963, p. 4.
Time, November 8, 1963, p. 70.
The Trend, 5:208 (May 1913).

III. One-man exhibition catalogues

Retrospective Exhibition of Paintings, Pastels, Drawings, Silverpoints and Water-colors by Joseph Stella, New York: Bourgeois Galleries, March 27–April 24, 1920.

Exhibition of Paintings by Joseph Stella, Des Moines, Iowa: City Library Gallery, Des Moines Association of Fine Arts, May 9–June 1, 1926.

Joseph Stella, Encaustic Paintings, New York: The New Gallery, April 16–May 1, 1926.

Mostra di Arte del Pittore Giuseppe Stella, Naples: *Italiani pel Mondo*, 1929; preface by Ferdinando Santoro.

Joseph Stella, Peintures, Aquarelles, Pointes d'Argent, Paris: Galerie Sloden, May 7–31, 1930.

Exhibition of Paintings by Joseph Stella, New York: Valentine Gallery, January 7–26, 1935.

Joseph Stella, Recent Paintings and Drawings, Newark, New Jersey: Cooperative Gallery, December 1937.

Joseph Stella, A Retrospective Exhibition, Newark, New Jersey: The Newark Museum, April 22, 1939; preface by Arthur F. Egner.

Joseph Stella, New York: Knoedler Galleries, April 27–May 16, 1942; preface by Henry McBride.

Stella, New York: A.C.A. Gallery, November 6–27, 1943; preface by Katherine Dreier, essay by Joseph Stella.

Joseph Stella, New York: Zabriskie Gallery, April 15–May 17, 1958; preface by Milton W. Brown.

Bibliography

Portraits by Joseph Stella, New York: Zabriskie Gallery, September 14–October 3, 1959.

Joseph Stella, New York: Zabriskie Gallery, November 14–December 10, 1960; preface by Robert J. Schoelkopf, Jr.

Collages of Joseph Stella, New York: Zabriskie Gallery, October 2–October 28, 1961.

Joseph Stella, New York: Whitney Museum of American Art, 1963.

Joseph Stella, New York: Robert Schoelkopf Gallery, January 2–February 5, 1963.

Joseph Stella, New York: Robert Schoelkopf Gallery, October 29–November 16, 1963.

Joseph Stella, New York: Harry Salpeter Gallery, November 1963.

Drawings of Joseph Stella, New York: Robert Schoelkopf Gallery, October 1964.

Joseph Stella, Mountainville, New York: Storm King Art Center, n.d.

Stella, South Orange, New Jersey: Seton Hall University, November–December 1964.

Joseph Stella, Rome, Italy: Galleria Astrolabio Arte, December 1966–January 1967.

Joseph Stella, College Park, Maryland: University of Maryland Art Gallery, September–October 1968.

IV. *Stella's work as illustrator*

The Independent. CXIV (May 9, 1925), "Men and Steel, The Art of Joseph Stella," pp. 525ff.

The Outlook. LXXXI (December 23, 1905), "Americans in the Rough," pp. 967ff.

The Survey. XIX (January 4, 1908), "Monongah," by Paul Kellogg, pp. 1313ff.

———— XXI (January 2, 1909), "As Men See America, I," frontispiece; "Some Pittsburgh Steel Workers," by John A. Fitch, pp. 553ff., "The New Pittsburghers," by Peter Roberts, pp. 553ff.

———— XXI (February 6, 1909), "As Men See America, II," frontispiece; "Pittsburgh Types," pp. 800A, 912A, *passim*; "Painters' Row" by Elizabeth Crowell, pp. 899ff.

———— XXI (March 6, 1909), "As Men See America, III," frontispiece; "Wage Earners of Pittsburgh," by John R. Commons, pp. 1051ff.; "The Process of Making Steel," by John A. Fitch, pp. 1065ff.; "The Steel Industry and the Labor Problem," by John A. Fitch, pp. 1079ff.

———— XXXVI (May 6, 1916), "Turned Back in Time of War," by Frederick C. Howe, pp. 147ff.

———— XXXXI (November 30, 1918), cover illus.; "The Shipbuilders," pp. 259ff.

———— XXXXI (January 4, 1919), cover illus.; "The Garment Workers," pp. 447ff.

———— XXXXI (February 1, 1919), cover illus.; "Bethlehem," pp. 615ff.

———— XXXXI (March 1, 1919), cover illus.; "Makers of Wings" (monotypes), pp. 781ff.

———— LI (November 1, 1923), "The Voice of the City, Five Paintings by Joseph Stella," pp. 142ff.

———— LI (March 1, 1924), "The Coal By-Products Oven," pp. 563ff.

Notes

I. Introduction

1. The first quotation comes from a long and generally enthusiastic review of Stella's exhibition at the Circolo Nazionale Italiano, in 1913, in an Italian language newspaper published in New York, possibly *Il Progresso Italiano*. The article was signed by Agostino de Biasi. The critic disclaims being biased against the new styles: "Are we prejudiced against the new pictorial tendency? No. Let us give it free passage. But on one condition. That he who feels it and expresses it be sincere" (II,1). Valentini's review appeared in the Italian-American newspaper, *Bollettino della Sera*, April 26, 1913.

2. Henry McBride, "Modern Art," *The Dial* (June 1926), 80:256.

3. Probably *L'Italia Letteraria*. This clipping fragment has no date, but the context suggests 1930–1934; it carries a subhead, Paris, April, and is signed Antonio Aniante.

4. B. S. Kospoth, Paris *Tribune*, June 28, 1931.

5. Ferdinando Santoro, "Giuseppe Stella," *Italiani pel Mondo* (August 1928), p. 808; Antonio Porpora, "Giuseppe Stella," *Italiani pel Mondo* (September 1926), p. 230.

6. John I. H. Baur, *Joseph Stella*, exhibition catalogue, Whitney Museum of American Art (New York: Shorewood Publishers, 1963), pp. 10, 20; hereafter referred to as Baur, *Joseph Stella*.

II. Growing Up in Muro Lucano

1. Several sheets torn from an unidentified Italian periodical found among Stella's papers carry a documented account of Muro Lucano and La Basilicata.

237

2. This is a reference to a sixteenth-century tragedy that has become a legend in Muro Lucano: a conventional story of an unfaithful wife and a jealous husband. Queen Giovanna's portrait hangs in the cathedral so that the memory of the events has stayed alive. In the nineteenth century, the castle was purchased by the Lordi family, which became related to the Stella family: Rosa Lordi married Michele Cerone, the nephew of Vicenza Cerone Stella, Joseph Stella's mother. Rosa Lordi Cerone, now living in New York, told me about Queen Giovanna and her portrait.

3. Various years between 1877 and 1880 have been given for Stella's birth, but the problem can now be considered settled in view of the date recorded by the United States Department of Justice, Immigration and Naturalization Service. A letter from the Department, now in Artists Files, "Joseph Stella" Whitney Museum of American Art, dated July 31, 1963, states: "Records of this Service show that Joseph Stella was born on June 13, 1877."

Family recollections were related to me by Sergio Stella, the artist's nephew and (with Michael Stella, Nicola's son) coexecutor of Joseph Stella's estate. According to Sergio, Antonio emigrated to the United States in 1894. Joseph followed in 1896, Nicola in 1901, and Sergio's father, Luigi, in 1902. Mother and father arrived about 1903 and Giovanni in 1904. The family resided in New York, and all remained in the United States except Luigi, who returned to Italy in 1916. He was wounded in World War I and sent back to the United States as a member of an Italian mission, for the duration. He then returned to Italy and settled in Pesaro.

4. De Fornaro, "A Forceful Figure in American Art," Arts and Decorations (August 1923), p. 17.

5. Stella's reference to "il collegio" is probably to the school he attended, a kind of junior college, in Naples, to which he refers in "Discovery."

6. This quotation is taken from a four-page manuscript in Stella's papers entitled "Notes about Stella." Written in the third person, it nevertheless seems to be by Stella himself. Hereafter I shall refer to it as "Notes about Stella," without page reference.

7. Published as "Discovery of America: Autobiographical Notes," *Art News* (November 1960) pp. 41–42, 64–67. I use the original typescript in English, hereafter referred to as "Discovery." Another typescript is in the files of the Whitney Museum of American Art.

8. See note 3, above.

9. *Italian Stories (Novelle Italiane)*, ed. Robert H. Hall, Jr. (New York: Bantam Books, 1961), pp. 281–283. Stella often renders eyebrows as opening out "like two feathers."

III. *Young Artist in New York*

1. Stella, "Discovery," p. 1.

2. Dr. Stella rapidly became a leader in the Italo-American community. He was deeply concerned with the problems of the immigrants, particularly with the high incidence of tuberculosis among them, and his articles dealing with the medical aspects of immigration problems were published frequently in *The Survey* between 1906–1908. His book, *Some Aspects of Italian Immigration to the United States*, appeared in 1924, with a preface by Nicholas Murray Butler. Dr. Stella became a

distinguished physician and numbered among his patients such eminent men as President Theodore Roosevelt and Enrico Caruso.

3. "Notes about Stella."

4. Letter from the National Academy of Design, October 3, 1963.

5. *American Art News*, March 24, 1906, p. 2.

6. Stella, "Discovery," p. 1.

7. Enrico Somaré, *Storia dei Pittori Italiani dell 'Ottocento* (2 vols., Milan: Edizione d'arte moderna, 1928), II, 455, 425.

8. By 1905, Henri was already influential at the New York School of Art. Guy Pène du Bois writes that he was in Henri's class "four or five years until 1905," when he left for Europe; he recalls how, "with Henri's advent life strode into the Life Class." According to Helen Appleton Read, Henri "brought with him a new set of values" when he came to the school. "The Henri classes became the rallying ground for eager youth." See Guy Pène du Bois, *Artists Say the Silliest Things* (New York: Duell, Sloan and Pearce, 1940), pp. 82–92; and *Robert Henri and Five of His Pupils: George Bellows, Eugene Speicher, Guy Pène du Bois, Edward Hopper, Rockwell Kent*, preface by Helen Appleton Read (New York: The Century Association, April 5–June 1, 1946). Also Rockwell Kent, *It's Me O Lord* (New York: Dodd, Mead, 1955), pp. 81–86.

9. Leslie Katz, "The World of The Eight," *Arts Yearbook 1* (1957), p. 76.

10. Stella began to frequent the Metropolitan Museum during these early years, copying what he saw "in a slavish, literal manner," as he told a reporter for the New York *Sun*, May 25, 1913. In the same interview, he recalled that an instructor (whom he did not identify) in one of the art schools he attended (probably the Art Students League), "interrupted his academical remarks by announcing 'I shall give you an informal talk on the greatest masters of the world: Velásquez, Frans Hals, Rembrandt, Whistler, Sargent and I.' "

11. Meyer Schapiro, "Rebellion in Art," *America in Crisis*, ed. Daniel Aaron (New York: Alfred A. Knopf, 1952), p. 234.

12. Frank E. Washburn Freund, "Joseph Stella," *Der Cicerone* (1924), 16: 963–971.

13. A few paintings in this style are in the storeroom, in poor condition. *Tarda Senectus* is representative.

14. Carlo de Fornaro, "Joseph Stella" (ms), property of Robert Schoelkopf, New York, 1939, p. 3.

15. Stella, "Discovery," p. 1.

16. It is not known how the sketches Stella had been making on the streets of New York were brought to the attention of the Rev. Lyman Abbott and William H. Howland, editor and treasurer, respectively, of *The Outlook*. Antonio Stella's connections in the field of immigrant problems may have helped the younger brother in this first publication of his work, which appeared in the issue of December 23, 1905. Ernest Poole, author of *The Voice of the Street* (New York: A. S. Barnes, 1906), had begun his career a few years earlier, as a writer of stories and articles that appeared in such leading social reform publications as *The Century*, *Everybody's*, *McClure's*, and *The Outlook*. In 1904 he covered the Chicago stockyards' strike for *The Outlook*, and in 1905 went to Russia to write an on-the-scene report for the same magazine (Ernest Poole, *My Own Story* [New York: The Macmillan

Company, 1940]). It was probably his connection with *The Outlook* that brought him into contact with Stella.

17. Paul V. Kellogg, "Monongah," *The Survey* (January 4, 1908), 19:1313. *The Survey* was another of the important magazines devoted to exposing the miserable living and working conditions of the immigrant laborers.

18. Illustrated, *The Outlook* (December 23, 1905), 81:968.

19. Stella, "Discovery," p. 2.

20. Other modern artists, from the Impressionists on, had found beauty in the industrial landscape. Since Stella's image of Pittsburgh is associated with volcanoes and since he had lived in the neighborhood of Vesuvius, it seems likely that this sensibility in him is accounted for, at least in part, in this way.

IV. Return to Europe

1. For discussion of nineteenth-century American art see, among others, John I. H. Baur, *The Karolik Collection of American Art, 1815–1865* (Boston: Museum of Fine Arts, 1949), and Oliver Larkin, *Art and Life in America* (New York: Rinehart, 1949; rev. 1960). With regard to American artists abroad, it should be noted that Winslow Homer was little influenced by European developments.

2. Maurer was twenty-nine; Karfiol, fifteen; Halpert, eighteen; Sterne, twenty-six; Marin, thirty-five; Weber, twenty-four; Russell, twenty; Bruce, twenty-seven; Walkowitz, twenty-six; Dove, twenty-seven; Carles, twenty-five; Pach, twenty-four; MacDonald Wright, seventeen; Demuth, twenty-four; Covert, twenty-six; Benton, nineteen; Schamberg, twenty-six; Sheeler, twenty-six; Dasburg, twenty-three; Dickinson, eighteen; Hartley, thirty-five.

3. Agostino de Biasi, *Il Progresso Italiano*? (April 1913).

4. See Chapter II, note 9.

5. Stella, "Discovery," p. 3.

6. Joseph Stella, "The New Art," *The Trend* (June 1913), p. 393.

7. Baur, "Stella."

8. Stella recounts this in both "Discovery" and "Notes About Stella." I have directed inquiries to authorities in Rome and Florence and have enlisted the help of colleagues in those cities in an effort to trace these works. So far, they have not been located, nor is there documentary evidence of the acquisition.

9. Stella, "The New Art," p. 393.

10. Stella, "Discovery," p. 3.

11. Joshua C. Taylor, *Futurism* (New York: Museum of Modern Art, 1961), p. 121.

12. It is interesting how closely Mancini's work of around 1880 resembles Stella's painting during the period of study at the Chase School twenty years later, as well as his subsequent "Rembrandt" style, based on a crepuscular *fin-de-siècle*-weakened grasp of Rembrandt's spirituality, Hals' gusty realism, and Velásquez' poetically lighted naturalism. See Dario Cecchi *Antonio Mancini* (Turin, 1966), and Fortunato Bellonzi, *Antonio Mancini* (Milan, 1962).

13. Stella, "The New Art," p. 394.

14. Stella, "Discovery," p. 4.

15. *Ibid.*, p. 5.

16. Stella, "Modern Art," an essay written in English, found among his papers.

17. Stella, "Discovery," pp. 4–5.

18. Baur, *Joseph Stella*, p. 20.

19. I am interested in Theodore Reff's suggestion that letters of Cézanne might have inspired certain of Stella's ideas, expressed in passages such as this. Emile Bernard had published "Souvenirs sur Paul Cézanne et lettres inédites" in the *Mercure de France*, October 1 and 15, 1907 (John Rewald, *Paul Cézanne Letters* [London: Bruno Cassirer, 1941], p. 13), and it is possible that Stella's attention had been drawn to these letters during his 1911–12 stay in Paris. There are interesting similarities. Compare the sequence of ideas and the vocabulary in this paragraph of Stella's essay with the following passage from a letter of Cézanne to Bernard. "The Louvre is the book in which we learn to read. We must not, however, be satisfied with retaining the beautiful formulas of our illustrious predecessors. Let us go forth to study beautiful nature, let us try to free our minds from them, let us strive to express ourselves according to our personal temperaments" (*ibid.*, p. 250).

20. Stella, "The New Art," pp. 394–395.

21. See, for example, in Jean-Paul Crespelle, *The Fauves*, color illustrations 6, 21, 33, 38, 46, 52. I use the term Fauve to indicate characteristics common to the painting of the artists mentioned, in 1906. Brilliant color applied with blunt, dash-shaped strokes, cursive strokes, or a mixture of the two kinds, distributed in an over-all design, creating a vivacious, vibrating effect.

22. Ernesto Valentini, *Bollettino della Sera*, April 26, 1913. For further discussion of Stella's participation in the Armory Show see Chapter V, and Appendix III, Figure 30.

23. The first quotation appeared in the Italian-American newspaper *Il Giornale Italiano*, April 24, 1913. The second, an unidentified clipping fragment, appears to be from an American newspaper printed in Italian.

V. Battle of Lights

1. Milton W. Brown, *The Story of the Armory Show* (Greenwich, Conn.: The Joseph H. Hirshhorn Foundation, 1963), pp. 205–206. Possibly because he had not yet returned to the United States by December 1912, when the invitations were issued, Stella originally had not been invited to participate in the Show by the domestic committee handling American artists. However, the invitation suggested a welcome to any artist who had something new to offer, and Stella surely would have felt that he fitted the description of desirable exhibitors: "The Association particularly desires to encourage all art work that is produced for the pleasure that the producer finds in carrying it out. In this way the Association feels that it may encourage non-professional, as well as professional artists, to exhibit the result of any self-expression in any medium that may come most naturally to the individual. . . . The Association would like to be informed of such cases and, through the medium of one of its members, become familiar with the output of such individuals" (*ibid.*, p. 64).

2. Stella, "Discovery," p. 6.

3. De Fornaro, "Stella," pp. 30–31.

4. A link between Stella and Pollock has been remarked by Emilio Vedova,

quoted in a letter to Nello Ponente: "The influence of Futurism, in my opinion, is to be looked for far beyond the repercussions contemporary with it . . . present day painting often goes back to it. From Stella, for instance, we can go as far as Pollock . . ." (Rosa Trillo Clough, *Futurism* [New York: Philosophical Library, 1961], p. 236).

5. "Felt" refers to Feltman's, a well-known refreshment stand; "Com," to Comet, a famous high-ride; and "Park" means either Luna or Steeplechase Park.

6. Letter included by Hazel and Ruth Hotchkiss (friends of Carlo de Fornaro) in their sale of the De Fornaro manuscript to Robert Schoelkopf.

7. This and all illustrations of Futurist paintings cited in this book are found in Joshua Taylor, *Futurism* (New York: Museum of Modern Art, 1961).

8. Werner Haftmann, *Painting in the Twentieth Century* (New York: Frederick A. Praeger, 1960), I, 162–163. He seems to be using "spaciousness" in the way it is commonly used with reference to American painting, that is, to denote the sense of openness and breadth with which artists supposedly have responded to the size of the country.

9. Stella, "Discovery," p. 6; see also Chapter XII.

10. There were no Futurists in the Armory Show. The reason commonly given, that the organizers of the show would not accede to the Futurists' insistence on exhibiting as a group, is untrue since this demand apparently was met (see Brown, *Armory Show*, pp. 57–58). The more likely explanation is that given by Gino Severini, who writes that Walter Pach invited him and the other Futurists to participate; but Marinetti, "because of his own plans for exhibitions and other projects," would not consent, and for reasons of "solidarity" the painters regretfully refused the invitation. "Today it is clear what a mistake we made in not being represented in that magnificent international exhibition," Severini comments (Gino Severini, *Tutta La Vita di un Pittore* [Milan: Garzanti, 1946], I, 165–166).

11. Villon's painting, and the two paintings by Picabia cited in this paragraph are illustrated in the catalogue of the *Armory Show 50th Anniversary Exhibition, 1913–1963* (New York: Henry Street Settlement and Utica, New York, Munson-Williams-Proctor Institute, 1963).

12. Haftmann, *Painting in the Twentieth Century*, I, 113, writes that Delaunay tested "le sens giratoire" of colors (whirling motion effect) in a series of paintings of a tower with a ferris wheel.

13. Stella, "Discovery," p. 14.

14. Both Stephan Bourgeois and Edgard Varèse who knew him during these years recalled Stella in this way.

15. Carlo de Fornaro, "Stella," p. 6. The quotations following are from pp. 7–8, 14, 31.

16. New York *Herald Tribune*, October 21, 1917.

VI. Brooklyn Bridge and the Industrial Scene

1. Interview with the Italian writer Bruno Barilli, published in *L'Ambrosiana*, Milan, September 1929.

2. Carlo de Fornaro, "Stella," p. 37.

3. Thomas Hart Benton, *An Artist in America* (New York: Robert M. McBride, 1937), p. 43; see also note 8 below.

4. Alfred H. Barr, Jr., *Picasso: Fifty Years of his Art* (New York: Museum of Modern Art, 1956), pp. 93–94, 115.

5. The first Suprematist paintings were exhibited in the winter of 1915, at the exhibition "0.10, The Last Futurist Painting Exhibition," in what was then Petrograd; see Camilla Gray, *The Great Experiment: Rusisan Art, 1863–1922* (London: Thames & Hudson, 1962), p. 192.

6. Amedée Ozenfant and Pierre Jeanneret, *Après le Cubisme*, vol. I of Commentaires sur l'art et la vie moderne (Paris: Edition des Commentaires, 1918); Gino Severini, *Du Cubisme au classicisme* (Paris: J. Povolozky & Cie., 1921).

7. Katherine Metcalf Roof, *The Life and Art of William Merritt Chase* (New York: Charles Scribner's Sons, 1917), *passim*.

8. The New York *Herald*, November 17, 1918. It is significant that the group of progressive artists that had centered around Alfred Stieglitz lost its cohesiveness during the war. As Benton remarks, "After the war our old prewar aesthetic gloom had disintegrated. Alfred Stieglitz had given up his 291 Fifth Avenue and the droning talk of the aesthetic soul probers he sheltered was ended . . . it is well in the past" (Benton, *An Artist in America*, p. 46).

9. *The Survey* (November 2, 1918), 41: x.

10. *Ibid.* (February 1, 1919), 41: 617.

11. I shall not take up Stella's work in printmaking in this book; it is insignificant in his *oeuvre*. The works cited in this paragraph are not illustrated in Jaffe, "Stella," except for *Night*, which is illustrated in this book also.

12. Stella, "Discovery," p. 7.

13. Albert Gleizes was in the United States during World War I, invalided out of the French army, and exhibited in group shows at the Bourgeois Galleries with Stella. (Frederick James Gregg, The New York *Herald* (?), November 1918. Also, *Annual Exhibition of Modern Art* exhibition catalogue, Bourgeois Galleries, May 1919). Two studies by Stella indicate his knowledge of an interest in two of Gleizes' Bridge paintings. There is no other evidence that Stella saw them, for they were not exhibited until many years later, but since both men moved in the same circle of progressive artists, the opportunity for Stella to see the work was not limited to public exhibitions. If we compare his watercolor (?) *Study* (Figure 48) with the Gavardie *Brooklyn Bridge* by Gleizes, we note that, despite the many differences, there is in common a curving form that extends diagonally across the surface, and that both make use of a pattern "derived from the crisscross of intersecting cables." (Daniel Robbins, *Albert Gleizes* exhibition catalogue, New York, Solomon R. Guggenheim Foundation, 1964, p. 56. This reference is also the source for the illustrations, and documentation with regard to Gleizes.) In the pastel *Study* (Figure 49), we see again the curving diagonal form and at the left a design composed of four slanting bars rising from the lower area, crossed near the top by four parallel lines. Features similar to these are prominent in *On Brooklyn Bridge* by Gleizes. In Stella's *Study* (Figure 49), three isosceles triangles are arranged, point downward, across the upper area of the sheet; in the Gleizes painting, one such triangle is placed just left of center, its inverted base coincident with the upper

edge of the canvas. It is interesting, however, that these features do not appear in Stella's finishing painting.

The only Bridge painting by Gleizes that Stella undoubtedly saw is the Guggenheim *Brooklyn Bridge*, exhibited at the Montross Gallery in 1916, although it does not seem to have interested him, either in connection with his studies for the *Bridge*, nor in his painting. In it Gleizes focuses on the concept of tension that the real bridge suggests, and the wide black diagonal pushing against the black arc evokes the image of a bow and arrow held taut. Stella, on the other hand, is interested in the web of wires and cables, and in the "lights resembling suspended falls of astral bodies or fantastic splendors of remote rites" (Joseph Stella, "Brooklyn Bridge, A Page of My Life"). Stella's image is like a maze. Gleizes' bridge form is completely abstract, but shares the picture space with a semiabstract cityscape seen behind the black diagonal and arc. In Stella's painting, the cityscape is a minor motif, and the bridge is small and representational; the major area of the painting is an imaginative design based on actual structural elements of the bridge fused with subway "caves . . . subterranean passages to infernal recesses."

14. Stella. "Discovery," p. 7.

15. This essay was privately printed and illustrated with the five sections of *New York Interpreted*, although it actually refers to the Yale *Brooklyn Bridge*. Through the interest of Hart Crane the essay appeared in *Transition*, nos. 16–17 (June 1929).

16. *American Contemporary Art* (New York: A.C.A. Gallery, November 1944).

17. Both quotations from Stella, "Discovery," p. 2.

18. *Ibid.*, p. 12.

19. Lloyd Goodrich and John I. H. Baur, *American Art of Our Century* (New York: Frederick A. Praeger, 1961), p. 52. Also see this reference for illustrations of all Precisionist paintings cited in this book unless otherwise noted.

20. Holger Cahill, *American Painting and Sculpture* (Newark, N.J.: Newark Museum, 1944), p. 51.

21. Illustrated in Henry Geldzahler, *American Painting in the Twentieth Century* (New York: Metropolitan Museum of Art, 1965).

VII. New York Interpreted

1. Santa Pudenziana is illustrated in Wolfgang Fritz Volbach, *Early Christian Art* (New York: Harry N. Abrams, n.d.); *Veduta di Città* in George Rowley, *Ambrogio Lorenzetti* (Princeton: Princeton University Press, 1958), vol. 2, fig. 94, titled *Townscape*, tradition of Ambrogio Lorenzetti.

2. F. Gilles de la Tourette, *Robert Delaunay* (Paris: Ch. Massin & Cie., 1950), p. 33. Also see *La Ville de Paris* illustrated here.

3. The *Bollettino della Sera*, April 26, 1913, and the Paris *Tribune* in a clipping fragment of about 1930 or 1931 mention that Stella exhibited in the Salon des Indépendants of 1912. His name does not appear in the catalogue, however.

Meyer Schapiro has suggested that the triangular forms in Stella's New York paintings may have been inspired by Delaunay's Eiffel Tower paintings.

4. Taylor, *Futurism*, p. 124. Taylor also publishes here, in English translations,

various manifestoes issued by the Futurist painters and sculptors between 1910 and 1912.

5. New York *Sun*, May 25, 1913.

6. *Courrier des Etat-Unis*, April 21, 1925.

7. *Corriere d'America*, February 18, 1940.

8. Pierre Francastel, ed., *Robert Delaunay* (Paris: S.E.V.P.E.N., 1958), p. 137; Andrew C. Ritchie, *Masters of British Painting* (New York: Museum of Modern Art, 1956), p. 106.

9. For discussion of Bergsonianism and Futurism, see, for example, Francesco Flora, *Dal Romanticismo al Futurismo* (2nd ed. rev.; Milan: A. Mondadori, 1925).

10. For illustrations see *John Marin* (Berkeley and Los Angeles: University of California Press, 1956); Goodrich and Baur, *American Art* (for Walkowitz); and Lloyd Goodrich, *Max Weber* (New York: Whitney Museum of American Art, 1949).

11. Stella, "Discovery," pp. 9–10.

12. Frederic C. Howe, *The Modern City and Its Problems* (New York: Charles Scribner's Sons, 1915), p. 25; italics mine.

13. The force of this tradition in Italy is striking; numerous polyptychs are listed in exhibitions of the years 1900–1912; Boccioni's *States of Mind* is the best known.

14. Stella, "Discovery," p. 12.

15. *Ibid.*

16. Stella recited most frequently from Dante, Shakespeare, Poe, and Whitman.

17. Stella, "Brooklyn Bridge, A Page of My Life."

18. I am indebted to August Mosca for many technical details.

19. Stella, "Discovery," p. 11.

20. Stella, "Discovery," p. 12.

21. The phrase is William James's, quoted in *The American Muse* (exhibition catalogue. The Corcoran Gallery of Art, published in cooperation with *Art in America*, 1959), p. 27.

22. Between pp. 32–33. I am indebted to John I. H. Baur for drawing my attention to the collage when I showed him this detail in the painting.

23. Charmion von Wiegand, "Joseph Stella — Painter of Brooklyn Bridge" (unpublished ms. found among Stella's papers), p. 2.

24. See also the curiously hostile description of Stella in *Man Ray, Self-Portrait* (Boston and Toronto: Little, Brown, 1963), p. 93.

25. Henry McBride, "Modern Art," *The Dial* (April 1923), pp. 423–424.

26. Baur, "Stella."

27. McBride, "Modern Art," p. 423.

28. Widely reproduced, *New York Interpreted* enhanced Stella's already distinguished position as a leading American artist. It is interesting to speculate on the role it possibly played in inspiring a masterpiece in another art form, the long poem, "The Bridge," by Hart Crane.

Brom Weber, in his biography of Crane, reviews some general evidence that suggests the possibility that Crane had "derived the symbol of the bridge from Stella's painting" (Brom Weber, *Hart Crane* [New York: The Bodley Press, 1948], p. 318). However, two aspects of the question must be considered: which work of

Stella's is involved in Crane's poem; and when did the poet have an opportunity to see the work that is assumed to have stimulated his imagination so strongly?

The Yale *Bridge* was exhibited at the Bourgeois Galleries in 1920. It was reproduced in the October 1921 issue of *The Arts*, in the first issue of *Broom* (November 1921), and in *The Little Review* of Autumn 1922, the "Stella Number"; these are the reproductions referred to by Weber. Although Crane probably had seen these reproductions, it was not until February 1923 that the first idea for a bridge poem seems to have formed in his mind. On February 6, he wrote his friend Gorham Munson, "I am ruminating on a new longish poem under the title of "The Bridge"" (Brom Weber, ed., *The Letters of Hart Crane* [New York: Hermitage House, 1952], p. 118). It seems more than coincidental that Crane's initial concept is recorded the very month when Stella's five canvases were on exhibition at the Société Anonyme (January 10–February 5); and yet Crane was not at that time living in New York, having moved back to Cleveland in 1919. There is, however, a Société Anonyme pamphlet which, although undated, must have been published at the time of the exhibition. It carries a text by Katherine Dreier about Stella and *New York Interpreted*, and reproductions of all five sections of the painting. It is likely that one of Crane's New York friends sent him a copy of this pamphlet.

The poem was a long time in preparation, and it was not ready for publication until 1929. On September 12, 1927, Crane wrote Otto Kahn, who was aiding him financially at the time. The letter is interesting in the way its imagery bears on the problem of the source of inspiration.

> Thousands of strands have had to be searched for, sorted and interwoven. In a sense I have had to do a great deal of pioneering myself. It has taken a great deal of energy . . . which has not been so difficult to summon as the time . . . until my instincts assured me that I had assembled my materials in proper order for a final welding into their natural form. For each section of the entire poem has presented its own unique problem of form, not alone in relation to the other parts. *Each is a separate canvas, as it were, yet none yields its entire significance when seen apart from others* (italics mine).

This passage is followed by the comment, "One might take the Sistine Chapel as an analogy" (Weber, *Letters of Hart Crane*, p. 305). One might with more reason take the five canvases of *New York Interpreted* as a closer analogy considering the subject matter, the imagery Crane projected in his ideas about his work, the multipartite organization of the poem, and in view of the fact that the Sistine Chapel paintings are not even on canvas.

Late in 1928 Hart Crane went to Europe and in Paris met "the amazing millionaire Harry Crosby," who, he wrote Malcolm Cowley on February 4, 1929, "is going to bring out a private edition of 'The Bridge' with such details as a reproduction of Stella's picture in actual color as frontispiece" (*ibid.*, p. 335). Crane's letter to Stella, requesting permission for the use of his painting for this purpose makes clear which bridge painting is at issue:

> Dear Mr. Stella:
>
> Sometime before leaving America Charmion Habicht [Wiegand] showed me a copy of your privately issued monograph called "New York," containing your essay on Brooklyn Bridge and the marvelous paintings you made not only of the Bridge but other New York subjects. This has been the admiration of

everyone to whom I have shown it. And now I am writing you to ask if you will give permission to an editor friend of mine to reproduce the three pictures . . . "The Bridge," "The Port," and the one called "The Skyscrapers." He would also like to reprint your essay . . .

I have also a private favor of my own to ask of you. I should like permission to use your painting of "The Bridge" as a frontispiece to a long poem I have been busy on for the last three years . . . called "The Bridge." It is a remarkable coincidence that I should, years later, have discovered that another person, by whom I mean you, should have had the same sentiments regarding Brooklyn Bridge which inspired the main theme and pattern of my poem (*ibid.*, pp. 333–334).

Inasmuch as Crane refers in the first paragraph to the Bridge painting that forms part of the *New York Interpreted* series it is obvious that "The Bridge" referred to is the same painting originally exhibited in January 1923.

This letter indicates that Crane had only recently become aware of Stella's work on the Bridge theme. However, that is next to impossible, what with the publicity and the reproductions of both "Bridges" in the literary magazines that Crane read regularly and in which his own work was published. But there is also the mistaken reference to three years instead of the actual six years we know Crane had spent on this long poem, so Crane's memory may not be entirely trustworthy. Despite the fact that Crane was not in New York in January and early February 1923, the evidence strongly suggests that Stella's *New York Interpreted* "Bridge" did provide an inspirational image for Crane's poem.

> Through the bound cable strands, the arching path
> Upward, veering with light, the flight of strings,
> Taut miles of shuttling moonlight syncopate
> The whispered rush, telepathy of wires.
> Up the index of night, granite and steel . . .
> Transparent meshes . . . fleckless the gleaming staves . . .
> Sybylline voices flicker, wavering stream
> As though a god were issue of the strings.

A comparison of Stella's response to Brooklyn Bridge with that of Crane's must take into account all five panels of *New York Interpreted*, for as Crane pointed out in his letter to Kahn, the section entitled "The Bridge" is inextricably a part of the whole work. Both the painter and the poet saw in the Bridge the symbol of the New World that is at the heart of American mythology. Each used it as a metaphor of transition from night to day, that is, from past to future. "Bridge, lifting night to cycloramic crest of deepest day," Crane writes, while Stella tells us in "Brooklyn Bridge: A Page of My Life," that "a new light broke over me . . . a new clarity . . . proclaimed the luminous dawn of *a new era.*"

Both the poem and the painting make use of metaphysical perception and yet are anchored in concrete observation. For Stella and for Crane, science and machinery had to be absorbed into contemporary art as naturally as the human figure and landscape had served the imagery of the humanist tradition. *The Bridge* and *New York Interpreted* express modern sensibility in a context of timeless and universal experience: each artist feels himself in transition, identified with the central aspirations of his time. The difference in the approach of the two artists to their theme is

in Hart Crane's specific identification with the American past and the whole American land — its mountains, valleys, and rivers. The Bridge, for Crane, reaches back to Pocahontas, to Columbus, and then back to Troy, and "It leaps from Far Rockaway to the Golden Gate." For Stella, too, the Bridge served as self-identification, but from a viewpoint focused by his consciousness as a European as well as an American, he saw the span "traced for the conjunction of worlds." The accent of Crane's contemporary speech echoing in the corridors of time is the American accent of human optimism, of earnestness, and of rational doubt.

> Walt, tell me, Walt Whitman, if infinity
> Be still the same as when you walked the Beach
> Near Paumanok.

Stella, in contrast, "felt . . . as if on the threshold of a new religion or in the presence of a new *divinity*."

Through Crane's poem there is an endless sense of motion — people on the move, rivers flowing. Stella's painting is devoid of human figures; the only water is that of the dark, still harbor, and the movement in *New York Interpreted* is throbbing rather than flowing. Cables and wires in Crane's poem are like veins and arteries carrying the sap of life through the body of the image. In Stella's painting, the cables and wires bind the image like cords wrapped around a shrouded form. Nevertheless, each in his way — Crane lyrical, Stella heroic — found in the Bridge, as Stella writes in his essay, "the shrine containing all the efforts of the New Civilization of America — the eloquent meeting point of all the forces arising in a superb assertion of their powers."

VIII. Nature Lyrics and Junk Art

1. De Fornaro, "Stella,'" p. 23.

2. Works by Redon cited in this book are illustrated in *Odilon Redon, Gustave Moreau, Rodolphe Bresdin* (New York: Museum of Modern Art, 1926).

3. Walt Kuhn had seen Redon's paintings for the first time in The Hague, when he went to Europe to collect works for the Armory Show, and had been highly excited with his discovery, writing Walter Pach: "We are going to feature Redon big (BIG). You see, the fact that he is so little known will mean a still bigger publicity." (Quoted in Brown, *Story of the Armory Show*, p. 56.) Although *Andromeda* was not in the show and there is no conclusive evidence that Stella saw it in Paris in 1911, the resemblances of some of its features to those in Stella's work suggest this as likely, in view of his interest in Redon whose visionary, symbolic art would understandably attract him. For readers who see in the *Nativity* and other works a resemblance to Art Nouveau, it may be pointed out that Stella shows no responsiveness to that style during the years of its influence, and by the time he returned to Europe, Art Nouveau had been abandoned by the progressive artists who interested him.

4. Yale University Sterling Library, American Collections, "Joseph Stella, Correspondence." Hereafter, YUSL, "Joseph Stella."

5. The photograph mentioned has been published several times; see Robert Lebel, *Marcel Duchamp* (New York: Grove Press, 1959). Stella participated in the International Dadaist exhibition at the Galerie Montaigne, in Paris, June 1922.

6. William C. Seitz, *The Art of Assemblage* (New York: Museum of Modern Art), p. 73.

7. *New York Times*, October 3, 1961.

8. During the closed period, Katherine Dreier traveled to the Orient. In view of the taste of the twenties for things Oriental, it is interesting to read in her letter to Stella, dated Peking, China, January 30, 1922 (found in Stella's papers), that she was studying Chinese brushwork. She writes of her amazement at how the Chinese artists could paint a leaf of a flower or tree with a single stroke, keeping the center liquid and fluid while the edges remained firm and crisp. She was sure that Stella would be as fascinated as she was.

9. YUSL, "Joseph Stella."

10. An intimate and charming glimpse of Stella is revealed in an inept yet vivid poem by Louis Eilshemius. Found among Stella's papers, handwritten by his artist-friend, and dated July 22, 1921, it tells of Stella's constant longing for Italy.

> There lives within our city
> A great Italian, who a painter is.
> He would to hear again the ditty
> The peasants sing, far far in Italy.
> Homesickness and slight living cares
> Eat up his heart, while painting here
> Works far too great for our own men to feel,
> Then grows his longing twicefold dree;
> for no one understands
> His soul-works, fair as those in olden lands!
>
> Oft times with him I'm seated;
> While in his room he paints at will,
> And when his day's work lies completed
> He tells me legends of his home afar:
> Santa Maria, in the Roman hills
> Perched high on craggy mountains wild.
>
> Each Thursday night at nine there passes
> Adown the valley Christ, in glow apparelled.
> Then all the peasants light their hundred candles
> And place them on the window sills.
> Then seems the village as if stars had fallen
> And settled on each house: so flicker-like all seems
> Then wonderment the soul of all the peasants fills,
> Then entones the painter a song of theirs:
> So rich . . . sonorous, delighting me.
>
> Thus in his room he paints away
> Soul works not many men can understand.
> And while he works at will, there stray
> Short memories of his glorious land.
> And when I'm seated there,

He sings the songs Italian peasants sing
So sweet, sonorous, rich and fair,
As tho I heard the peasants' carolling.

IX. Nudes and Madonnas

1. Stella, "Discovery," p. 14.

2. *The New Yorker* (April 18, 1925), p. 17. Meyer Schapiro called to my attention a physical resemblance between the Leda in Stella's painting and the artist. That Stella could unconsciously create an image of himself in a woman is not surprising since, according to Stephan Bourgeois (Chapter VI), he could play Desdemona with convincing grace and tenderness.

3. Henry McBride, New York *Sun*, April 11, 1925.

4. "Discovery" reports that he returned "around 1924," but in Stella's correspondence (YUSL, "Joseph Stella") letters dated as early as March 14, 1923, were addressed to 451 West 24th Street, New York.

5. Henry McBride, New York *Sun*, April 11, 1925.

6. De Fornaro, "Stella," pp. 55, 58, 54. He writes that Stella's *Man With a Mask*, given to the Brooklyn Museum by Mrs. William H. Good in 1928, was inspired by these balls. This is puzzling because the Brooklyn work is actually a still-life, with a half mask prominent in the foreground, lying on a table, not worn. I think De Fornaro was simply mistaken about which work had gone to Brooklyn, since Stella did paint a man with a mask, *Pulcinella*, exhibited in Naples in 1929.

7. Letter from United States Department of Justice, July 30, 1963.

8. The research with regard to Mary French Stella was developed by Mrs. H. W. Nice, Hon. Sec., Council, the Barbados Museum and Historical Society. See Whitney Museum Artists File, "Joseph Stella."

9. Information from Mrs. Mildred Baker, former Director of the Newark Museum and a friend of "the Stellas" during the 1920's. Grosvenor House, a social settlement house, is still in existence.

10. *New York Times*, April 18, 1926.

11. Stella, "Discovery," pp. 14–15.

12. In a variation of the work of this period, the nudes and heads are analogized into a *Swan* that is moving out of the darkness into a rainbow-striped light.

13. "Correspondence, Weeks-Stella," Iowa State Education Association. Although Stella maintained contact with Carl Weeks for many years, Weeks did not add anything of importance to his collection of Stellas after his initial purchases. Few twentieth-century artists were represented in Salisbury House, which featured a rather eclectic collection of paintings, sculptures, and *objets d'art*, including a coromandel screen, Van Dyck's *Portrait of Cardinal Domenico Rivarola*, a sixteenth-century Brussels Brabant tapestry, a suit of armor, and some fine furniture, oriental rugs, and rare books. Stella's *Tree of My Life* and *The Birth of Venus* are exhibited in a passageway along with a Daniel Quare walnut veneer hall clock with marquetry decoration, a Jacobean oak bench and monk's chair, a bronze *Head of Apollo* by Bourdelle, a Siamese eighteenth-century standing Buddha, and a *Still Life* by Alexander Brook.

Carl Weeks died in 1963. His private "castle," as he liked to call it, is now the

home of the Iowa State Education Association. I am indebted to Ina E. Carlin, former secretary to Mr. Weeks, for sending me photostats of the Weeks-Stella correspondence.

14. In a fragment of writing in which Stella outlined a plan for an autobiography in Italian, he notes in the statues and niches of his village church "memories of Egypt and Greece in the draperies falling in straight folds, hieratic, archaic."

15. McBride, New York *Sun*. There is no date on the clipping, but the review refers to Stella's exhibition at the Valentine Gallery, April 1928.

16. I.S.E.A., "Correspondence, Weeks-Stella."

17. Elzéard Rougier, *La Ville des Santons* (Marseilles: Augustin Tacussel, 1927). This is primarily a folk art, and although the figurines are often made of clay, they are characteristically rather crude and have the angular, somewhat stiff quality of folk wood-carving. The figurines of Marseilles were occasionally also of carved wood, and in Italy wood is commonly used for these Nativity scene figures. Stella must have bought some of these figurines, for Charmion von Wiegand, in her unpublished article about Stella, written around 1940, reports that the fireplace mantel in his studio was crowned with "countless knicknacks — curling green gourds, African masks, French puppets, a plaster madonna," and we see in a painting, *Marionettes* (Figure 96), exhibited at the Galerie Sloden in 1930, a puppet horse and knight that probably posed also for one of his major works of the early thirties, *The Holy Manger* (Figure 100).

18. See epigraph, Chapter X.

19. In 1926 Stella held an exhibition of these "encaustique" paintings (so listed in the catalogue) at the New Gallery Club. It consisted of a large number of flower subjects and a group of portraits which included both *Portrait of Kathleen Millay* and *Portrait of Norma Millay*. There has persisted a story that *The Amazon* was actually a portrait of Kathleen Millay, although Stella himself does not indicate this. In *Italiani pel Mondo* (1926), an illustration of a half-nude seen frontally was reproduced with the title "Kathleen Millay," clearly not our *Amazon*.

20. Von Wiegand, "Joseph Stella," p. 6. I suspect this figure is grossly exaggerated, although Stella did speak to Mosca of the large amounts of money he earned for a while. In October 1934, when Stella returned from Europe, he deposited one thousand dollars in the Greenwich Savings Bank at 2 percent interest. Each three months when the interest, five dollars, fell due, it was credited to his account and Stella promptly withdrew it. One cannot say he was living on his income, even with Depression prices.

21. Reported by everyone with whom I have talked.

22. Stella, "Discovery," p. 13. Stella loved the brilliant coloring and patterns of butterflies; when he died, his nephew gave August Mosca a box of mounted butterflies found among the artist's effects. Also among his papers was this note: "Dear Joe, During our walk we found this butterfly lying dead in the fields. We thought you would like its beautiful color and design . . . Joe and Louise."

X. *France, Italy, and North Africa*

1. Haftmann, I, 207–208; the references to Carrà that follow are from pages 209, 229.

2. Quoted in Chapter IV.

3. See Figure 93 and Checklist numbers 192, 216.

4. All illustrated in Haftmann, vol. II.

5. August Mosca, "Memories of Stella" (letter to Rabin and Krueger), p. 2 (carbon copy in Mosca's possession).

6. De Fornaro, "Stella," p. 57.

7. John I. H. Baur, *Revolution and Tradition in Modern American Art* (Cambridge, Mass.: Harvard University Press, 1958), p. 67.

8. The term "Romantic Realists" is used as defined and discussed by Baur, *ibid*, especially Chapter V. See this reference also for illustrations of the Romantic Realists cited in this book.

9. See Faith and Edward D. Andrews, "Sheeler and the Shakers," *Art in America* (1965), 1:90–95.

10. *American Landscape* (1929) does not represent an area of interest in Stella's art during the years under discussion here. As shown in Chapter IX, it was painted so that a facet of his work considered important by the artist might be included in his Paris exhibition at the Galerie Sloden in 1930, substituting for the paintings that he was unable to have sent to him from the United States.

11. In an interview, Georgia O'Keeffe told me of her admiration for Stella's work but emphatically denied influence in either direction of Stella on her, or of her on Stella.

12. Note, however, that Stella's recognition of the significance of French art in the twentieth century is evident in his letter to the *Courrier des Etats-Unis* (Chapter VII, note 6).

13. August Mosca told me that Stella made many drawings on St. Francis themes during the years he knew him; he thinks Stella intended to do a large painting based on the life of the saint. In Stella's papers there is a copy of *Frate Francesco, Rivista di Coltura Francescana*, Milan, March–April 1929, and Italian newspaper clippings about St. Francis.

14. Illustrated in Roberto Salvini, *All the Paintings of Giotto* (New York: Hawthorne Books, 1963).

15. An Italian critic, Michele Biancale, responded more sympathetically to Stella's eclecticism in the group of paintings he exhibited at the Exhibition of Sacred Art. Reviewing the show in *Il Popolo di Roma*, February 25, 1934, he writes: "If you remove the superstructure you may find Ghirlandaio or El Greco; if you take the long cloaks off of the praying figures, you discover Giotto. But this is not important; it is the result that counts, and this is beautiful: Stella has set himself to pray pictorially in every language . . . and it seems to us that he is the most aesthetically equipped in this difficult undertaking" (II,15).

16. This title seems justified in view of the fact that Stella actually called one of his tropical subjects *Cathedral of the Tropics* (De Fornaro, "Stella," p. 68). The painting De Fornaro describes is not this one, but the expressive intention was similar.

17. At Stella's one-man show at the Valentine Gallery, New York, 1931, *Red Flower* was exhibited with *African Tree* and other titles that indicate North African subject matter.

18. The variety of styles in which Stella worked at this time astonished a number of critics. A reviewer of Stella's exhibition at the Washington Palace, 1932, wrote in an unidentified Italian language newspaper: "One hardly knows where to begin to look . . . a painting in the manner of the Byzantine masters next to one that recalls Japanese painting . . . the room revolves like a magic carrousel . . . oils of every size, of all shades, of all schools, of every tendency and technique. There are paintings in the best Italian classical manner, others distinctly surrealist, still others of an abstract tendency; there are some that recall the futurist school, and others composed in a primitivizing style in which one sees themes and colors in the Flemish taste . . . the visitor wonders: Where is Stella? . . . Stella remains elusive: he is in all of the extraordinarily varied works, and in none of them" (II,14).

19. Samuel Putnam, *Paris Was Our Mistress* (New York: Viking Press, 1947), p. 233. George Seldes left painting and became well-known as a political journalist, publisher of *In Fact* during the late 1940's and early 1950's.

20. *Ibid.*, pp. 234ff., gives an account of the cane fight, mistakenly remembering it as occurring on New Year's Day, after a *vernissage* at the Galerie de la Jeune Peinture. Harry Salpeter, in *Esquire* (July 1941), also describes the incident, but without giving the names of Stella's opponents. A fragment of a clipping from the Paris *Tribune*, January 24, 1932, provides the names and corrects the date.

21. Stella opened an account at the Greenwich Savings Bank on October 29, 1934.

XI. Paintings of the Last Years

1. Stella and his wife — if indeed they were married — lived at 2431 Southern Boulevard in the Bronx. For Stella's addresses in New York and Paris during most of his life, see Baur, *Joseph Stella*, chronology compiled by present author.

2. In Bertram Wolfe, *Strange Communists I have Known* (New York: Stein and Day, 1965), a portrait of Putnam by Stella is illustrated with the medium indicated as "etching." I believe it is a silverpoint, the work listed in this exhibition plan.

3. Although apparently exhibited for the first time at the Newark Museum Retrospective in 1939, *Spring in the Bronx* was illustrated in *Il Progresso Italo-Americano*, March 21, 1937, and probably was painted in 1936.

4. B. J. Kospoth interview with Stella reported in the Paris *Tribune*, June 28, 1931.

5. Mosca, "Memories," p. 9.

6. The *Barbados Advocate*, March 1, 1938.

7. Letter found among Stella's papers.

8. Interview.

9. Alfredo Schettini, interview in unidentifiable Neapolitan newspaper, September 24, 1938.

10. Von Wiegand, "Joseph Stella," p. 8. The comment about Georgia O'Keeffe and Diego Rivera is Miss Von Wiegand's opinion. Compare Miss O'Keeffe's own opinion, cited in Chapter X, note 11. As for Rivera, I doubt that he was affected by Stella's work.

11. Giacinta Stella and her son, Sergio, lived at 33-15 Crescent Boulevard, Astoria.

12. This and the preceding excerpts are all from Mosca, "Memories," pp. 8-10.

XII. Conclusion

1. Stella was right, for the wrong reason. In the Newark Museum *News Notes*, Summer 1969, we read that *New York Interpreted* is to be the highlight of the exhibition, *Treasures of 60 Years*, opening June 7. The announcement observes, "It is interesting to note that, in almost fifty years, the series has arrived at a point of uncanny contemporaneity. Today, Stella's stylistic impressions . . . seem close to psychedelic in concept."

2. I am grateful to Dr. Gendel for the time he spent in reading the manuscript, in studying Stella's paintings and in discussing the problem with me.

3. Stella, "Discovery," p. 6.

4. One of Stella's best self-portraits (Figure 106) is a pencil drawing in the Soyer Collection. Soyer and Stella painted portraits of each other which are now in the Brooklyn Museum. In a letter of February 19, 1962, to Axel von Saldern, Curator of Paintings and Sculpture of the Brooklyn Museum, Soyer recalled: "Stella spent a great deal of time in my studio the last few years of his life. He was quite ill and feeble. He would just sit and talk about art and aesthetics, but mostly he would reminisce. He was a friend of the great of his time, when they were young and were not yet great—Modigliani, Pascin, Soutine, etc. He knew Matisse and Picasso. His language was vivid and rich, very latin in character and he would evoke images of incidents in the lives of the artists. Some were quite surrealistic in their descriptive sharpness. On occasion, when he would feel well, he would ask for paper or canvas and would draw or paint. It was on such a day that we painted one another. He liked to do profiles. He would argue that it was more difficult than full-face, that a profile requires incisive drawing, sensitivity, and discipline and he would cite as examples the great portraits of women in profile by Piero della Francesca, Pollaiuollo, and others." Two other portraits by Soyer of Stella are in the Newark Museum and the Detroit Art Institute. I am grateful to Mrs. Margaret B. Zorach, Brooklyn Museum Art Reference Librarian, for sending me Verifax copies of the Soyer-Von Saldern correspondence.

5. Goodrich has dealt with this problem a number of times. See his essay "What is American in American Art" in *Art in America* (Fall 1958), 46: 19–33.

6. Baur, *Revolution and Tradition*, p. 149.

Index

Index

Illustrations

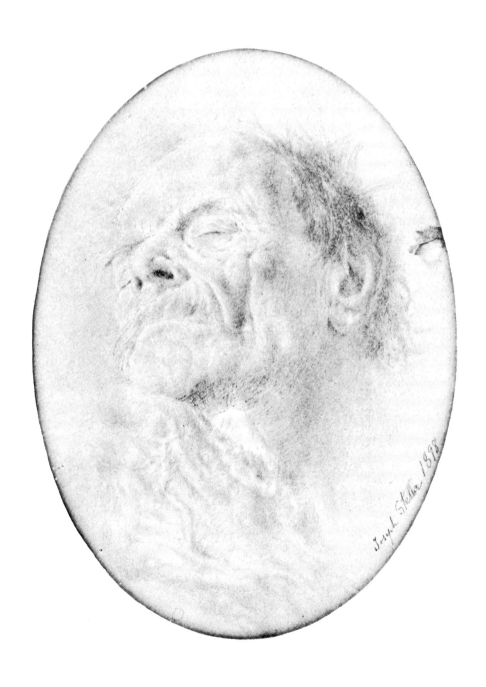

Head of an Old Man, V 1898? I

Pencil. 8 x 5⅞

Collection: Rabin and Krueger Gallery

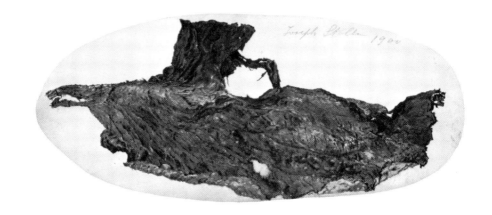

2 *Bark* 1900?

Crayon. 4¼ x 9⅞
Collection: Rabin and Krueger Gallery

Head of Man with a Hat 1900 **3**

Crayon touched with white. 9 x 8¼
Collection: Rabin and Krueger Gallery

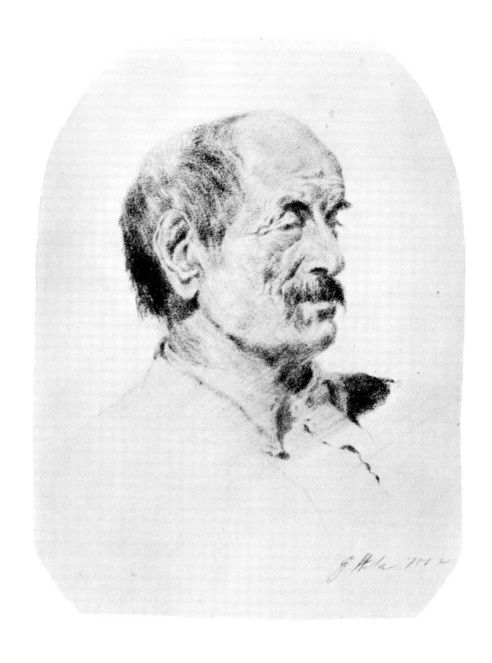

4 *Head of an Old Man*, VIII 1900

Crayon. 7⅞ x 5⅞

Collection: Rabin and Krueger Gallery

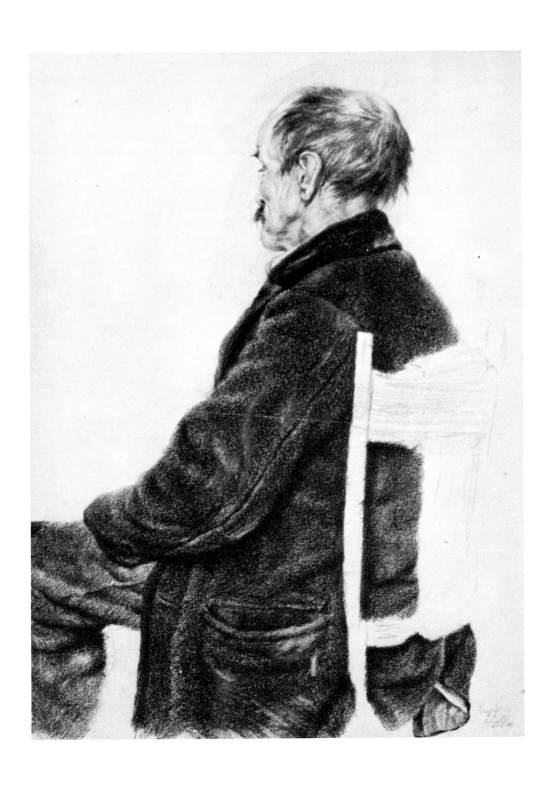

Old Man, XI, Seated c. 1900 5

Pencil, crayon, and charcoal. 9½ x 7
Collection: Rabin and Krueger Gallery

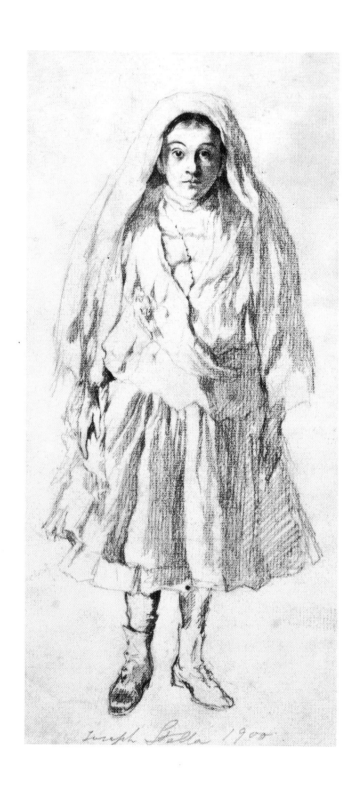

6 *Standing Young Girl* 1900?
Pencil. 10⅞ x 4¾
Collection: Rabin and Krueger Gallery

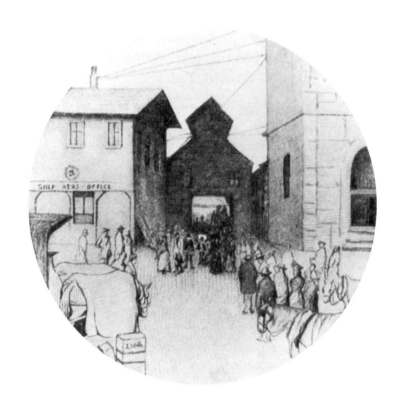

Americans in the Rough:
The Gateway 1905 7

Pencil

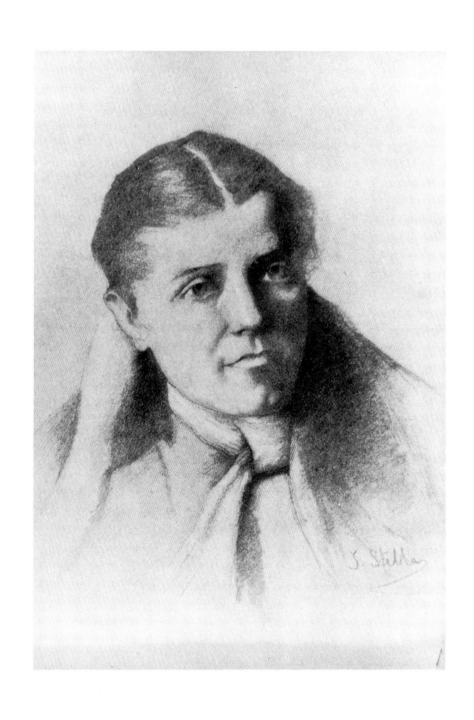

Americans in the Rough:
A German 1905
Pencil(?)

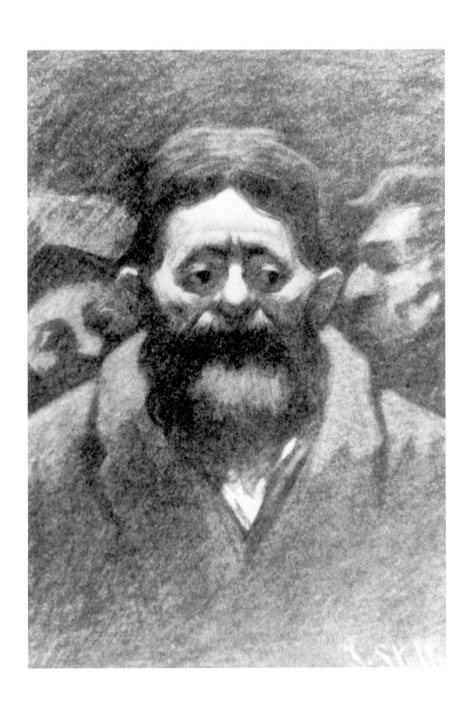

Americans in the Rough:
A Russian Jew 1905

Charcoal(?)

9

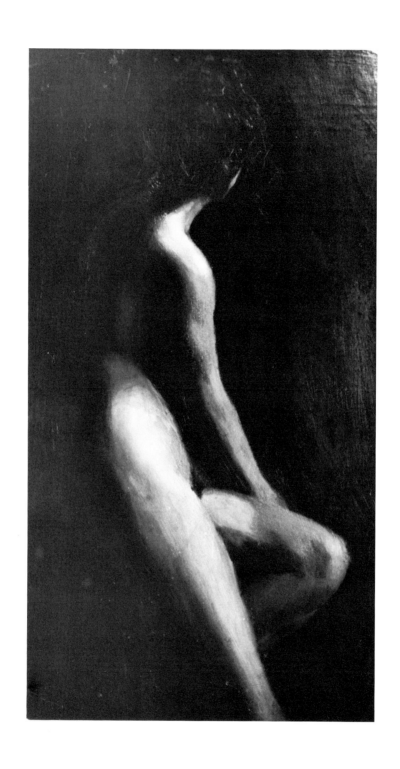

10 *Nude* c. 1902

Oil. 27 x 15
Collection: Sergio Stella,
Glen Head, N.Y.

Face of an Elderly Person 1907? 11
Charcoal and chalk. 9½ x 7½
Collection: Rabin and Krueger Gallery

12 *Monongah: Morning Mist at the Mine Mouth* 1907
Pencil and charcoal(?)

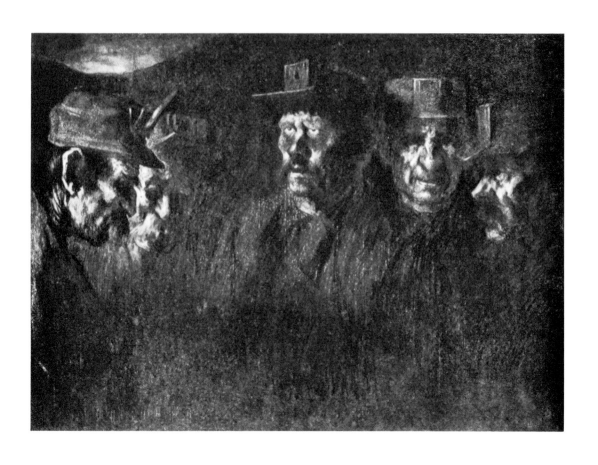

Monongah: Rescue Workers 1907 13
Pencil and crayon(?)

14 *The Cripple* c. 1908

Pencil. 11½ x 7⅞
Collection: Dr. and Mrs. Franklin Simon,
Millburn, N.J.

Pittsburgh II: Italian Leader 1908 15

Conte crayon. 23½ x 19
Collection: Zabriskie Gallery

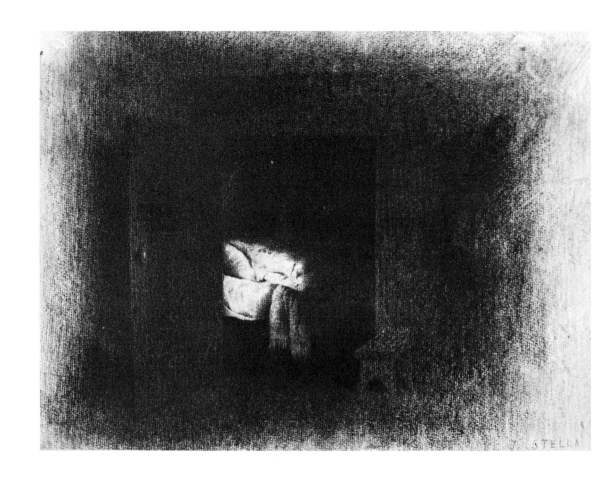

Pittsburgh II: Painter's Row:
Dark Bedroom 1908

Charcoal. 12½ x 16½
Collection: Sergio Stella,
Glen Head, N.Y.

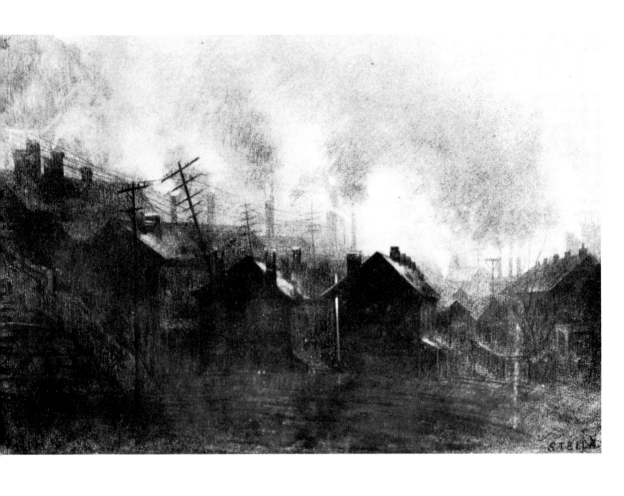

Pittsburgh II: Painter's Row:
Workers' Houses 1908 17

Charcoal. 12 x 18¼
Collection: Mrs. Angela Gross,
Maplewood, N.J.

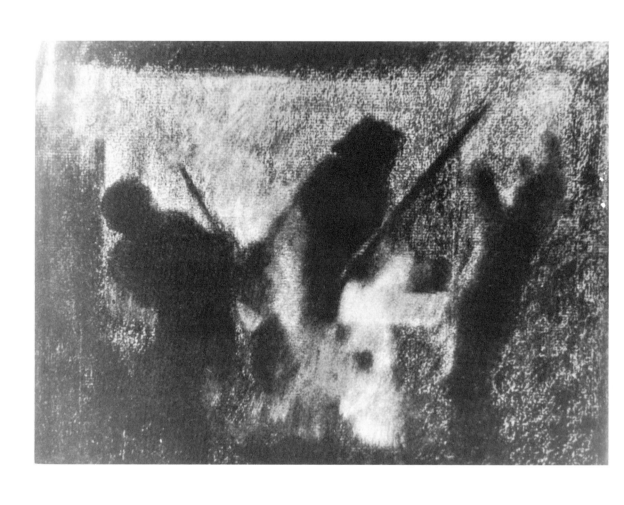

18 *Pittsburgh III: Before the Furnace Door* 1908
Charcoal and pastel(?)

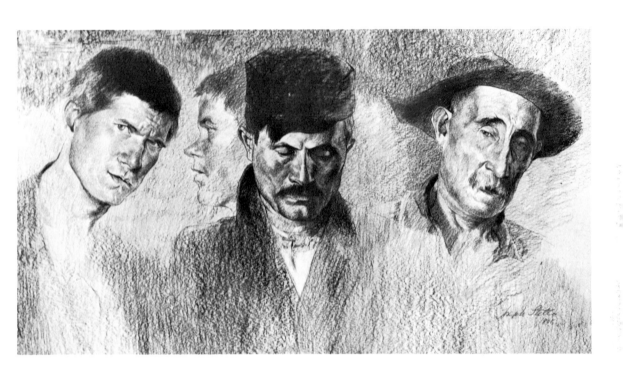

Pittsburgh III: Four Miners 1908 19

Charcoal. 18¼ x 34⅜

Collection: Mr. and Mrs. Caesar P. Kimmel,
Livingston, N.J.

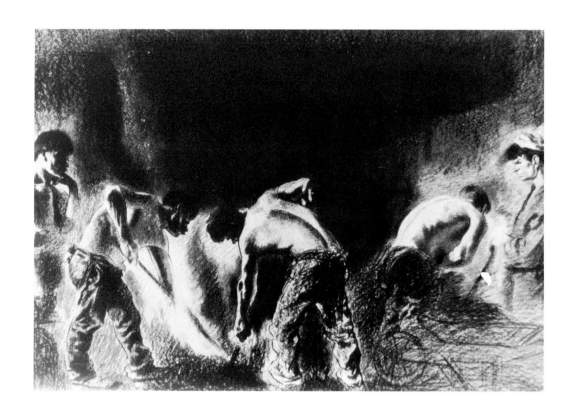

20 *Pittsburgh III: The Stokers* 1908
Charcoal and pastel(?)
Collection: Alexander Bonci, Italy

Pittsburgh, Winter 1908 21

Charcoal. 17⅛ x 23 (sight)
Collection: Rita and Daniel Fraad,
Scarsdale, N.Y.

Joseph Stella 1910

22 *Head of an Old Man, I* 1910?

Crayon. 10⅞ x 8⅞
Collection: Rabin and Krueger Gallery

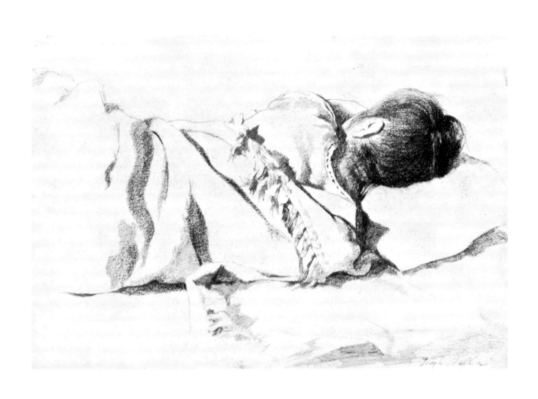

Back of a Woman, Sleeping c. 1910 23

Pencil. 5½ x 8¼
Collection: Mr. and Mrs. Raymond J. Horowitz

24 *Italian Church* c. 1910
Oil. 22¼ x 28¾ (oval)
Collection: Joseph H. Hirshhorn Foundation

Venetian Architect
(*Voce del Passato*) c. 1910 25
Oil. 48½ x 40
Former collection: Brooklyn Museum
(destroyed by fire, 1956)

26 *Man Seen from the Rear* c. 1912

Crayon. 8 x 6⅞
Collection: Gallery 6M

Rocky Landscape with Trees 1912 27

Pencil and crayon. 11¾ x 7⅝
Collection: Rabin and Krueger Gallery

28 *Still Life* 1912

Oil. 23¼ x 28¼
Collection: Charles Silber, Newark, N.J.

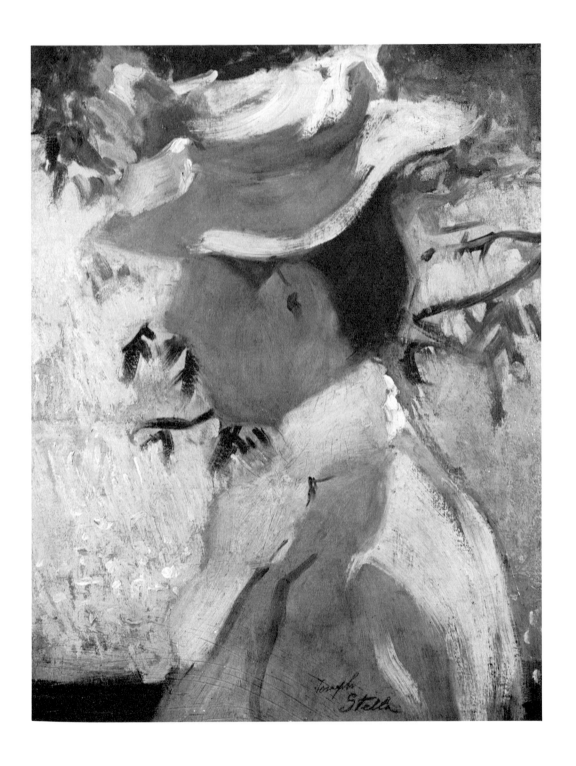

Study of a Woman c. 1912 29

Oil. 18 x 14
Collection: Dr. and Mrs. Marvin Kantor,
Whittier, California

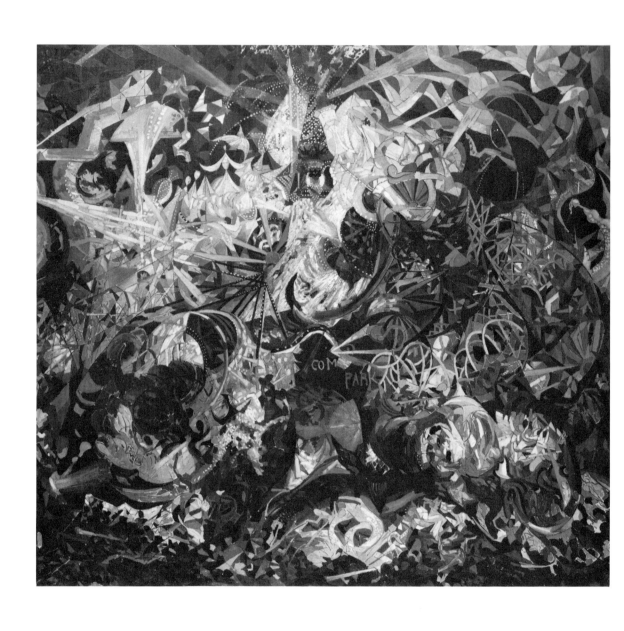

30 *Battle of Lights, Coney Island* 1913

Oil. 75¾ x 84
Collection: Société Anonyme,
Yale University Art Gallery

Battle of Lights, Coney Island, detail,
self-portrait, masked 30a

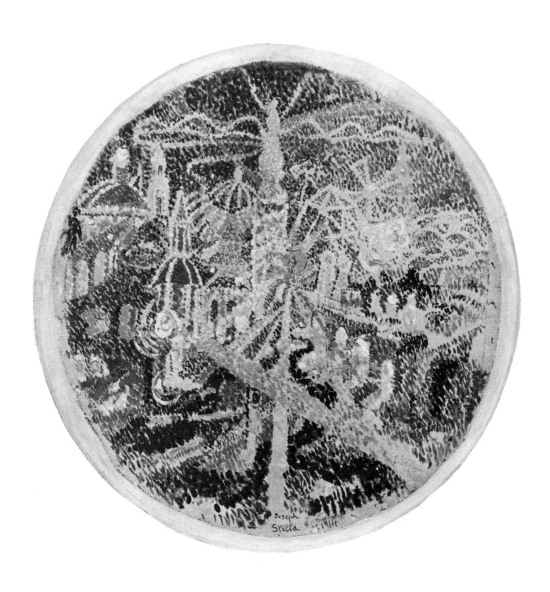

31 *Study for Battle of Lights, Coney Island* 1913

Oil. 20¼ diameter
Collection: The Museum of Modern Art, New York,
Elizabeth Bliss Parkinson Fund

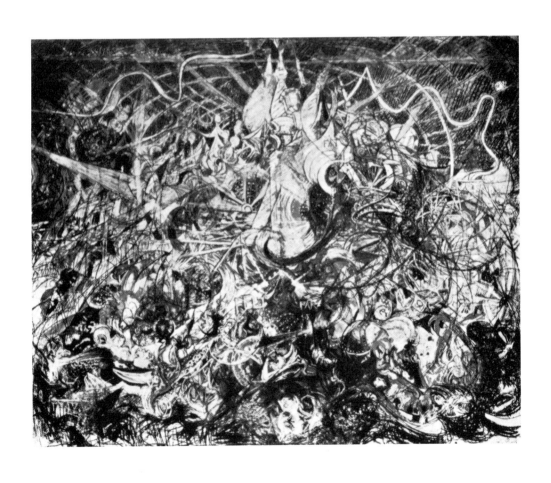

Mardi Gras c. 1913 32

Pencil(?)

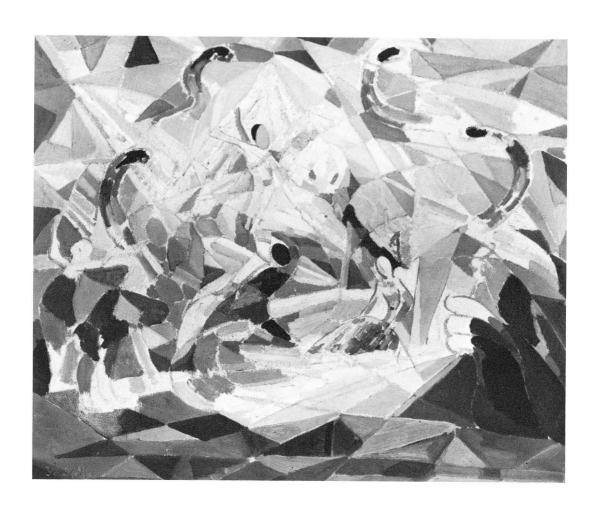

33 *Der Rosenkavalier* 1913

Oil. 24 x 30
Collection: Whitney Museum of American Art,
Gift of George F. OF

Abstraction, Garden c. 1914 34

Pastel. 18⅛ x 24 (sight)
Collection: Rabin and Krueger Gallery

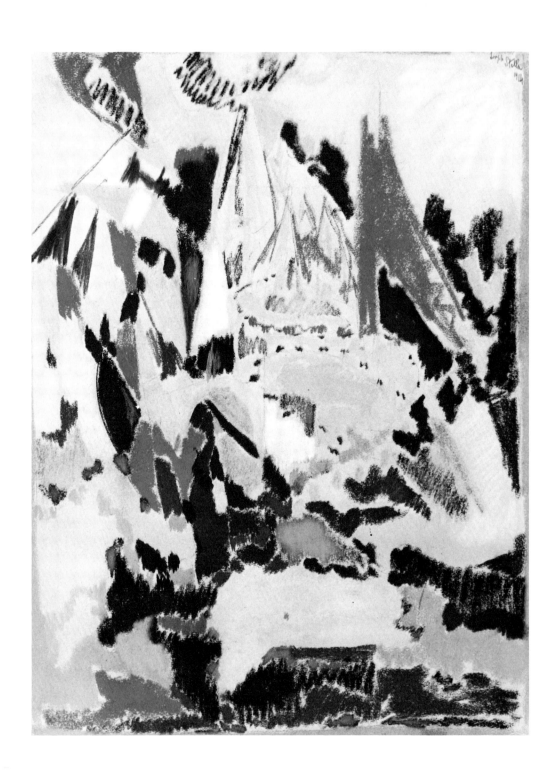

35 *Composition* 1914

Pastel. 25 x 19
Collection: Mrs. Edith Gregor Halpert

Spring c. 1914 36

Oil. 20⅜ x 14¼

Collection: Mr. and Mrs. Harry L. Koenigsberg

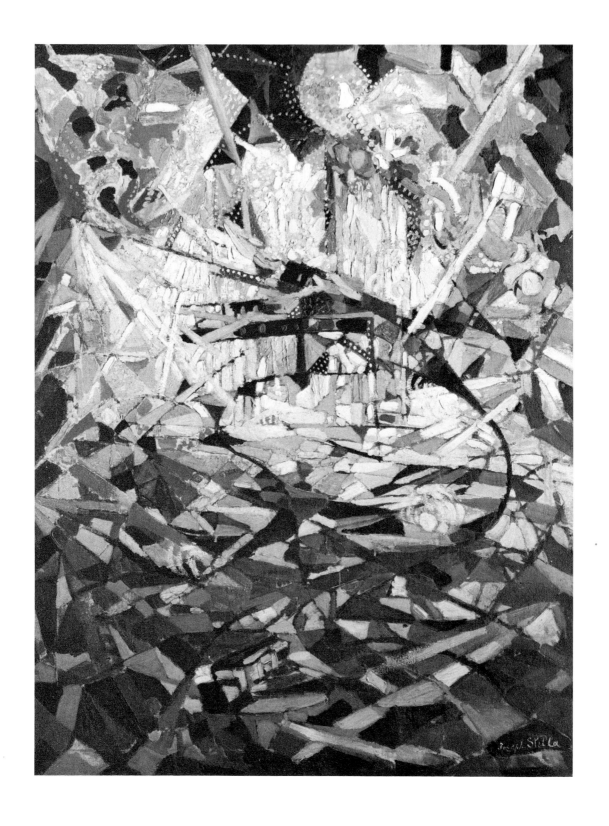

37 *Battle of Lights, Coney Island* between 1914–1918

Oil. 39 x 29½

Collection: F. M. Hall,
University of Nebraska Art Galleries

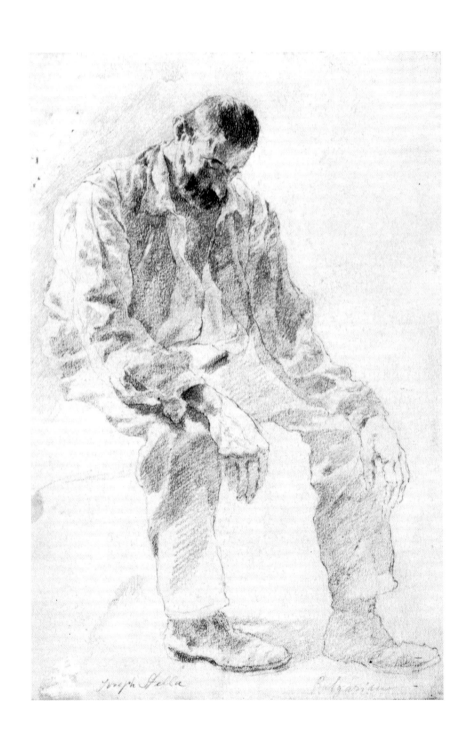

Ellis Island: A Bearded Bulgarian 1916 38

Pencil. 8⅞ x 3⅞
Collection: Rabin and Krueger Gallery

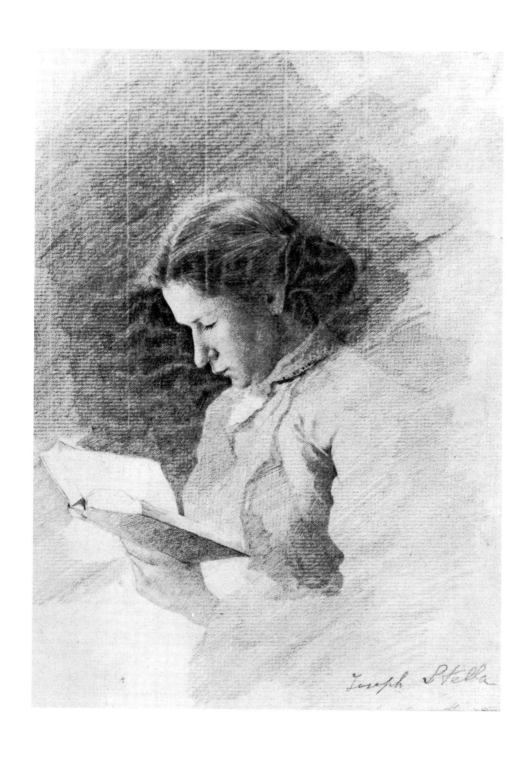

39 *Ellis Island: Young Woman Reading* 1916

Pencil. 9 x 7
Collection: Rabin and Krueger Gallery

Night 1917 40

Pastel

41 *Bethlehem: The "Insides" of the Clock of War* 1918
Charcoal(?)

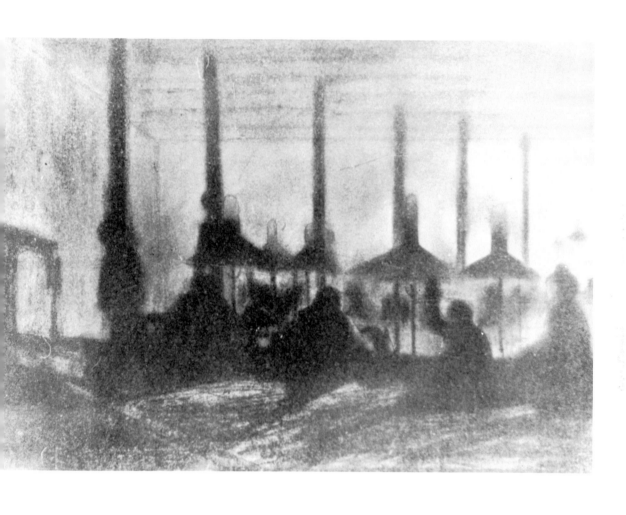

The Garment Workers: In a New York
Loft Building Workshop 1918 42
Charcoal(?)

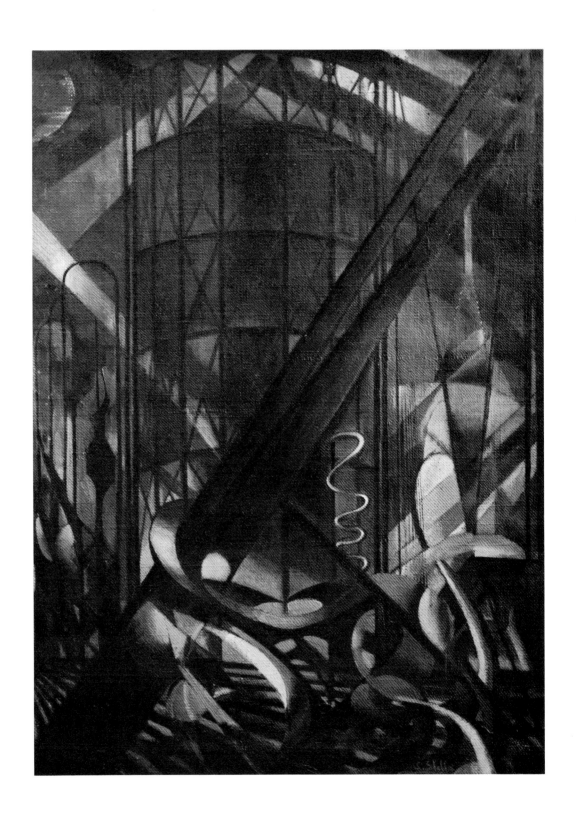

43 *The Gas Tank* 1918

Oil. 40½ x 30

Collection: Mr. and Mrs. Roy R. Neuberger

The Song of the Nightingale 1918 46
Pastel. 18 x 23 ½
Collection: The Museum of Modern Art, New York,
Bertram F. and Susie Brummer Foundation Fund

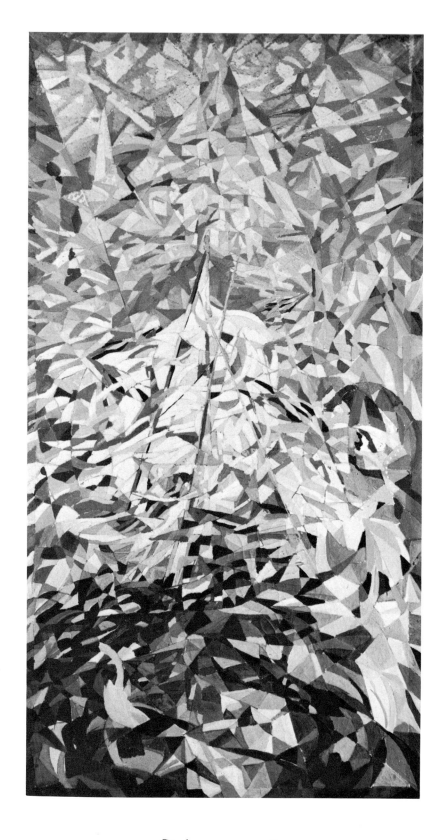

47 *Spring* c. 1918

Oil. 75 x 40⅛
Collection: Société Anonyme,
Yale University Art Gallery

Study for Brooklyn Bridge c. 1918 48

Watercolor(?)

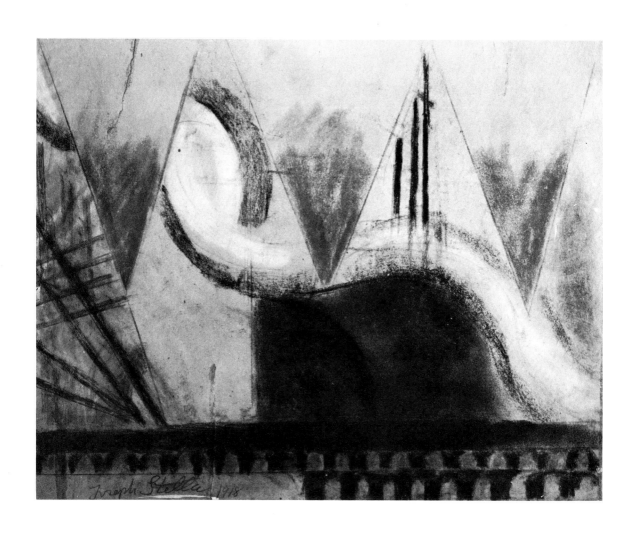

49 *Study for Brooklyn Bridge* c. 1918

Pastel. 12¾ x 16
Collection: Zabriskie Gallery

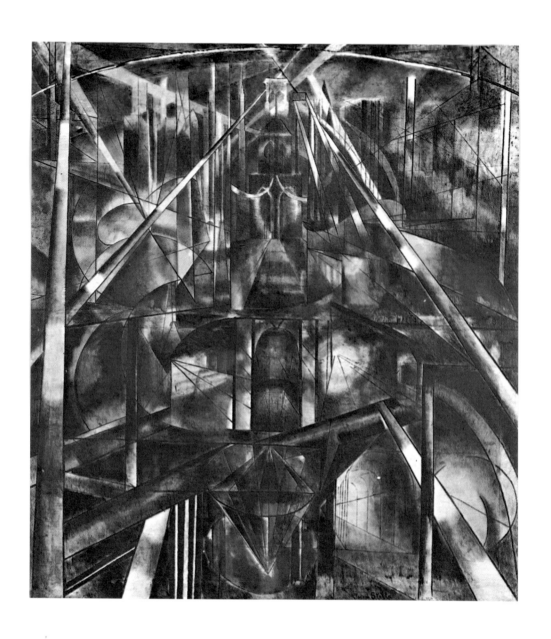

Brooklyn Bridge c. 1919 50
Oil. 84 x 76
Collection: Société Anonyme,
Yale University Art Gallery

51 *A Child's Prayer* 1919

Pastel. 23½ x 18¼

Collection: Estate of Isabel Lachaise

Flower Study c. 1919 52

Silverpoint and crayon. 12⅞ x 6½
Collection: Rabin and Krueger Gallery

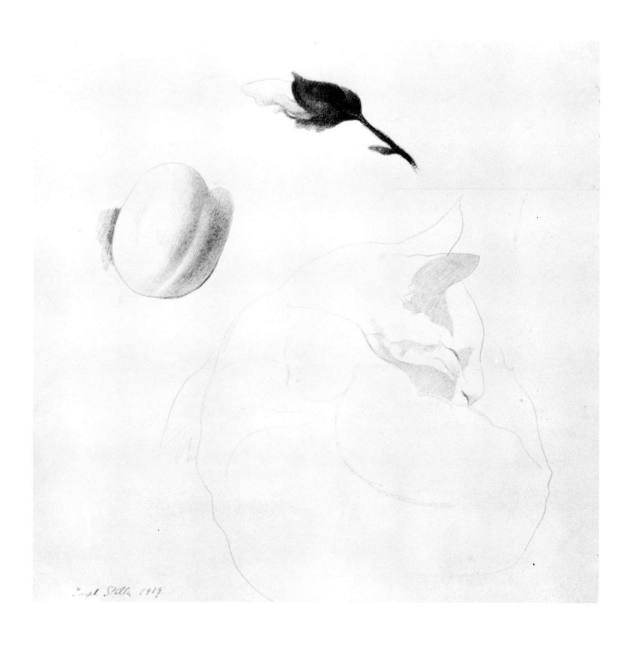

53 *Fruit, Flower, and Cat* 1919
Pencil and crayon. 8⅝ x 8⅞
Collection: Rabin and Krueger Gallery

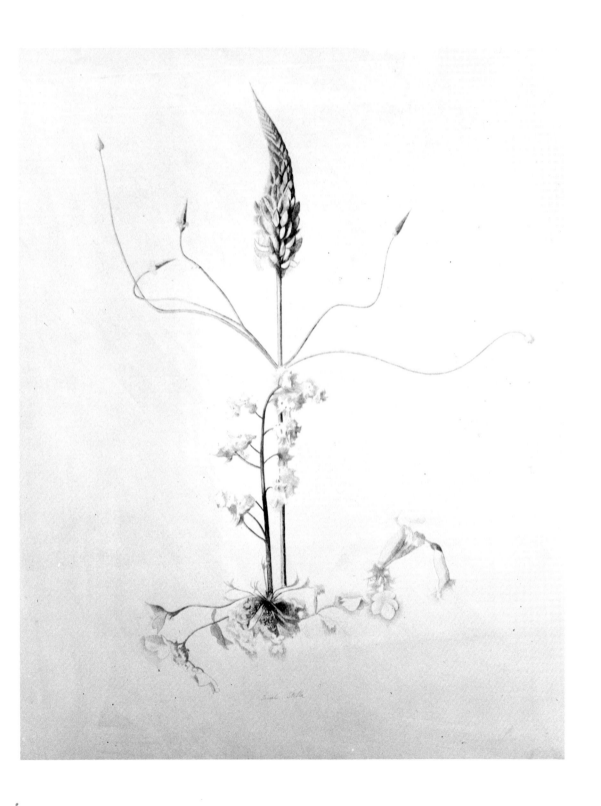

Lupine c. 1919 54

Pastel. 27½ x 21½ (sight)
Collection: Mr. Robert Tobin,
San Antonio, Texas

55 *Moon Dawn* c. 1919
Pastel

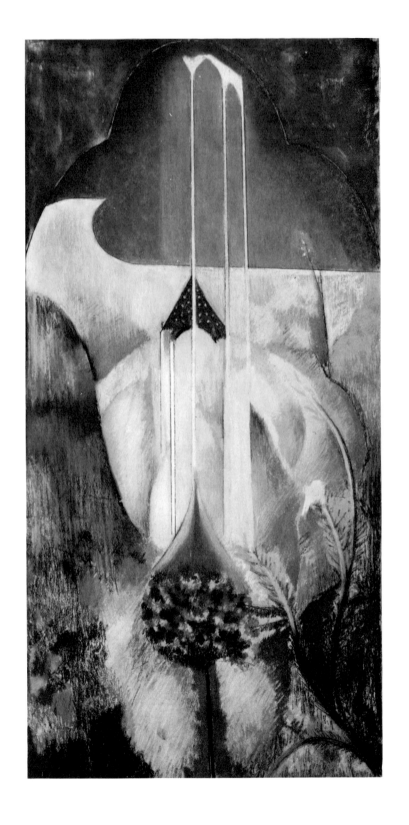

Nativity c. 1919 56

Pastel. 37 x 19⅛

Collection: Whitney Museum of American Art

57 *Pomegranate* 1919

Crayon. 14 x 18
Collection: Rabin and Krueger Gallery

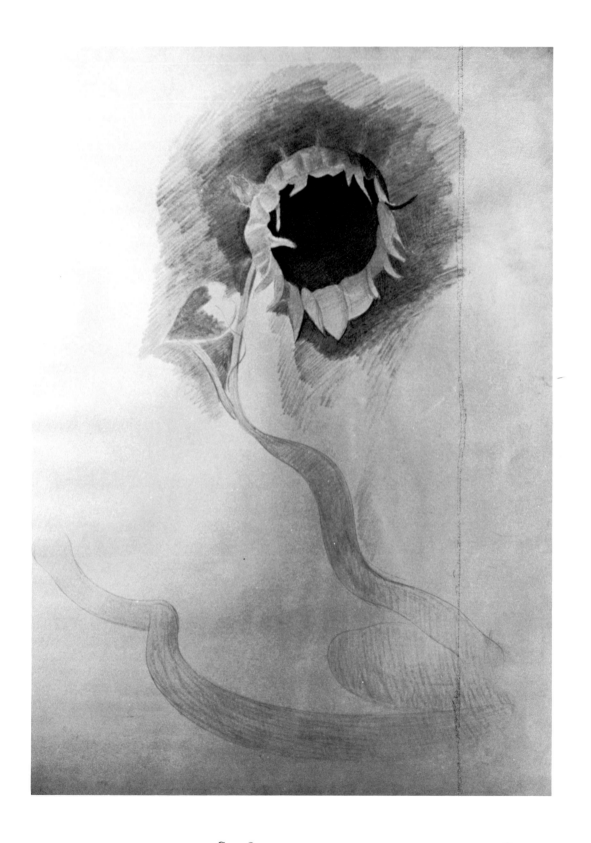

Sunflower c. 1919 58

Crayon. 28½ x 21¾
Collection: Sergio Stella,
Glen Head, N.Y.

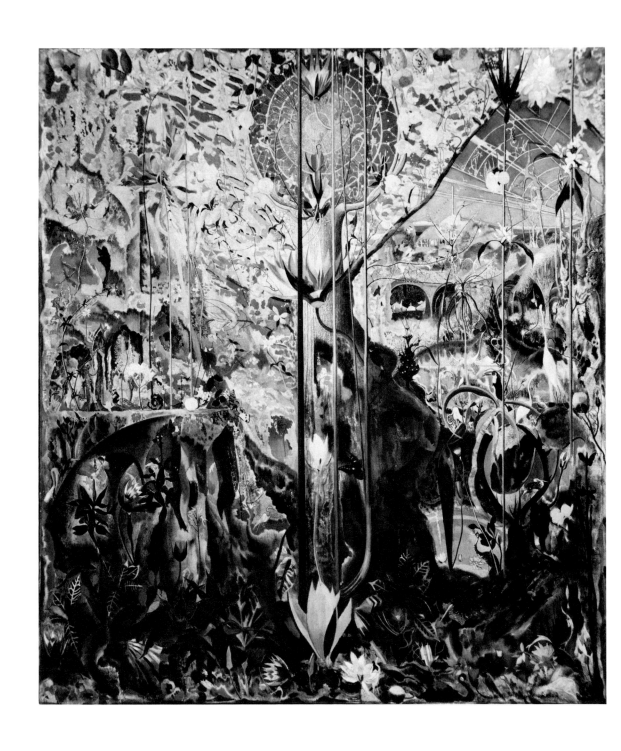

59 *Tree of My Life* 1919

Oil. 83½ x 75½
Collection: Iowa State Education Association,
Des Moines, Iowa

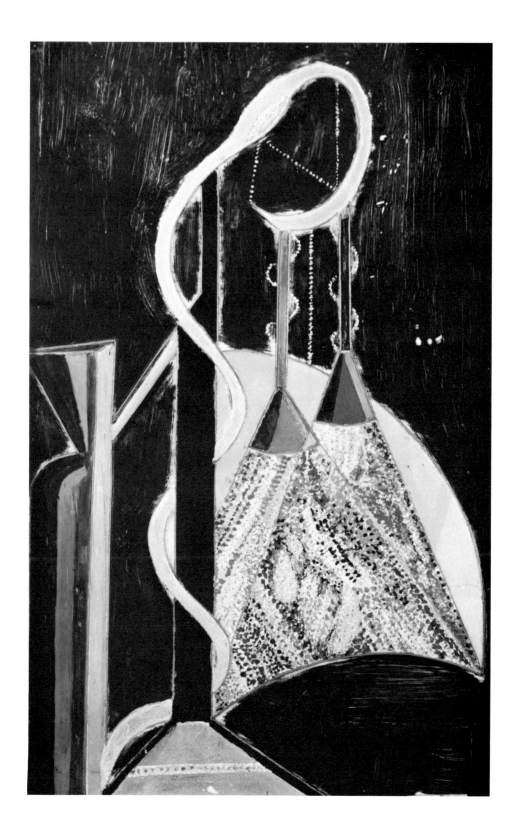

Untitled c. 1919 60

Oil on glass
Collection: Rabin and Krueger Gallery

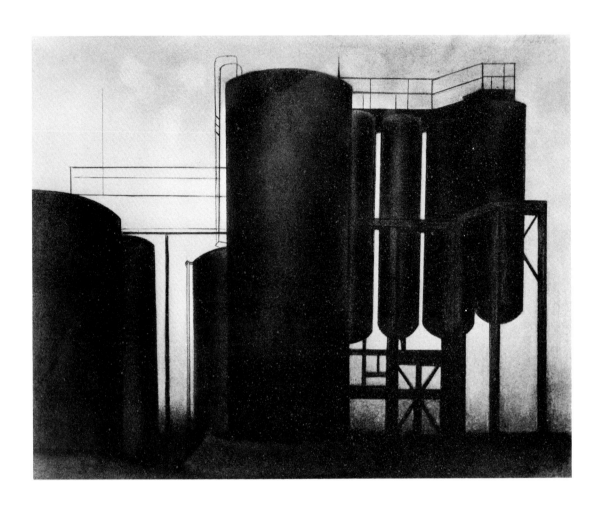

61 *By-Products Storage Tanks* c. 1920

Charcoal. 22 x 31 (sight)
Collection: Santa Barbara Museum of Art, Gift of Wright Ludington

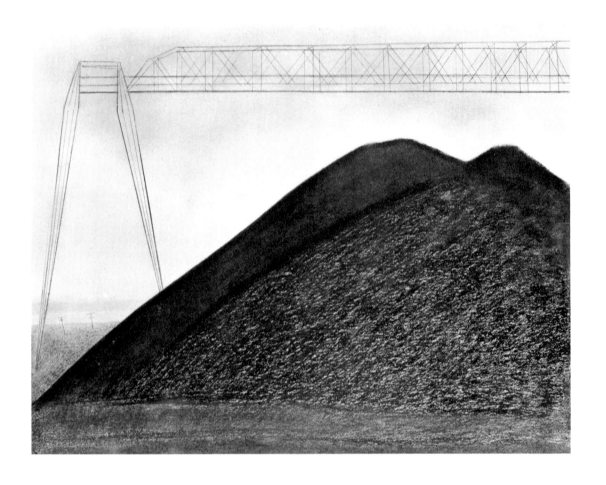

Coal Pile c. 1920 62

Charcoal. 20 x 26
Collection: The Metropolitan Museum of Art,
Whittlesey Fund, 1950

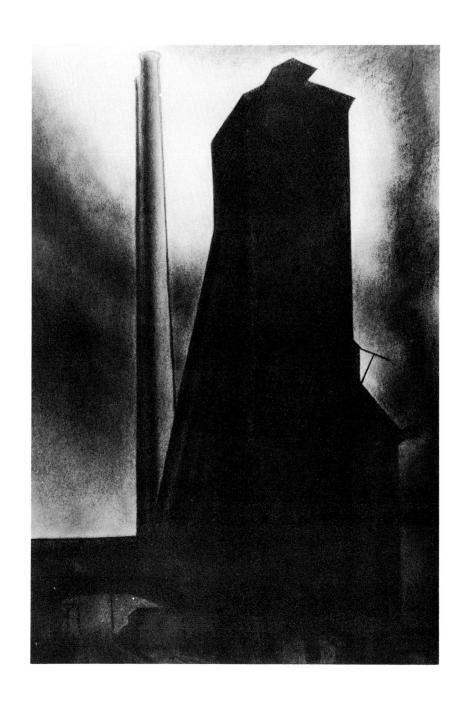

63 *Crusher and Mixer Building* c. 1920

Charcoal. 34⅛ x 22¾ (sight)
Collection: Santa Barbara Museum of Art, Gift of Wright Ludington

Orange Bars c. 1920 64

Charcoal and pastel. 24½ x 19
Collection: Mr. and Mrs. Emanuel M. Terner

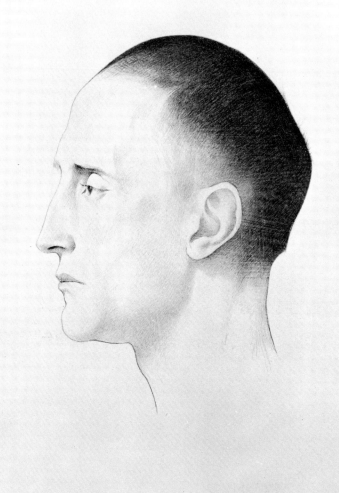

65 *Profile of Marcel Duchamp* C. 1920

Silverpoint. 28¼ x 22¼
Collection: The Museum of Modern Art, New York,
Katherine S. Dreier Bequest

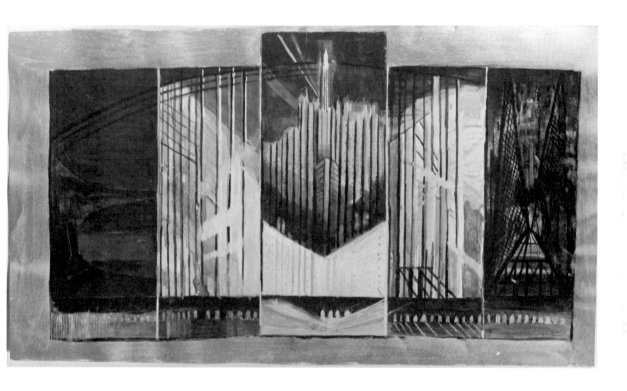

Study for New York Interpreted c. 1920 66

Watercolor and gouache. 10½ x 19⅝
Collection: Yale University Art Gallery

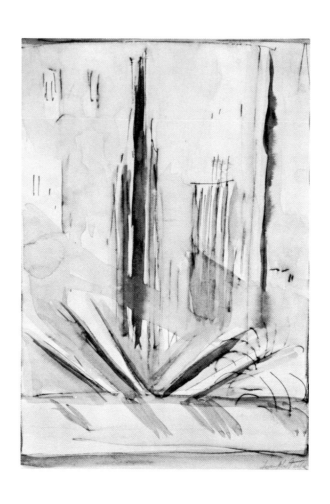

67a *Study for New York Interpreted* c. 1920
City Buildings

Pen and wash. 11¾ x 8¼
Collection: Rabin and Krueger Gallery

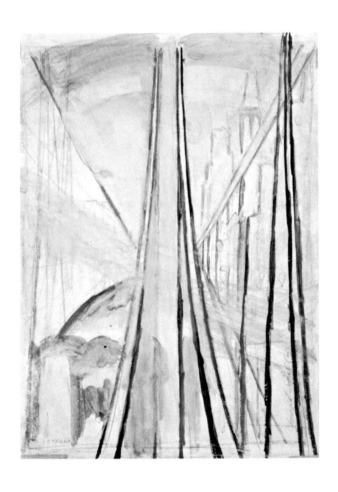

Study for New York Interpreted c. 1920 67b
The Bridge

Crayon and watercolor. 12 ⅜ x 9 ¼
Collection: Rabin and Krueger Gallery

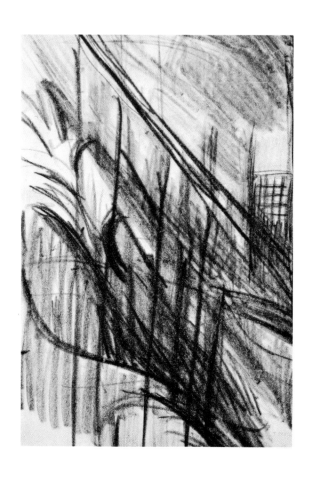

67c *Study for New York Interpreted* c. 1920
The Bridge

Crayon. 13¾ x 9¾
Collection: Rabin and Krueger Gallery

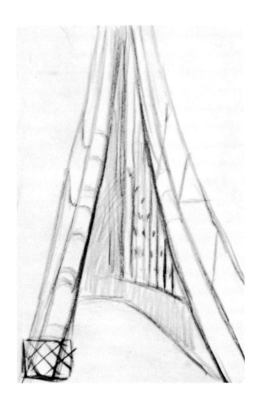

Study for New York Interpreted c. 1920 68a
The Bridge

Crayon. 7 x 4½
Collection: Rabin and Krueger Gallery

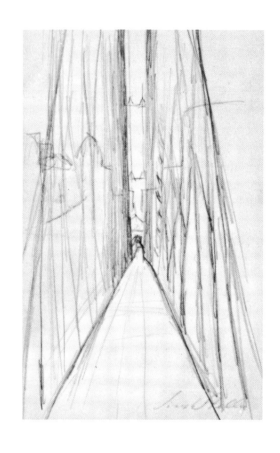

68b *Study for New York Interpreted* c. 1920
The Bridge

Pencil. 7⅞ x 4⅞
Collection: Rabin and Krueger Gallery

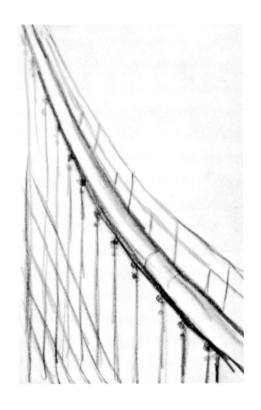

Study for New York Interpreted c. 1920 68c
The Bridge

Crayon. 7 x 4½
Collection: Rabin and Krueger Gallery

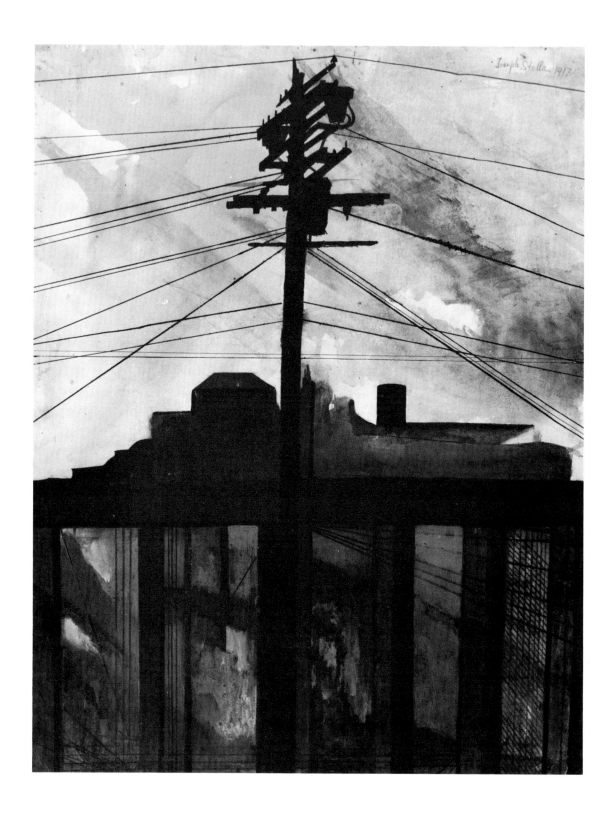

69 *Telegraph Pole* c. 1920

Gouache. 24½ x 19½
Collection: Mr. and Mrs. M. P. Potamkin,
Philadelphia, Penn.

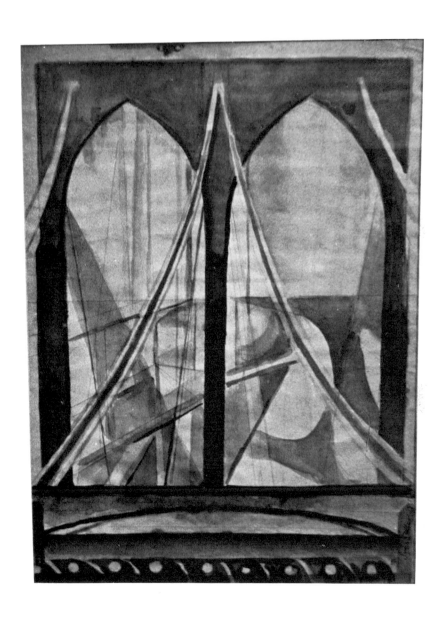

Sketch for New York Interpreted,
"The Bridge" between 1920—1922 70

Pastel 23 x 17
Collection: The Downtown Gallery

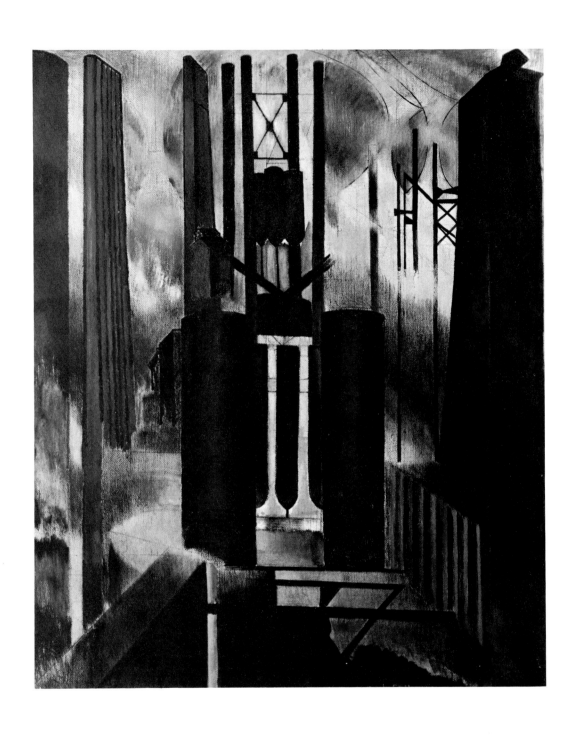

71 *Factories* c. 1921

Oil. 56 x 46
Collection: The Museum of Modern Art, New York,
Lillie P. Bliss Bequest

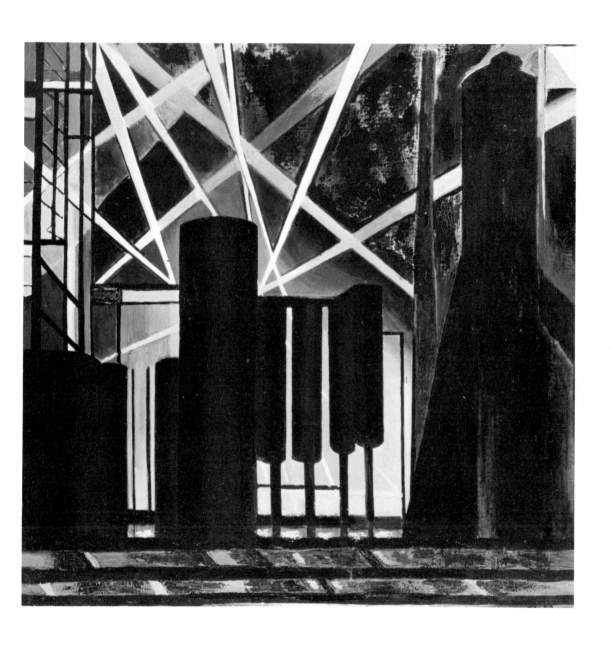

Factories c. 1921 72

Oil 24 x 24

Collection: The Art Institute of Chicago

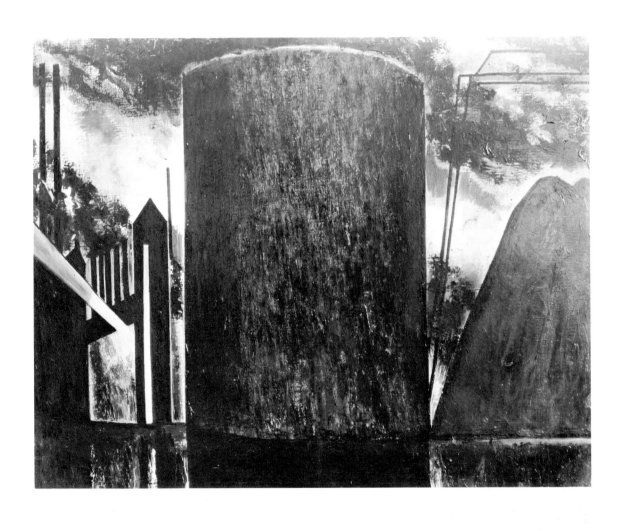

73 *Factories at Night — New Jersey* c. 1921

Oil. 28⅞ x 36½

Collection: The Newark Museum, Newark, N.J.

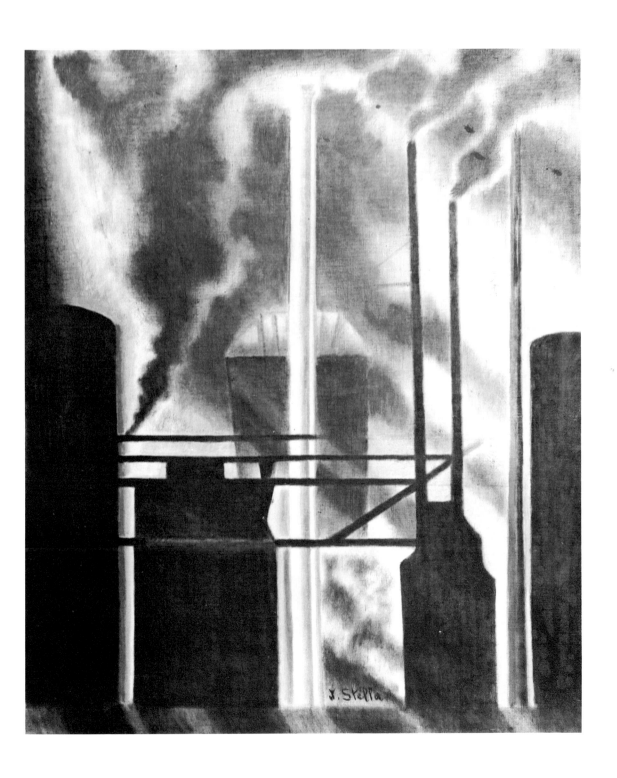

Smoke Stacks c. 1921 74

Oil. 36 x 20
Collection: Art Department, Indiana State University,
Terre Haute, Indiana

*"New York . . . monstrous dream,
chimeric reality, . . . Alma Mater
of the derelict of all the world."*

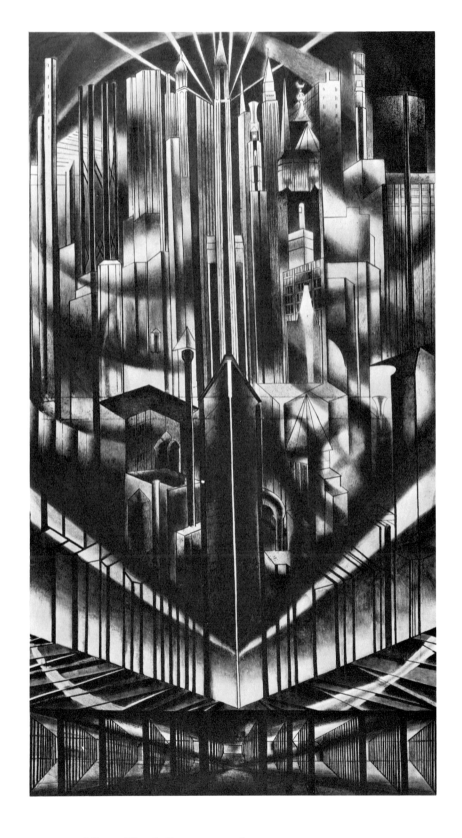

New York Interpreted 1920–1922 75a
"The Skyscrapers"

Oil. 99¾ x 54
Collection: The Newark Museum, Newark, N.J.

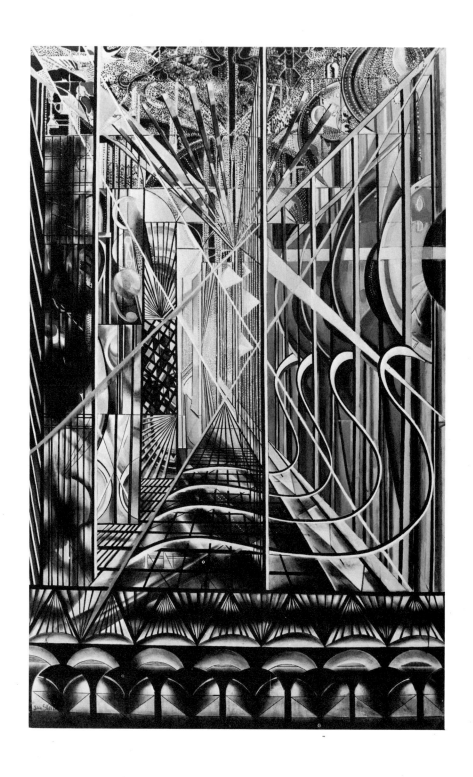

75b *New York Interpreted* 1920–1922
"*White Way, I*"

Oil. 88½ x 54
Collection: The Newark Museum

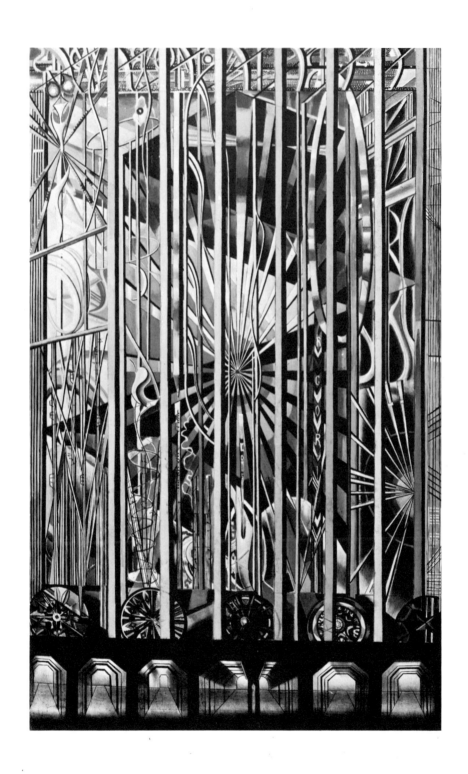

New York Interpreted 1920–1922 75c
"*White Way, II*"

Oil. 88½ x 54
Collection: The Newark Museum

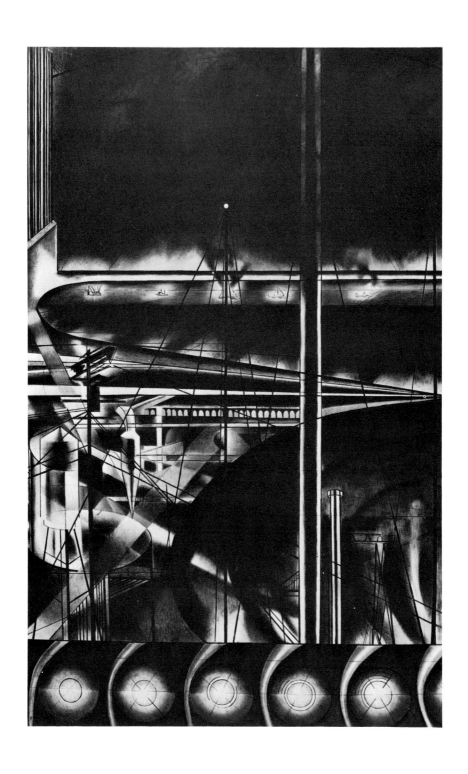

75d *New York Interpreted* 1920–1922
 "The Port"

 Oil. 88½ x 54
 Collection: The Newark Museum

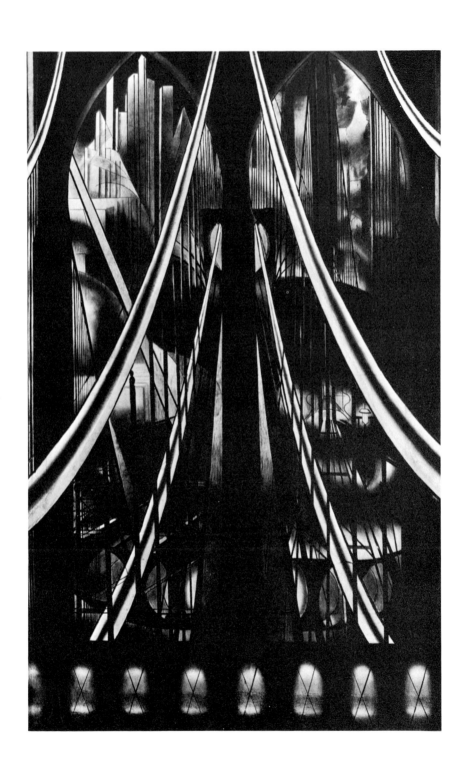

New York Interpreted 1920–1922 75e
"The Bridge"

Oil. 88½ x 54
Collection: The Newark Museum

New York Interpreted,
"*The Bridge*," *detail*, "*PAID*"

75f

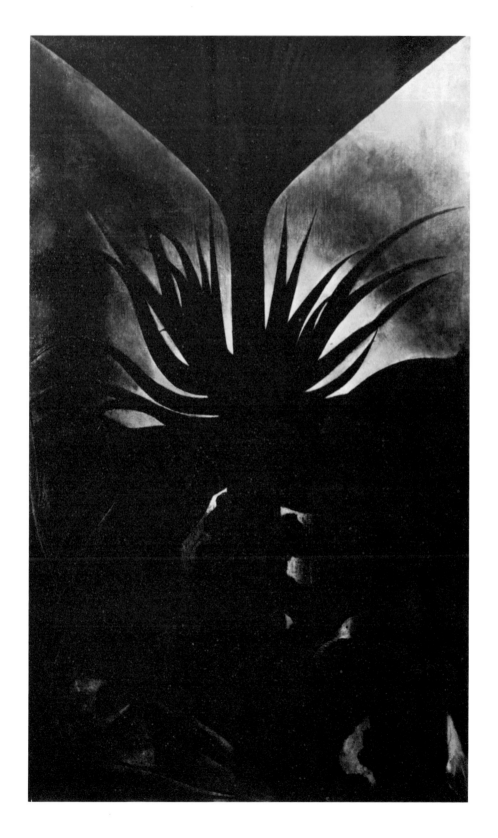

Tropical Sonata c. 1921 76

Oil. 48 x 29

Collection: Whitney Museum of American Art

77 *Study for Skyscraper* c. 1922
Collage

The Bookman c. 1922 78

Collage 7 x 4½

Collection: Joseph H. Hirshhorn

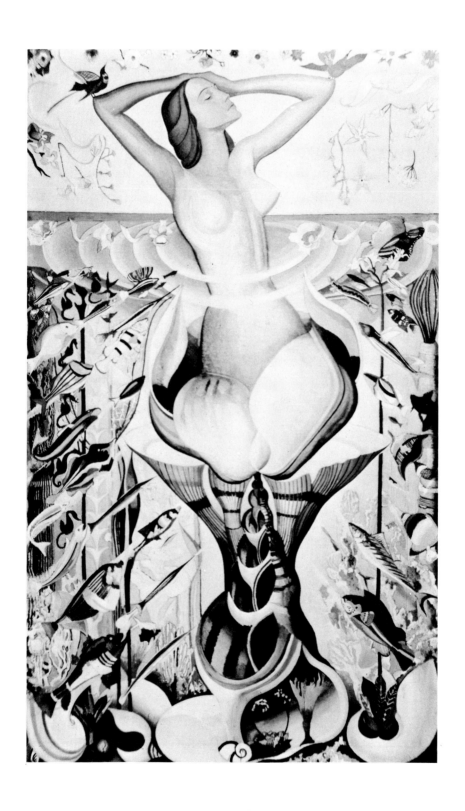

79 *The Birth of Venus* 1922

Oil. 85 x 53

Collection: Iowa State Education Association

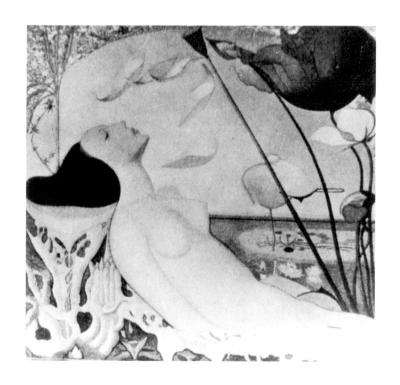

Undine 1922 80

Oil.

Former colletion: Stephen C. Clark?

81 *The Virgin* 1922

Oil. 39⅜ x 38¾
Collection: The Brooklyn Museum

The Amazon 1924 82

Oil. 27 x 22
Collection: Rabin and Krueger Gallery

83 *Portrait of Helen Walser* c. 1925

Oil

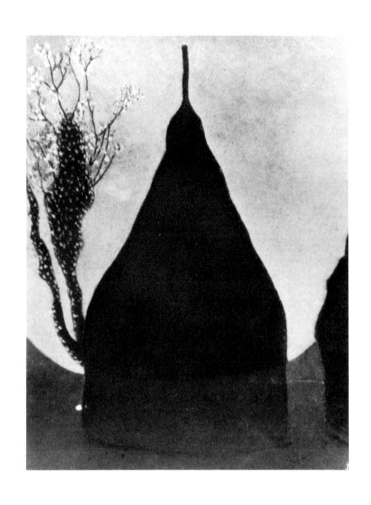

Morning c. 1927 88
Oil

89 *Muro Lucano* 1928

Oil. 32 x 25¾
Collection: Lawrence H. Bloedel,
Williamstown, Mass.

Sirenella c. 1928 90
Oil

91 *American Landscape* c. 1929

Oil. 78½ x 39 (sight)

Collection: Walker Art Center, Minneapolis

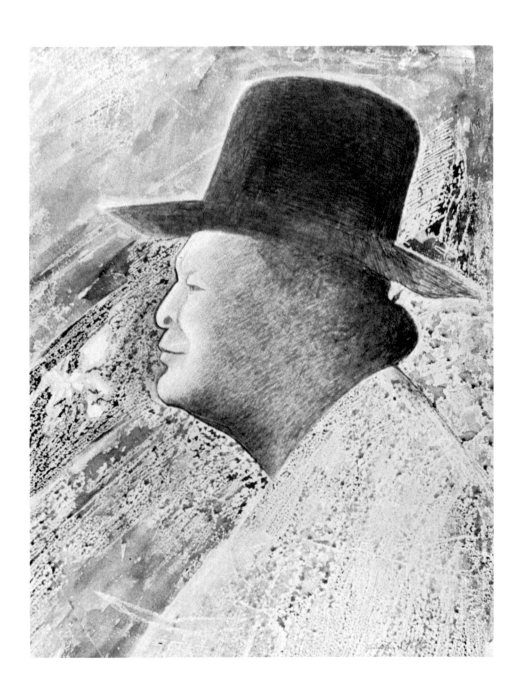

Self-Portrait c. 1929 94

Watercolor and wax. 20 x 15 ½
Collection: Mr. and Mrs. Herbert A. Goldstone

95 *Still Life with Yellow Melon* 1929

Oil. 15 x 18⅞
Collection: Rabin and Krueger Gallery

Marionettes c. 1930 96

Oil. 25½ x 32¼
Collection: Rabin and Krueger Gallery

97 *Impression of Venice* c. 1931

Oil. 20¾ x 16½
Collection: Mrs. Joanna Davanzo,
Essex Fells, N.J.

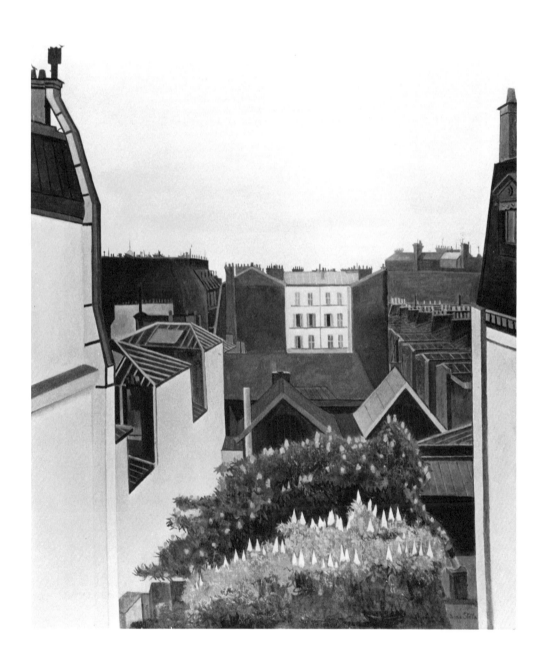

Paris Rooftops 1931 98

Oil. 39¼ x 33⅜
Collection: Mr. and Mrs. Samuel Halpern,
East Orange, N.J.

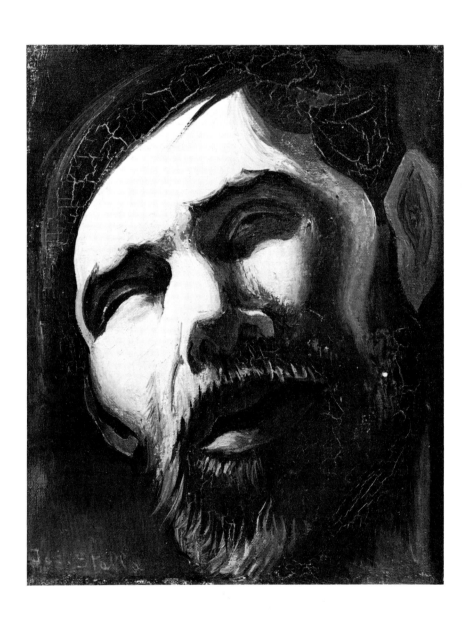

99 *Head of Christ* c. 1933
Oil. 9½ x 7½
Collection: Mr. and Mrs. Herbert A. Goldstone

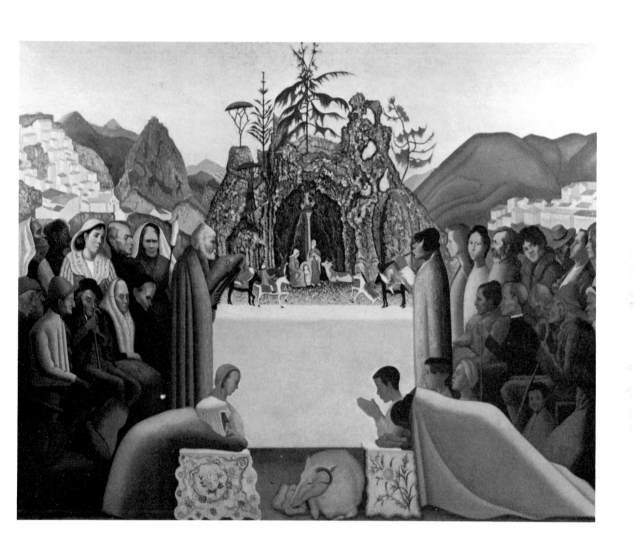

The Holy Manger c. 1933 100

Oil. 60 x 76

Collection: The Newark Museum, Newark, N.J.

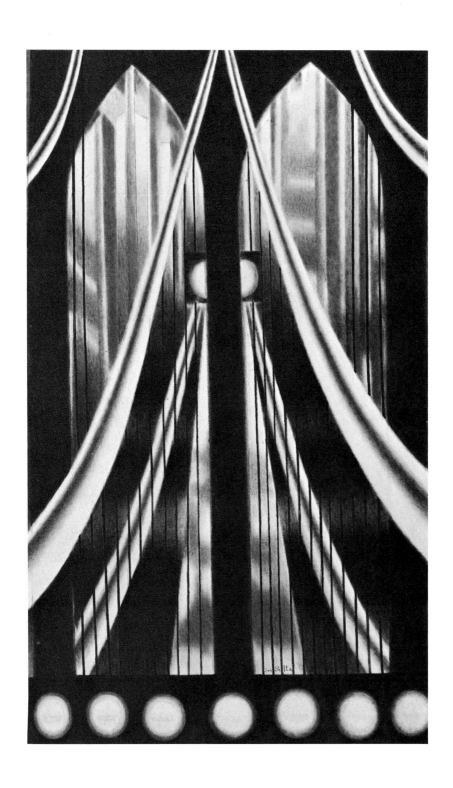

101 *Bridge* c. 1936

Oil. 55½ x 35½

Collection: San Francisco Museum of Art,
Work Projects Administration Allocation

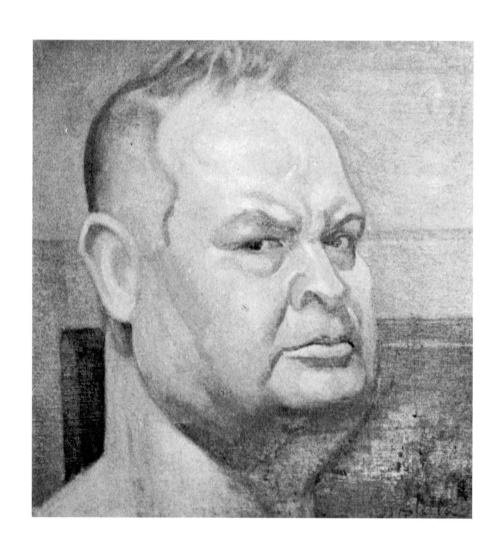

Self-Portrait c. 1937 102
Oil

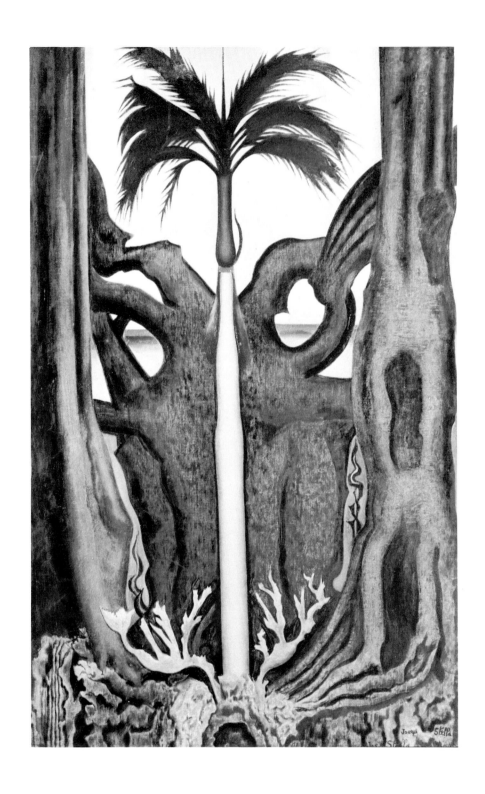

103 *Song of Barbados* 1938

Oil. 58 x 37
Collection: Rabin and Krueger Gallery

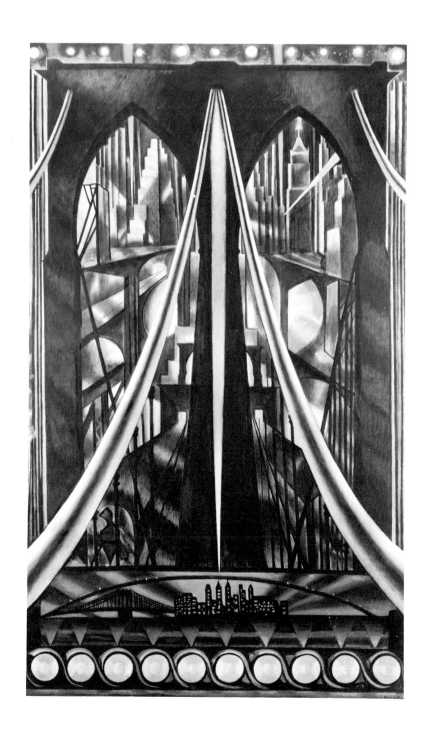

Brooklyn Bridge: Variation on an Old Theme 104
1939
Oil. 70 x 42
Collection: Whitney Museum of American Art

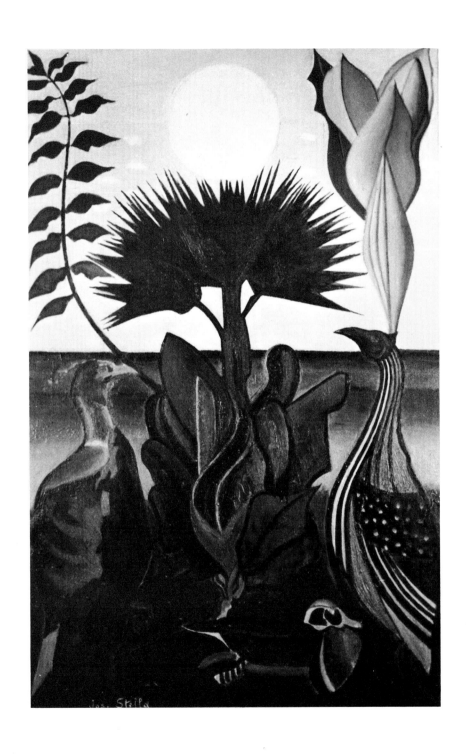

105 *Full Moon, Barbados* 1940

Oil. 36 x 25
Collection: Sergio Stella,
Glen Head, N.Y.

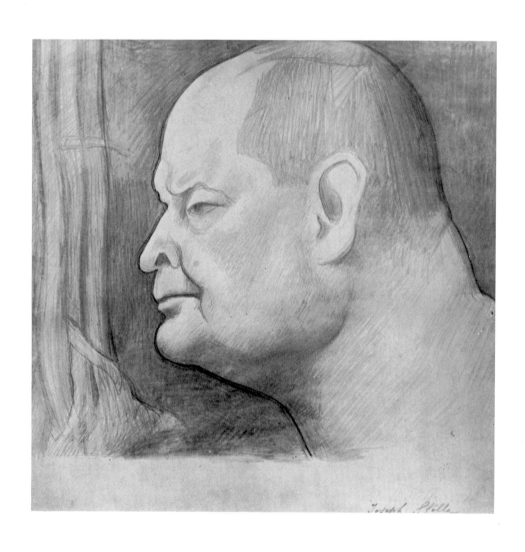

Self-Portrait c. 1940 106

Silverpoint. 13¾ x 13¾
Collection: Mr. and Mrs. Moses Soyer

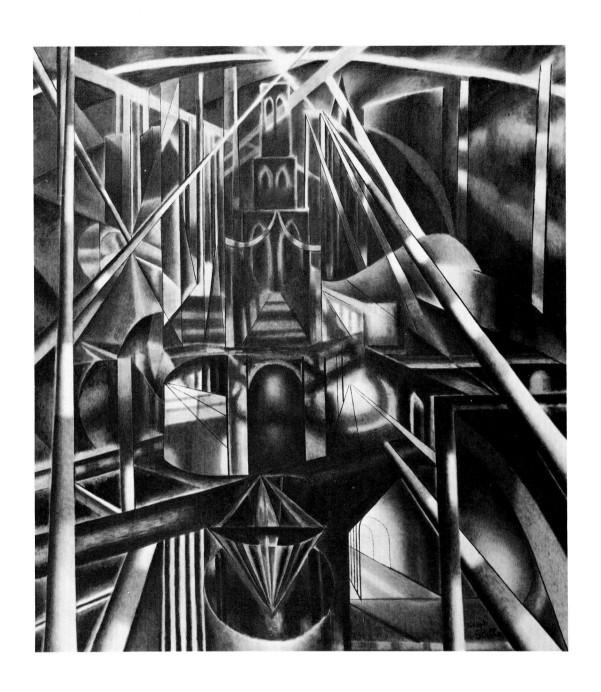

107 *Old Brooklyn Bridge* c. 1941

Oil. 76 x 68

Collection: Wright Ludington,
Santa Barbara, California

Figures, including Self-Portrait c. 1944 108

Pencil and wash. 7¾ x 13⅛

Collection: Rabin and Krueger Gallery

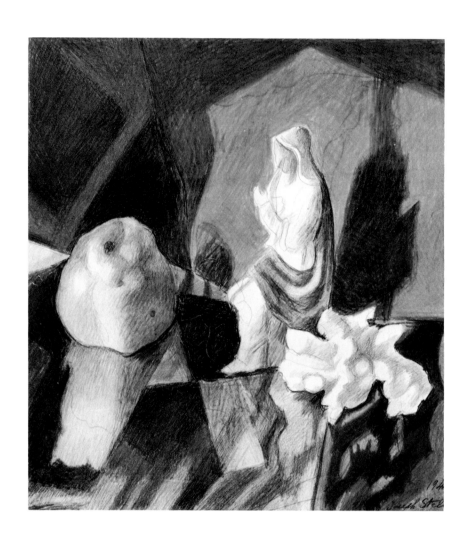

109 *Still Life with Small Sculpture* 1944

Pencil and crayon. 14 x 13½

Collection: Mr. and Mrs. John D. Frisole, Short Hills, N.J.

Number 21 n.d. 110

Collage. 10½ x 7½
Collection: Whitney Museum of American Art

111 *Graph* n.d.

Collage. 13 x 9⅞
Collection: Robert Schoelkopf Gallery

Head n.d.

Collage. 12 x 9
Collection: Mrs. Frederick Arkus,
Yorktown Heights, N.Y.

Leaf n.d.

Collage with natural leaf. 11 x 8½
Collection: Zabriskie Gallery